A LANDSCAPE OF INSECTS
— AND OTHER INVERTEBRATES —

A LANDSCAPE OF INSECTS
— AND OTHER INVERTEBRATES —

Duncan Neil MacFadyen

Photographs by Shem Compion

First published by Jacana Media (Pty) Ltd in 2009

10 Orange Street
Sunnyside
Auckland Park 2092
South Africa
+2711 628 3200
www.jacana.co.za

© Text: Duncan Neil MacFadyen, 2009
© Photographs: Shem Compion, 2009

All rights reserved.

ISBN 978-1-77009-767-4

Front cover pic: Monkey Beetle, *Peritrichia* species,
 on flowering succulent in Namaqualand
Cover and text design by Jacana Media
Set in RomanSerif
Printed by Craft Print, Singapore
Job No. 001023

See a complete list of Jacana titles at www.jacana.co.za

For over thirty years, Strilli Oppenheimer has initiated conservation and research projects on invertebrates. This book is dedicated to her in appreciation for this work. She has always encouraged an appreciation of the small creatures with which we share this planet.

Contents

◄ The breathtaking beauty of the many flowering plants in Namaqualand is the first sign of the wealth of invertebrate life that can be found here.

Foreword .. ix

Acknowledgements ... xi

Introduction ... xv

Limpopo Basin, Limpopo Province 1

Bankenveld Grassland, Gauteng Province 51

Urban Gardens, Gauteng Province 121

East Coast, KwaZulu-Natal 141

Kimberley, Northern Cape 165

Kalahari, Northern Cape .. 211

Namaqualand, Northern Cape 253

Glossary .. 270

Bibliography ... 273

Index .. 274

Foreword

◀ Insects are abundant in this flower paradise – you just have to look for them.

Who would have thought that by exploring the magnificent landscapes and unique ecosystems of the Diamond Route, there would emerge a gem that invites us to explore the most unknown of our creatures – our insects and invertebrates – yes, the creatures that are unknowingly so much a part of our lives? In reading this book, my eyes were opened to a world that I almost did not know existed or, should I say, had taken for granted.

We have many books and educational devices that teach us about the popular mammals, birds, trees and plants, but I have found very few books that illustrate the life of insects and invertebrates in such a unique, informative and interesting manner. This is not surprising at all though, as it has been written by Duncan MacFadyen, who has a deep-rooted passion for conservation in general and for our previously ignored creatures in particular. Duncan has managed to fill the gap in the literature, for the first time allowing us to touch our own environment. It was interesting to discover that many of the invertebrates featured in this book had never appeared in any form of literature before.

The insects were all photographed in their natural environment by Shem Compion, who illustrates not only their uniqueness but also how they are connected to and interact with their environment. Shem captures the beauty of each creature. It is of great value to see these systems in operation on properties being protected by De Beers and the Oppenheimer family, our beautiful Diamond Route. This is a massive national brand which links the properties owned by the Oppenheimer family and De Beers, conserving vast conservation areas and providing a safe haven for a wide variety of unique, rare and ecologically important plants and wildlife as portrayed in this book.

The book highlights the importance of our invertebrates. It is ecologically based, highly informative and a must-read for all nature lovers. It provides us with new educational experiences for young and old alike.

I should like to congratulate all who took part in bringing this book to life. I hope everyone who reads it will enjoy the exploration.

NF Oppenheimer
Chairman, De Beers Consolidated Mines

Acknowledgements

◄ Grasslands are particularly rich in insect species diversity and abundance and are thus important to conserve.

To produce a work like this requires an enormous amount of input, support and knowledge from various sources. I would like to thank Denis Brothers, Ruth Müller, Beth Grobbelaar, James Harrison, Shirley Hanrahan, Margaret Keiser, Dawid Jacobs, Peter Roos, Keith Roos, Mike Picker, Riaan Stals, Mervyn Mansell, Martin Kruger, Graham Henning, Clarke Scholtz, Michael Stiller, Jason Londt, Richard Stephan, Warwick Tarboton, Michelle Hamer, Hamish Robertson, Ansie Dippenaar, Ian Engelbrecht, Lynn Owen and John and Astri Leroy for their generous assistance.

Warwick Davies-Mostert, Cyrintha Barwise, John Power, Jackie Sparke, Cheryl Forester, Elsabe Bosch, Johan Kruger, Andrew Stainthorpe, Sharon Stainthorpe, Dudley Wessels, Tim Neary, Aletta Wessels, Gus van Dyk, Antoinette Froneman, Ross Berber, Barry Peiser, Madelaine Goodman, Maroti Tau and Dawid Klopper assisted me a great deal in the field and provided the logistic support required to ensure the success of this book.

I would like to thank my father and mother, Neil and Jane MacFadyen, for their company and help on my field trips and for their never-failing support and guidance throughout the duration of this project.

Paul Durand deserves special thanks for his assistance in reviewing parts of the manuscript and for his enthusiasm and support.

A special thank you goes to Keith Roos, and John and Astri Leroy for allowing me to use some of their excellent photographs of spiders, scorpions and butterflies taken at Brenthurst Garden, Venetia Limpopo Nature Reserve and Benfontein Farm. Thank you to John Leroy for all the information. I thoroughly enjoyed our exciting discussions on spiders.

My thanks also go to Dawid Jacobs for helping me to identify the tricky heteropterans, for giving me information on their ecology and for his willingness to assist at all times.

Jacana Media undertook to publish this book; Bridget Impey, Janet Bartlet, Russell Martin, Shawn Paikin, Jenny Prangley and Kerrie Barlow deserve thanks for their enthusiasm and support throughout the process.

Thank you also to Suzette Plantema for taking on the daunting task of editing the book and for her excellent advice and to Clarke Scholtz and

▲ Longhorn beetles have characteristic, long antennae from which these wood-boring beetles get their name.

▼ Weevils are beetles that have long snouts used for piercing plant tissue.

▶ Spiders often wait patiently to ambush prey on grass inflorescences.

xii A Landscape of Insects

Dawid Jacobs for reviewing the content.

A huge thank you goes to Ruth Müller, her wonderful friendship, companionship on field trips, enthusiasm and great knowledge of a wide array of beetle species meant a lot to me during the preparation of this book. Thank you also for always having a cold beer waiting when I needed it most.

Thank you, Shem Compion, the main photographer of this book. I greatly appreciated your company, friendship, shared passion for the African bush and endless patience when mine was running out, especially when a prize beauty flew away into the bush without a photograph. Your work is outstanding and it is an honour to have worked in the field with you.

Finally, I would like to thank Nicky and Strilli Oppenheimer, whose great passion for insects and all other invertebrates was the driving force behind this book. The great diversity of creatures represented in this book were photographed on their properties collectively referred to as the Diamond Route. What a huge contribution these areas make to conservation in South Africa! Thank you.

Duncan MacFadyen

Acknowledgements

This book could not have been produced without the help, support and resourcefulness of a select group of people. I am thankful to all who contributed and gave their time in helping us.

Thank you to Mr and Mrs Oppenheimer, who through their love of insects and nature have made this project possible. Without such patrons, important projects such as this may never come to fruition.

Cyrintha Barwise, Andrew Stainthorpe, Maroti Tau, John Power, Elsabe Bosch, Sharon Stainthorpe, Gus van Dyk, Antoinette Froneman, Peter Roos, Warwick Davies-Mostert and Ansie Dippenaar: I thank you for sharing your knowledge, logistical support and assistance when in the field and for accommodating us on our travels.

To Zendré Lategan, thank you for your never-ending support and love, even when I was away more than at home. Your enthusiasm, encouragement and also being my harshest critic are greatly appreciated. I will never forget your words 'Context, I want to see context …'

To my family, Ruth and Sara Compion, thank you for your constant support and love. If there have been any who have believed in my photography and in me, it is you two, and I will always appreciate that.

I would like to acknowledge Ruth Müller, who joined us on most of our field trips. Ruth, it was a joy to learn from such a knowledgeable but humble person. I feel a better person for knowing you.

From the first time we discussed the idea of this book, Duncan MacFadyen's infectious enthusiasm has never faltered. Duncan, thank you for all you have done to turn a great idea into a success. Your friendship, companionship, photographic assistance and knowledge of insects are greatly appreciated, especially when a cold one is calling at the end of a hot photo shoot.

Thank you to Jacana and in particular Bridget Impey, Janet Bartlet and Kerrie Barlow for taking on the project and pushing us to make all the deadlines.

To my photographic colleagues, and specifically Andre Cloete and Greg du Toit: thank you for your input and creative discussions, which stimulated a lot of my creativity for this book. Thank you also to Greg Mathee from NPS, Nikon SA for help with equipment and support during this project.

Shem Compion

▲ The comical face of the royal tiger beetle is distinctive.

▼ The motionless, yet beautifully coloured dancing jewel is a characteristic sight along many rivers and streams.

▼ Certain species of ladybirds feed on plant matter and visit flowers on which to feed.

Introduction

◀ The skyline in the northern Limpopo province is broken by the eerie shapes of majestic baobab trees, home to numerous insect species that live in or on practically every part of the tree.

This book is intended to introduce readers to the great beauty, diversity and ecological importance of South African insects as found on the so-called Diamond Route. This is a range of nine properties scattered across South Africa that are owned by De Beers and the Oppenheimer family and that exist primarily to promote conservation and research. The invertebrates investigated in this book were observed in the range of habitat types found on the Diamond Route, which include mopane woodland, riverine forest, bankenveld grasslands and the evocative sandscapes of the Kalahari. South Africa's richly endowment of insect life is amply reflected in this volume. The book is a stepping stone in the process of documenting and conserving this huge diversity. It is of vital importance that the invertebrate species represented here and their ecological processes remain available for our use and appreciation in the future.

Invertebrate groups constitute an abundant, diverse and highly successful form of life on earth and they count among our most trusted and valued friends. They are commonly found in every house, garden and reserve and form part of the abundant wildlife seen on walking trails. By introducing the public to the most common group of creatures and presenting both common and unique insects in an aesthetically pleasing way, this book fills a gap that has long existed. Even though there are many nature enthusiasts and outdoor activities are very popular in this country, most nature lovers ignore insects (with the exception of the larger, more colourful ones). This book will ensure that the complaint 'We saw nothing in the game park' need never be voiced again. Heightening and attuning one's senses to smaller creatures will make the game park or even one's own garden a guaranteed adventure.

The importance of insects in various ecological processes and the extent of their biodiversity should not be underestimated. Although insects are an abundant and highly successful group, they have not been given the recognition they deserve for the immense task they perform. For instance, many people do not know that an insect feeding on plant matter can consume a greater biomass than the large herbivores in a reserve. Insects

xvi A Landscape of Insects

▲ At certain times of the year, *Protea caffra* flowers brighten the grassy landscape of the Bankenveld and attract hordes of creatures of different shapes, colours and sizes.

▼ Contrasting with the undulating grassy plains, the river courses dissecting the Bankenveld have characteristic rocky red outcrops and are often well wooded.

are also a vital food source for numerous other creatures, including birds, small mammals, fish, reptiles and other invertebrates. Birds migrate to reach warmer climates where insects are available as food. A huge number of migratory birds and birds with local movements are dependent on insects. Even birds that feed on seeds require insects, rich in protein, to ensure the optimal growth of their young. Many small mammals are also chiefly insectivores. Shrews and elephant shrews, for instance, feed on insects only, which boost the energy levels they require for their high metabolisms. Shrews have runways that they patrol a number of times a day, to snap up the insects that cross them.

Insects are hugely important in the nutrient cycle and are responsible for the rapid breakdown of wood into organic material, which returns to the soil. These species are therefore instrumental in fertilising the soil. Other organic material, such as leaf litter, grass and seed pods, is also broken down and returned to the soil. Furthermore, insects are vital in the pollination of many plants; without their contribution, extinction would occur at a rapid rate and

the knock-on effect would be devastating. If large numbers of plants were to face extinction and disappear, all the ecological systems associated with these species would fail. Whereas the plight of endangered mammals is often given great attention, rare and endangered invertebrate species often receive much less coverage. Numerous species are in fact on the brink of extinction, with many more already extinct as a result of the indiscriminate destruction of their habitats, especially forests, wetlands and savannahs. Other factors that have contributed towards greatly reducing the numbers of species are the use of insecticides, the expansion of alien vegetation and general habitat degradation.

Insects are intriguing as many are champions of camouflage, capable of changing colour to suit their mood or environment. Some species are so well camouflaged that they morphologically resemble twigs, thorns, leaves, flowers or bark. This is done either to catch prey or to avoid predators. Certain species resemble flowers and wait for pollinators to approach. Their success rate is unbelievable. A number of species mimic other distasteful or poisonous species. Warning colours adopted by harmless species are easily confused with the real thing. There are, however, species that are poisonous and clearly parade in colours like red, yellow and black. Interesting predator–prey relationships also exist within the insect world. Certain species actively hunt others, sometimes of the same species. Different hunting techniques are often adopted by different species, some relying on speed to run down their prey while others wait in ambush.

The sheer number of species is so overwhelming that, with the exception of a few taxonomic groups of which butterflies are the most prominent, field identification is often not attempted. In these pages, representative species will be introduced to the reader so that the common groups can be easily grasped. We hope that this introduction to the world of invertebrates will form the beginning of a whole new experience for readers. We hope, too, that this book will encourage people to conserve and protect insects as a worthy component of a healthy ecosystem. Although it focuses on insects and other invertebrates, it also celebrates South Africa's wondrous landscapes and ecology. Nature lovers, students, farmers, conservation agencies and tourists visiting the region will all find something of interest and beauty here.

▲ Longhorn beetles often make a rasping noise when disturbed – it is assumed that this deters predators.

▼ Colourful succulents, interspersed with small boulders and Quiver-tree Aloes, *Aloe dichotoma*, are a spectacle not to be missed in Namaqualand during the right season.

Limpopo Basin, Limpopo Province: landscape

◄ The full moon rises over the steamy hot arid bushveld of the Limpopo basin.

The bushveld of the Limpopo basin is generally distinguished by its vast, undulating landscapes and rising granite koppies, where large boulders are interspersed with huge Baobab trees (*Adansonia digitata*) and Mopane (*Colophospermum mopane*) forests. It is a beautifully harsh and rugged landscape. Each autumn, the veld turns in colour, as the Mopane trees transform to yellow, orange and brown. In the dry season, when rain is scarce, the grass all but disappears and bare earth beneath the trees is a common sight. The landscape snakes towards the Limpopo River in the north where forests of Nyala (*Xanthocercis zambesica*) and Ana trees (*Fadherbia albida*) fringe the river. It is an unforgiving landscape, with extreme heat and limited rainfall, yet this region supports an amazing array of insects and other invertebrates.

The area is characterised as savannah. Savannah refers to a vegetation type consisting of scattered trees and shrubs and a continuous ground layer dominated by grasses. The veld grasses are sweet but the soil is arid and moribund grass rarely occurs. The effect is usually that of open parkland, although there is considerable variation in the density of the woody component. Trees in this area generally reach 3 to 7 m and have a root system much older and more extensively developed than the aerial parts. These root systems make the trees well adapted to frequent periods of summer drought, whereas the generally deciduous nature of most species allows for a dormant period during the dry winter months.

The Limpopo area changes drastically with the seasons. The summer months bring a short and intense rainy season, followed by cold and dry winters. The valley is semi-arid, with an average annual rainfall of 380 mm. Much of the rain comes with unpredictable thunderstorms from November to

2 A Landscape of Insects

▲ Rocky outcrops and towering Baobab trees are characteristic features of this harsh, yet beautiful, part of South Africa.

▼ Mopane trees and stunted bushes are the dominant wood plant in the Limpopo region.

▼ The harsh, rocky areas of the Limpopo region are home to a number of specialised tree species, such as this rock fig.

March, with the peak of the wet season falling in January. At this time of year, it is not unusual for the river to become a raging torrent, creating an impassable barrier between north and south. The river's waters are augmented by the Shashi River and other tributaries further west.

Severe drought conditions are often prevalent and during these times the Limpopo dwindles to a small trickle of water, allowing for easy crossing. Temperature extremes are common in this region. The average maximum and minimum daily temperatures are 32°C and 18°C in January and 22°C and 4°C in July. However, extreme temperatures of 42°C have been recorded in the peak of summer and –7°C in winter. Summers are hot and winters have warm days and cold nights. Frost may occur from June through to August.

The soil is often loamy and clayey in this undulating granitic landscape; sandstone, shale and basalt also occur in the area. The soils vary in colour from deep reddish-brown clays through to well-drained sandy soils.

The vegetation comprises a fairly dense growth of Mopane (*Colophospermum mopane*), as well as Knob Thorn (*Acacia nigrescens*), Baobab (*Adansonia digitata*), Velvet Leafed Corkwood (*Commiphora mollis*), Shepherds Tree (*Boscia albitrunca*), White Seringa (*Kirkia acuminata*), Marula (*Sclerocarya birrea*) and Umbrella Thorn (*Acacia tortilis*). Red leaved Bushwillow (*Combretum apiculatum*) is common in the hilly outcrops.

The Limpopo region is the most diverse Mopane veld-type in South Africa and is richer in the different Mopane species than other Mopane-dominated areas. The leaves of the Mopane are easily identifiable by their butterfly shape and attract the edible mopane worm, or *mashonza*, as it is known in Tshivenda. The Limpopo Valley is also famous for its bulky Baobab trees, which are casually scattered across the landscape. Eerie-looking rows of Baobabs are dotted against the various rocky outcrops and hills in the region.

The shrub layer is moderately well developed and specimens of Raison Bush (*Grewia flava*), Sourplum (*Ximenia americana*), Sicklebush (*Dichrostachys cinerea*) and *Boscia foetida* occur. The herbaceous layer includes grasses such as *Enneapogon cenchroides*, Kalahari Sand Quick (*Schmidtia pappophoroides*), *Cenchrus ciliaris*, *Panicum maximum* and *Digitaria eriantha*.

The sandy-loamy soil, low rainfall, high temperatures, infrequent frost and periodic incidence of fires all influence the distribution of invertebrate communities and dictate population groupings.

Riverine forests of varying densities occur along the banks of the

▲ These Mopane leaves are the staple diet of the Mopane worm which may occur in large numbers and defoliate trees over large areas.

Limpopo, providing a sanctuary for many different species of insects and other invertebrates. Along the Limpopo River *Acacia karroo* and Ana trees (*Fadherbia albida*) are interspersed with other tall, well-leaved species and dense undergrowth.

Game reserves and game farms are common in the area and have fortunately conserved vast areas of land in the region. Unsustainable cattle and game farming in certain areas have, however, affected invertebrate habitats through overgrazing, trampling and bush encroachment. The overgrazing and trampling in much of the Limpopo area has led to the weakening of the grass cover and to the local encroachment of woody and in some cases spiny and

4 A Landscape of Insects

unpalatable species. Bush encroachment is a major veld management problem in the area today.

Fire and elephants are important in regulating the density of the woody component, and protected areas are usually covered with a dense thicket or almost closed canopy woodland. However, the complete removal of the woody component in certain areas would not necessarily increase the quality of the grass. The trees, with their deeper roots systems, may encourage the growth of grasses particularly through the transfer of plant nutrients from deeper soil layers to the more superficial root layers of the grass.

Elephants literally have the potential to shape these landscapes, changing them to grasslands through their destructive influence. Damage by elephants is threefold: they tear off leaves and branches, strip the bark from the trunks, and also push over entire trees. The effect they have on woody plants is clearly visible. Even insects feeding on plants in certain areas can be the main herbivores, resulting in the decline of plant cover and a reduction of up to 75% of the biomass.

COLEOPTERA (beetles)

Beetles make up the largest order in the whole animal kingdom. They include insects of economic importance, some destroyers of wood, seed, crop and stored products, and other useful predators of aphids and scale insects. The beetles include some of the largest and some of the smallest of all insects. Certain longhorns found in the tropics measure up to 15 cm in length, whereas in contrast there are minute fungus beetles that are less than half a millimetre long.

Beetles are found everywhere, but most do not attract much attention because of their colouring and their covert ways. Some are attractive, even spectacular in colour and shape, which makes them popular among insect collectors. The most striking characteristic of beetles as a group is the structure of their front wings which are horny or leathery. They are not used for flight but are a protective cover for a second, inner set of wings and the soft upper surface of the abdomen. The scientific name for the order of beetles is Coleoptera, which means 'horny winged', derived from the front wings, or elytra. The membranous hind wings are carried folded beneath the elytra when not in use.

Many beetles have lost their ability to fly and their second pair of wings is

▲ Insects are as diverse in habits as they are in shape and colour, and many species congregate in large numbers at a suitable food source.

▼ The medieval-looking armoured ground cricket may be found crossing the road in this region, but they are more at home on the branches of small bushes.

much reduced or no longer exists. In these beetles the elytra are firmly joined together to form a strong covering of the abdomen.

Another important feature of beetles is their mouth parts, which are adapted to biting, sucking and chewing. The life histories of different types of beetles are extremely varied, and members of this most successful order are found living in every conceivable habitat on earth. All beetles undergo a complete metamorphosis, passing through the four stages of egg, larva, pupa and adult.

Beetles are an exciting yet complex group comprising a vast number of varieties and ecologically different families. They make up about 40% of all insects found. Certain families cultivate interesting symbiotic relationships with other insects, in which they are fed and protected by their hosts.

▲ Almost all parts of a plant are fed upon, leaves and petals being a general favourite of most insects.

▼ The Monster Tiger Beetle is an active hunter of other insects and favours sandy areas with limited vegetation.

▲ Carabidae > Carabinae > *Calosoma planicolle* (Pupa Thief)

▼ Carabidae > Harpalinae > *Bradybaenus opulentus* (Marsh Ground Beetle)

Carabidae (ground beetles)

Ground beetles as a group contain over 25 000 described species, including many that are important predators in all terrestrial habitats. Ground beetles vary significantly in size from 3 to 60 mm. They are for the most part dull in colour, and many species live for a long time surviving in burrows during cold periods. Uniformly black or brown colours are characteristic in many of the nocturnal species but some diurnal species, such as *Graphipterus*, have strikingly cryptic colour patterns on their wing covers. Metallic colours are not very common. Ground beetles have more or less streamlined but loosely organised bodies. The head is flattened, with the sharp, powerful mandibles facing forward. The antennae, inserted between the eyes and the base of the mandibles, are thin and long, consisting of 11 segments equipped with keen senses of touch and smell. The beetle keeps them clean by pulling them from time to time through a special comb organ on the lower forelegs (tibiae). The eyes are well developed and prominent. The thorax has a well-defined lateral margin but is otherwise smooth and devoid of adornments. The wing covers are simple but very often sculpted with a number of longitudinal grooves. The legs are strong and well adapted for running. Specially developed predatory habits are seen in the genus *Calosoma*, of which *Calosoma planicolle* is a common African species. These are handsome, shiny black, about 60 mm long with several longitudinal grooves on the elytra. *Calosoma* may often be seen hunting about in the trees in search of the moth pupae and larvae, which form a large part of their diet.

The Pupa Thief carabid *Calosoma planicolle* is a large, shiny black insect, of about 40 mm long. Its wing covers bear longitudinal grooves. This species usually lives in trees and hunts other insects on the branches for food. It is a nocturnal creature and as a result is not often encountered.

The Marsh Ground Beetle, *Bradybaenus opulentus*, is a small, fawn-coloured insect, about 14 mm long. It usually has green or brown designs on the wing covers and neck shield. When examined closely, the fine grooves on the wing covers can be seen. This creature is a nocturnal predator of other insects in open savannah and woodland areas.

Cicindelinae (tiger beetles)

The eggs of the tiger beetle are laid in the soil, usually after rain when the ground is soft and the beetle's ovipositor can easily penetrate the soil. Tiger

beetle larvae feed on many different types of arthropods and do not appear to be very particular about what they eat.

The tiger beetle's haunts are betrayed by the small, neat, round holes about the diameter of a pencil which it leaves dotted about on hard patches of sand. This interesting white larva has a large flat head, a pair of strong, curved jaws and four tiny eyes gleaming like beads on either side of its head. With its six well-developed legs, it can crawl about on the ground quite easily. On the fifth segment of the abdomen is a curious hump. This carries two upward-pointing hooks, which enable the larva to keep a grip on the side of its tunnel and to move up and down with astonishing speed. When it surfaces, its head and the hard first joint of the thorax form a plug to close the mouth of the burrow. Little pellets of soil are, however, scattered about 20 mm from the hole.

The larval stage of some species may last for four months, depending on the availability of food. The larva may take a year or more to reach full size, its rate of growth depending on the number of victims that happen to fall into its trap. The prey is seized in the sharp curved mandibles by a swift backward movement of the head and pulled down into the burrow where it is eaten. When the larva is fully grown, it creates a cell next to its tunnel, not too far below the soil surface, within which it changes into a pupa.

The tiger beetle *Myriochile melancholica* is an active little insect, about 12 mm long, dark brown with fine speckling on its wing covers. It is winged and flies well, if only for short distances. The adults prefer open sandy areas like roadsides and the edges of dams. They are mainly active during the hottest hours of the day, running rapidly in search of prey. When disturbed, many of them take flight but soon settle once more.

The Royal Tiger Beetle, *Chaetodera regalis*, is an impressive-looking insect, about 18 mm long, with yellow wing covers beautifully patterned with black. The legs and underparts are a brilliant metallic blue which shimmers in the sunlight. As in the case of most tiger beetles, this species is active during the heat of the day when it patrols the river courses on sand banks in search of insects to eat. It does not fly well and usually lands a few metres from its take-off.

The tiger beetle *Lophyra neglecta* is a pretty insect, about 12 mm long, with yellow wing covers and characteristic dark brown markings. Their bodies are a coppery colour. They are common around puddles and dam edges where they hunt for insects, flying rapidly, sometimes landing on plant material standing in the water.

▲ Carabidae > Cicindelinae > *Myriochile melancholica*

▼ Carabidae > Cicindelinae > *Chaetodera regalis* (Royal Tiger Beetle)

▼ Carabidae > Cicindelinae > *Lophyra neglecta* subsp. *intermediola*

▲ Melyrinae > *Melyris apicalis*

▼ Malachiinae > *Hapalochrops sumptuosus*

Melyridae (soft-winged flower beetles)

There are only two genera of Melyrinae in southern Africa, *Melyris* with approximately thirty species and *Falsomelyris* with only three species. The melyrids are small, most are soft-bodied, and have a flattened, elongated, oval shape. They are usually small, metallic blue or green beetles with strongly keeled wing covers. The body is usually covered with long, erect bristles, or setae.

The antennae are 10- or 11-segmented and inserted on the back of the frontal segment, away from the eyes. They can be thread-like, saw-like or fan-shaped, and in male beetles the basal segments are frequently modified. The neck shield has distinct side edges.

The tarsi have five segments, with the fourth segment either simple or bilobed. The tarsal claws are simple, each of them often having fleshy appendage underneath. The wing covers are sometimes shortened, exposing several of the apical abdominal segments, or tergites. Many species are brightly coloured and sexual differences occur in certain groups. Historically the melyrids are related to the cantharids and, like the cantharids and the more closely related clerids, are almost always carnivorous as adults; they are frequently found on flowers.

Melyris apicalis, a soft-winged flower beetle, is approximately 7 mm long, with bright green wing covers and contrasting reddish-brown underside and legs. They are extremely common on grassy growth, where they can easily be seen mating. They are pollen feeders and visit a variety of plants, including weeds. This is generally a calm species which does not attempt to escape when approached.

Malachiinae

The subfamily Malachiinae are a group of beetles which have recently been placed within the family Melyridae. These small, elongated and flattened beetles, often with brightly coloured wing covers. Interestingly, there are commonly two different forms within the same species and even between the sexes. The males often have the basal segments of the antennae modified to receive the female's antennae and for receiving pheromones during their elaborate courtship and mating behaviour. Most of the adults are carnivores, though certain species do not appear to feed and are relatively short-lived. The larvae are predacious or dung-feeding in certain species. There are some

species that are wingless; these are ground dwellers. They behave like ants and there is possibly a stronger relationship that is not clearly understood.

The beautiful beetle *Hapalochrops sumptuosus* is approximately 10 mm in length. The body is broad and flattened, with an orange neck shield and wing covers with four emerald-green blotches. The group is not well understood and needs further research into their ecology, behaviour and reproductive cycle.

Chrysomelidae (leaf beetles)

The Chrysomelidae constitute another large family of plant-eating beetles whose various subfamilies show interesting differences in their biology. The group is one of the largest families of Coleoptera. Their body shape varies greatly within the family, from long and narrow to hemispherical, broad and flat. They also vary greatly in size. The adult Cryptocephalinae are often brightly coloured yellow or orange with black spots or bands as a warning to predators that they are poisonous. Although some seem to taste unpleasant to other predators, they may be mimicking the ladybird and blister beetles, which are unpleasant to the taste or even poisonous and occur on the same plants and flowers.

Members of the comparatively large subfamily Cryptocephalinae are cylindrical in shape, generally short and compact. They live on the branches and leaves of the plants they feed on and, when disturbed, characteristically drop off the plant. Interestingly, their larvae use their own excrement as a means of camouflage or protection. The biology of the African species is unknown, but elsewhere the larvae live in ants' nests where they feed on vegetable debris. Most adults of this subfamily show interesting variations in colour, size or some other trait between the females and males (dimorphism). The males sport enlarged jaws and elongated forelegs. The larvae also live on plants and build cases. A number of South African species belong to the genus *Melitonoma*.

The leaf beetle *Melitonoma mutisignata* is an attractive beetle, about 6 mm long, with canary yellow wing covers marked with numerous black polka dots. These little creatures are difficult to see as they live hidden by the foliage of trees and bushes.

The tortoise beetle *Cassida* sp. is bright green with white markings on the wing covers. About 10 mm long, they are usually found on leaves, which

▲ Chrysomelidae > Cryptocephalinae > *Melitonoma mutisignata*

▼ Chrysomelidae > Cassidinae > *Cassida* sp. (tortoise beetle)

camouflage them beautifully. They are an active species, moving fast and flying readily. They feed on leaves and are relatively common in dry Mopane woodland.

Tenebrionidae (darkling beetles)

The enormous family of Tenebrionidae is a group of beetles with considerable variations in appearance, habits and the habitats in which they are found. They are all generally dark brown or black in colour, sometimes with white and red markings. Some tenebrionids are unable to fly because they have lost the use of their second pair of wings. The adult beetles usually live for a long time and are mostly nocturnal.

The members of the genus *Prunaspila* and its relatives are very slow-moving. These flat beetles are covered with sparse long hairs, which help to trap and hold a layer of sand and other debris which acts as camouflage. The family Tenebrionidae also has arboreal species. The members of the subfamily Alleculinae are small to medium-sized (5–15 mm), sometimes brightly coloured, elongated or elongate-oval in shape, and moderately to considerably

▲ Tenebrionidae > Alleculinae

▼ Tenebrionidae > Adelostomini > *Prunaspila bicostata*

convex. Their antennae are long and thread-like. They do not have defensive glands and thus a repugnant smell. These beetles are strongly attracted to artificial light. The adults can be frequently observed on vegetation or in flowers as most feed on pollen. Alleculinae larvae are seldom seen as they live in decaying wood and plant litter.

This tenebrionid beetle (top right) is a rather ordinary-looking beetle, about 12 mm long, with an elongated dark-brown body with a reddish-coloured sheen and fine patterns on the wing covers. It is strongly attracted to light, where they may occur in large numbers. They are scavengers and usually live on branches and logs in a variety of different vegetation types

The tenebrionid beetle *Prunaspila bicostata* is a drab, oval, slightly flattened insect, about 9 mm long. Under dry and hot conditions, it develops a waxy bloom on which sand and other organic matter appear to stick. They scuttle around on the ground especially under dead branches and decomposing plant material, feeding on plant and animal matter during the evening or on overcast days, seemingly avoiding the heat of the day.

This is a rather nondescript tenebrionid beetle, about 13 mm long, with an elongated dark-brown body with fine patterns on the wing covers. This species is attracted strongly to light but is found naturally on branches and logs.

An armoured insect, *Metriopus platynotus* is about 18 mm long, matt black with a series of longitudinal ridges across the wing covers. It lives on the ground where it scavenges for plant and animal material on which it feeds. It cannot fly but is well adapted to running, frequently being found on paths and roads. They are relatively common in the dry, sandy areas of Limpopo, where they frequent open savannah.

The tenebrionid *Stenodesia arachnoides* is an unusual-looking insect, about 10 mm long. It resembles an armoured tank, with sculpted wing covers. A brownish-black colour, they are usually covered with sand. They are most often found under rocks and stones, where they are almost invisible to the naked eye. Once alarmed, their rapid movement betrays their whereabouts. They can cover considerable distances in a relatively short period of time as their legs are adapted to speed. They move almost spider-like across the ground. They are scavengers feeding on animal and plant material whenever this is available.

▲ Tenebrionidae > Alleculinae

▼ Tenebrionidae > Adesmiini > *Metriopus platynotus*

▼ Tenebrionidae > Adesmiini > *Stenodesia arachnoides*

▲ Cleridae > *Orthopleuroides* sp.

▼ Cleridae > Clerinae > *Thanasimodes gigus*

▼ Meloidae > *Coryna surcofi*

Cleridae (chequered beetles)

Adult clerids are often found on flowers, while many others are attracted to artificial light. Their habitat is dead wood, and their predominant food is the larvae of wood-boring beetles in the galleries and burrows in which they live. The main families attacked by the clerids are Buprestidae, Cerambycidae and Bostrichidae.

As the adults feed on wood-boring beetles, this group could be regarded as beneficial to humans. Both the adults and larvae of most clerids prey on other insects. The less typical members of the family, the *Orthopleuroides* sp., have metallic-blue coloration. The larvae and adults feed on a variety of high-protein material and have also been recorded as feeding on fly larvae. They occur on carrion, in bones as well as in some herbaceous plants and tubers with a high protein content.

The clerid beetle *Orthopleuroides* sp. is a metallic greenish-blue colour, with distinctive white patches on the wing covers. This beetle is about 10 mm in length. The neck shield is flexible, enabling the insect to move its head independently from the body. They feed on smaller insects.

Thanasimodes gigus is a chequered, medium-sized beetle approximately 20 mm in length. The body and antennae are dark brown and sparsely coated with fine erect hairs. The wing covers are elongated, with two characteristic light-brown blotches. This species is relatively common on flowers and foliage in the Limpopo region.

Meloidae (blister beetles)

Numerous species of blister beetle are found throughout Africa. These are conspicuous insects which fly slowly and deliberately as if they have no foes – the poisonous substance in their bodies protects them from their insect-eating enemies, such as birds and lizards. Their striking colours warn their enemies to leave them alone. The group has a characteristic smell which attracts anthicid beetles which collect the poisonous substance for their own chemical defence. There is an apparent chemical recognition between these two families. Large numbers of *Mylabris* species have been observed swarming on patches of flowers or individual flowering *Acacia* trees and there may be some pheromonal attraction leading to the formation of large congregations of beetles to enhance their breeding behaviour.

Adult beetles of genera such as *Mylabris*, *Ceroctis*, *Coryna* and *Epicauta*

have unmodified chewing mouth parts and are plant feeders. These beetles are found on flowers throughout the summer months, especially on plants of the pea and bean family whose petals they eat, thus preventing the formation of pods.

The meloid *Coryna surcofi* is about 13 mm long, black, its body covered with greyish hairs. The wing covers are marked with irregular yellow markings. Adults feed in flower heads, leaves and buds.

The meloid *Cylindrothorax* sp. is approximately 15 mm long, with an elongated, black body and a reddish pink neck shield. The wing covers are matt black. Adults feed on the flowers of a range of vegetation types.

The medium-sized meloid *Ceroctis* sp. is about 12 mm long, with a matt black body. The wing covers are black edged with orange. The adults feed on a variety of different buds, flowers and leaves.

The medium-sized meloid *Decapotoma transvaalica*, a common species in the northern parts of South Africa, is about 12 mm long, with a black body and antennae. The wing covers are beige, outlined in red, with several irregular black patches and spots. The adults feed on a variety of buds and flowers.

The large meloid *Psalydolytta lorigera* is about 30 mm long, with a black body and antennae. The wing covers are black, striped longitudinally with cream. They are strongly attracted to light and may congregate in quite large numbers. The adults feed on a variety of buds and flowers. It is a common species in the Limpopo region of South Africa.

▲ Meloidae > *Ceroctis* sp.

▼ Meloidae > *Decapotoma transvaalica*

◄ Meloidae > *Cylindrothorax* sp.

▼ Meloidae > *Psalydolytta lorigera*

14 A Landscape of Insects

Trogossitidae (gnawing beetles)

The Trogossitidae are an interesting group of small to medium-sized beetles, elongated, ovoid and rather flat in shape. Their antennae are 10- or 11-segmented, ending in a characteristic club. The head is clearly visible from above. The neck shield has distinctive, well defined lateral margins. The first segment of the legs lies crosswise but does not project. The segments have no lobes, with the end segment divided and covered in hairs between the claws. The body is sometimes clothed with scales. The adults and their predacious larvae live beneath bark or in the tunnels of wood-boring insects.

Trogossitidae are medium-sized, elongated beetles with forward-facing mandibles. They are generally dark brown in colour and have distinctive edges on their neck shields. They are regularly found on tree trunks in wooded areas. Their larvae live under bark or in the tunnels of wood-boring beetles.

Curculionidae (weevils)

Whereas the eyes in the family Curculionidae may be well developed, they are comparatively small or even rudimentary to absent for soil-dwelling species. Weevils vary in size from 1 to 60 mm, but are on average about 10 mm in length. They are variable in colour, and their brown or black background colour is often concealed by brightly coloured scales or hairs. Most species are cryptically coloured with warning or metallic colours rarely seen. The legs are mostly short and stout and the tarsi are armed with strong claws and adhesive lobes, enabling the weevils to walk on smooth leaf surfaces.

Many species have different sexes with two different forms, the males having longer and stronger forelegs but a shorter snout and piercing and sucking mouth parts than the females. The *Hadromerus* sp. usually lives in trees, and their larvae develop in plant tissues. Most curculionid beetles move slowly and sluggishly, but some, such as *Hadromerus* sp., are able to run agilely up and down tree trunks. When disturbed, they will quickly move to the other side of a twig or leaf. They also feign death or simply drop off their host plant remaining motionless amongst the grass and dead leaves on the ground when disturbed.

This species of weevil, *Hadromerus* sp., is brownish green in colour, with distinct yellowish markings on the edges of the wing covers and neck shield. It is approximately 12 mm long, with a distinct forward-facing head. The legs are well adapted to climbing on twigs and branches, where it is commonly found. They feed on plant material and are often found on *Acacia* sp.

▲ Trogossitidae

▼ Curculionidae > Entiminae > Tanymecini > *Hadromerus* sp.

Sphadasmus camelus, also a weevil, is brownish grey in colour, with a long snout and conspicuous dark eyes. It is about 13 mm long. The legs of this species are well adapted to climbing on branches where it is commonly found. It feeds on plants, from which the snout is used to draw out the nutrients. It is relatively common in well-wooded, semi-arid environments.

Scarabaeinae (dung-rolling beetles)

The best-known of the dung rolling beetles is the Egyptian Sacred Scarab, although many other scarabs are found throughout Africa with similar behavioural traits. The extensive family of Scarabaeidae includes some of the most conspicuous and abundant of all the African insects, such as dung beetles, rose beetles, rhinoceros beetles, chafers and many others. The dung beetles are some of the best-known of all the beetles, largely due to their quirky appearance and easy visibility.

South Africa has a very diverse and varied group of dung beetles. The scarabaeids are bulky beetles and can vary in size from small to quite large (7–48 mm). Most species are brown or black, a few are brightly coloured in blues, greens or purplish black. They are all alike in that their antennae terminate in a fan of three or more flattened joints that can be folded one over the other. Their stout front legs are armed with strong teeth, well adapted to their feeding habits. These are used as scoops and rakes, to break up droppings left on the road or countryside by passing creatures, the best parts of which they gather together in a ball. Certain species make balls by patting and pressing the dung with their front legs.

The three main groups of Scarabaeinae occurring are those that dig chambers directly under the dung pile into which dung is carried, those that feed on the surface in the dung heap directly, and those that move the balls of dung to a more suitable place. This is done to reduce competition at the original dung site, where in some cases more than 2000 individuals may congregate. After rolling their food into a ball, the majority of Scarabaeinae, the most abundant of the African dung beetles, then bury it for themselves and their larvae. All members of the genus *Gymnopleurus* fashion and roll dung balls.

The Small Green Dung Beetle, *Gymnopleurus sericatus*, is a dry savannah and bushveld species. It is approximately 12 mm in length, dark metallic green, and finely sculpted on closer inspection. It is active by day, usually once temperatures increase as the morning progresses. They cut dung from fresh

▲ Curculionidae > Conoderinae > Sphadasmini > *Sphadasmus camelus*

▼ Scarabaeidae > Scarabaeinae > *Gymnopleurus sericatus* (Small Green Dung Beetle)

▲ Scarabaeidae > Scarabaeinae > *Onitis cupripes* (Bronze Dung Beetle)

▼ Scarabaeidae > Melolonthinae > Sericini

▼ Scarabaeidae > Rutelinae > *Adoretus punctipennis*

16 A Landscape of Insects

dung pads, moulding it into small balls which they roll away and bury at some distance from the original site, thereby reducing completion and disputes with other beetles. One egg is laid per brood ball, which is then further shaped by the female. The larva which hatches then feeds on this ball until it becomes a pupa and emerges as an adult.

The Bronze Dung Beetle, *Onitis cupripes*, is an oblong-shaped, medium-sized dung beetle, approximately 25 mm in length. The wing covers are brownish in colour, with conspicuous longitudinal grooves, a characteristic of the genus. These beetles come out at twilight, being predominantly active at dusk and dawn. This species does not roll dung balls but draws dung down holes under or directly besides the dung site. Dung is packed in these holes, in which they may lay several eggs. Mature larvae manufacture pupal cases around them with their own faeces before emerging as adults.

Melolonthinae (leaf chafers)

These are nocturnal scarabs belonging to the subfamily Melolonthinae. It is a widespread group with a large number of cryptic or camouflaged species which are difficult to identify. The only reliable means of identification is by examination of their genitalia under a microscope. The species within this group are mainly brown or black beetles. Adults emerge at sunset after spending the day buried in the ground and are often seen swarming about trees and bushes in early spring and summer evenings. The adults are all strongly attracted to light and make up the bulk of beetles found in artificial light at night. They are leaf chafers and are similar in appearance and habit to the night-flying rutelines. The majority are small beetles of approximately 10 mm in length. A few species, notably the genus *Sparrmannia*, are large, approximately 20 mm, and have long, dense yellow fur on the thorax and underside of the abdomen.

This beetle belonging to the tribe Sericini is a relatively drab, glossy reddish-brown scarab beetle. It is approximately 10 mm in size and has a bulbous round body and wing cover. The neck shield is particularly large and, as a result the head is obscured. This species is readily attracted to artificial light and may congregate in large numbers at such a source.

Rutelinae (leaf chafers)

The Rutelinae are similar in habit to the Melolonthinae but differ in that many are diurnal and therefore brightly coloured, such as the greyish *Adoretus*

species, which occurs on foliage. Only a few brightly coloured diurnal leaf beetle species (other than monkey beetles) occur in southern Africa. They are leaf-feeders and some species sporadically defoliate plants when occurring in large numbers. The species within the large and important genus *Adoretus* are well distributed and common in South Africa. The females tunnel into soil or litter to lay eggs and have been found at depths of one metre. The leaf chafer larvae are known as white grubs and are typically scarabaeoid in appearance.

This leaf chafer *Adoretus punctipennis* is a medium-sized scarab beetle with grey-coloured wing covers, finely dotted with light brown. It is approximately 15 mm in length and has orange, forward-pointing antennae. The adults are diurnal and feed on the leaves and flowers of a wide variety of vegetation. They are usually observed in dense foliage in well-wooded, semi-arid savannahs.

Cetoniinae (fruit chafers)

The brightly coloured species of the subfamily Cetoniinae are generally glossy, fruit-eating beetles within the family Scarabaeidae. They are diurnal and strong flyers, often frequenting flowers as adults. They vary from a metallic black, through to a variety of different colours, patterned, patched and squiggled in yellow, white and black. The males in a number of species have impressive horns. They are usually stout, flat and rather square beetles of medium to very large size (10–68 mm). They do not lift their wing covers in flight, as do most beetles, and therefore have a hollow on the sides of the wing covers where the hind wings fold out. When viewed from above, this hollow space exposes part of the hind wing. The protruding head and the bases of the antennae are always visible from above. The sexes of many species differ in the development of the structures on the head and front legs.

The Amethyst Fruit Chafer, *Leucocelis amethystina*, is a colourful insect, about 12 mm long, usually a bright metallic blue, with a very conspicuous, distinctive reddish-brown neck shield. The adults feed on the flowers of a variety of trees and shrubs, including numerous species of forb. These are common plants found in a variety of habitats and are particularly abundant in woodland savannahs and grassland. Amethyst Fruit Chafers are active in the heat of the day when they scout about to find suitable food sources.

Xeloma aspersa is a chocolate-brown fruit chafer, with sparse brown hairs on the wing covers. It is relatively common in the dry savannah regions of

▲ Scarabaeidae > Cetoniinae > *Leucocelis amethystina* (Amethyst Fruit Chafer)

▼ Scarabaeidae > Cetoniinae > *Xeloma aspersa* (Brown-haired Fruit Chafer)

▲ Scarabaeidae > Cetoniinae > *Niphetophora rhodesiana*

▼ Scarabaeidae > Cetoniinae > *Dischista cincta* (Common Savannah Fruit Chafer)

▼ Buprestidae > *Psiloptera foveicollis*

Zimbabwe and Limpopo province. It feeds on sap flows as well as fruit and is often particularly attracted to fermenting fruit. It has been recorded feeding on the flowers of *Vernonia oligocephala* and *Protea caffra*. The adult of the species flies predominantly between November and December.

Niphetophora rhodesiana, a mottled brown-and-black fruit chafer, was not recorded from southern Africa until recently. The males of the species have a strongly upturned anterior margin, while it is rounded and slightly bilobed in females. Adults are active between November and February, peaking in December. These beetles feed on both flowers and fruit and, like *X. aspersa*, are readily attracted to fermenting fruit.

Dischista cincta is a particularly common species of fruit chafer observed in large numbers at any suitable food source. It is brownish yellow in colour, with distinctive yellow edges to the neck shield. It is medium-sized beetle, approximately 24 mm in length. The adults feed on flowers and fruit, and a flowering *Acacia* sp. may have thousands of these chafers feeding on a single tree.

Buprestidae (jewel beetles)

The South African region is expected to have a large number of endemic, or range-restricted, buprestids. Known as jewel beetles, they are nearly always metallic or bronze in colour, some being so beautiful that they are incorporated in jewellery in certain countries. Buprestids are small to large (1.5–50 mm) torpedo- or wedge-shaped beetles. They are most active in the heat of the day and extremely alert. They have good eyesight and fly off vigorously when disturbed. All buprestids are day flyers. The genus *Psiloptera* accounts for most of the southern African species of the chalcophorine subfamily; most are strikingly coloured and common in the semi-arid bushveld savannahs. Groups often feed on one or a few related genera of plants only, such as *Evides* which feeds off Marula. Some species are generalists and have more than one host plant-type and are thus more widely distributed.

The Emerald Jewel Beetle, *Evides pubiventris*, is a spectacular-looking beetle with a bright, metallic green colouring. The wing covers are longitudinally ridged and strongly punctured. This is a medium-sized beetle, approximately 25 mm in length. Their host plants are of the family Anacardiaceaea, and they are regularly encountered on Marula trees (*Sclerocarya birrea*), where they are active at the hottest times of the day. They feed voraciously on the leaves of

these trees; a single leaf can be consumed in mere minutes.

The jewel beetle *Psiloptera foveicollis* is a dark-coloured beetle with glossy black wing covers, edged with creamy white. This is a medium-sized beetle, approximately 28 mm in length. The neck shield has two conspicuous and distinctive eye-shaped black dots. They are commonly found on *Acacia* sp., particularly *Acacia tortilis*. They are active during the heat of the day and fly off readily when disturbed.

▲ Buprestidae > *Evides pubiventris* (Emerald Jewel Beetle)

▲ Cerambycidae > Prioninae > *Macrotoma palmata* (Large Brown Longhorn)

▼ Cerambycidae > Lamiinae > *Eunidia natalensis*

▼ Cerambycidae > Lamiinae > *Hecyromorpha plagicollis*

Cerambycidae (longhorn beetles)

The longhorn beetles belong to the large group Cerambycidae, which contains numerous wood-boring species and also a fair number of species that mine the stems and roots of herbaceous plants and semi-woody plants, as well as some seed eaters. These striking beetles can be identified by their exceptionally long antennae, which are thread-like and usually at least half as long as the body, often much longer (especially in males). The antennae can be directed backwards, above and parallel to the body. They are often inserted on distinct protuberances located near the kidney-shaped eyes. These beetles vary greatly in size and range from small to large (3–100 mm), being elongate, cylindrical, subcylindrical or flattened. The adults are often brightly coloured in metallic greens, blues, reds and yellows in a variety of shapes and sizes. Adult longhorn beetles often have a disruptive coloration with conspicuous lines cutting irregularly across the contours of the body. Many species are also dark in colour and hairy. The mandibles are greatly enlarged in the males of several species.

The neck shield is usually slightly rounded dorsally with a single spine sometimes being found laterally on each side. However, it may be flattened, with distinct lateral margins bearing several teeth. In several species the hind legs are greatly expanded. The Prioninae are medium to large-sized (25–100 mm) beetles that are mostly nocturnal. Their larvae are able to mature successfully only in rotten, moist wood. The adults are usually encountered on the trunks or branches of their hosts or are attracted to artificial light. Representatives of the Prioninae are some of the largest beetles in southern Africa. The diurnal Lamiinae species are often very brightly coloured, but the nocturnal species are mostly of more sombre colours. The larvae of many species of Lamiinae feed only on herbaceous plants and sometimes grasses. Certain species cause their host plants to produce galls, or swellings. This group of beetles is by far the most successful of cerambycids, and those found in southern Africa are no exception.

The Large Brown Longhorn, *Macrotoma palmata*, is an impressively large beetle, reaching a total length of up to 60 mm. The body is dark reddish-brown and somewhat flattened. The square neck shield has spines on the sides and the mandibles in this species are large and well developed. This beetle can give a nasty bite if handled carelessly. The species prefers well-wooded areas where its larvae bore into and feed on tree trunks, predominantly the *Acacia* sp. Its larvae secrete an enzyme which assists in the digestion of cellulose. This species is attracted to artificial light and may be observed around outside lighting.

The longhorn beetle *Eunidia natalensis* is a brick-red-coloured beetle, with greyish wing covers pitted with red brown, about 12 mm long. The larvae bore into the stems of a variety of different wood plant species in semi-arid and woodland areas.

This dark greyish-brown longhorn beetle *Hecyromorpha plagicollis* has punctures on the neck shield and the base of the wing covers. It is approximately 12 mm long. The woodboring larvae bore into stems of woody plant species in parklands and wooded areas. The species is regularly attracted to artificial light.

Olenecamptus olenus is a brown longhorn beetle, with light-cream mirror images on the wing covers and the neck shield extending on to the head. This species is approximately 17 mm long and has equally long antennae. The woodboring larvae bore into stems of Silver Cluster Leaf (*Terminalia sericea*) and various other woody plants.

The attractive longhorn beetle *Ancylonotus tribulus* is a brown beetle, with greenish, lichen-like patterns on its wing covers, neck shield and head. It is a large species, approximately 33 mm long, with bi-coloured antennae. This species is a master of camouflage, blending into the bark of tree stems so that it is often difficult to see.

The longhorn beetle *Crossotus stigmaticus* (page 22) is greyish-brown, with numerous ridges on the neck shield and on the bases of the wing covers. This species is approximately 14 mm long. This species is closely related to *Crossotus plumicornis*; however, it lacks the plumes on the antennae found in *Crossotus plumicornis* and is a lighter colour. The species is regularly attracted to artificial light.

This greyish-green longhorn beetle *Crossotus plumicornis* (page 22) has punctures on the bases of the wing covers. This species is approximately 18 mm long. The antennae of this species are particularly interesting as they are fringed with fine hairs, alternating between light- and dark-brown patches. It is also readily attracted to artificial light.

The longhorn beetle *Hecyra terrea* (page 22) is brown, 19 mm long, with punctures on the bases of the wing covers. The species has a characteristic pinkish underside which is diagnostic. The antennae are exceptionally long, extending well over the wing covers. The species is readily attracted to artificial light.

Dichostates compactus (page 22) is a grey longhorn beetle, with knobs on the bases of the wing covers and the neck shield. This species is readily attracted to artificial light. It is common in dry, well-wooded savannahs in South Africa. Its larvae are woodborers that attack dead or dying plants only.

▲ Cerambycidae > Lamiinae > *Olenecamptus olenus*

▼ Cerambycidae > Lamiinae > Ancylonotini > *Ancylonotus tribulus*; (Lichen Longhorn)

▲ Cerambycidae > Lamiinae > *Crossotus stigmaticus*

▶ Cerambycidae > Lamiinae > *Hecyra terrea*

▶ Cerambycidae > Lamiinae > *Dichostates compactus*

▼ Cerambycidae > Lamiinae > *Crossotus plumicornis* (Plume-antennae Longhorn)

Bostrichidae (auger borers)

There are many species in the family Bostrichidae in South Africa. These beetles are cylindrical in shape, well adapted to living in the tunnels which they bore in wood. Their sizes vary considerably between 2 mm and 32 mm. They also exhibit a great variety of forms. The head points downwards and the posterior of the body is often squared off and may be armed with spines, teeth or hooks. The neck shield is provided with curved spines or horns in front and it has smooth, rasp-like scales at the back. The surface of the wing covers is usually smooth or more or less ribbed and sculpted. The legs have toothed, saw-like outer edges and the apices are armed with heavy spines or large hooks. These appendages are used to assist the adult when moving forward in the burrow. Both adults and larvae bore into wood, as their common name indicates. They feed on the wood of many different trees.

The wood-boring beetle *Bostrychoplites pelatus* is an elongated insect, approximately 12 mm in length. The body of this dark-brown insect characteristically tapers off at the rear. The partly punctured neck shield has two characteristic forward-pointing spikes forming a V-shape. Both adults and larvae of this relatively widespread species are woodborers and common in the semi-arid woodland savannahs of the Limpopo region.

The auger borer *Bostrychoplites cornutus* is a cylindrical, dark-brown insect, characteristically squared off at the rear. It is about 10 mm long, with a domed neck shield with two forward-pointing spikes. The wing covers are sculpted with lines running longitudinally. Both adults and larvae are woodborers, the larvae boring mainly into dry wood and the adults living on weakened trees. This species favours well-wooded savannahs and forest fringes.

▲ Bostrichidae > Bostrichinae > *Bostrychoplites pelatus*

▼ Bostrichidae, *Bostrychoplites cornutus* (auger borer)

Elateridae (click beetles)

The click beetles belonging to the family Elateridae are elongated insects, mostly of sombre black or brown colour. A few have white or yellow markings and certain species have brightly metallic-coloured wing covers. They are elongated, dorsoventrally flattened beetles varying between 2 and 80 mm in length. The head is partly hidden by the prothorax, or corset on the thorax.

The eyes are prominent and the antennae vary considerably in length and shape. They may be as long as the body or barely reach the end of the prothorax. A common characteristic of all the members of this family is the elongated posterior corners of the neck shield which form distinct processes.

▲ Elateridae > *Lanelater semistriatus*

▼ Lymexylonidae > *Atractocerus brevicornis* (Ship-timber Beetle)

The adults can be distinguished from all the other families of beetles, not only by the elongated, acutely pointed posterior angles of the neck shield but also by the presence of a click apparatus. If it is placed on its back, it will sham dead for a while and then, with a slight clicking sound, leap into the air, right itself and run off. Its prothorax is jointed with the rest of the body so that the insect can move freely, but when it is on its back, the two parts are held rigid, with the body slightly arched. There is a hard-pointed projection on the underside of the prothorax that fits into a notch. When this projection slips out of the notch into the cavity below, it causes the insect to jerk itself into the air. The beetle has little or no control over its orientation in the air, and does not always land on its feet.

The all-black click beetle *Lanelater semistriatus* is an interestingly shaped beetle, about 30 mm long. The hind angles of the large neck shield are pointed, and the head is deeply inserted into the neck shield. The antennae in this species are thread-like. These beetles have the ability to jump into the air when lying on their backs or when avoiding predators, because of a special spine and notch mechanism, which gives a loud click as they jump. This species is nocturnal and is strongly attracted to artificial light. They feed on foliage, with leaves and flowers being their main food source.

Lymexylonidae (ship-timber beetles)

The family Lymexylonidae is a group of unique insects that on first observation may not be recognised as beetles. They are moderately large, cylindrical and coloured brown to dark-brown often with broad eyes almost touching the middle of the head. The common and widespread *Atractocerus brevicornis*, is the only member of the genus and is characterised by reduced wing covers and hind wings that, at rest, are held open in a fan shape. This family is strongly attracted to artificial light at night. The small family of lymexylid beetles contains only a few known African species. The adult is very elongated, with tiny wing covers and long, exposed hind wings that fold fan-wise over the dark-brown abdomen. These beetles may be as large as 38 mm in length and they are relatively abundant in certain regions. The larvae bore in the stems and hard wood of weakened trees and are also very elongated. They are reported to feed on a fungus which grows in their tunnels.

Atractocerus brevicornis is another interesting beetle, about 32 mm long, dark brown with reduced wing covers resulting in the abdomen and folded

wings being totally exposed. This is an extremely long and narrow invertebrate which does not resemble a beetle. The species is common in arid savannahs and in the forest edges of the Limpopo basin where they are woodborers feeding on the hard woods of a variety of plant species.

Histeridae (hister beetles)

The Histeridae are found in a broad array of habitats in South Africa. Members of the largest subfamily, the Histerinae, are usually of medium size and characterised by a large ventral plate over the prothorax, which may project right over portion of the lower part of the head. The largest genus, *Hister*, includes some unique species which are particularly common in dung and plant detritus. They are found under bark, in rotting wood and on fungi where certain species feed on fungal spores. This group varies considerably in size from small to relatively large (1–20 mm). The majority are black but certain species are brightly coloured in orange, green or red, and in some cases even

▼ Histeridae > Histerini > *Hister* sp. (Steel Beetle) – page 26

bicoloured. The group is characterised by large mandibles and well-developed eyes, which are only very rarely absent. The antennae in this group are short, elbowed and cupped. The wing covers are considerably shortened and may have one or two abdominal segments exposed. The legs are short and broad and well adapted to their sheltered habitats.

The Steel Beetle, *Hister* sp. (page 25), is a glossy black beetle, about 10 mm long. The wing covers are longitudinally grooved and slightly shortened in this species, exposing part of the abdomen. They have noticeable mandibles and a conspicuous head which can be retracted into the neck shield. This species is often found under or next to pads of dung where they feed on other insects attracted to the dung. Both adults and young feed on other insects in this way.

HETEROPTERA

Many people refer to any insect as a 'bug'. However, to the biologist a bug is a member of the order Hemiptera, one of the largest groups of insects, and certainly one of the most important from the economic point of view. The members of this order vary widely in size, shape, habit and life history, but all have mouth parts that are adapted for piercing and sucking and these nearly always take the form of a distinctive proboscis. Bugs live entirely on liquids, such as the sap of plants or the blood of other living creatures, and they have no mandibles for chewing. Many are wingless. Those that have wings vary in structure, so it is impossible to derive a general definition of a bug.

The name of the order, Hemiptera, which means 'half-winged', refers only to the type of wings found in some bugs. This enormous group of insects includes stink bugs, bed bugs, water bugs, twig wilters and cicadas. This vast group is currently divided into four suborders, the Sternorrhyncha (plant lice, mealy bugs, scale insects), Auchenorrhyncha (cicadas, leaf hoppers, etc.), the Coleorrhyncha (a small group with about 25 species from Australia) and the Heteroptera (the true bug). Previously there were only two suborders, the Homoptera and the Heteroptera. In the Auchenorrhyncha the forewings, when developed, are more or less uniform and generally held roof-like over the abdomen. However, the forewings of the Heteroptera are generally divided into a thick and leathery basal part, with a membranous outer part. They are usually folded flat on the abdomen, with the tips of the two wings overlapping.

▲ Scutelleridae > *Sphaerocoris annulus* (Picasso Bug)

▼ Scutelleridae > *Sphaerocoris testudogrisea*

Although some are wingless, most members of this suborder can be identified by the nature of their forewings, which are leathery and thickened at the base and membranous at the tip. When the bug is at rest, the wings are held flat over the body while the tips usually overlap. The suborder is large, containing many species of economic importance, as many feed on the seeds of plants and some species may be vectors, especially the Auchenorrhyncha, feeding on plant juices and thus transferring viruses. Most are terrestrial, but a number of families are aquatic, and some are parasites on vertebrates.

Scutelleridae (shield-backed bugs)

The Scutelleridae are predominantly found in tropical and subtropical areas. *Sphaerocoris testudogrisea* and *Calidea dregei* are common, widespread species in Africa. The Scutelleridae are commonly called shield-backed bugs. They look very like beetles but their underside reveals the slender proboscis that identifies them as being bugs. Many are brightly coloured in metallic greens, yellows and blues, like members of the genus *Calidea*.

The Picasso Bug, *Sphaerocoris annulus*, is a stunningly beautiful insect, about 9 mm long, with an oval, convex shape. The colourful neck shield and forewings are made up of numerous squiggles and blotches of olive green, tan, orange and black that look as if they have been painted on the insect. This species is found in the north-eastern bushveld of the country, where it feeds on herbaceous forbs, and also found in KwaZulu-Natal and the more tropical parts of South Africa, often in the vicinity of water.

Sphaerocoris testudogrisea is closely related to *S. annulus*. Although less colourful, it is equally unique and attractive. This species is approximately 7 mm long, with an oval, convex shape. The neck shield and forewings are shaded brown and white, with fine black speckles. They are very common throughout Africa, south of the Sahara, where they feed on herbaceous forbs.

The bug *Solenosthedium liligerum* is a fairly large species, about 14 mm long. The body is a metallic brownish olive-green colour, finely pitted with green speckles. The forewings are blotched with three yellow marks which sometimes form a continuous yellow band. This is a widespread bushveld species which does not congregate in large numbers and is normally observed singly on trees and shrubs. It rapidly flies away when disturbed.

▲ Scutelleridae > *Solenosthedium liligerum*

Pentatomidae (shield or stink bugs)

Shield bugs or stink bugs form a large family of well over 400 known species in South Africa. The group is one of the largest in the suborder Heteroptera and is commonly known as shield bugs because of the shield-like structure (the scutellum) between the wings. Although these different-sized creatures are not considered the most glamorous in the insect world, some have strikingly beautiful colours, complete with unique, interesting shapes. Pentatomids are mostly medium to large shield-shaped bugs, sometimes brightly coloured,

▲ Pentatomidae > Asopinae > *Macrorhaphis acuta*

▶ Pentatomoidea (nymph)

▼ Pentatomidae > Pentatominae > *Pseudatelus foveatus*

and usually with well-developed stink glands, which explains their common name As the name indicates, the pentatomids have, with few exceptions, five segmented antennae, the bases of which are usually covered by the dilated jugae, or head part above the snout, when observed from above. They are further characterised by a very large scutellum, or shield, that reaches to the apex of the base of the forewings. In some groups the scutellum is much enlarged to cover nearly the whole top part of the abdomen. They nearly always have single eyes (ocelli) and a rostrum, or beak, segmented into four.

The bug *Macrorhaphis acuta* is a medium-sized, strongly elongated insect, about 14 mm long. The body tapers strongly towards the end. This species is light brown with mirror image darker-brown blotches, especially noticeable at the end of the forewings. Unlike most other pentatomids, they are predators and prey mostly on soft-bodied insects, especially butterfly and moth larvae. They are very commonly found on plants in woodland savannah and grasslands.

Pseudatelus foveatus is a medium-sized shield bug, about 16 mm long. The body is blackish in colour with fine speckles of yellow. The head is sharply pointed with the eyes situated on the projection. They are common plant feeders in arid woodland areas and dry forest edges.

Carbula limpoponis is a small shield bug, about 7 mm long. The body is brown in colour with black forewings. The scutellum (shield) is a pale yellowish-white and forms a contrasting triangle with the black forewings. The margins of the thorax have sharp spines in certain individuals, absent in others. These common creatures are plant feeders in arid woodland areas and are commonly observed under bark during winter.

Pseudatelus notatipennis is a medium-sized shield bug, about 16 mm long. The body is blackish-brown in colour with a white line running from the base of the head fading away as it progresses down the centre of the forewings. As with most members of this group, the head is sharply pointed with the eyes situated on this projection. They are plant feeders and common in arid Mopane woodland.

Glypsus conspicuus is a medium-sized shield bug, about 18 mm long. The body is a blackish colour. A distinguishing feature of this species is the yellow-and-black antennae, which are relatively long and can move in various positions. These bugs are plant feeders and common in semi-arid areas. Unlike most other pentatomids, they are predators, preying mostly on soft-bodied insects, especially butterfly and moth larvae.

▲ Pentatomidae > Pentatominae > *Carbula limpoponis*

▼ Pentatomidae > Pentatominae > *Pseudatelus notatipennis*

▼ Pentatomidae > Asopinae > *Glypsus conspicuus*

▲ Coreidae > Coreinae > *Leptoglossus membranaceus*

▼ Coreidae > Pseudophloeinae > *Clavigralla tomentosicollis*

Coreidae (twig wilters)

The large family Coreidae incorporates many diverse forms. In general, they are stout, medium to large bugs (5–40 mm) of dull coloration (usually a dull brown or yellow). Most species have a small head, which appears quadrangular as the part of the head in front of the antennal insertions is short. The antennae are segmented into four and situated above a line running through the centre of the eyes and the apex of the head. Simple eyes (ocelli) are always present. The thoracic scent-gland openings are usually well developed and prominent. The forewings are usually complete and very few wingless or partially winged species are known. The wing-cover membrane usually carries a number of sub-parallel veins running longitudinally. Many species show sexual dimorphism, and in some species the hind legs have modified structures with spikes that appear leaf-like and are usually better developed or present only in the males. These are thought to be used in territorial battles and for defence against predators.

Leptoglossus membranaceus is a large bug, about 18 mm long. The body is blackish, it has antennae with red bands and red markings on the abdomen and head. A distinguishing feature is the flattened leaf-like projections on the hind legs. These creatures are plant feeders which feed on a variety of species, including wild calabashes (*Cucumis* sp.). They are common in the semi-arid areas of north-eastern South Africa.

Clavigralla tomentosicollis is a medium-sized bug, about 10 mm long. The body is uniformly brown, with the membranous parts of the wings a dark cream colour. Two darker-brown projections protruding from the margin of the thorax area are a distinguishing feature. The species has dark, flattened, leaf-like projections on the hind legs. They are plant feeders which feed on a variety of species.

Reduviidae (assassin bugs)

The Reduviidae or assassin bugs are a large and diverse family of predatory bugs subdivided into about 30 subfamilies. Of these, 13 have so far been recorded in southern Africa. Handling assassin bugs is not recommended as they can inflict a painful bite and the burning can persist for some time. Assassin bugs that have been identified after biting people in South Africa belong to the genera *Pseudophonoctonus*, *Perates*, *Rhynocoris*, *Cosmolestes* and *Edocla* sp.

The assassin bug *Pseudophonoctonus paludatus* is a large insect, about 13 mm long. The body is uniformly pink, with the membranous parts of the wings dark brown in colour. There is a pattern of darker pink and grey on the scutellum, or shield, which is a distinguishing feature in this group. This creature is a predator of other insects and is usually found on foliage waiting to ambush its prey. It is regularly found in arid wooded savannah.

This attractive assassin *Cosmolestes pictus* is a large bug, about 15 mm long. The body is white, with orange, yellow and black forewings and scutellum (shield). There are white markings on the bases of the forewings. This creature is a predator of other insects and is usually found in dense foliage. It is not often observed and favours well-wooded savannah

The assassin bug *Edocla* sp. is a large insect, about 12 mm long. The body is black, and irregularly shaped. The female is wingless and hunts and ambushes insects dwelling on the ground. This species is difficult to observe and is seldom seen. It favours well-wooded savannah with sandy patches. The females are usually wingless and are often found under stones or logs, whereas the males are usually fully winged and are often observed at sources of artificial light.

▲ Reduviidae > Harpactorinae > *Pseudophonoctonus paludatus*

◄ Reduviidae > Reduviinae > *Edocla* sp.

▼ Reduviidae > Harpactorinae > *Cosmolestes pictus*

▲ Pyrrhocoridae > *Dysdercus intermedius* (cotton stainer)

Pyrrhocoridae (cotton stainer bug)

Cotton stainer bugs are usually robust, and both nymphs and adults are usually brightly coloured in red, orange and black. They differ from the Lygaeidae (seed bugs) in that they lack the two simple eyes on top of the head. The males are smaller than the females, and mating couples may often be seen, walking about back to back. All southern African species seem to be plant feeders and are associated with plants in the Malvaceae and related families. They prefer to feed on ripe or developing seeds of these plants but will also readily feed on the stems. They are referred to as cotton stainers because they feed on cotton, transmitting a fungus on to the balls which causes discoloration. They also feed on indigenous plants of the same family as the cotton plant.

The cotton stainer *Dysdercus intermedius* has distinctive body markings. It is about 14 mm long, with an elongated body orange in colour with bands of white. The forewings are grey with the membranous parts of the wings black towards the end. This is a bushveld species and strongly associated with Baobabs. They feed on plant material, especially seeds and stems. This is a gregarious species and may form small groups at a suitable feeding source.

Alydidae (broad-headed bug)

The Alydidae are slender insects with relatively large, broad, triangular heads. The tip of the antenna is usually the longest segment and is curved. The Alydidae are divided into three subfamilies, the largest of which in southern Africa is the Alydinae. They usually have thickened hind legs with spines.

This broad-headed bug is medium-sized at about 12 mm long, with a slender body, broad triangular head and enlarged hind legs. They are brown in colour and their antennae have two bands of orange. They are extremely active and fly away rapidly when disturbed. They are plant feeders feeding mainly on *Acacia* spp. seeds; they may occur in large numbers on the ground where seeds have fallen from trees.

Rhyparochromidae (seed bugs)

Some species within the subfamily are very active insects and are wasp-like in their movements. The Rhyparochromidae, by far the biggest and most diverse subfamily of the Lygaeidae, are small to medium-large (2–20 mm) and dull in colour, mainly found in black and various shades of brown. Many genera and species have a range of host plants but some do show host-plant specificity. Some species, for example *Dieuches armatipes*, mimic ants. Some species has been recorded as associating with termites; they probably feed on the seeds accumulated by the termites. Most of the Rhyparochromidae live in the litter that collects below plants, where they feed on mature, fallen seeds. They may sometimes climb plants to feed on maturing seeds but only a few of the species are truly arboreal. The thickened, spined forelegs of the Rhyparochromidae have led people to believe that they were predacious. However, these are most probably used to facilitate the handling of seeds and to crush the hard seed coat. The males in certain groups 'prepare' seeds for the females, presenting them with definite display behaviour. When the female begins to feed and is preoccupied with this, the male copulates with her. The Rhyparochromidae are oviparous, but a few species are recorded as ovoviviparous, producing eggs outside the body, a very rare condition in the Heteroptera. New classification has elevated the subfamily Rhyparochrominae to the family Rhyparochromidae.

The bug *Dieuches armatipes* is large, about 11 mm long, with an elongated body. They are blackish brown and cream in colour and the proximal half of the antennae are white. They are active bugs and run rapidly when disturbed. They are common is well-wooded, semi-arid environments where they are feed on plants.

▲ Alydinae > *Alydidae* (nymph) (broad-headed bugs)

▲ Rhyparochromidae > Rhyparochrominae > *Dieuches armatipes*

Rhopalidae (scentless plant bugs)

The Serinethinae are represented in southern Africa by a few species belonging to *Leptocoris*, which are medium-sized bugs with an oblong, ovate body with long slender legs. Some of the species are rust-brown with black legs and forewing membranes. They closely resemble the pyrrhocorids or lygaeid bugs. However, the multi-veined membrane on the forewing is a distinguishing characteristic. When an adult is disturbed, it readily takes flight, flying relatively low for long distances. Members of this family are sometimes called scentless bugs on the account of the presence (or absence) of poorly developed scent-gland openings. These bugs are chiefly associated with low plants and weeds belonging to the family Sapindaceae. They seem to prefer the reproductive parts of the plants such as the buds, flowers and seeds but may also feed on leaves and stems.

The nymph of *Leptocoris* sp. is a bright luminous pink. It is a rather strange-looking creature, with bright pink eyes. Wings have not yet developed in this specimen. These are plant feeders, and are common in well-wooded areas.

LEPIDOPTERA

Butterflies are the most popular of all the insect groups, because of their striking colours and gentle natures. Butterflies, like most insect species, have a range of different habits and habitats, and some species can be used as ecological indicators of the health of the environment as they are very sensitive to the condition of the vegetation in any area. Moths are not as colourful as their butterfly cousins and many species of micro-moths are practically impossible to identify, swarming around artificial lights in their thousands. These little moths are usually a few millimetres long and all appear a uniform brown or grey in colour. There are, however, larger, more colourful moths as well. Some species have warning eye spots and flashy colours.

Butterflies are diurnal and are rarely seen after dark, while the majority of moths are nocturnal, with a few day-flying species. Moths flatten their wings horizontally when they are at rest as opposed to the majority of butterflies, which fold their wings above the body when resting. There are some exceptions and a few select species of butterfly almost appear moth-like in the resting position. The antennae of butterflies usually end in a knob, while moths have either comb-like or hair-like antennae.

Butterflies and moths have an interesting array of feeding patterns, the

▲ Rhopalidae > Serinethinae > *Leptocoris* sp. (nymph)

majority sipping nectar from flowers through the proboscis, However, certain species of moths have no mouth parts and do not feed at all. These species pupate, mate, lay eggs and die within a relatively short period of time. The caterpillars of both butterflies and moths are fascinating, though there is not much literature on them and very little information is available on the South African species. The larvae seem to come in every shape, size and colour.

Caterpillars can be smooth, tufted, spiked and extremely hairy. The hairy ones often have tiny barbs containing toxins which cause pain in human skin. This is a defence mechanism to ward off potential predators. Caterpillars are generally herbivores and have adapted chewing mouth parts in contrast with the adult stage where a proboscis is used to draw up nectar. Caterpillar locomotion also differs considerably; they can be sluggish moving up a branch but can also move with amazing speed, hunching their backs to do so. Caterpillars move by means of three pairs of true, jointed legs and four or more fleshy, unjointed legs, which disappear during the pupation process. These legs have surprising strength, and removing caterpillars from a surface is often difficult as they cling tightly to it. Throughout their time as a caterpillar, the skin is shed, growing with each shedding before pupation. Moth larvae pupate underground or spin a cocoon, while a butterfly caterpillar's body transforms into a chrysalis, which is usually suspended from a branch or twig. The adults then gnaw their way out of their chambers, emerging in spring or summer.

Utetheisa pulchella, a moth species, is common and may be found in large numbers in a variety of different habitats. It is a pretty, slender, medium-sized moth, with a wing span of approximately 35 mm. It is easily identified by its white forewings, which are heavily speckled with red and black. A diurnal species, it feeds on a number of different grass and forb types. When disturbed, these moths usually fly a short distance before landing in the vegetation once more.

The Small Verdant Hawk Moth, *Basiothia medea*, is a beautiful species. It is a medium-sized triangular moth, with a wingspan of around 50 mm, and is bright olive-green in colour. The edges of the wings, the antennae and the eyes are brown. They are nocturnal but also active at dusk when they sip nectar with great accuracy from a variety of different flowers. The females lay eggs singly on host plants. The larvae are characteristically smooth and bear a short upright horn at the end of the abdomen, resembling the upright tail of

▲ Lepidoptera > *Utetheisa pulchella* (Crimson-speckled Footman)

▼ Sphingidae > *Basiothia medea* (Small Verdant Hawk Moth)

▲ Agaristidae > Ctenuchida > *Amata cerbera* (Heady Maiden)

▼ Crambidae > Spilomelinae > *Glyphodes indica* (Pearl Moth)

▼ Saturniidae > *Imbrasia belina* (Mopane Worm)

a dachshund. This species favours open bushveld and is strongly attracted to artificial light.

The Heady Maiden, *Amata cerbera*, is a small diurnal moth, with a wing span of approximately 30 mm. The wings are blackish-blue with clear windows. It has a bluish-green body with four orange bands on the abdomen. This is a species frequenting the arid savannah; its larvae feed on a variety of grasses.

The Pearl moth, *Glyphodes indica*, is a small species with a wingspan of approximately 22 mm. It has a brown head and wings, with a pale triangle in the centre. The species is characterised by a rufous tail, which it spreads when alarmed. This is a semi–arid, woodland species which is strongly attracted to artificial light.

The Mopane Worm, *Imbrasia belina*, is a well-known, colourful and captivating character. The black worms are peppered with round scales in indistinct, alternating whitish-green and yellow bands, and are armed with short black or reddish spines covered in fine white hairs. Even though they are referred to as the Mopane Worm, they are in fact larvae, which may feed off a number of different plant species, including *Diospyros, Ficus, Terminalia* and the Mopane tree itself. In Mopane-dominated areas, these larvae may occur in large numbers and are an important source of protein to many local communities, being either dried and eaten or cooked with tomatoes and onion. They are highly nutritious. The common bushveld species may occur in huge numbers and may totally defoliate trees over large tracts of land. The adult, the Mopane Moth, is a large Emperor moth, with a wingspan of 120 mm. Their wings are fawn and feature two black-and-white stripes that isolate the eye spots.

A beautiful butterfly, *Acraea natalica*, is brightly coloured with red, orange and pink wings. The wings have clearly defined black spots and distinctive hind-wing margin spots on the underside. This species has a black body with white spots and typically elongated wings. It is a slow-flying species and glides through the air unless harassed. The white elongated eggs are laid in batches on *Passiflora* sp. The larvae that hatch are cylindrical, with six rows of branch spines on all segments except the first and last. The Natal Acraea is common and widespread in forest edges of the Limpopo River and surrounding savannah. It is observed all year round. It is more common during late summer when it often congregates with hordes of other butterflies on flowers.

The African Monarch, *Danaus chrysippus aegyptius*, is a large, tawny-

orange butterfly with black veins and wing tips. White windows are characteristic on the upper and inner wing edges. The head and thorax are black, with dense white spots. This butterfly is common and is often seen drifting slowly across the savannah, parks or gardens. The African Monarch is observed year round; however their numbers peak in spring and autumn. A single, oval, creamy-white egg with longitudinal ribs is laid on various *Asclepias* spp. The larvae absorb the toxins from their food plant and as a result are poisonous and distasteful to birds and other insects. The creamy larvae are ringed with black and yellow, alerting predators to their toxic nature. Adults of this species also exude a brown liquid that is repugnant. The female Common Diadem butterfly mimics the African Monarch, hoping to avoid predators through this guise.

Ella's Bar, *Cigaritis ella*, is a medium-sized butterfly with a wingspan of approximately 25 mm. Dark bars on a paler background, with numerous silvery stripes and spots, characterise the underside while the upper side has dark bars on a paler background orange, with blue reflecting scaling at the wing bases. The eggs are bun-shaped, with a prominent pattern of criss-cross ribs forming hexagons divided into triangles, and are laid singly on the shoots

▲ Nymphalidae > Heliconiinae > *Acraea natalica* (Natal Acraea) (female)

◄ Nymphalidae > Danainae > *Danaus chrysippus aegyptius* (African Monarch)

▼ Lycaenidae > Lycaeninae > *Cigaritis ella* (Ella's Bar)

▲ Lycaeninae > *Axiocerses amanga amanga* (Bush Scarlet)

▼ Pieridae > Pierinae > *Colotis antevippe gavisa* (Red Tip)

▼ Nymphalidae > Charaxinae > *Charaxes jasius saturnus* (Foxy Emperor)

of the Sour Plum (*Ximenia caffra*). The larvae are known to hide under the bark and are rarely observed. These are active, confrontational butterflies, often found on hill tops and well-wooded savannahs where they feed on a wide variety of flowering plants, including stands of weeds.

This is a medium-sized group of small butterflies with an upper side characteristically red with black margins. The Bush Scarlet, *Axiocerses amanga amanga*, has broad, pearl-white basal streaks on the forewings on the underside. It inhabits wooded savannahs where it is a colonial breeder. The males actively defend their territories which include stands of Sour Plum (*Ximenia caffra*), the food plant of their larvae. They are rapid flyers who are known to congregate on hill tops during the heat of the day. They often fly about before alighting with characteristically spread wings. Both sexes feed on flowers of various herbaceous plants the year round. They are most abundant in the months of September through to November. They are easily spotted on vegetation as their bright red coloration betrays their presence. The larvae are dorsally flattened, a slug-shaped green or brown and are attended by certain species of ants. The larvae appear nocturnally, secreting themselves during the daylight hours in a variety of shelters.

This is a large genus of small to relatively large white butterflies belonging to the Pieridae. The majority have delicate orange or red tips to the forewings. The Red Tip, *Colotis antevippe gavisa*, inhabits open woodland and is usually seen on flowers. This charming species is white, with red or dark-orange wing tips and black veins and black marginal borders on both wings, with a black band extending from the thorax partly across the wings. They breed on the Sheppard's Tree (*Boscia albitrunca*). Depending on the rainfall, they are known to fly throughout the year. They are generally weak flyers, increasing speed only when pursued. The group is found in the dry, hot savannah areas of South Africa. Single white, elongated eggs are usually laid on branches; the larvae are elongated green cylinders with pale longitudinal or dorsal stripes. They are covered in short hairs, which may be poisonous.

The Foxy Emperor, *Charaxes jasius*, is an impressive, flashy, robust butterfly which is capable of flying exceptionally fast. They inhabit the under-canopies of large trees. This orange-and-black species is easily identified by the green veins on the underside of the forewings. They are aggressive butterflies and strongly territorial. They feed on tree sap rather than nectar, and are easily attracted to fermenting fruit, especially the banana. They are often observed

drinking water, especially from rainfall puddles. The eggs are smooth and round and have radial markings similar to the spoke of a bicycle wheel. They are laid singly or in batches on *Croton* sp. The green larvae have distinguishing horns on their head shields, which are longer than the ones found laterally. This is another common butterfly flying all year round and frequents forests edges, river edges and tall Mopane veld.

The Topaz Tip, *Colotis amata calais*, is a medium-sized butterfly with a wing span of approximately 34 mm. The wings have a background of salmon pink with brownish borders, and there are creamy-yellow bands near the wing tips in the female. The hind wing is greenish yellow. Flight in this species is slow, weak and close to the ground. It lands often on the flowers of weedy herbaceous plants to feed. The elongated, cream eggs are laid in batches on *Salvadora* sp. This species is not well distributed in South Africa but is common in the Limpopo basin, where it is found all year round, depending on the rainfall.

▲ Pieridae > Pierinae > *Colotis amata calais* (Topaz Tip)

ORTHOPTERA

Bradyporidae (armoured ground crickets)

The large, ungainly insects called corn crickets or armoured ground crickets are also classified as long-horned grasshoppers, despite their bizarre appearance. They are endemic to Africa, where about 12 species have been described. The group is widespread but most abundant and noticeable in the more arid areas of southern Africa. If this insect were magnified a thousand times, it would resemble a fearsome extinct reptile. Many people are afraid of corn crickets; they have a reputation for being poisonous. However, there is nothing to suggest that they secrete anything other than the repelling fluid commonly found in Orthoptera. Lizards have been observed catching and

▼ Bradyporidae > *Acanthoplus discoidalis* (armoured ground cricket)

eating the nymphs of certain species. However, they can inflict sharp bites with their powerful jaws. If the shield on the back of a male armoured ground cricket's thorax is raised, the remnants of its wings become visible. They form a pair of stout, membranous stumps that can be rubbed over one another to produce a loud, rasping noise. The female does not have these stumps and cannot produce any sound. The tympanal organs are found on the front legs just below the knees.

This large species of corn cricket, Acanthoplus discoidalis, is approximately 40 mm in length. The body is cream-coloured, with stripes of dark brown and yellow. The head, neck shield and legs are characteristically slate-grey in colour. The eyes and the long antennae are reddish-brown. The grey neck shield has a number of large grey spines with yellowish tips. The abdomen is large and bulky, convex in shape with small dark spines running along the margin. This species is primarily herbivorous but if necessary will scavenge and turn cannibalistic, devouring its kin found in a road-kill. They are eaten by a few mammals only, such as the Bat-eared Fox and Jackal, and also by some large birds, such as the Kori Bustard. The eggs can lie unhatched in shaded soil for a second year if there is no rainfall. This results in significant numbers in the following year. The species is common on low trees and shrubs in semi-arid savannahs but may also often be seen on the ground.

Tettigoniidae (long-horned grasshopper)

This group of insects is characterised by long, slender antennae of more than 30 joints, extending for more than the length of the body. Currently, 19 subfamilies are recognised in Africa. The members of the family can be referred to loosely as long-horned grasshoppers, although in the absence of local or common names for the African species it seems reasonable to use the American name 'katydid' for the various subfamilies, which is derived from the repetitive nocturnal song of certain tettigoniids in the eastern United States.

The African katydids have not been studied in any detail, and so the potential number of species occurring here is not known. Many are green in colour and largely nocturnal. They are difficult to collect and study because they climb in bushes and trees. The silent females, who lack the stridulatory apparatus of the males, can usually be recognised by a conspicuous sword-like ovipositor. The eggs are laid in the soil or in flat slits cut by the ovipositor into the bark of bushes and trees. The males are often loud and persistent singers.

▲ *Clonia* sp. (Saginae) (nymph) – page 42

They do not stridulate in the same way as the short-horned grasshoppers but make their sound by rubbing their wings rapidly one over the other. The left front wing is armed with fine rasp-like teeth near the base. When it is held together closed, the left front wing overlaps the right. When the wings are rubbed together the resulting vibrations are amplified by the wing, which acts as a resonator. In contrast to these vegetarian subfamilies, the Saginae are exclusively carnivores and fierce predators of other insects. They are large and conspicuous katydids, and the genus *Clonia* contains the most species. Also strictly nocturnal, their drone is a singing buzz.

This is a large predatory katydid, called a Sagine (page 41). They are about 60 mm in length and have a bright-green, slender body with silvery markings. The species is fully winged and able to fly relatively well. An identifying feature is the concentric brown bars found in the anal area of the hind wings. This is a well-known bushveld species and a voracious predator of other insects. They are chiefly nocturnal and are often seen on roads at night. The female lays its eggs in the ground usually under dense foliage.

This is a medium-sized katydid, approximately 30 mm in length. The body is green with the exception of the legs, which have a brownish hue. They are nocturnal creatures feeding predominantly on plants but they are also known to feed on certain insect groups. They are nocturnal creatures and strongly attracted to artificial light, often being seen at windows or outside lights of accommodation in game reserves. They are widespread in the bushveld regions of South Africa. They are slow moving, usually green or a pale brown in colour, and are closely related to crickets. The majority of katydids eat leaves, seeds and grasses. The call of the katydid is a characteristic sound of the African bush. It is produced by rubbing the sharp rasp-like edges of one front wing against the rough edge on the bottom of the other front wing. The sound produced is pure, with each note clearly audible and is amplified by a small, round membranous area near the wing base. The katydid is a shy, unobtrusive creature, more often heard than seen.

Katydids have long antennae, which are sometimes longer than their bodies. The female often has a long, sword-like ovipositor which she uses to penetrate plant tissue to lay her eggs. The females find the males by 'listening' for their calls and can locate them accurately with relative ease. Many katydids are masters of camouflage, the Bark Katydid blending skilfully with the bark of tree trunks, while the green bodies of others practically disappear in foliage.

▲ Tettigoniidae > *Phaneroptera* sp. (Leaf Katydid)

▲ Orthoptera > Pamphagidae > *Lamarckiana bollivariana* (Rain Locust)

▼ Mantodea > *Oxypiloidea* sp. (Bark Mantid) – page 44

Pamphagidae

This is a large locust, approximately 80 mm in length with characteristic flattened grey antennae and a pale cheek stripe. The males are winged and fly some distance when disturbed. They are nocturnal in habit and the males call for females from trees. They are a relatively common species in semi-arid environments.

MANTODEA

There are approximately 115 species of mantids in southern Africa, in a variety of colours, shapes and patterns. Mantids are well known to most people as they are commonly found in gardens and homes. It may take some time to

▲ Hymenoptera > Mutillidae > *Dasylabris stimulatrix*

▼ Diptera > Syphidae > *Phytomia incisa*

locate them on a branch as their camouflage is exceptional. Mantids are attracted to light and readily set up home in a kitchen or lounge provided there is a reliable food source available. They become quite 'tame' and have been known to take food from the hand. At a quick glance, the mantid appears to have only four legs. The other two are adapted with spines to grab and handle food. They are ambush hunters and generalists, eating any insect which is easy enough to handle.

The Bark Mantid, *Oxypiloidea* sp. (page 43), is a small insect, approximately 24 mm in length. They are extremely well camouflaged, cryptically coloured and therefore difficult to detect when not moving. They are a mottled grey-brown with a variety of ridges and bumps along the body. The head is knobbed. They are an active species, moving quickly when disturbed. They are tree dwellers and are always found on or around tree bark. They ambush other insects using their camouflage to get within striking distance of their prey.

HYMENOPTERA

This female velvet ant, *Dasylabris stimulatrix*, is really a medium-sized wingless wasp approximately 15 mm in size. This is a species with a reddish-brown thorax and a series of white spots on the abdomen. The body is extremely hard and coarsely punctured. It is covered with soft velvety hairs. They infest the larvae of other insects as parasites, biting their way into a cell, then resealing the nest chamber after laying their egg on the host's larvae. They occur in well-wooded, arid savannahs and can usually be seen running purposefully on the ground in search of food.

DIPTERA

Flies make up one of the largest orders of insects both in number and in the richness of their species. Flies are considered best adapted to flying. With only one pair of wings, they are experts in maintaining balance and stabilising the body whilst in flight. Flies can hover motionless in the air, they can fly forwards, backwards and even upside down. They are prolific breeders and often occur in large numbers when conditions are right. They are a vital source of protein and an important component in many food chains. The adult flies and larvae are eaten by spiders, other insects, reptiles, amphibians, birds as

well as small mammals. From an ecological point of view, flies are important as they bring about the rapid breakdown of flesh, animal tissue and other waste material. Some flies are important in the pollination of plants, as in the case of the Stapeliads, which give off a rotting smell to attract flies as the primary pollinating agent.

Phytomia incisa, a large bee mimic, has a wingspan approximately 15 mm in length. It looks like a bee with large conspicuous black eyes and a dull-brown thorax. The eyes are so large in the male that they appear to cover the entire head. The abdomen is orange, with indistinct black stripes. The male is an expert at hovering and swarms to attract females in the spring. This species is relatively common on flower heads on trees, bushes and forbs in semi-arid savannahs.

Billea gigantea, a fairly large fly, has a wing span approximately 11 mm in length. The body is black, with distinctive white markings on the abdomen. The eyes are large and brown. The wings are diaphanous and project backwards. The adults feed on nectar, while their larvae are internal parasites of other insects, usually the larvae of butterflies and moths. There is a fair degree of host specificity at the taxonomic level of the order; there is little or none at the species level. This species is important in controlling certain species regarded as pests and is common on flowering forbs in the Limpopo region of South Africa.

NEUROPTERA

Palparellus nyassanus, a large ant lion is approximately 70 mm in length. The antennae are long, noticeably clubbed and well defined. This is a species often observed flying at dusk amongst rocks in grasslands and woodland areas. It has delicate, clear, rounded wings with bold brown markings. This is a savannah species often alighting on grass stalks. It flies lazily when disturbed, to land some metres further off.

Blaberidae

The cockroach *Derocalymma* sp. is about 20 mm in length. Its flat, dark-brown, oval body has lighter markings. The wings have a rough surface and are often much longer than the actual body. The neck shield is triangular and has well-defined ridges on the margins. This is an open woodland species which occurs under the bark of dead and living trees. Interestingly, the nymphs do not congregate and are solitary in habit.

▲ Diptera > Tachinidae > *Billea gigantea*

▼ Neuroptera > Myrmeleontidae > *Palparellus nyassanus*

▼ Blaberidae > *Derocalymma* sp.

▲ Nephilidae > *Nephila senegalensis* (Golden Orb Spider)

ARACHNIDA

The female Golden Orb Spider, *Nephila senegalensis*, is a very large species, approximately 30 mm in length. It has a cylindrical abdomen and characteristic black-and-yellow banded legs. The third pair of legs is considerably shorter than the others. The cephalothorax, or first body section, is silvery, while the abdomen is black and marked with yellow - the patterns and colour intensity may vary.

The species spins a huge sticky web of closely spaced, strong, golden silk, which remains in place for a long time and is repaired when broken or dirty. The web is protected by a barrier web at the back and front. An array of old prey remains are often left hanging in the trip-lines. This common species of spider can be found singly or in large numbers, in which case the webs may touch or even overlap. The large female usually shares her web with several small males. She may lay up to 1000 eggs and can produce several egg sacs. The species is well distributed in South Africa and is common in the semi-arid woodland savannahs of the Limpopo basin.

The beautifully striped female Banded Orb Web Spider, *Argiope trifasciata*, represents a large species 25–30 mm in length. The body is pale yellow and finely banded with black. The cephalothorax is silver in colour. This species is strongly associated with short grasses found in moist areas of vleis or along river courses. They prey on other insects, often a great deal larger than themselves, such as grasshoppers and katydids. The web often has thicker zigzag strands, which are assumed to stabilise and keep the tension in the threads of the web. Ultraviolet light rays shining through these strands may also direct insects into the web. This species is relatively common in grassland and semi-arid savannah regions.

The Horned Baboon Spider, *Ceratogyrus darlingi*, is the largest of the South African baboon spiders, being 75–90 mm in length. The body is a distinctive grey-brown colour, with light banding on the legs. The species has a single distinctive horn projecting from its head, hence the common name. As in the case of most baboon spiders, it spends the majority of its time in a hole in the ground. However, they have been known to move about 20 m from these burrows. They are long-lived spiders and appear to have a sense of memory and know their habitat. They may zigzag some distance away from their burrows but, when disturbed, scuttle directly back to the right burrow. A

baboon spider may take 5 to 7 years to reach maturity. This species is readily encountered in semi-arid savannah regions of South Africa.

Harpactira sp., a baboon spider, is approximately 55 mm in length. The body is dark brown with numerous light-brown hairs. The photograph shows a 22-mm, creamy-white parasitic wasp grub feeding off an anaesthetised baboon spider, like a leech sucking blood. The grub makes an incision in the spider and then sucks out the nutrients. Amazingly, the larvae do not damage the critical organs until just before they pupate, thus keeping the spider, its food source, alive. If the spider should die and decompose before the grub was sufficiently mature, the grub would starve and die.

▲ *Argiope trifasciata* (Banded Golden Orb)

◀ Theraphosidae > *Ceratogyrus darlingi* (Horned Baboon Spider)

▼ Baboon spider (*Harpactira* sp.) and pompilid parasitic wasp grub *(Tachypompilus ignitus)*

▲ Salticidae > *Portia* sp.

▼ Salticidae > *Hyllus* sp.

▼ Salticidae > *Thyene* sp.

Portia sp., a jumping spider, is small and has a total length of between 12 and 17 mm. The pedipalps of the male are often decorated with thick brushes of hairs in contrasting colours. The spider has a red-brown colour with elaborate, creamy-white 'pompon-like' pedipalps. These are used in courtship and in sizing up an opponent during battles between males. These spiders feed on other spiders and have a special trick to lure their prey. They tap on the web of another spider species, which is fooled into thinking that it has caught an insect. On coming to investigate, it becomes the prey. *Portia* sp. is a solitary, diurnal species which, unlike other jumping spiders, moves slowly appearing to stalk its prey. This spider is said to be 'the cleverest' of all spider species and appears to have a short-term memory. While hunting, they seem able to calculate the distance between themselves and their victims, and then to distract and catch their prey efficiently.

Hyllus sp., a jumping spider, is a relatively large species approximately 22 mm in length. This interesting-looking insect is brown with characteristic black-and-white markings and an exceptionally hairy body. As with all jumping spiders, the eyes are forward-projecting and clearly visible. It is a vigorous and active predator of other insects. The species is a real wanderer and a great generalist, being found on bushes, rocks and branches. It is a diurnal, visual hunter and is common in semi-arid savannahs.

Thyene sp., a sweet, 'baby-faced' jumping spider, is a small species, approximately 6 mm in length. This creature is a pale pinkish cream with characteristic brown spots on the cephalothorax. Although it is probably anthropomorphic to say this, the spider has conspicuous, protruding, soulful eyes. It is an active hunter, feeding mainly on the ground, where it catches flies and other small insects. The jumping spiders are a large, diverse group inhabiting a wide array of habitats and fulfilling a number of ecological niches. This species is diurnal and common in semi-arid savannahs.

Thalassius sp., the fishing spider, is a large, robust, fast-moving spider approximately 30 mm in length. This species is greenish brown, with numerous white speckles over the body and legs. They skim rapidly over water, dragging their hind legs behind them. The vibrations under and on the surface of the water alert them to the presence of small fish, tadpoles and other insects. The female characteristically holds her egg sacs in her jaws and pedipalps. Interestingly, before the young are ready to emerge, the mother attaches the egg sac to some vegetation, then spins a web around it and stands guard

over it. When the young hatch, they bunch together under the mother for protection until they disperse, at which stage the female dies.

Parabuthus mossambicensis, a medium-sized scorpion, is approximately 65 mm in length. The distinctive coloration of this insect with its dark-brown body and orange tail and pincers makes it readily identifiable. As with most venomous scorpions, the pincers are small, while the tail is large. It is thought that the scorpion relies on its venom and therefore does not require large pincers to hold and kill its prey. The species is often found under rocks where it waits for its prey, usually unfortunate insects trying to escape the heat of the day by sheltering there. It also frequently forages during the evenings and may be attracted to insects in artificial light. Like many other species, the female carries its young on its back to protect them. The tail segments in the male are longer than those of the female. Scorpions can be easily located at night by using an ultraviolet light, which causes them to take on a luminous yellow-green shine.

▲ Pisauridae > *Thalassius* sp.

▼ *Parabuthus mossambicensis* (skin change)

Bankenveld Grassland, Gauteng Province: landscape

◄ A huge, thunderous storm brews over the iron-rich red sandstone outcrops of this pristine area.

The Highveld covers most of the north-eastern parts of South Africa and can be broadly defined as a plateau lying at an altitude above 1200 m. Much of the central part of the plateau is natural grassland. The Bankenveld ecotone is a transition between grassland and savannah biomes. Ecologically this is very valuable as the invertebrates of each of these biomes are contained within the system, creating a rich biological diversity. The grassland areas are characterised by large open plains with scattered wetlands and rocky outcrops. Invertebrate life is extremely rich here, with much to discover for any enthusiast. The influence of the savannah means that there is a greater variety of different tree species. These areas are also more rocky and mountainous with rivers and tributaries often forming majestic rock gorges. The clear water streams cascade through the landscape, resulting in interesting rock formations and are bordered by riverine bush teeming with invertebrate life. This is a transitional climatic zone lying between the typical grasslands of the high inland plateau and the bushveld of the lower plateau.

The summer rainfall is between 650 and 850 mm per annum. Temperatures vary between −2°C and 39°C, with an average of 16°C. The relatively high summer rainfall, dry winters, severe night frosts and marked diurnal temperature variations are unfavourable for tree growth. Most of the grasses and other herbs in the grassland also die back during winter. The area has rocky mountains, hills, ridges and plains of quartzite, conglomerate, shale, dolomite and sometimes andesitic lava. Grassland soils are varied and usually conform closely to the underlying geological structure. The differences in plant communities can thus be linked to these variations.

The rolling hills of the Bankenveld, with its rocky outcrops, valleys and

▲ Cabbage trees are common on the sides of the rocky ridges and are conspicuous among the many Proteas.

▼ These rocky vegetated areas are popular with a variety of insect species which provide a safe haven.

▼ Protea flowers are regularly visited by a variety of fruit chafers and are often observed embedded into the head of the flower.

52 A Landscape of Insects

ravines, are characteristic of this area. There are scattered red sandstone rocks and associated soils. The diversity of the grass species and flowering plants is notable, and wooded outcrops contrast with the surrounding grassy areas. The Suikerbos (*Protea caffra*), Lavender tree (*Heteropyxis natalensis*) and *Croton gratissimus* are common here. The rivers that dissect these areas are bordered by lush vegetation trees such as the river bushwillow *Combretum erythrophyllum* and *Acacia karroo*.

These varied habitats are home to an amazing abundance of invertebrate life, which correspond with the richness in plant diversity. The Bankenveld is a transition zone between bushveld and grassland and is fairly rich in woody plants, including elements of bushveld. Most of the woody plants grow in the rocky areas, particularly on hillsides and in sheltered ravines, where a sparser grass layer offers less competition to their seedlings and decreases the effects of bushfires. The microclimatic conditions prevailing on the north-facing slopes of hills are responsible for the bushveld elements, which penetrate quite far south into the Bankenveld. Some of the prominent trees found here are *Acacia caffra*, *A. karoo*, *Protea caffra*, *Celtis africana*, *Cussonia paniculata*, *Euclea crispa*, *Burkea africana* and *Diospyros lycioides*. The soils are generally poor and sour, resulting in grassland that has low grazing potential in winter, referred to as sourveld. The veld is particularly rich in non-grassy herbs and forbs, which contribute considerably to the wealth of plant species in this veld type.

This area has extreme temperatures. The majority of insect species either die off as a result of the cold or lie dormant until the temperature rises in spring. Numerous species pass the winter in the form of eggs which hatch in the spring. The Bankenveld is dominated by grasses, in a generally flat-to-undulating landscape, where trees are absent except in localised habitats like rocky outcrops.

The Bankenveld is considered fire-maintained grassland which might develop into savannah if it was possible to exclude fires from the system. Winter frost plays an important role in the distribution of the woody elements in this transitional zone. The grassland vegetation is restricted to exposed sites in the irregular, undulating landscape, which lies at high altitude. Fire and grazing play a major role in this grassland zone. Lack of fire is often detrimental to bulbous plants, which are easily smothered by moribund grass. Excessive burning and selective grazing, on the other hand, can have a profound effect

on the composition of various grass communities, often upsetting the balance between sweet and sour grasses. Fire is an extremely important factor in the veld type, and many of the non-grassy forbs could not survive for long in its absence. Late winter seems to be the best time for burning. A striking feature of many flowering plants in the biome is their perennial underground storage organs. These include bulbs, tubers and rhizomes, which enable the plants to survive fire, spells of summer drought and the cold, arid winters.

Frost occurs in the habitat, in some cases quite severely. Frost, fire and grazing (including insect herbivory) maintain the dominance of grasses and prevent the establishment of trees. Geophytes are abundant and many are adapted to grow and flower after fire has raged through the grassland. Insects that feed on grasses have adapted to the sour, leached grass species that occur in the area. These grasses have sour, high-fibre content, withdrawing the nutrients from the leaves during winter, which makes them unpalatable to many species.

▲ The crystal clear waters of the Wilge River dissect the grassland and form breathtaking gorges which are home to huge numbers of dragonflies and damselflies.

This area is greatly under threat from mining, agriculture and development. Much of the grassland suffers heavily from overutilisation, large areas having been destroyed for the cultivation of crops, particularly maize and sunflowers, and for the development of extensive urban areas and industry. It is also home to a wide diversity of plants and animals.

The Bankenveld landscape has also been drastically changed by alien, exotic trees, particularly *Eucalyptus* and Australian *Acacia* species, which have been widely planted to provide shade and shelter. These green oases often contain chemicals which poison the ground below, allowing only the seedlings of their own species to germinate. Other invasive woody plants are a major threat to the grassland, particularly along rivers and streams, where they displace the indigenous vegetation – the hosts of many insect species. Selective grazing, trampling and the incorrect use of fire have unfortunately led to the deterioration of most of the Bankenveld. The area has been severely encroached upon by wattles and other alien species abound in disturbed areas.

Insects are often not recognised for the essential role they play in ensuring the survival of plant species. Some are only admired for their beauty and uniqueness. Seasonal flowering patterns seem to be adapted to optimise the activity of the pollinators.

Fire plays an important role in maintaining and creating suitable conditions for invertebrates. Where natural and accidental burns occur, it is difficult to quantify the effect of fire on the diversity and abundance of species. Fires vary in frequency, intensity, extent, season and their interactions with other disturbance processes; as a result, different fires may have different effects.

Decaying wood harbours invertebrate activity – usually large numbers of larvae and eggs at various times of the year. Low-intensity fires can be expected to cause less damage to eggs and larvae as the fires burn faster. The life cycles of many of the species can be extended, with cases of over 35 years on record. These species are more susceptible to fire as they are found near the surface of the wood. The larvae drill deep into the wood only after hatching. The implications are that diversity and abundance would be affected to a greater extent by regular burns of high intensity during times when the beetles are laying eggs, namely in the summer months. High quantities of

◀ A large number of insects feed on plant juices which they extract through holes created on the leaf surface.

wood debris are an important component of a healthy ecosystem linked to biodiversity and ecosystem processes. These areas are high centres of biological interaction and energy exchange, in many ways symbolising the complexity of the ecosystem.

COLEOPTERA

Beetles are special in that their fore wings have been modified into a hard wing case, sometimes protecting a second pair of membranous wings. The wing covers are in some instances totally fused, while the flightless species have no membranous wings. The legs of these beetles are adapted for running.

Lycidae (net-winged beetles)

The genus *Lycus* is very common in South Africa and may occur in large numbers in savannah and grassland areas. Lycids are widely distributed, with their main representation in the tropics. At first glance, these creatures do not resemble beetles, as they have flattened, leaf-shaped wing covers. Different species have different-shaped wing covers; some are broad, while others are narrow. They are all usually a characteristic chestnut brown with black tips forming a band towards the broad end.

These beetles are called net-winged beetles because of the fine network of veins and ridges on their leathery wing covers. The wings have characteristic longitudinal ridges. The beetles are black and yellow or orange. The adults are often seen sitting atop grass stems or flying lazily about. The wing covers of *Lycus* males are often very different in shape from those of the females. Since several species may occur together in the same area, it is often difficult to match the males and females unless they are observed mating.

The net-winged beetle *Lycus rostratus* is an insect approximately 20 mm in length. The body is black, while the neck shield is black with broad orange borders. The wing covers are expanded, black at the base and tip and slightly black along the top margins. The antennae are black and strongly serrated. The legs, also black, are well adapted to grasping grass and flower stalks. This species feeds on the flowers of forbs and trees and is common in the Bankenveld grasslands where large numbers can be seen resting or mating on grass inflorescences.

This small beetle, *Cladophorus marshalli*, is an insect approximately 9 mm in length. The body and neck shield are black in colour while the elongated,

▲ Lycidae > *Lycus rostratus*

▼ Lycidae > *Cladophorus marshalli* (Slender Net-winged Beetle)

▲ Carabidae > Lebiinae > *Graphipterus circumcinctus*

▼ Carabidae > Lebiinae > *Graphipterus bilineatus* (Two-lined Velvet Ground Beetle)

parallel-sided wing covers have no lateral extensions and are orange with a black tip. The antennae are black, serrated, with an orange base. This species feeds on flowers and is relatively uncommon in the Bankenveld grasslands and savannahs when compared with other species of the group.

Carabidae (ground beetles)

Some diurnal species of ground beetles such as *Graphipterus* are cryptically coloured to blend into their surroundings. The large genus *Graphipterus* contains small to medium-sized diurnal species with velvet down and vivid colour patterns on their wing covers. The genus *Anthia* and the subgenus *Thermophilum* include very large and conspicuous species with diurnal, crepuscular and nocturnal habits. These beetles are especially numerous in the arid, sandy regions of the Karoo and Kalahari.

The ground-dwelling species are often encountered in moist areas, on the banks of dams and rivers. Others live under decaying plant material such as logs or leaf litter, and some prefer open sandy patches among tufts of grass or stones. The adult ground beetles are often long-lived and records suggest that certain species live in excess of five years. It is thought that certain nocturnal species are capable of topographical learning, memorising the layout of an area and return to the same shelter every morning. Certain species of *Anthia* are reported to display territorial behaviour.

A diurnal species, the ground beetle *Graphipterus circumcinctus* is an insect approximately 14 mm in length. The body is black and relatively flat. The species is considerably streamlined with its flattened head and sharp, powerful, forward-facing mandibles. The neck shield is black in the centre with white edges, while the wing covers are black with white margins. This beetle has thin antennae which are regularly kept clean by pulling them through a special comb organ on the leg. The eyes are well developed and prominent. The legs are strong and well suited to running and catching the small diurnal insects on which they feed. This species is exceptionally active and inhabits sandy grassland environments.

Graphipterus bilineatus, a diurnal species of ground beetle, is an insect approximately 18 mm in length. The body is black, with two strips of pale hairs between the compound eyes. The neck shield has a black line in the centre, with brownish edges. The wing covers are densely covered with brown hairs and have two longitudinal black stripes. This beetle has thin, forward-

projecting antennae. The legs are long, black and slender and well suited to quick running as they catch and devour other ground-dwelling insects. This species is active at the hottest time of the day and is common in Bankenveld grasslands.

Cypholoba macilenta, a ground beetle, is a medium-sized insect approximately 25 mm in length. The head and neck shield are a glossy black colour and clearly separated. The neck shield is slightly lobed with a central depression. The antennae are long, projecting forwards. The wing covers

▲ Carabidae > Anthiinae > *Cypholoba macilenta*

▲ Carabidae > Harpalinae > *Ooidius dorsiger*

▼ Carabidae > Anthiinae > Anthia thoracica

▼ Carabidae > Anthiinae > *Cypholoba gracilis*

are black and longitudinally grooved. There is a network of raised lines and orange punctures on the upper three-quarters of the wing covers. The legs are black and well adapted to stalking other ground-dwelling insects.

Ooidius dorsiger, a ground beetle, is a small insect approximately about 10 mm in length. The body is glossy orange in colour. The head is also a glossy orange but a shade darker than the rest of the body. The neck shield is large with lateral extensions. The wings covers are brown and longitudinally grooved, with orange margins. The legs are orange and well adapted for moving on wood, where it preys on other insects.

Anthia thoracica, a ground beetle, is a large insect approximately 45 mm in length. The head, neck cover and wing covers are a glossy black. The neck shield is slightly expanded and flattened. The wing covers have deep longitudinal grooves. The legs are strong and well adapted to running. The antennae are segmented and long and project forwards. This species is a predator of ground-dwelling insects and is relatively common in the sandy and rocky areas of the Bankenveld grasslands.

Cypholoba gracilis, a ground beetle, is a small insect approximately 19 mm in length. The head and neck shield are black and clearly demarcated. The neck shield has a distinctive grey longitudinal line. The antennae are long and segmented and project forwards. The wing covers are black and longitudinally grooved, forming a characteristic pattern of raised lines and punctures. The legs are black and adapted for quick movement, facilitating the capture of small insects. This species is common in open grassland with relatively sparse vegetation and sandy patches. It is active during the heat of the day.

Cicindelinae (tiger beetles)

The tiger beetles are known for their speed as they can move exceptionally fast between stones and herbaceous vegetation, being extremely difficult to catch. Certain species can fly and are attracted to artificial light. The giant tiger beetle belonging to the genus *Manticora* can inflict a severe bite if handled carelessly. They are voracious predators, actively hunting their prey. Their adaptations for this way of life include a broad head with prominent eyes, large acutely toothed mandibles and long, strong, hairy legs. The jaws of the males are exceptionally large and it is believed they are used for clutching the female when mating. Although a swift runner, the large black tiger beetles are wingless and cannot fly.

Manticora mygaloides, a large tiger beetle, is approximately 50 mm in length. This beetle is black with strongly flattened wing covers. The body is covered with fine hairs, which are only noticeable on close inspection. It has very large mandibles, used for feeding on other ground-dwelling insects. This species is largely nocturnal in habit and may often be seen on dirt roads at night. They are very active insects, vigorously hunting their prey, usually at night or in the early mornings or late afternoons. The male clutches the female with its large mandibles while mating and the mating pair can often be observed moving around in this position. The female lays her eggs in soft, moist, sandy soil. This species is relatively common in the Bankenveld grasslands of South Africa.

▲ Carabidae > Cicindelinae > *Manticora mygaloides*

Paussidae (ants' nest beetles)

The ants' nest beetles belong to the family Carabidae. Most species of Paussidae can be recognised by their strangely shaped antennae, in which the terminal joints are fused together to form a curiously shaped club. Ants' nest beetles are remarkable insects. The largest of them are just less than

14 mm in length with the majority being in the region of 7 mm. The much enlarged antennae appendages, characteristic of this group, are reported to serve as handles by which the beetles are dragged by ants and are a source of secretions favoured by ants.

An important adaptation to life in a nest of aggressive ants is the subcutaneous gland system which secretes a volatile substance. This is greedily licked up by the ants and serves to pacify them. The position of the gland is indicated by the presence of the golden-yellow hairs on the surface. These beetles are rarely found in the open as they are usually in the ants' nest. They are sometimes attracted to artificial light at night. When irritated, they eject a volatile, caustic fluid, similar to the bombardier beetles, and if this lands on the skin or in the eyes, it can result in severe pain and burning.

Paussus dohrni, an ants' nest beetle, is a small insect approximately 8 mm in length. The body is a smooth, glossy chestnut brown. The wing covers are a light chestnut brown with a darker brown grain. The stubby legs are without distinct segmentation. The antennae appear to be on stalks, becoming leaf-like. Ants are known to drag these beetles around by their antennae without harming them. The group has an intimate association with ants and may spend the majority of their time in ants' nests. The species favours grassland environments and is strongly attracted to artificial light.

Melyridae (soft-winged flower beetles)

Astylus atromaculatus, the exotic Spotted Maize Beetle, is a small insect approximately 10 mm in length. The head and antennae are black while the body is covered with scattered erect black hairs. The neck shield is pale and has two distinctive black spots. The wing covers are light yellow with large black patches. These are predominantly pollen feeders and may congregate at a suitable food source in large numbers. Eggs are laid in clusters under fallen leaves. The larvae are ground-dwelling and feed on decomposing plant material before they emerge as adults.

Chrysomelidae (leaf beetles)

The subfamily formerly known as Alticinae is a large group of relatively small beetles within Chrysomelidae known as flea beetles. New classification of the group has placed this subfamily within the Galerucinae. They are known as flea beetles because of their enlarged hindlegs; as their common name

▲ Carabidae > Paussidae > *Paussus dohrni*

▼ Melyridae > *Astylus atromaculatus* (Spotted Maize Beetle)

suggests, they can jump very well, a feature which probably helps them to escape their predators. Most are small, compactly built beetles with either a yellowish or metallic colouring. Certain species are of great interest as the source of San arrow poison. The larvae feed on poisonous plants and in turn become poisonous as a result of the toxins they ingest. In some instances the larvae are parasitised in the larval stage by the larvae of a host-specific *Lebistina* beetle belonging to the ground beetle family. An interesting example of mimicry is found in the genus *Lebistina* and flea beetles of the genus *Diamphidia* (Chrysomelidae). The larvae of the ground beetles live as parasites on the larvae and pupae of the flea beetles, while the adult ground beetles closely resemble the adult flea beetles. The San peoples use *Diamphidia* to poison their arrows, and it is assumed that the ground beetles are shunned by predators such as birds because they are mistaken for these poisonous flea beetles. Their poison is potent enough to kill a animal many times their size, e.g. a large antelope will die in 35 minutes. Many larval and adult flea beetles are leaf feeders, but some have adapted to very different types of life. They live on a variety of food plants, often in considerable numbers. The majority of the larvae feed on the roots of plants, but free-living larvae feed on or within the leaves of the host plant. Adults usually chew holes in the leaves, resembling 'shot holes'. Mature free-living larvae drop off the host plant in the soil below and burrow into the ground, where they pupate, as do other flea beetle larvae. Many of the Galerucinae (formerly Alticinae) have a wide distribution, including *Decaria*, *Blepharida* and *Toxaria*. The larvae of flea beetles feed on the leaves of the host tree and, when mature they drop off on to the soil below and burrow very deep into the ground, where they pupate.

Decaria sp., a leaf beetle, is tiny at approximately 4 mm in length. The head, neck shield and wings covers are a smooth, glossy black. It is relatively common in grasslands but is often overlooked as a result of its smallness. This species is a plant feeder in grassland and savannah areas.

Phygasia limbata, a small leaf beetle, is approximately 4 mm in length. The head is black, while the neck shield is a glossy orange. The wing covers are a contrasting greyish cream with black upper parts and a clear black central line dividing the two covers. It is common in grasslands, where it feeds on plant foliage.

Bonesioides kirschi, a leaf beetle, is a glossy black insect approximately 10 mm in length. The head, neck shield and wings covers are clearly differentiated.

▲ Chrysomelidae > Galerucinae (formerly Alticinae) > *Decaria* sp.

▼ Chrysomelidae > Galerucinae (formerly Alticinae) > *Phygasia limbata*

▼ Chrysomelidae > Galerucinae > *Bonesioides kirschi*

▲ Chrysomelidae > Eumolpinae > *Colasposoma* sp.

▼ Chrysomelidae; Eumolpinae: *Paraivongius* sp.

▶ Chrysomelidae > Eumolpinae > *Platycorynus dejeani*

▼ Chrysomelidae > Eumolpinae > *Colasposoma* sp.

The antennae are relatively long and segmented while the neck shield and wing covers are smooth and slightly rounded. This species is relatively common in grasslands and may be observed on a variety of plants on which it feeds.

Colasposoma sp., a small leaf beetle, is a glossy bronze insect approximately 8 mm in length. The head is partially embedded in the large neck shield. The antennae are relatively long, segmented and usually project upwards. The neck shield and wing covers are smooth and slightly rounded. This species is common in dense grasslands where it feeds on the foliage of a variety of plant species.

Paraivongius sp., a glossy, brown leaf beetle, is approximately 7 mm in length. The head is partially embedded in the large neck shield. The antennae are relatively short, segmented and usually project forwards. The neck shield and wing covers are smooth and slightly rounded while the wing covers are finely grooved longitudinally with large black blotches. This species is relatively uncommon in Bankenveld grasslands and feeds on the foliage of a variety of different plant species.

Colasposoma sp., a brightly coloured leaf beetle, is a striking metallic green in colour, approximately 7 mm in length. The head is compact and partially embedded in the neck shield. The antennae are relatively short and dark with an orange base. The legs are brownish orange. The neck shield and wing covers are smooth and a brilliant metallic green. This species is relatively

common in grasslands and savannahs and feeds on the foliage of a variety of plant species.

Platycorynus dejeani, a leaf beetle, is approximately 11 mm in length. The head, neck shield and wing covers are a glossy metallic green with a bronze sheen. The head is small, contrasting with the large neck cover. The antennae are relatively long and segmented. The neck shield and wing covers are smooth and slightly rounded. This species is relatively common on foliage in the Bankenveld grasslands.

Blepharida ornata, a leaf beetle, is approximately 9 mm in length. The compact body is slightly rounded. The head and neck shield are brown while the wing covers, also brown, are finely grooved longitudinally with broken lines of creamy-white tile-like patches. The hind legs are well adapted to jumping, which is characteristic of this group, hence the name flea beetles. The antennae are brown and threadlike, sometimes held against the body. The species is common on foliage in savannah and grassland areas.

Tenebrionidae (darkling beetles)

The best known of all the Tenebrionidae are the medium-sized 'toktokkies' of the genus *Psammodes* and its relatives. These heavily bodied, wingless beetles derive their names from their habit of knocking on the ground loudly at intervals, apparently to attract mates and deter rivals. To produce this tapping noise, the beetle raises the abdomen and brings it down on the ground several times in quick succession.

Psammodes sp., a large tenebrionid beetle, is approximately 32 mm in length. The body is a stout glossy black and is globular in shape. The antennae are bead-like, projecting forwards. The wing covers are smooth, with characteristic longitudinal reddish-brown lines. The neck shield has large reddish-brown blotches. This is a wingless, ground-dwelling species, well adapted to running and feeding on plant and animal matter. It is often found in rocky areas in Bankenveld grasslands.

Dichtha cubica, a medium-sized tenebrionid beetle, is approximately 22 mm in length. The body is black, stout and globular with ridged wing covers. The antennae and legs are pale cream owing to the dense down which covers them. This is a wingless, ground-dwelling species, which is well adapted to running. It is a scavenger, readily feeding on decomposing animal and plant material and inhabiting sandy areas in grassland and savannahs.

▲ Chrysomelidae > *Blepharida ornata*

▼ Tenebrionidae > Molurini > *Psammodes* sp.

▼ Tenebrionidae > Molurini > *Dichtha cubica*

▲ Tenebrionidae > Molurini > *Phanerotomea* sp.

▼ Tenebrionidae; *Phanerotomea* sp.

▼ Tenebrionidae > Drosochrini > *Micrantereus* sp.

Phanerotomea sp. (top left), a medium-sized tenebrionid beetle, is approximately 25 mm in length. The body is glossy brown, and elongated with tapering wing covers. The antennae are short and bead like. This is a wingless, ground dwelling species which is well adapted to running. The adults tap rhythms on the ground with the tips of their abdomens to locate and attract mates. This species feeds on plant and animal matter.

Phanerotomea sp. (middle left), a medium sized tenebrionid beetle, is approximately 25 mm in length. The body is smooth and globular and matt black in colour. The antennae are bead-like with a brown tip. This is a wingless, ground-dwelling species with well-developed legs. It feeds on plant and animal matter in semi-arid grasslands.

Micrantereus sp., a medium-sized tenebrionid beetle, is approximately 24 mm in length. The body is matt black, stout and globular in shape. The antennae are bead-like and project forwards. The wing covers are rough, with characteristic longitudinal ridges and numerous tubercles in-between. In contrast, the neck shield is smooth. This is a wingless, ground-dwelling species which feeds on plant and animal matter. It is often found in rocky areas in Bankenveld grasslands and savannah woodlands.

Vutsimus sp., a medium-sized tenebrionid beetle, is approximately 16 mm in length. The body is black with an enlarged abdomen. The antennae are bead–like, projecting forwards. The head and neck shield are a smooth matt black. The wing covers are slightly glossy, with characteristic longitudinal grooves. This is a wingless species which is well adapted to rocky areas in Bankenveld grasslands, where it feeds on decomposing plant and animal matter.

Himatismus villosus, a small tenebrionid beetle, is approximately 12 mm in length. The body is dark brown and strongly elongated with a pointed abdomen. The head and neck shield are covered in golden hairs, which can be seen on close inspection. The wing covers are dark brown, with longitudinal bands and patches of golden and cream hairs. This species is a scavenger, readily feeding on decomposing plant material. It inhabits trees and bushes and has a wide distribution range. When disturbed, it lies motionless, holding its legs close to its body and readily playing dead.

Lagria sp., a small tenebrionid beetle, is approximately 10 mm in length. The head, neck shield and wing covers are black, while the black wing covers have a greenish tinge and are slightly elongated. The antennae are long, serrated and curve outwards. This species is a scavenger, feeding on decomposing

◀ Tenebrionidae > Amarygmini > *Vutsimus* sp.

▲ Tenebrionidae > Lagriinae > *Lagria* sp.

◀ Tenebrionidae > Epitragini > *Himatismus villosus* (Tapering Darkling Beetle)

▲ Tenebrionidae > Alleculinae

▼ Cleridae > *Thanasimodes gigus*

▼ Cleridae > *Graptoclerus ludicrus*

plant material. It inhabits herbaceous plants and is common in Bankenveld grasslands.

This small tenebrionid beetle belonging to the subfamily Alleculinae is approximately 8 mm in length. The head and neck shield are black with the latter covered in fine hairs. The slightly elongated wings are a contrasting brown and are also covered with fine hairs. The antennae are dark brown, relatively long and serrated. This species feeds on decomposing plant material and is found on herbaceous plants in grassland and savannahs.

Cleridae (chequered beetles)

These beetles are referred to as chequered beetles, as some are brightly coloured with coloured bands and patterns. The Cleridae are a moderately large family with a diversity of habits and range of forms and structures, making its members difficult to identify as clerids. Adults of the genus *Thanasimodes* and many others which occur in South Africa have colours that predators know to avoid, such as black with orange or red and white bands. They probably mimic certain velvet ants and derive protection from their disguise. By contrast, the adults of other species are camouflaged to resemble the lichen-covered bark on which they are found. These small to moderately sized elongated beetles have wing covers that are usually parallel-sided. The body is frequently covered with erect hairs.

Thanasimodes gigus, a medium-sized chequered beetle, is approximately 20 mm in length. The body and antennae are dark brown and sparsely coated with fine erect hairs. The head and neck shield are punctured. The wing covers are elongated, with longitudinal lines and punctures. There are two characteristic light-brown blotches on the wing covers. This species is relatively common on tree trunks and under bark in Bankenveld grasslands and is readily attracted to artificial light.

Graptoclerus ludicrus, a small chequered beetle, is approximately 7 mm in length. The head and neck shield are black and densely coated with fine erect hairs. The wing covers are reddish-brown in colour with two black bands going halfway towards the middle. The front legs are also reddish brown, while the upper parts of the remaining four legs are black with reddish-brown lower sections. The antennae are brown and project forwards. This species is relatively common on foliage in Bankenveld grasslands.

Meloidae (blister beetles)

The blister beetles belonging to the subfamily Zonitinae do not parasitise grasshoppers and locusts, as do other beetles within the family, but rather bees. The adult *Zonitomorpha stella* lays her eggs on flowers or in the ground. When the eggs hatch, active larvae called triungulin creep up on to the flowers where they wait for bees to arrive; the bees to which they cling carry them unknowingly to the beehive. Large numbers of them perish because they fail to find a suitable host but a triungulin that succeeds in getting into a cell in the beehive devours the eggs and then the store of honey and pollen that the bee has provided for its young. The triungulin larvae of the Zonitinae have silk glands on the abdomen, a unique feature of Meloidae.

Zonitomorpha stella, a small blister beetle, is approximately 15 mm in length. The elongated body is smooth and orange in colour. The head and neck shield are unmarked; however, the wing covers bear a broad black band extending on to the body. The long antennae are brown, serrated and curve outwards. The legs are brown with some pale orange parts. The adults feed on flowers and leaves and are relatively common in wooded savannahs and grasslands.

Mylabris oculata, the common CMR Bean Beetle, is about 30 mm in length. It is soft-bodied and elongate in shape. The head and neck shield are black and the antennae orange with the exception of the basal segments, which are black. It has black wing covers with two basal yellow spots and two broad yellow transverse bands. These were the colours of the Cape Mounted Rifles (CMR), hence their name. The beetles are diurnal and are common on flowers. The adults secrete cantharadin, which can cause severe blistering of human skin.

Mylabris holosericea, a blister beetle, is approximately 13 mm in length.

▲ Meloidae > Zonitinae > *Zonitomorpha stella*

▼ Meloidae > Meloinae > *Mylabris oculata* (CMR Bean Beetle)

▼ Meloidae > Meloinae > *Mylabris holosericea*; (Carpet Bean Beetle)

▲ Meloidae > Meloinae > *Mylabris alterna*

▼ Meloidae > *Decapotoma lunata* (Lunate Blister Beetle)

▼ Coccinellidae > Coccinellinae > *Cheilomenes lunata* (Lunate Ladybird)

68 A Landscape of Insects

The elongated body is black and densely covered with greyish-white hairs. The wing covers are yellow, with irregular black markings. The antennae and legs are black. The adults feed on flower heads, leaves and buds and are relatively common in Bankenveld grasslands.

Mylabris alterna, an eye-catching blister beetle, is approximately 25 mm in length. The elongated body is black with numerous short, fine, erect hairs. The head and neck shield are unmarked; however, the wing covers carry a series of longitudinal reddish-orange stripes shaded from pale to dark with four red blotches towards the end of the body. The legs and antennae are black. The adults feed on grassland flowers.

Decapotoma lunata, a crescent-shaped blister beetle, is approximately 14 mm in length. The elongated black body is covered in numerous fine, erect black hairs. The head and neck shield are punctured and the wing covers are black with three transverse, irregular lines. The antennae are black with the exception of the last five segments, which are orange. The adults feed on a variety of flowers and foliage in grassland and savannah areas.

Coccinellidae (ladybirds)

The predacious ladybirds select their egg-laying sites with great care, usually plants already infested with aphids, so that their young will not have to look far for food after they hatch. The female *Cheilomenes lunata* lays yellow, cigar-shaped eggs in clusters of about 25, usually on the underside of leaves. The eggs develop rapidly, in 5–10 days. After hatching, the small black larvae, which have six legs and three simple eyes on each side of the head, feed voraciously on aphids, spearing them with their sharp, sickle-shaped jaws and sucking out their body fluids. As the larvae increase in size, they develop conspicuous spots of pale yellow on the black background of the body. Eventually they leave the plant to seek a place to pupate, attaching themselves head downwards with a sticky secretion that oozes from the tail end. Once in position, the body thickens and shortens and, after a few hours, the skin splits to reveal the yellow pupa inside. In approximately ten days the adult beetle emerges. Initially it is pale yellow but its colour slowly darkens to red, with black, crescent-shaped markings from end to end. The beetles mate before dispersing in spring.

Cheilomenes lunata, a shiny crescent-shaped ladybird, is approximately 7 mm in length. The head and neck shield are black with red or orange markings. The wing covers have an attractive pattern of red or orange patches.

It is a common, well-known species and is predatory, especially on aphids. Interestingly, the newly hatched larvae remain with their egg batches before eating any unhatched eggs. This species occurs in a number of different urban and rural habitats in South Africa.

Exochomus flavipes, a glossy black ladybird, is tiny, approximately 4 mm in length. The body is rounded and exceptionally shiny. The neck shield is black with characteristic orange patches on each side. This common species is predatory on a variety of other insects including aphids. It occurs on plant stems and foliage and is recorded from a diverse array of habitats in South Africa.

Curculionidae (weevils)

Eremnus sp. is a small weevil approximately 4 mm in length. The body is a pale blue-green. It has an exceptionally long, dark, narrow snout on which the antennae project forwards. The eyes are conspicuous on the light head. The

▲ Coccinellidae > *Exochomus flavipes* (Black Mealy Bug Predator)

▼ Curculionidae > *Eremnus* sp.

▲ Trogossitidae > Trogossitinae > *Melambia* sp.

wing covers have faint longitudinal grooves with numerous long, white, erect hairs. This species is common but often overlooked because it is so small. It feeds on plant material, inhabiting savannah and grassland environments.

Trogossitidae (gnawing beetles)

Melambia sp., a medium-sized gnawing beetle, is approximately 28 mm in length. The matt black body is strongly elongated with distinctive forward-facing mandibles. The head and neck shield are smooth, as opposed to the wing covers which are deeply grooved longitudinally. The antennae are short and bead-like and project sideways. This species is regularly found in grassland and savannah regions of South Africa where they are most commonly observed on dead or living wood.

Scarabaeidae (dung beetles), subfamily Scarabaeinae

There are some species of dung beetle that do not roll dung balls but usually bury the dung below or close to the original source. This behaviour is typical of members of the genus *Onitis*. When preparing to lay her eggs, the female first digs a tunnel in the soil beneath the dung. At the bottom of the burrow, she excavates a large chamber, often of irregular shape because of obstructions such as stones and roots but large enough to accommodate a mass of dung. A telltale sign that these dung beetles are present at a dung source is the evidence of excavated soil thrown up in a heap to the side of the dung. After excavating the chamber, the female proceeds to fill it with carefully selected dung pieces. While packing the chamber, she lays her oval, white eggs at intervals as the filling proceeds. She makes a neat spherical cell around the eggs, coating the walls with a brown liquid regurgitated from her stomach. This is food she has partially digested and is intended to feed the delicate larva when it hatches. She continues to do this until about six eggs are laid and the cavity is full. Interestingly, the egg cells are always constructed near the outer surface of the mass and never in the centre; this is apparently to ensure the eggs and larvae have sufficient air. The eggs hatch and the hump-backed larvae feed almost immediately, eating out large hollows, until they are fully grown. Each makes itself a neat cell from the remains of the food and then pupates. The pupae are beautiful, looking as if they have been carved from white crystal. They have interesting horns on their back to keep their soft, delicate bodies away from the damp floor. The immature stages of the life cycle of dung beetles usually last between 30 and 50 days but it can be as long as two years in the case of *Onitis*. A species of *Sceliages* is suspected of feeding only on dead millipedes.

Oniticellus egregius, a striking scarab beetle, is approximately 19 mm in length. The body is a smooth glossy black. The head is also black and fits into a socket on the neck shield. The smooth, black neck shield is large and bulky, with pale-cream edging. The wing covers are black, with pale cream margins, and are grooved longitudinally. The legs are also pale cream. This is an active species which is relatively common in Bankenveld grasslands.

Proagoderus sapphirinus, a scarab beetle, is approximately 12 mm in length. The body is a green metallic bronze. The bronze head is axe-shaped with a dark margin. The large neck shield is rounded with a central green depression at the base of the wing covers, and two dark bronze lines form a V above the

▲ Scarabaeidae > Scarabaeinae > Oniticellini > *Oniticellus egregius*

▼ Scarabaeidae > Scarabaeinae > Onthophagini > *Proagoderus sapphirinus*

▲ Scarabaeidae > Gymnopleurini > *Gymnopleurus sericatus*

▼ Scarabaeidae > Scarabaeinae > *Onitis crenatus*

▼ Scarabaeidae > Scarabaeinae > Gymnopleurini > *Allogymnopleurus thalassinus*

head. The wing covers are greeny bronze with longitudinal grooves, while the legs are a metallic green. The species burrows below dung sources, packing the dung used for breeding purposes into the blind ends of a tunnel, forming one sausage-shaped mass or a series of oval masses. One egg is laid in each mass.

Gymnopleurus sericatus, a scarab beetle, is approximately 14 mm in length. The body is a dark metallic green. The green head is axe-shaped with a roughly toothed margin. The large neck shield is smooth and rounded. The wing covers are a dark metallic green, with even longitudinal grooves. The legs are also metallic green. This species is active by day. The beetles cut dung from a fresh dung pad, rolling it into a ball, which they bury. They are common in grassland and savannah environments.

Onitis crenatus, a scarab beetle, is approximately 22 mm in length. The head and neck shield are a shiny, metallic purplish black; the neck shield is punctured. The purplish black head is axe-shaped with a plain margin. The large neck shield is smooth and shiny. The wing covers are a dull metallic green and deeply grooved longitudinally. The legs are also a dull metallic green. This species is predominantly active at dawn and dusk. It draws dung into tunnels by the side of or below the original dung source, forming brood sausages into which a series of eggs are laid. It is common in grassland and savannah environments.

Allogymnopleurus thalassinus, a large scarab beetle, is approximately 14 mm in length. The body is broad and somewhat flattened. The body is a dull black while the neck shield is large and punctured. The wing covers are a dull black with longitudinal grooves. The legs are dull black in colour and well developed for digging. The species is active by day. It cuts dung from a fresh dung pad, rolling it into a ball, which it buries. Male and female beetles often push the ball together, sometimes resulting in one member on top of the ball. It is common in grassland and savannah environments.

Pachylomerus femoralis, a very large scarab beetle, is approximately 50 mm in length. The dull black body is broad and somewhat flattened, with raised polished areas. The neck shield is characteristically wider than the abdomen. The front legs are adapted to grasping; they are also strong and toothed for digging. This species is active by day and commonly seen flying. It often burrows next to a dung source, filling tunnels with rolled dung for feeding and breeding purposes. The species is common in areas with deep soils in grassland and savannah environments.

Scarabaeus ambiguus, a large scarab beetle, is approximately 24 mm in length. The dull black body is broad and somewhat flattened. The insect is often covered with soil, making it look dirty. The head is strongly toothed. The legs are powerful, strongly developed and toothed for digging. This species is predominantly nocturnal but also active at dusk and dawn. It cuts dung, moulding balls, which it rolls to be buried. It is common in grassland and savannah environments.

Sceliages sp., a medium-sized scarab beetle is approximately 19 mm in length. The glossy black body is broad and rounded. The antennae are characteristically orange in colour. The smooth, shiny neck shield is rounded while the black wing covers are moulded with indentations along the sides. The legs are powerful and strongly developed for digging. This species is active during the day. It cuts dung and moulds balls, which it rolls some distance to be buried. It is common in grassland and savannah environments. This species only feeds on millipedes.

▲ Scarabaeidae > Scarabaeinae > *Scarabaeus ambiguus*

◄ Scarabaeidae > Scarabaeinae > *Pachylomerus femoralis*

▼ Scarabaeidae > Scarabaeinae > *Sceliages* sp.

▲ Scarabaeidae > Dynastinae > *Cyphonistes vallatus* (Fork-horned Rhino Beetle)

▼ Scarabaeidae > Dynastinae > *Cyphonistes vallatus*

▼ Scarabaeidae > Dynastinae > *Rhizoplatodes castaneipennis*

Dynastinae (rhino beetles)

Most rhino beetles are nocturnal and strongly attracted to artificial light. The common Fork-horned Rhinoceros Beetle, *Cyphonistes vallatus*, is a large and widely distributed species in South Africa. The larvae of some rhino beetles feed on the roots of living plants. The adults of certain species have been recorded as severing the shoots of young stems just below ground level, while the larvae eat the roots. In some species, the adults do not feed. The larvae are typically scarab-like and, with the exception of a few root-dwelling species, often occur in humus or dung. Interestingly, they are recorded as pupating underground without forming a cocoon.

Cyphonistes vallatus (top left), a large scarab beetle belonging to the subfamily Dynastinae, is approximately 29 mm in length. The body is a dark shiny brown. The head has a long, forked horn with a forward-pointing projection on the neck shield in males. The neck shield is shiny and smooth with a few punctures. The wing covers have numerous lines and shallow punctures. The legs are powerful and toothed for digging. The species is active at night and attracted to artificial light. It probably does not feed and is relatively short-lived. It is relatively common in the grasslands and savannahs of the eastern parts of South Africa.

Cyphonistes vallatus (middle left), a scarab beetle belonging to the subfamily Dynastinae, is approximately 26 mm in length. The body is a dark shiny brown, with relatively hairy underparts. The head is short, toothed and slightly retracted into the neck shield, which is large, slightly flattened and finely punctured. The wing covers are grooved longitudinally. The legs are powerful and toothed for digging. The species is relatively common in Bankenveld grasslands.

Rhizoplatodes castaneipennis, a scarab beetle belonging to the subfamily Dynastinae, is approximately 25 mm in length. The body is a dark shiny brown. The head has a short, single, strongly curved horn. The neck shield is smooth and slightly flattened while the wing covers have fine longitudinal grooves. The legs are powerful and toothed for digging. The species is relatively common in Bankenveld grasslands.

Bolboceratinae (earth-boring dung beetles)

Bolbaffer princeps (top right), a medium-sized scarab beetle, is approximately 17 mm in length. The body is very convex and globular in shape. This insect is a reddish brown with distinctive orange antennae. The head has a small,

nondescript horn. The neck shield is pitted, with a short transverse central ridge and single dark-brown circular patches. The wing covers are rounded with fine, longitudinal grooves. The underparts of the body have woolly reddish hairs. The species is attracted to artificial light. It is an inhabitant of grassland and savannah environments.

Cetoniinae (fruit chafers)

The majority of the species within the subfamily Cetoniinae feed by day on plant sap such as gum and nectar and on ripe fruit, flowers and young shoots. They are inactive at night often occurring in groups in 'sleeping trees'. Large numbers can be observed in the evenings flying to such trees like roosting birds. The larvae are typical in their scarab-like appearance but their mode of movement is unique. When exposed, they turn on to their backs, wriggling forwards. Hairs and protuberances on their back and sides give them a grip on the ground. All the mature larvae form pupal cocoons of soil, plant debris or their own faeces, glued together with salivain which they hibernate. On hatching, the beetle eats its way through the cocoon and crawls through the decaying matter to emerge as an adult.

Dischista rufa, a medium-sized fruit chafer, is approximately 24 mm in length. The members of this group have brown wing covers and large white patches on the underside. The head often bears distinctive white bands, although these may be absent in the same species. In dry areas, the upper and under colours become lighter. The brown wing covers become a yellowish brown, while the black areas change to a shiny dark green. The biology of *D. rufa* is similar to that of the common garden fruit chafer *Pachnoda sinuata*, with the adults feeding on fruit and flowers (*Acacia karroo*, *Acacia caffra*, *Terminalia sericea*). It also feeds on the 'manna' crystals which form on certain trees damaged by borers, and in beehives, particularly on the Highveld. The larvae have been recorded in rhino dung. This species may fly between October and May but are most common from January to April.

Plaesiorrhinella plana, a medium-sized fruit chafer, is approximately 25 mm in length. The body is a dark shiny brown, as if polished, with a broken yellow belt across the lower part of the wing covers. These beetles are not spotted. This common species is easily recognised by their colour pattern and medium size. Their distribution seems to be limited to the eastern savannahs of southern Africa, fringing the Highveld and extending into all forests. To the

▲ Bolboceratinae, *Bolbaffer princeps*

▼ Scarabaeidae > Cetoniinae > *Dischista rufa* (Common Savannah Fruit Chafer)

▼ Scarabaeidae > Cetoniinae > *Plaesiorrhinella plana* (Yellow-belted Fruit Chafer)

▲ Scarabaeidae > Cetoniinae > *Rhabdotis aulica* (Emerald Fruit Chafer)

▼ Scarabaeidae > Cetoniinae > *Pachnoda sinuata* subsp. *flaviventris* (Black and Yellow Garden Fruit Chafer)

north of the range a series of other forms take over. The adults appear in early October, peak in December and disappear by the end of February. The larvae live in humus and take two months to pupate, after which the pupa lies dormant for eight months. The adults are extremely common and feed on a variety of different flowers (*Protea caffra*, *Acacia* spp., *Ziziphus mucronata*, *Lannea discolor*) and various fruiting plants. They are also attracted to beehives and flower sap of *Combretum molle*, *Acacia* spp. and *Ziziphus mucronata*. Adults have been found in numbers in maize croplands.

Rhabdotis aulica, a medium-sized fruit chafer, is approximately 24 mm in length. This group of chafers is very closely related to *Pachnoda*, and their general appearance, extensive ventral markings and some specific features, such as the white lines on the head, are common in both genera. *Rhabdotis* is a separate lineage, though, marked by the metallic dorsal coloration. *R. aulica* is often found on flowering trees and fruit together with the *Pachnoda* species. It is easily distinguishable from the other species in this group by its bright metallic green or blue upper-body coloration and by the absence of any but the lateral lines on the neck shield. The underside often has bright coppery-red reflections. This species is common in southern Africa, but it does not extend beyond an area demarcated by Malawi in the north and Botswana to the west. It flies from October throughout summer and has been collected as late as June. The adult females are prone to fly into rooms through open doors and windows, even if these are several storeys high. The larvae and pupae have been found in open-air pens where there is a mixture of cattle and goat manure. The adults feed on a wide variety of flowers (*Acacia karroo*, *Protea caffra* and *Terminalia sericea*) and on a variety of fresh fruits. They often fall on to shiny corrugated roofs and into open water.

Pachnoda sinuata, a common species of fruit chafer, is approximately 26 mm in length. The greatest diversity in this species is found in the tropics of Africa. South Africa is at the fringes of the area of diversity. The dorsal colour patterns in *Pachnoda* tend to be conservative and follow definite, recurring patterns. This species is the most common chafer in South Africa and is often confused with a relative, *P. impressa*, which lacks the black humeral spots. Subspecies, *flaviventris*, varies the most in coloration and it is well adapted to gardens and cultivated areas and seems to be expanding in tandem with human settlement. The larvae are unspecialised, breeding readily in any compost heap and also among the roots of plants or in manure (including bat

manure), where they construct cocoons out of the available matter. The adults feed on virtually all fruit, even when this is still quite green. Flowers also form part of their diet – they consume the entire flower. The indigenous species on which they feed include *Acacia karroo*, *Euphorbia tirucalli*, *Terminalia sericea*, *Lannea discolor*, *Protea caffra* and wattle. They fly mainly between October and April. However, for some reason they have never been recorded in July. The adults sometimes fall on to shiny corrugated iron roofs.

Plaesiorrhinella trivittata, a beautifully patterned fruit chafer, is approximately 20 mm in length. The body is very distinctive with its black-and-brown markings and the yellow mirror-imaged blotches on the wing covers. In southern Africa, two species of this subgenus occur. It is active from late September to mid-January with a second generation often occurring in March through to April. It is one of the commonest savannah fruit chafers, occurring throughout southern African savannahs and extending into East Africa. The adults feed on a variety of flowers (*Protea caffra*, *Acacia* spp., *Pavetta* sp., *Terminalia sericea*) and fruits (*Solanum* spp., figs, etc.). They have also been recorded as feeding on sap flows.

Leucocelis amethystina, a brilliantly coloured fruit chafer, is approximately 12 mm in length. This species has iridescent metallic, greenish-purple wing covers and a contrasting orange thorax. It is very variable in colour but can easily be differentiated from any similar species by comparing the sculpture of the wing covers. The colour of the wing covers varies, from light blue to light green, with the violet and dark-green varieties being most common. The neck shield is usually reddish brown, often with a black base or black median line. It is widely distributed, from southern Africa into the tropical western and eastern regions of the continent. The adults are active from October to May, while the majority fly between November and January, and feed on flowers of a variety of indigenous and exotic trees and shrubs, such as *Terminalia sericea*, *Acacia* spp., *Protea caffra*, *Dombeya rotundifolia*, *Dischrostachys cineria* and *Grewia flava*. They may also be attracted to fermenting fruit and have been collected on cattle dung.

Anisorrhina algoensis, a distinctive fruit chafer, is approximately 22 mm in length. The males of this species can readily be recognised and identified by the dilated or upturned horns at the end of the body. The black forms occur throughout their distribution range, while those with exceptionally developed male horns seem to be found in mountainous regions. The species feeds

▲ Scarabaeidae > Cetoniinae > *Plaesiorrhinella trivittata*

▼ Scarabaeidae > Cetoniinae > *Leucocelis amethystina* (Amethyst Fruit Chafer)

▼ Scarabaeidae > Cetoniinae > *Anisorrhina algoensis*

mainly on flowers (*Protea caffra*, *Peltophorum africanum* and *Acacia* spp.) but also on the fruit of wild figs and the sap of flowers. It flies between November and January.

Leucocelis adspersa, a fruit chafer, is approximately 18 mm in length. It is usually very dark green and may appear black. Very rarely, the wing covers are a lighter green, and some specimens are known to have reddish wing covers. This chafer has creamy-coloured speckles on the wing cover and thorax, a pattern that can vary a little. It is one of the few *Leucocelis* species with long hairs on the underside and only a narrow part in the middle. It is most often confused with *Cyrtothyrea marginalis* because of the dark coloration and reddish margin of the neck shield, but in good light the green sheen of *L. adspera* is always discernible. This species is often observed on *Protea* and *Acacia* spp. flowers and the adults are active from September to February. It also feeds on the flowers of a variety of Cape fynbos and Karoo shrubs.

Dicronorrhina derbyana, a large fruit chafer, is approximately 50 mm in length, coloured bright-green emerald and white. The head of the male has a median crest, while the female's is evenly rounded. The colour pattern is rather constant, with only the extent of the median white band on the wing covers varying. Usually these beetles are green, often with an orange tint and also, but very rarely, blue or purple. The adults seem to prefer sap flowers above fruit and have been recorded on the sap flows of *Combretum molle*, *Combretum imberbe*, *Combretum zeyheri*, *Ziziphus mucronata* and *Acacia* spp. They are, however, also readily attracted to fermenting fruit and have also been found on the flowers of *Acacia* spp., *Lantana camara* and *Combretum* spp. The adult males aggressively defend the sap flows they have made their territory, even against other fruit chafers such as *Goliathus albosignatus*, using their horns to push the opponent away. The females, which visit the sap flows, seem to be the main reason for these contests, as the males spend little time feeding themselves. The adults fly from late November, becoming more common in January, reaching a peak as late in the year as April and disappearing in May. The females lay about 30 eggs, which hatch in six weeks. Larval development takes seven and a half months, the pupal stage two months.

▲ Scarabaeidae > Cetoniinae > *Leucocelis adspersa*

Buprestidae (jewel beetles)

The plant genus *Acacia* is clearly important to a number of buprestid species as a wide variety of species feed on their flowers and leaves. During the winter months in those areas where temperatures are extreme, the buprestid numbers drop drastically; in some cases, none are found at all. The greatest diversity and abundance of buprestid fauna occur in the summer months, usually peaking in January and February. In the grassland environments, where grass and forbs are more abundant than trees, many species have leaf- or stem-mining larvae.

▲ Scarabaeidae > Cetoniinae > *Dicronorrhina derbyana*

▲ Buprestidae > *Acmaeodera ruficaudis*

▼ Buprestidae > *Psiloptera gregaria*

▼ Buprestidae (unknown species)

The large genus *Acmaeodera*, which occurs throughout the subcontinent, is readily encountered in this environment. A unique feature of this genus is the fused wing covers, which are lifted in flight. Many *Acmaeodera* species appear to mimic wasps, bees and hemipterans. Many species only attack new growth and plants weakened by drought, frost and defoliation by other leaf-feeding insects and dying (rather than completely dead) wood. They do not infest seasoned wood. The metallic colouring of jewel beetles probably serves to confuse predators, as the beetle appears to disappear suddenly when it settles on foliage. From an ecological point of view, the jewel beetle family is extremely important as it assists the process of decomposition.

Acmaeodera ruficaudis, a small jewel beetle, is approximately 8 mm in length. The body is blackish grey. The head is small and partially embedded in the neck shield, with the antennae short and projecting sideways. The neck shield is also blackish grey and finely punctured. The longitudinally grooved wing covers are a dull black with numerous tan markings. The legs are black. This species has a wide distribution and is regularly observed on the foliage of trees and herbaceous plants.

Psiloptera gregaria, a medium-sized jewel beetle, is approximately 32 mm in length. The body is a striking metallic gold. The head is golden and has characteristically large, black eyes. The neck shield is metallic gold and square, with one small black dot on each side. The elongated wing covers are also metallic gold with a series of fine longitudinal ridges and rows of punctures. The legs are golden and well adapted to grasping leaves. The species is regularly recorded on the bushwillow *Combretum molle*.

This small unidentified jewel beetle is approximately 5 mm in length. The elongated body is a metallic bronze while the head, neck shield and wing covers are finely punctured. The membranous wings are clear and the abdomen a metallic greenish-blue in colour. The antennae are short, projecting sideways. The distribution is unknown but it appears to feed on the pollen of *Acacia* spp.

Cerambycidae (longhorn beetles)

Those species of Cerambycidae occurring on the ground, bark or dead wood have camouflage markings with mottled greyish-brown patterns. Nearly all cerambycids attack trees that are dead or dying, they rarely attack healthy plants. Many longhorn beetles make a 'squeaking' or 'creaking' noise when they are picked up, which they produce by rubbing the hind margin of the prothorax

against a roughened area found between the bases of the wing covers. The rubbing movement can easily be observed while the beetle is 'squeaking'. The precise function of these noises is not known; however, they do not appear to be made during mate recognition, and it seems unlikely that they would deter a predator. It is unclear whether the insect itself can hear these sounds. Specialised auditory organs have not been observed in any beetles but it is possible that certain organs, found scattered over the bodies of many insects, may be able to detect air-borne vibrations such as those made by longhorn beetles. These organs consist of one or more microscopic rod-like structures situated just beneath the outer integument and are connected to nerve fibres. They appear as denser spots in the thin white integumental layer and are situated just below the spiracles in each segment of the longhorn beetle.

Prosopocera paykulli, a species of longhorn beetle, is a medium-sized insect approximately 24 mm in length. The body is narrow, elongated and light brown in colour. The antennae are characteristically longer than the body. The neck shield is light brown with a broad pale-cream stripe running through the centre. The wing covers are light brown with two pale-cream, mirror-image stripes and black dots. This species is a relatively common in woodland savannahs and vegetated areas around rocky outcrops in grasslands.

Glenea apicalis, a strikingly marked species of longhorn beetle, is a medium-sized insect approximately 15 mm in length. The body is broad and cream-coloured. The antennae are long and characteristically banded in black and pale blue. The neck shield is cream with two characteristic broad, dark-brown longitudinal stripes. The brown wing covers are heavily punctured, with an uneven band of pale cream. The legs are also cream-coloured. This species is relatively common on herbaceous plants in vegetated areas around rocky outcrops in grasslands.

Bostrichidae (auger beetles)

The Bostrichidae lay their eggs on the cut surface of a branch or in natural cracks in wood. The larvae make their own galleries after they hatch. Alternatively, the males and females co-operate to make a gallery in which the eggs are laid. On hatching, the larvae burrow up and down the wall of the plant and their tunnels become packed behind them with a fine dust consisting of inedible fragments and excrement. The tunnel runs at right angles to the surface for a short distance and then turns to run parallel with the grain of the wood. The

▲ Cerambycidae > Lamiinae > *Prosopocera paykulli*

▼ Cerambycidae > Lamiinae > *Glenea apicalis*

▲ Bostrichidae > *Bostrychoplites pelatus*

▼ Scutelleridae > *Sphaerocoris testudogrisea*

beetle remains in the galleries for some time, apparently to guard the eggs and the newly hatched young from parasites and other enemies. When it is fully grown, the larva is yellowish white, about 3 mm long, curved and with a swollen thorax. It pupates in a chamber which it hollows out at the end of its tunnel and about a week later the adult beetle emerges, biting its way through the wood in a round, neat hole. Three or four generations of these beetles occur per year and as a result they can increase rapidly in number.

Bostrychoplites pelatus is elongated and dark brown, characteristically tapering off at the rear. It is about 12 mm long, with a partly smooth and partly punctured neck shield, its two forward-pointing, spike-like antennae forming a V-shape. The wing covers are heavily punctured with distinct longitudinal grooves. The feet have saw-like teeth along their outer edges to assist with gripping on to wood. Both the adults and the larvae are woodborers in trees in well-wooded rocky ridges in Bankenveld grasslands. The species is readily attracted to artificial light.

HETEROPTERA

Scutelleridae (jewel bugs)

Some of these bugs are often beautifully coloured in rainbow shades and as a result are referred to as jewel bugs. This is a small group; however, some species are common and regularly encountered. The shield-back bugs are medium to moderately large (6–20 mm), usually elongated or oval. They also have an enlarged scutellum, or shield, covering the whole dorsal part of the abdomen and the largest part of the wing covers. They have three-segmented feet and the proboscis is usually inserted near the apex of the head. As examples, the brightly coloured *Calidea dregii* has a pattern of metallic green or blue dots on a reddish background and *Sphaerocoris testudogrisea* has numerous fine freckles. *Alphocoris indutus* is an elongated, straw-coloured bug which superficially resembles some curculionid beetles. They are usually found feeding on the ripening seeds of grasses. The jewel bugs can be distinguished from beetles by the scutellum, which is a single structure covering the wings, whereas with beetles the forewings are separated into two halves. The lack of chewing mouth parts and the presence of a proboscis are also distinguishing features.

Sphaerocoris testudogrisea falls in the same genus as the beautiful Picasso Bug, *Sphaerocoris annulus*. This species is approximately 9 mm long. It has a

convex, oval, almost tortoise-like shape. The legs are brown and adapted to climbing on plants. The antennae are short and project forwards. The enlarged scutellum and forewings are brown with sparse fine brown spots. The species is common in the Bankenveld grasslands, where it may be observed on the herbaceous forbs on which it feeds.

This unidentified nymph (top right) belongs to the family Scutelleridae. This species is approximately 7 mm long, with a bulbous, oval and convex shape. The nymph is light brown in colour with dark brown patterns on the head, neck shield and forewings. No wings are present; these develop as the nymph matures. The nymphs of this group feed on the foliage of herbaceous plants.

Alphocoris indutus, a medium-sized bug, is approximately 8 mm in length. The body is elongated, spindle-shaped and well adapted to climbing on the foliage of vegetation. This insect is pale with feint longitudinal yellowish lines. The antennae are short and project forwards. The species feeds on tender grass shoots and ripening grass seeds. Historically, it was described from the Eastern Cape but is widespread across South Africa and Central Africa. It is common in Bankenveld grasslands, where it occurs in relatively large numbers.

Calidea dregii, an eye-catching insect, is approximately 12 mm in length and spindle-shaped. Two rows of black spots feature on a background of bright iridescent green, blue, yellow or red on its back. The underside is red

▲ Scutelleridae (nymph)

◄ Scutelleridae > *Calidea dregii* (Rainbow Shield Bug)

▼ Scutelleridae > *Alphocoris indutus*

▲ Pentatomidae > Pentatominae > *Dymantis relata*

▼ Pentatomidae > Pentatominae > *Durmia horizontalis*

▼ Pentatomidae > Pentatominae > *Bagrada hilaris* (Bagrada Bug)

or orange with a number of green plates. This species is literally rainbow-coloured. The antennae are short and segmented and often project sideways. It feeds on a range of indigenous plants by piercing young seeds, causing the plants to shed their seeds and distorting the seed heads. The eggs are laid in a spiral on a stalk. It is widespread and common over large parts where it may occur in relatively large numbers.

Pentatomidae (shield bugs)

The Pentatomidae receive their common name from the shape of their flattened bodies. Many are brightly coloured and some are garden insects. All of them can give off an unpleasant smell to protect them from their enemies. At first sight many of the shield bugs may be mistaken for beetles but the underside of the head should serve to distinguish them from beetles, as beetles are armed with biting jaws; all the bugs have a slender, tubular proboscis which is carried folded back against the underside of the body and situated between the bases of the legs when not in use. The proboscis consists of a grooved sheath, the labium, in which four slender lancets are lodged. These lancets correspond to the mandibles and maxillae of other insects and are highly modified to serve as piercing and sucking organs. The labium does not enter the puncture made by the lancets but serves only as a protective covering and guide for the lancets. A pumping action of the pharynx assists food to pass up the capillary tube formed by the four lancets.

Dymantis relata is a medium-sized shield bug, approximately 12 mm in length. The body is light grey-brown with a fine cream line running from the head, ending at the tip of the scutellum, just in front of the dark membrane of the forewings. The forewings also have a number of raised diagonal lines. The antennae and legs are red, the former with darker tips. These creatures are plant feeders and occur mainly in in grassland and savannah regions.

Durmia horizontalis is a small shield bug approximately 8 mm in length. The body is shield-shaped with a clearly visible, large, yellow scutellum. The insect is tan-coloured with maroon thorax and wings and characteristic sharp, dark spines present on the margins of the thorax. The antennae and legs are brown, the former with pinkish tips. They feed on *Solanum* sp. and a variety of grasses and are relatively abundant in grassland and savannah regions.

Bagrada hilaris is a small shield bug, approximately 6 mm in length. The body is brightly coloured orange, white and steel blue. The young nymphs

are shiny red, later becoming brownish red in colour. The antennae and legs are steel blue, the latter with cream bases. Bagrada Bugs feed on a variety of plants, leaving the leaves shrivelled and dry. The Bagrada Bug is also called the Painted or Harlequin Bug, and is found in East and southern Africa, Egypt, Congo and Senegal. The global distribution includes Southern Asia and Southern Europe (Malta and Italy). It is very common in South Africa and occurs in dry areas such as the Karoo, Kalahari and Namaqualand.

Antestiopsis thunbergii is a small shield bug, approximately 8 mm in length. This species is black, with intricate markings in orange and white. The three orange spots on the neck shield and forewings are characteristic. It is very similar to the Bagrada Bug, *B. hilaris*, only larger and with distinctive orange spots. The body is flattened and may vary in coloration. It feeds on the young shoots, buds and fruit of most deciduous trees and proteas. The eggs are laid in neat clusters, resembling tiny circular containers with lids. This species is common in grassland and savannah regions.

Piezodorus flavulus is a medium-sized shield bug, approximately 9 mm in length. The body is typically bug-shaped with a broad, raised neck shield. This species is plain light-green in colour, with pink shading on the antennae,

▲ Pentatomidae > Pentatominae > *Antestiopsis thunbergii* (Antestia Bug)

▼ Pentatomidae > Pentatominae > *Piezodorus flavulus*

▲ Pentatomidae > Pentatominae > *Coenomorpha nervosa* (Bark Stink Bug)

▼ Pentatomidae > Pentatominae > *Pseudatelus natalensis* (nymph)

neck shield and the bases of the wings. It feeds on flowers and foliage and is common in grassland and savannah regions but is rarer than the similar *Piezodorus purus*, which is often attracted in its thousands to artificial light.

Coenomorpha nervosa, the Bark Stink Bug, is a medium-sized shield bug approximately 20 mm in length. The body is noticeably flattened. This species is brown, streaked with grey with light-orange marbling and stripes on the edge of the abdomen. The antennae are relatively long and black with orange banding towards the ends. The legs also have some orange-and-black banding. They feed on the foliage of trees and are assumed to take a degree of parental care. This species is common in grassland and savannah regions, where it is usually observed on trees.

Pseudatelus natalensis, a nymph, is a small bug approximately 10 mm in length. The body is broad and flattened and it lacks developed wings. The start of wing development can be seen against the abdomen. This species is greyish in colour, with numerous red and slate-blue speckles. A distinctive red line runs from the head to the abdomen. There are red markings on each side of the neck shield. This nymph feeds on flowers and foliage and is common in grassland regions.

Bankenveld Grassland, Gauteng Province 87

The nymph (top right) is possibly *Coenomorpha nervosa* and is approximately 10 mm in length. The nymphs are oval and convex in shape, with a loose bluish-white waxy layer. As nymphs, they are herbivores and are often observed on trees at different stages in their development.

The typical *B. rufus* is a small, black shield bug approximately 4.5mm in length, with two broad red markings on the scutellum covering the largest part of the abdomen and on the forewings. The body is broad and stout, with a distinctive shield. The two white spots on the base of scutellum are characteristic of the species. A white line runs longitudinally from the head onto the scutellum. The underparts are a creamy white. They feed on the seeds of grasses. The species is common in grassland and savannah regions.

Bolbocoris rufus also occurs in a black form, which, like the others, is approximately 4.5 mm in length. The body is broad and stout, with a distinctive shield. It is matt black with numerous punctures across the neck shield and forewings. The legs are pale cream, contrasting with the black body. This variation is uncommon across its range.

▲ Pentatomidae > Pentatominae (nymph)

▼ Pentatomidae nymph

◄ Pentatomidae > Podopinae > *Bolbocoris rufus* (black variety)

▼ Pentatomidae > Podopinae > *Bolbocoris rufus*

▲ Pentatomidae > Pentatominae > *Menida* sp.

▼ Pentatomidae > Pentatominae > *Veterna sanguineirostris*

▶ Pentatomidae > Pentatominae > *Acoloba lanceolata*

▼ Pentatomidae > Phyllocephalinae (nymph)

88 A Landscape of Insects

Menida sp. is a small shield bug approximately 6 mm in length. The species is glossy black, with numerous white markings of varying sizes on the forewings and the bases of the scutellum. The body is flattened, broad and with a slightly raised neck shield. There is also conspicuous black-and-white banding on the edges of the abdomen. The legs are orange. These bugs feed on young shoots and the buds and fruit of a variety of plants. The species is common in grassland and savannah regions.

Veterna sanguineirostris is a small shield bug, approximately 10 mm in length. The body is shield-shaped and it has a yellow-and-green scutellum. The bug is green with purplish-grey wings and thorax and dark-purple spines on the margins of the thorax. The closed wings form a noticeable dark-brown patch. The antennae are orange. These insects feed on foliage and are relatively abundant in grassland and savannah regions.

The unidentified nymph pictured bottom left belongs to the subfamily Phyllocephalinae and is approximately 15 mm long. The body is significantly flattened and elongated. The nymph is brownish orange in colour with a lime-green neck shield. The nymph lacks developed wings. The antennae are short and brownish orange. These nymphs feed on foliage and are regularly observed in grassveld.

Acoloba lanceolata is a striking, medium-sized insect about 15 mm long. The body is significantly flattened and elongated. It is tan-coloured with a

▲ Pentatomidae > Pentatominae > *Acoloba lanceolata*

▼ Pentatomidae > Pentatominae > *Agonoscelis versicoloratus* (Sunflower Seed Bug)

clearly visible lime-green scutellum, or shield. The head is cone-shaped and lime green in colour with light-tan lines around the black eyes. The neck shield is green, with a tan base. The wings have darker-brown longitudinal patches. The antennae are dark and project forwards and outwards. It is common on a variety of different grass species.

Agonoscelis versicoloratus, the Sunflower Seed Bug, is a small shield bug approximately 11 mm in length. The body is shield-shaped and it has a striped black head, yellow-tipped scutellum and exposed yellow-banded margins to the abdomen. The forewings are brick red with cream speckles. The antennae are black and project forwards and outwards. They feed on seeds and are relatively abundant in grassland and bushveld regions.

A Landscape of Insects

Agonoscelis puberula is a small shield bug approximately 10 mm long. The shield-shaped body has a striped black head, a cream-tipped scutellum and has a cream V-shaped pattern. . The abdomen is exposed with yellow-and-black banded margins. The forewings are brown with numerous cream speckles. The antennae are black and segmented. They feed on herbaceous plants and are relatively abundant in grassland regions.

Phricodus hystrix is a small shield bug approximately 6 mm long. The body appears jagged, with a web-shaped abdomen. This species is mottled in dark brown, cream and grey. The antennae are broad, dark brown and segmented. They feed on herbaceous plants in grassland regions.

Gonopsis sp. is a small shield bug approximately 12 mm in length. The body is shield-shaped with a chestnut-coloured scutellum. The insect is rust brown with clearly visible cream-and-chestnut lines on the neck shield and wing cover. The neck shield is an expanded kite-shape, with dark-tipped

▲ Pentatomidae > Pentatominae > *Agonoscelis puberula*

▶ Pentatomidae > Phyllocephalinae > *Gonopsis* sp.

▼ Pentatomidae > Pentatominae > *Phricodus hystrix*

spines on the margins of the thorax. The antennae are short and orange. These creatures feed on foliage and are relatively abundant in grassland and savannah regions.

Coreidae (twig wilter bugs)

These elongated twig wilter bugs are usually black, brown or green in colour and are known to suck the sap of plants, causing tender twigs to wilt. They are well known to gardeners. The odour-producing glands, secreting a stinky fluid, are particularly well developed in this family. The slits through which the liquid exudes can be seen with the naked eye on the underside of the adult body near the bases of the hind legs. These are surrounded by a slightly raised, roughened border, called the evaporating surface. From here the liquid is retained so that it evaporates slowly. In immature bugs these slits are found on the back; these, too, can be seen with the naked eye. The change in position of the glands apparently becomes necessary when the bug acquires two pairs of wings on casting its skin for the last time; the openings to the glands would be covered by the wings if they were still located on the back and the smelly fluid could not be so widely or freely dispersed.

Cletus sp. is approximately 10 mm long. The body is elongated, with long, reddish-brown antennae with darker tips. The species is light rust-brown with reddish-brown forewings. The neck shield is brown with dark spines on the margins of the thorax. These are plant feeders, feeding on a variety of different plant species, including wild *Solanum*, and are common in stands of weedy vegetation in open, sunny situations. The species is widespread in grassland and savannah systems.

Plinachtus pungens is approximately 13 mm long. The body is stout, with long, black-and-yellow banded antennae. This species is pale green with purplish-brown forewings. The neck shield is purplish brown with dark purple spines on the margins of the thorax. They are plant feeders, feeding on the seeds and foliage of a variety of species like *Searsia* spp. and are widespread in grasslands and savannah environments.

Cletus pusillus is approximately 8 mm long. The body of this bug is elongated, with long, yellow antennae with darker tips. It is brown in colour with lighter-brown shading on the neck shield, which has raised margins on the thorax but lacks spines. These bugs are plant feeders which feed on a variety of species. This species is relatively common in Bankenveld grassland.

▲ Coreidae > Coreinae > *Cletus* sp.

▼ Coreidae > Coreinae > *Plinachtus pungens*

▼ Coreidae > Coreinae > *Cletus pusillus*

▲ Coreidae > Pseudophloeinae > *Myla microphthalma*

▼ Coreidae > Coreinae > *Petascelis remipes* (Giant Twig Wilter)

▼ Lygaeidae > Lygaeinae > *Oncopeltus famelicus* (Milkweed Bug)

Myla microphthalma is approximately 8 mm long. This species is pinkish in colour with light-brown shading on the neck shield, which has dark ink spines on the margins of the thorax. The body is elongated, with long, pinkish-coloured antennae. They are plant feeders which feed on the seed pods of Fabaceae and are relatively widespread in grassland and savannah ecosystems.

Petascelis remipes, a very large bug, is approximately 37 mm in length. This species is a velvety dark brown in colour with thin yellow lines running along the sides and down the centre of a very dark-brown thorax. The body is bulky; it has long, black antennae with tan bases. The forewings are velvety grey in colour with darker shading. A characteristic feature is the enlarged, wing-like projections of the hind legs. It is a gregarious and bold species, which does not hesitate to advance when disturbed and, like others in this group, is capable of squirting an excretion in its defence for some distance. This species is widespread in grassland and bushveld environments.

Lygaeidae (seed bugs)

Within the old classification, only three families belonging to the Lygaeoidea were known to occur in southern Africa. These were the Lygaeidae, Berytidae and Piesmatidae. In the latest classification the majority of subfamilies have been elevated to family status. Twelve families are known to occur in southern Africa but more than half of the described species belong to the Rhyparochromidae. The Blissidae and Lydaeidae are also relatively well represented. The southern African fauna show a strong resemblance to those found in the Mediterranean, and at least one-quarter of the genera are also present in the Mediterranean Basin or in Asia Minor, with at least 15 species common to both areas. There is also a strong Indian element present and about one-third of the genera are common to both these areas. Although only about 10% of the southern African genera are restricted to the continent, the great majority of the species are endemic.

Oncopeltus famelicus, the large Milkweek Bug, is a rather attractive insect approximately 12 mm in length. The elongated body is unmistakable, as it is boldly marked in black and orange (a morph that is mainly orange also exists and is often seen together with the typical form). The forewings have a characteristic single white spot where they end. The antennae and legs are black. The undercarriage of the thorax has orange markings contrasting with the black legs. This is a widespread grassland species feeding on the pods of

the Common Milkweed (*Asclepias fruticosus*) and other milkweed species, hence the common name.

Spilostethus trilineatus, a medium-sized bug, is a striking insect approximately 9 mm in length. The elongated body is unmistakable and recognised by the distinctive red bars on a blackish-grey background. The membranous parts of the wings create a contrasting cream vent. The antennae and legs are black. This is a widespread grassland species which feeds on the pods of the Milkweed (*Asclepias*), *Solanum* and a variety of similar plant species.

Spilostethus rivularis, a medium-sized bug, is approximately 11 mm in length. The elongated body is unmistakable and is easily recognised by the red stripes on a blackish-grey background forming a distinct, continuous pattern. The membranous parts of the wings create a contrasting dark-brown vent. The antennae and legs are dark brown. This is a widespread and common grassland species which feeds on the pods of the Milkweed (*Asclepias*) and a variety of similar plant species.

▲ Lygaeidae > Lygaeinae > *Spilostethus trilineatus*

▼ Lygaeidae > Lygaeinae > *Spilostethus rivularis*

Reduviidae (assassin bugs)

The most reliable feature distinguishing the assassin bugs from other bugs is the longitudinal, cross-striated, stridulatory groove, found in front of the sternum, although in some species it is weakly developed. In almost all the species the feet are segmented into three parts, there are simple eyes (ocelli) present and the claws lack arolia, the soft structure at the claw base. The antennae are usually long and thread-like with four segments although there can be up to eight. On the fore and middle legs of many species, there are specialised soft, spongy areas. These organs act as suction cups and probably serve to hold prey. Assassin bugs have a short, curved, three-segmented proboscis. When not being used as a weapon, the proboscis fits into a groove in the ventral surface of the thorax. The majority of this species are predators of other insects, which they grab hold of and stab with their proboscis, which is armed with four sharp lancets. They inject the prey with toxic saliva which kills it and breaks down the soft tissue into a liquid; they then suck the juices out of their victims and discard the hollow remains. All members of the subfamily Ectrichodiinae are obligatory predators of millipedes, an animal which seems to have few natural enemies because of its hard shell and chemical secretions. They often attract a number of bugs, which can be seen gathered around the body of the millipede.

Rhynocoris violentus is a relatively large assassin bug approximately 15 mm in length. The body is orange, with a dark-brown thorax and forewings. The head is dark brown with cream eye-stripes. The scutellum * is dark brown with a distinct cream horizontal stripe and a central white spot edged with black. The legs are orange with dark-brown lower sections. This bug is a predator of honey bees and other insects, which it ambushes from sunny positions, and is usually found on foliage or flowers waiting for its prey. This species is often found in grassland or savannah.

Pantoleistes princeps, a dark assassin bug, is a large species approximately 26 mm in length. The body is glossy black, with yellow-and-black banded legs and thin leaf-like expansions to the sides of the abdomen. The head is thin and black with an exceptionally long, brown proboscis. The antennae are brown with broad, darker bands. The scutellum, or shield, is black and slightly raised. This creature is an ambush predator of other insects and is usually found on tree trunks or branches at some height from the ground. This species is commonly found in grassland and bushveld.

▲ Reduviidae > Harpactorinae > *Rhynocoris violentus*

▼ Reduviidae > Harpactorinae > *Pantoleistes princeps*

▲ Reduviidae > Harpactorinae > *Rhynocoris rapax*

▼ Reduviidae > Harpactorinae > *Blapton ramentaceus*

▼ Reduviidae > Harpactorinae > *Rhynocoris pulvisculatus*

Rhynocoris rapax, a flower assassin, is a medium bug approximately 12 mm in length. The body is pale cream, with contrasting orange-and-black markings. The upper parts of the head and antennae are black, with pale underparts. The abdomen is pale cream with black striping. The forewings are orange and black, with black markings. The neck shield is cream and obvious. This is an ambush predator of other insects, usually found in dense foliage. It is an eye-catching species commonly found in open grassland and bushveld.

Blapton ramentaceus is a unique, medium-sized assassin bug approximately 14 mm in length. The body is brown and covered with numerous brown spikes and hairs. The antennae are long and appear to drop forward. The legs are exceptionally long, spider-like and brown with dark joints. It is an ambush predator of other insects and is usually found on branches in open grassland and bushveld.

Rhynocoris pulvisculatus, a dark assassin bug, is a medium to large species approximately 15 mm in length. The underside of the body is glossy black, with a reddish-brown to purplish-brown neck shield and forewings. The head is thin and black, and the long, dark-brown antennae look like stalks. The legs are black, except for the lower section of the front legs, which are a reddish orange A characteristic feature of this species is the exposed abdomen with

▲ Reduviidae > Harpactorinae > *Rhynocoris tristis*

▼ Reduviidae > *Rhynocoris erythrocnemis*

▼ Alydidae > Alydinae (bug nymph)

black-and-white banded margins. It is an ambush predator of other insects and is usually found in grass or on herbaceous forbs. It is commonly found in open grassland and bushveld.

Rhynocoris tristis is a large species approximately 13 mm in length. The body, neck shield and forewings are blackish with small white spots. The head is thin and the long, blackish-grey antennae resemble stalks. A striking feature of this species is the exposed abdomen with black-and-red banded margins. This creature is a predator of other insects and is usually found waiting in ambush on herbaceous forbs. This is an interesting assassin bug in that it does take some care of its eggs. The adult will guard the eggs until they have hatched to protect them against their enemies, like the hymenopteran egg parasites. Several females may contribute to the eggs that the male guards. When the male gets hungry he may eat some of them but will always eat those on the edges of the egg brood, the ones most likely to have been attacked by hymenopteran parasites. This species is found in wetland environments in grassland and savannah.

Rhynocoris erythrocnemis, a medium-sized assassin bug, is approximately 15 mm in length. The body is dark reddish to purplish brown and characteristically covered with fine pale-grey down. The upper parts of the legs are black, with orange lower parts, ending in black feet. The head is small and black and has a powerful re-curved beak used to impale other insects. This species is often found in exposed sunny positions in the Bankenveld grasslands. Great care should be taken as this species can deliver a painful bite if handled carelessly.

Alydidae (broad-headed bugs)

At times, hundreds of Alydidae of different species amass under one tree. When approached, they readily take flight, flying short distances away. The Alydidae nymphs very much resemble ants but they do not seem to be associated with them. The imitation is probably a method to deceive their predators.

The broad-headed bug nymph pictured bottom left belongs to the subfamily Alydinae. It is small, about 9 mm in length and is a dark-grey ant mimic. The body is slender, with a broad triangular head and enlarged hind legs. The nymphs are brown with clear, undeveloped wings. The abdomen is elongated and constricted, making them even more ant-like in appearance. They feed on plants, mainly on *Acacia* spp. seeds.

Mirperus jaculus, a species of broad-headed bug, is medium–sized, approximately 12 mm in length. The slender body, broad triangular head and enlarged bow-legged hind legs are distinctive. It is reddish brown in colour with white triangular markings at the wing bases. They are extremely active bugs, flying rapidly when disturbed. Well associated with the seeds of *Acacia* spp., they are regularly observed on the fallen pods under trees and the pods of other members of the Mimosa family. In Africa, the species is well known for sucking the pods of cowpeas. They are exceptionally common in Bankenveld grasslands, where they often occur in large numbers.

▲ Alydidae > Alydinae > *Mirperus jaculus*

▲ Gerridae > *Limnogonus capensis* (water strider)

Gerridae (water striders)

The water striders are small, slender, dark-brown insects about 10 mm in length and wonderfully adapted to their way of life on the elastic film that constitutes the water surface. The underside of the body is clothed in a coat of dense, white, scale-like hairs giving the insect a silvery appearance, in sharp contrast to the dark upper side. The hairs prevent the bug from getting wet. If pushed underwater with a stick, it bobs up again immediately, quite dry.

At first sight, the water strider seems to have only four legs but it actually has six, like the rest of its kind. The first pair of legs is short and usually tucked away beneath the front of the body. They are placed here so as to act as efficient grasping organs by means of which the bug can hold its prey floating on the water. A timid creature, it does not normally hunt healthy prey but contents itself with the juices of insects that are struggling on the surface and cannot defend themselves. When the water strider finds a victim, it seizes the body in its front legs, brings the proboscis forward and thrusts the four lancets deep into the tissues. The bug's long, thin middle and hind legs bear stiff brushes of water-repellent hairs on the feet and on the hind legs below the knee joint. These are the only parts of the insect that come into contact with the water surface. The modifications support the insect on the

water, enabling it to skim swiftly over the surface, held up only by the surface tension. The body itself does not touch the water. When something happens to break the surface film, such as a shower of rain, the striders rush to shore and hide under fallen leaves until the water is calm again.

A number of different species of water strider are found in South Africa. Most are winged so that when the water of a pool dries up they can fly away, usually at night in search of new abodes. However, there are a few kinds that are wingless. With certain other species two or three different types are found, some having fully developed wings, others only half-wings while still others are completely wingless, despite the fact that they all belong to the same species. Water striders use the surface film as a means of communication, as well as a means of support. If an insect falls into the water from an overhanging tree, its struggles set up vibrations in the surface film that are picked up by the strider, which has special sensory areas in its feet; very soon the prey is located, stabbed with the proboscis and sucked dry. Water striders also use surface vibrations to send messages relating to their courtship and mating. The male holds on to a suitable floating object, sending out a series of high-frequency ripples by moving its legs up and down. Responsive females who receive these vibrations through the surface film will approach the male, sending out answering signals at a lower frequency. As soon as the male picks up this message, it responds by changing the frequency of its own vibrations to low-frequency replies. Further specific messages and responses result in mating, following which the female lays her eggs in or on the object that the male used as a floating base for the whole courtship procedure. Then the male sends out another type of surface vibration at a yet another frequency, to mark his territory and keep other male water striders away.

Limnogonus capensis, a pond skater, is a medium-sized insect approximately 11 mm in length. The body is compact with very elongated legs to row the insect across the water at high speed. The upper parts of the body are greyish brown, with white sides. Pond skaters also have a white median mark along the thorax. Only the middle legs are used for locomotion; the forelegs are used for feeding and mating. It feeds on insects that have fallen on the surface of water once it has detected the vibrations of the struggling insect. Pond skaters are capable of flight and may be attracted to artificial light in relatively large numbers. This species is often found in stagnant water in a wide range of habitats.

▲ Gerridae > *Limnogonus capensis* (water strider)

HOMOPTERA

The Homoptera suborder includes such well-known species as cicadas, leaf hoppers and aphids. Also included are scale insects and mealy bugs, which are so highly modified that they probably would not be recognised as insects by the inexperienced. Homoptera are traditionally divided into two series, the Auchenorrhyncha, with three segmented tarsi, or ankles, and short, bristle-like antennae, and the Sternorrhyncha, which have one or two segmented tarsi and long, thread-like antennae, unless the legs or antennae or both of these are lacking.

Cercopidae (spittle bugs)

Many of us can recall sitting under a tree and experiencing what feels like rain dripping down from the branches. Spittle bug nymphs create a frothy ball as a home by mixing plant sap and a waxy substance, which prevents them from drying out and reduces predation. The nymphs moult and grow inside this ball. A tree can be 'raining' with numerous batches of nymphs at different stages in development. When nearing the final moult, the nymph leaves the ball and matures into an adult. These adults are winged and either fly or jump when disturbed.

Locris arithmetica, the Red-spotted Spittle Bug, is a medium-sized insect approximately 23 mm in length. The bugs are red with characteristic black spots and banding on the neck shield. They are typically encountered in small groups but can occur in hundreds at a suitable food source. The nymphs are associated with 'cuckoo spit' froth, which protects the young from predators and from drying out. They are common on indigenous stands of weeds in Bankenveld grasslands.

Membracidae (treehoppers)

The common and quaint little bugs of the family Membracidae are easily recognised by the shape of the first segment of the thorax, which is prolonged over the back and often bears horn-like projections which give the insect a rather bizarre appearance. The bugs are small; few are greater than 6 mm long when fully grown and are mostly brown. The female lays her eggs in slits cut into the twigs of trees and shrubs. The resulting young, usually black, are

▲ Hemiptera > Cercopidae > *Locris arithmetica* (Red-spotted Spittle Bug)

gregarious, feeding in groups on the sap of the plant. They are attended by ants eager for the sweet liquid they secrete. The ants are known to stroke the young treehoppers with their antennae and the latter respond by exuding liquid excrement or 'honey dew' from their long anal tube. The tube contains an eversible 'anal whip', which can be waved rapidly from side to side, probably as a defensive mechanism. It is assumed that in return the treehoppers are protected by these ants, which swarm would-be predators.

These interesting little insects often disguise themselves as thorns, with thorn-like protrusions coming off their thorax. They are not easily observed unless actively searched for. Treehoppers, like many of their true bug cousins, feed off the sap of a number of different tree species. They are generally shy and inconspicuous, appearing to avoid being seen.

Umfilanus declivis, a tree hopper, is a small insect with a wingspan of approximately 16 mm. The body is stocky, with two stout lateral horns and a curved, backward-projecting process. The wings are a clear brown with a light-brown patch at the base and are held sideways against the abdomen. The head and thorax have a characteristic white mark. Interestingly, the blackish nymphs are gregarious, often found together with adults, and usually attended to by ants. This species is relatively common on a wide range of leguminous trees, shrubs and creepers in bushveld and grassland environments.

Cicadidae (cicadas)

Perhaps the most characteristic feature of any hot, drowsy day in Africa is the monotonous shrill call of the cicada. Interestingly, only the male cicada sings, the females being voiceless. If one of these insects is caught, it is easy to determine its sex by examining the underside. At the tip of the abdomen, the female has a sharp ovipositor; the male instead has two semicircular plates, called opercula, at the base of the abdomen, just behind the hind legs; these cover the sound-producing organ. This organ, so characteristic of the cicada family, consists of a cavity on either side of the abdomen in which the 'drums' or tymbals, the folded membranes and the 'mirrors' are lodged. The tymbals are folded membranes resembling miniature drums, with strong muscles attached to them. By contracting and expanding these muscles, the tymbals are made to vibrate and sound is produced, like pressing the bottom of a vessel in and out. The folded membranes on each side of the cavity act as sounding boards to increase the amplification. If one of the opercula is

▲ Membracidae > *Umfilanus declivis*

lifted with the point of a pin, the mirror, which seems to function as an ear, can be seen at the back of the cavity as a small, white, round, shining plate. By raising and lowering the opercula, the male can increase or diminish the volume of its sound. This action also has a ventriloquial effect, making it difficult for the human listener to locate the exact source of the sound. Two or three cicadas will generally be found close together on a tree, their proboscis embedded in the branch, feeding on the sap. One or more will be male, singing tirelessly, while the silent members will be females. It is believed the cicada's song serves as an assembly call, and that it may also have a stimulating effect on the mating instinct.

The cicada has four membranous wings, which are stiff and flat and held roof-wise over the body. It has two large compound eyes, with three, small simple eyes between them. The antennae are short, black and thread-like. It has the mouth parts of a true bug type, consisting of a grooved proboscis in which are lodged four slender lancets for piercing the tissues of plants and sucking out the sap. Throughout its life cycle the cicada is a sap-sucker. The female lays her eggs in slits made in the bark of trees.

The life cycle of the African cicada has never been studied in detail but it seems that the eggs take about six weeks to hatch. The young cicada resembles its parents but is more stoutly built with two curious front legs, with greatly enlarged spiny thighs and shanks that serve as digging implements. At birth, the little creatures drop to the ground and at once burrow beneath the surface. They spend their entire immature lives tunnelling through the soil in search of tender young roots, whose sap they feed upon. Some cicadas spend over 15 years as nymphs underground until the conditions are right for them to emerge. When the nymph is fully grown it burrows its way upwards to the surface and out into the light and air. It climbs a few centimetres up a nearby tree-trunk, digs its claws in and clings there motionless for some time. Then its skin splits down the back and the adult cicada struggles laboriously out of the nymphal skin. After the wings have expanded and dried, it is ready to fly away and spend a few brief weeks revelling in the sunshine and singing its shrill, monotonous song.

The genus *Munza* is indicative as the species within the group has tymbal covers present. Only the males have a pair of circular tymbals, which are the sound-producing organs. This species produces a shrill, droning sound in summer. The wings are characteristic of the species as the forewings have

▲ Homoptera > Cicadinae > *Munza furva*

eight, and the hind wings, six apical areas. The outer posterior margins of the wings are also very broad. The head is not frontally produced but deflected in front of the eyes. *Munza furva* has a wingspan of approximately 75 mm and prominent white spots on the upper hind wing. The species is relatively common in grassland and savannah environments and strongly attracted to artificial light and even fire.

LEPIDOPTERA

Eurema brigitta, the Broad-bordered Grass Yellow, is a medium-sized butterfly with a wingspan of approximately 33 mm. The undersides of the wings are bright yellow with broad black borders along the front and outer margins of the forewings, broadening around the tip and along the outer margin of the hind wings. This species flies slowly and close to the ground, often settling on flowers to feed. A single slender, spindle-shaped, cream egg is laid on a

▼ Pieridae > Coliadinae > *Eurema brigitta brigitta* (Broad-bordered Grass Yellow)

variety of plant species. This species tolerates dry conditions and is common in the frost-prone Bankenveld grasslands.

The *Charaxes candiope*, the Green-veined Emperor, is a large butterfly with a wingspan of approximately 75 mm. The base of the wings is yellow, with the remaining surface reddish brown in colour. It has a broad, black band along the outer wing margin with a row of orange spots. The green veins near the front margin of the forewings are a characteristic feature of this species. The undersides of the wings are brownish with darker markings, yellow patches and distinct green markings near the main wing veins. The females have two long tails, while the upper tail is shorter in the males. The eggs are smooth and round, have radiations similar to a bicycle wheel spoke and are laid singly or in small groups. This is an exceptionally fast-flying butterfly, attracted to fermenting fruit. The species flies year round in the warmer areas, but is mostly commonly observed in September and June in the Bankenveld grasslands.

ORTHOPTERA

An interesting fact about all the Pyrgomorphidae is that they lack the stridulatory mechanism in the form of a file and scraper and therefore cannot produce the sounds that are so characteristic of grasshoppers. Nevertheless, like other grasshoppers they have well-developed 'ears' or tympanal organs. These are not situated on the head but on the abdomen, just above the base of the hind wing. If the wings are lifted they are clearly visible to the naked eye as circular depressions on the body. Each is about 3 mm in diameter and is covered by a tightly stretched eardrum.

Zonocerus elegans, the attractive Elegant Grasshopper, is a large insect approximately 40 mm in length. The head is mainly black, and the black antennae have orange bands. The eye is characteristically and conspicuously orange. The forewings are fairly short and pinkish black at the base. Usually it has short, non-functional wings but occasionally long-winged forms are found. The abdomen is unmistakably striped with orange, black and white bands, often with a pinkish tinge.

This species is common on low shrubs in grasslands and savannah regions, where it shows a preference for the milkweed *Asclepias fruticosus* and *Solanum panduraeforme*. It rarely feeds on grasses. When disturbed, it can produce a

◄ Lepidoptera larva

▲ Nymphalidae > Charaxinae > *Charaxes candiope* (Green-veined Emperor)

▼ Orthoptera > *Zonocerus elegans* (Elegant Grasshopper)

▲ Tettigoniidae > *Phaneroptera* sp.

▼ Tettigoniidae > bush cricket

foul-smelling yellow fluid. Interestingly, the eggs are laid communally and remain in the ground for about six months, before hatching in the spring. Despite its elegant appearance, it has a repulsive smell produced by a yellow fluid that it exudes when threatened. In certain areas, it may be destructive feeding on plants. A member of the family Pyrgomorphidae, it is found throughout most of Africa south of the Sahara.

Tettigoniidae (katydids)

The katydids have their tympanal organs, their 'ears', situated in the most extraordinary place, on the front legs. On the tibia of each front leg, just below the femoral joint, a slight swelling can be seen. There are usually two longitudinal slits in this swelling. These reveal the external openings of two cavities, the membranous walls of which are connected to the auditory receptors. At the base of each front leg is an opening, the auditory spiracle, which is connected to a tube that runs up the femur, past the joint and down to the auditory receptors behind the slits. This arrangement gives the insect a remarkably sophisticated hearing system. When singing, resting or feeding, the katydid is vulnerable to attack but uses the spiracles and trachea in combination as a very sensitive omni-directional sound receiver to alert it to potential danger. On the other hand, the slits on the forelegs are unidirectional sound receivers, and the females use this system with a high degree of accuracy to locate the singing males.

The bush katydids (subfamily Phanopterinae) are widely distributed in Africa and occur in very many habitats; they are partial to gardens and other cultivated areas, and are common in Acacia savannah. Many species are winged, nocturnal and uniformly greenish in colour although some have yellowish wing markings. The males sing with a low, rasping sound, not a continuous trill. The eggs are laid in leaves, which are first split along the edge with the flattened ovipositor.

This bush cricket (bottom left) is a medium-sized katydid belonging to the family Tettigoniidae and is approximately 32 mm in length. The body is green except for the knees, neck shield and the base of the head, which are reddish brown in colour. They are nocturnal insects, often heard calling in the evenings. This creature feeds predominantly on plant parts and also on certain insect groups. It is widespread in the Bankenveld grasslands and bushveld savannahs.

This small bush cricket belonging to the family Tettigoniidae is about 15 mm in length. The body is green except for the legs, antennae and a brown stripe running from the head to the base of the abdomen. This species has a characteristic arched back, is wingless and has legs well adapted to living on foliage. It feeds on plant parts and is widespread in the Bankenveld grasslands and bushveld savannahs.

Lophothericles sp., a bush hopper, is a small insect approximately 20 mm in length. The head is flattened from side to side. The eye is large and orange in colour. The antennae are short, project upwards and are also orange-coloured. The neck shield is relatively large, distinctive and finely sculpted. The cylindrical body is green and wingless and tends to taper towards the end. This species is often found sitting with its hind legs positioned at 90° to the body. The hind legs are well developed with serrated spines. The plants on which it feeds vary considerably, and this species is usually found on shrubs in grasslands and bushveld regions.

▲ Eumastacidae > Thericleinae > *Lophothericles* sp.

- Hymenopodidae > *Harpagomantis tricolor* (Flower Mantid) (adult)

- Hymenopodidae > *Harpagomantis tricolor* (nymph)

- Hymenopodidae > *Harpagomantis tricolor* (nymph)

MANTODEA

H. tricolor, a medium-sized mantid, is approximately 31 mm in length. The body is attractively mottled in pinks, browns and greens. It lacks the forewing 'eye spot' present in another species. A double spine projects forwards from the middle of the head. The eyes are pink with white spots and situated on forward-projecting spines, giving the head a W-shape when viewed from the side. The forewings are attractively banded in pink and green. This species mimics flowers and in this way ambushes visiting insects. The wingless nymphs are spectacularly ornamental and are beautifully mottled in pink and green, carrying the abdomen curled above the body. This species stands motionless and is easily overlooked on flowers with which their colour blends. It is is relatively common in savannah and grassland environments.

This nymph of *Harpagomantis tricolor*, is bright yellow in colour and thus associates itself with yellow flowers for camouflage purposes. The species has a variety of different colour forms which assist it to ambush prey from different-coloured backgrounds. The forward-projecting spines, giving the head a W-shape, are characteristic of the species.

◄ Braconidae > *Archibrachon servillei* (braconid wasp)

▼ Vespidae > *Belonogaster* sp.

HYMENOPTERA

Archibrachon servillei, a medium-sized, stout wasp, is shiny reddish orange in colour except for the last five abdominal segments and the wings. The antennae are black and almost as long as the body. The legs are reddish orange and black while the wings are black with a reddish-orange square cell three-thirds along the margin. The long and conspicuous ovipositor in the female may be used to drill into plant stems.. The species primarily parasitises the larvae and pupae of butterflies and moths, and also the larvae of flies, beetles and bugs. It is an attractive species and relatively common in grassland and savannah regions.

Belonogaster sp., a medium-sized wasp, has a wingspan approximately 25 mm in length. The dark-brown body has a long, narrow reddish-brown waist. The head, thorax and tips of the wings and abdomen are black. The antennae are a reddish-brown colour. Overwintering creatures may occur in relatively large numbers in sheltered areas. This species builds a papery, multi-celled nest of wood pulp and saliva, which can be attached to a branch, rock

▲ Scoliidae > *Scolia* sp. (mammoth wasp)

roof of a house. This is a social species but relatively aggressive and the wasp will defend its nest if disturbed. Interestingly, the young are fed with chewed-up caterpillars. The species is widespread and common in grassland areas.

Scolia sp., a mammoth wasp, is a stocky, medium-sized insect approximately 25 mm in length and black in colour with brilliantly metallic iridescent wings. The male is more slender than the female and sometimes a different colour. This species parasitises the larvae of beetles, especially scarab beetle larvae that live in the soil or in decaying organic material. The larvae of this species feed externally and, when mature, will pupate in a tough cocoon in the soil. It is common in Bankenveld grasslands and may often be observed in search of hosts near compost heaps or dung piles.

PHASMATODEA

Leptynia trilineata, a stick insect, is medium-sized and approximately 62 mm in length. It is a slender species, delicate and wingless, pale brownish cream in colour, with greenish-tinged upper legs. The abdomen is clearly segmented and usually held upwards. The antennae are long and project forwards. This species sways rhythmically when disturbed and is exceptionally well camouflaged when motionless, its body parts closely resembling dry grass stalks. It is a plant feeder, especially on grass species. This insect is common in the Bankenveld grasslands, but is easily overlooked as it is so well camouflaged.

DIPTERA

Physocephala sp., a medium-sized fly species, has a wingspan approximately 16 mm in length. It resembles hover flies but has a narrow waist, long projecting proboscis and an exceptionally large head. The body is reddish brown in colour with a dark mark on the head. The head is transparent and folds over the back. The large brown eyes are conspicuous. This species is an excellent wasp mimic. The adults feed on nectar, while the larvae are parasites on various insects, especially wasps. Hooked eggs are attached to the wasp in flight and the larva develops inside the host. In some cases the adults resemble their hosts.

Paraclara sp., a species of tachinid fly, is a medium-sized fly with a

▲ Phasmatidae > *Leptynia trilineata* (stick insect)

◀ Conopidae > *Physocephala* sp. (big-headed fly)

▼ Tachinidae > *Paraclara* sp. (tachinid fly)

wingspan approximately 18 mm in length. This species is brick red in colour, with a black abdomen. The legs are pinkish in colour. The wings are black with orange longitudinal windows. The adults feed on nectar and often have a characteristic buzzing flight. The larvae of all species are internal parasites of other insects. Butterflies and moths are the most common hosts; bugs, beetles and grasshoppers may also be affected. The female may lay her eggs directly on to the host or a plant which she knows the host will visit. The fly larva kills the host on pupation only, feeding off the non-vital organs before this. From an agricultural perspective the species is important as it suppresses the numbers of moth caterpillars that damage crops and are therefore important in maintaining a balance in nature.

Gonioscelis ventralis, a medium-sized robber fly, is approximately 25 mm in length. The body is relatively elongated and covered with yellowish hairs.

▼ Asilidae > *Gonioscelis ventralis* (female)

The dark wings are held directly backwards over the abdomen. The hairy legs are orange and the body, which is also hairy, is usually a combination of browns and blacks. The face and legs are bristly. The two large black eyes are positioned pointing forwards and are characteristic of a predatory creature.

The robber fly is armed with a robust beak which it uses to impale its prey. Robber flies are fascinating insects as a result of their interesting behaviour and somewhat comical features. They hunt other insects and are always present, where insects congregate in flowers. The species feeds on the flower-feeding scarab beetles, which they grab in their front legs and then devour.

Robber flies are common on hot, dry days and are often experienced flying in front of one's face when one is out walking on a path. They are very irritating as they land, fly off and land again. These flies are selective about the prey they attack. The assessment they make of the suitability of the potential prey probably includes factors such as its size, defence mechanisms and accessibility. After the prey has been injected with a fluid that liquidises its insides, it is then sucked dry. Robber flies often appear 'tame' and can be approached with ease if no violent movements are made. Mating appears to occur without any show of courtship while the fly is sitting or over short distances in flight. The female lays her eggs in natural grooves in the bark of trees or between soil particles. Even as larvae, the flies are predaceous, feeding on small insects in the soil, leaf matter or in compost before emerging as adults only to repeat the cycle. The species occurs in a wide array of habitats and is common in Bankenveld grasslands.

NEUROPTERA

Italochrysa impar, a delicate lacewing, is approximately 30 mm in length. The eyes are a distinct reddish brown. There are a few brown markings near the base of the wings. The antennae are dark with light, yellow bases and project upwards. The intricate diaphanous wings are held backwards against the body. This species inhabits open grassland and is interesting from an ecological perspective as the larvae of this genus are generally associated with ants. The adults feed primarily on pollen and are regularly observed on grass stalks in Bankenveld grasslands.

Trogaspidia sp. is a medium-sized, wingless wasp approximately 12 mm in length. The head, antennae and legs are black while the thorax is a reddish brown. The black abdomen has two white spot markings and two silvery bands.

▲ Neuroptera > Chrysopidae > *Italochrysa impar*

▼ Hymenoptera > Mutillidae > *Trogaspidia* sp.

▲ *Orthetrum julia* (Julia Skimmer) (male)

▼ *Trithemis arteriosa* (Red-veined Dropwing) (male)

▼ *Trithemis dorsalis* (Dorsal Dropwing) (male)

The coarsely punctured body is extremely hard. It is covered with soft velvety hairs. These wasps parasitise the larvae of other insects and are relatively common in Bankenveld grasslands, where they are usually observed running on the ground. The male has dark wings with a metallic sheen and are often a different colour from the female. In some cases they lack the characteristic abdominal markings.

ODONATA

The Julia Skimmer, *Orthetrum julia*, is a medium-sized dragonfly with a wingspan of approximately 60 mm. The adult males are a powder blue, with a pale-blue abdomen and a slate-coloured thorax. The females are dark brown in colour with two pale thoracic stripes. The species settles with its wings forward and downwards on reeds and grasses from which airborne attacks on prey are launched. The aquatic nymphs have very small eyes and are entirely covered with hairs. This species is often the commonest skimmers found along well-wooded rivers, ponds and streams in Bankenveld grasslands.

Trithemis arteriosa, the Red-veined Dropwing, is a medium-sized dragonfly with a wingspan of approximately 58 mm. The body is slender with distinguishing black lateral marks at the tip of the thin abdomen. The adult males have a red body with red leading wing veins; the females and immature dropwings are yellow or dull orange in colour. The species settles with wings downwards and forwards on reeds and grasses from which short forays are made for food or to pursue mates or intruders. It is widespread in a wide variety of vegetation types in most aquatic habitats, including brackish pans in semi-arid environments. The oval nymphs are mottled with spines and inhabit these water bodies. The species is common along rivers and streams in Bankenveld grasslands.

Trithemis dorsalis, the Dorsal Dropwing, is a medium-sized dragonfly with a wingspan of approximately 62 mm. The adult males (bottom left) have dark-blue bodies with a complete brown panel at the end of each wing. The bodies of females (top right) are pale blue and yellow. They have clear wings and also a complete brown panel at the end of each wing. This species often settles with wings upwards or downwards on the very end of a reed stalk or branch. This species is common along rivers and streams, especially upland grassland regions of the Bankenveld.

Platycypha caligata, the strikingly coloured Dancing Jewel, is a medium-sized damselfly with a wingspan of approximately 45 mm. The body is slender and the abdomen characteristically points upwards. The dorsal area of the abdomen in adult males (middle right) is a bright sky blue with a thin blue dorsal stripe along the brownish-orange thorax. The lower parts of the legs in the males are very broad and flat, with reddish outer and white inner surfaces. The females (bottom right) are greenish brown in colour. The species settles on reeds, rocks, stumps and branches with its clear wings held upwards. It is widespread and common in rocky streams and pools, usually at high altitudes but also in the Lowveld and Highveld. The labial masks of the aquatic nymphs are exceptionally short. The species is common along rivers and streams in Bankenveld grasslands, where the males court females using the reddish lower parts of the legs and by vibrating them in a way that displays the white inner surface.

Pseudagrion spernatum, the delicate Natal Sprite, is a medium-sized damselfly with a wingspan of approximately 52 mm. The slender adult is uniformly coloured on top, with the top of the thorax being a dull navy blue and the top of the abdomen a glossy navy blue with a characteristic powder-blue tip. The head and the eyes are black from above, with a pruinose-blue forehead and a bright-blue post-ocular spot. The lower sides of the thorax and underside of the eyes are apple green. The thorax is incompletely transected by dark-bluish lines. This species often settles on grass or low herbaceous plants and flies slowly and sluggishly. It is common in vegetated margins of streams and rivers dissecting Bankenveld grasslands.

▲ *Trithemis dorsalis* (Dorsal Dropwing) (female)

▼ *Platycypha caligata* (Dancing Jewel) (male)

◄ *Pseudagrion spernatum* (Natal Sprite)

▼ *Platycypha caligata* (Dancing Jewel) (female)

- Philodromidae > *Tibellus minor* (grass lesser wandering spider) (female)
- Sparassidae > *Palystes superciliosus* (rain spider)
- Araneidae > *Neoscona moreli* (Grass Hairy Field Spider) (male)

ARACHNIDA

Tibellus minor, a grass lesser wandering spider, is approximately 10 mm in length. As the name suggests, it is usually found on grass. They have elongated bodies and long legs. The first and second pairs of legs are longer than the remaining pairs and give this species a crab-like look. This species is light brown with darker stripes running lengthwise on the abdomen. They are not easily seen when motionless and are free-living hunters. This species is common in the Bankenveld grassland region.

The Grass Hairy Field Spider, *Neoscona moreli*, is approximately 12 mm in length. The body is pale fawn, with brown longitudinal lines on the thorax and a yellowish pattern on the abdomen. The species readily sits, head down, at the centre of its web. After prey is caught, it is wrapped in silk. This species is widespread on grass and forbs in the Bankenveld grassland region of South Africa.

The rain spider *Palystes superciliosus* is feared because of its impressive size, but is in fact not dangerous. This large spider may reach 40 mm in

length, with a leg span of up to 100 mm. They are generally fawn-brown in colour with darker leaf-shaped patterns on the dorsal side of the abdomen. These nocturnal, wandering hunters regularly come indoors, which is quite unintentional as they are looking for insects that are attracted to artificial lights. They are able to bite, and their fangs easily puncture human skin, but the symptoms are only a mild itching and slight swelling. Females lay large numbers of eggs, up to 700 in greyish, cushion-like sacs. The sac is then covered with leaves and held together with silk and guarded by the mother. This species is widespread and readily found across South Africa.

The hairy field spider *Kilima decens* is approximately 11 mm in length. This species is brownish grey in colour and has a distinct dark-brown, irregular pattern on the oval abdomen. It is known to hide in retreats constructed of silk and surrounding vegetation, to the side of the web. They monitor what alights on the web by holding on to a silken thread attached to the web hub. Interestingly, this species is nocturnal and constructs its webs in grass usually late in the evening and removes them early in the morning. The grassland often appears covered with spider webs in the early morning; they become even more conspicuous when drenched with dew and can be quite a spectacular show. This species is widespread in South Africa and is particularly common in grassland environments.

▲ Araneidae > *Kilima decens* (hairy field spider)

▲ Lycosidae > *Zenonina mystacina* (wolf spider)

▼ Lycosidae > *Zenonina albicaudata* (wolf spider)

▼ Miturgidae > *Cheiracanthium furculatum* (sac spider) (female)

Zenonina sp., a wolf spider, is approximately 15 mm in length. The head and large abdomen are brown, while the rest of the body is a lighter brown. The hairy forelegs are a pale cream. Most wolf spiders live on the ground and they are often found under rocks, stones and logs. They occasionally move over plant material. They are ambush and roving hunters. The female wolf spiders characteristically carry their egg sacs attached to their spinnerets. They make great mothers and, even when handled, refuse to drop or leave their egg sac. This species is common in savannah and grassland environments

Cheiracanthium furculatum, a sac spider, is a small spider approximately 12 mm in length. The body is a pale cream, with darker, leaf-shaped markings on top of the abdomen. The legs are long, and the face, including the fangs, is black. The male and female are of a similar size but can be differentiated by the difference in their pedipalps. These spiders are probably responsible for 75% of recorded spider bites throughout southern Africa. This is probably because this species often shares the same habitat as humans. The bite forms a painful sore like a boil, which oozes pus, taking about a fortnight to heal. The spider venom is cytotoxic, which results in the flesh being eaten away. This species builds a slightly oval retreat of silk on leaves, walls or in the folds of curtains, hence the common name 'Don't'. It is an active ambush hunter, which does not catch its prey in a web. This species readily catches prey its own body size or significantly larger than itself. It is common in leaf litter, on the ground or in foliage, and occupies a number of niches.

The photograph (top right) clearly shows the larder of the Dauber Wasp, *Sceliphron spirifex*, packed with spiders. The Dauber Wasp appears to concentrate on spiders of a similar size, in this case about the size of a crab spider. The mud nest of this medium-sized, black-and-yellow wasp may have numerous chambers, each with a larder of spiders and a single egg. The spiders are anaesthetised by the wasp and, on hatching and until pupating, the wasp grub feeds on them. These wasps are common in the Bankenveld grasslands and are strongly associated with human structures, where their nests can be large and conspicuous.

Thomissus blandus, a female crab spider, is a small insect approximately 11 mm in length. The body is pale cream with rich chestnut bands across the abdomen. The crab-like legs are typically translucent. Unlike the Yellow Flower Crab Spider, this species does not change its colour according to the soil that it finds itself on. Like most crab spiders, they are ambush predators, camouflaging themselves on flowers. They do not catch their prey in a

web. The male may be very small, 500 to 600 times lighter than the female. The species frequents a wide range of habitats and is relatively common in Bankenveld grasslands.

Thalassius spinosissimus, a fishing spider, is a sturdy insect approximately 35 mm in length. The body is dark brown with a bluish tinge and there is a distinct pale-yellow band around the edge of the cephalothorax. The species favours still bodies of water and is not found in fast-flowing streams. It feeds on fish and scavenges on insects which have fallen into the water. It is interesting to see how it anchors itself to a rock or plant with a line of silk, and then wriggles its legs on the surface of the water to attract fish. When a fish is close enough to the spider, it embraces it with its legs and injects venom into its prey. The spider rapidly feeds on the fish and within about 25 minutes only a heap of tiny bones and scales remains. The venom is fast-acting and exceptionally effective on fish; as a result, the spider can catch fish which are double its body size. The venom has no negative effect on humans. The spider can submerge itself for over 30 minutes by entrapping air bubbles on its body. It is regularly observed on stagnant bodies of water on rivers in the Bankenveld and in other parts of South Africa.

The scorpion depicted here was found on the south-western edge of its distribution range. These scorpions occur from the Loskop Dam area; the Steelpoort River appears to form the eastern boundary of their distribution. It is found on rocky outcrops, where it likes to live in a single rock crack for most of its life (unless it outgrows the crack). Interestingly, they are very long-lived, taking about five years to reach adulthood, and living for another three or four years after that. The rock scorpion has recently received a red listing assessment but the population is considered safe.

▲ Larder of *Sceliphron spirifex* (Dauber Wasp)

▼ Thomisidae > *Thomissus blandus*

◀ Liochelidae > *Hadogenes longimanus* (Long-handed Rock Scorpion)

▼ Pisauridae > *Thalassius spinosissimus* (fishing spider)

Urban Gardens, Gauteng Province: landscape

◀ An organic garden can support a wide diversity of invertebrate species provided a variety of different habitats are created.

Worldwide, gardening is undergoing a major revolution. For centuries, establishing any garden, large or small, generally involved the imposition of artificial designs on the natural setting, which has created an ongoing battle with nature. With changing times, there is a growing awareness and appreciation of how fragile and important the balance of an ecological system is in any garden. Respect for the natural landscape and its ecology has become a primary consideration. Instead of imposition and intervention, gardeners now seek to work with nature rather than against it. Gardens nurtured over the years not only evolve new plant communities but balance ecosystems and microclimates in which insects within all the feeding hierarchies are present. This, coupled with a knowledge of plants, will ensure that a healthy, active garden is maintained and a contribution is made to nature conservation. Gardens adjacent to one another naturally form green corridors, providing a natural reservoir of plant and insect life and allowing movement and recolonisation to occur.

Gardens in South Africa often harbour many more invertebrates than one would think, especially when there is a combination of indigenous and exotic plants. The use of herbicides and insecticides obviously has a negative impact on many species, usually the species for which the poisons are not meant. Rolling lawns of indigenous grasses, bordered by an abundant growth of different plants, lend themselves to a high diversity and profusion of insect life. Insects in a garden are important in maintaining a healthy ecological balance. As in the wild, there is a delicate balance between the 'pest' species and those that feed on them. In our attempts to control the 'pest', this balance is usually affected. As a result the 'good' insects which maintain this balance

▲ The foliage of high trees is home to a number of species which are not regularly encountered.

▼ In many cases there is a relationship between invertebrates and plant species, thus the more diverse a garden, the more diverse its inhabitants.

are killed, which indirectly creates a bigger problem in the end. In urban gardens, a healthy population of insects results in healthy populations of other species, such as the more popular birds and other creatures. Leaf litter and dead wood are important in a garden, material which we so quickly want removed.

Johannesburg is an area of climatic extremes, with warm to hot summers and cold winters. Frost is common from June onwards, and plants and insects need to be well adapted to these conditions. Life slows down over the winter period and there is little insect activity. However, with the arrival of spring, life seems to burst out and there is an almost electric energy in the air.

The soil in urban gardens is largely affected by the way it is treated by the gardener. Soil can turn into barren, non-living material if treated wrongly. It should be treated as a living part of the ecosystem. Leaf litter should not be removed but allowed to breakdown and fertilise the soil naturally. Some fertilisers purchased from nurseries introduce nasty chemicals into the soil, which in turn have a negative effect on the natural balance.

Harmonising indigenous and exotic plants is key to a healthy system. The slow evolution of a garden from a purely exotic to a natural one should be carried out with great sensitivity. Plants that were once considered weeds should now belong in a garden. The paths, the arteries of the garden, should be maintained and kept free of weeds but everywhere else they should be allowed to run their natural course. Cultivated exotic plants are always present in urban gardens, the presence of indigenous, endemic species really boosts the ecological web. Typical plants and bulbs flowering through spring and summer, include species such as *Gladiolus*, *Crocosmia*, *Watsonia*, *Albuca* and *Gnidia*, *Vernonia*, *Leonotis*, *Wahlenbergia* and *Asclepia*. These should be blended with *Themeda triandra* and *Hyparrhenia hirta*, the all-important Highveld grassland species. The pioneering use of indigenous flowering plants has proved to be a magnet for birds and insects.

The implementation of organic, ecologically friendly garden practices, coupled with the planting of indigenous grasses and plants, brings gardens to life ecologically. New invertebrate species reappear and the fascinating web of diversity is enlarged considerably. Natural gardening is all about one's relationship with the garden and involves learning about plant systems and families and the creatures that are dependent on them. The most important thing is to work with nature and not against it.

Exotic plants are not necessarily taboo, but creating a balance with indigenous species is important. Woodboring and other species living in the leaf litter are also a part of this balance and are essential in breaking down material and recycling this into the soil, providing natural fertilisation. Nothing beats the experience of walking into a garden in the warmth of the sun and seeing a hive of activity on newly blossomed flowers.

No matter how small the garden, it should play a role in conserving nature. When a garden is grounded in its natural environment, with plants that support the various invertebrate groups, walls and boundaries cease to matter, because there is a link to the wider environment outside. Plants and animals should be allowed to fulfil their natural cycles as this is all part of establishing a healthy balance in a garden. Such an indigenous, organic approach is aimed at encouraging the web of rich diversity in which all forms of life thrive.

▲ Leaf-litter in well-shaded parts of the garden is an important micro-habitat for many species of invertebrates.

▲ The absence of herbicides and insecticides is the secret to a healthy garden, and therefore allows nature to balance itself, a process in which insects play a major role.

▶ Patches of herbaceous flowering plants are always a major attraction for pollen-feeding species such as this bee-mimicking fly.

COLEOPTERA

Carabidae (ground beetles)

Ground beetles were once thought to be entirely predacious but there is now evidence that many groups are at least, in part, plant-eating. Some of them are specialised feeders, creatures that feed exclusively on a particular plant or other food source. The name 'ground beetle' is to some extent misleading, as certain groups are for the most part found on plants, on decaying wood or under the bark of trees. The great majority of ground beetles are terrestrial, with relatively few arboreal hunters; some live permanently in the nests of birds. Many of the terrestrial groups have lost their wings and have fused wing covers, while some arboreal species are capable of flight. The wingless species are generally diurnal in habit with large eyes, while the nocturnal ones have unremarkable eyes.

Metagonum sp., a ground beetle, is a rather drab beetle, about 13 mm long. It is dark brown with light-brown legs. It is a predator of other insects, especially those associated with decaying wood. This species is relatively common and widespread in South Africa and may be observed in piles of decomposing wood.

Chrysomelidae (leaf beetles)

The members of the subfamily Eumolpinae in the large family Chrysomelidae are very common in South Africa. One of the larger genus within this group is *Colasposoma* with over 40 described species, many of which feed on *Ipomoea*. This large subfamily includes some very different types of leaf beetles. For the most part, they have more or less cylindrical neck shields and flattened heads. Many species within this group are glabrous and metallic in colour but others are covered with dense down or even small scales. There are also considerable size differences within the subfamily. The adults feed on leaves while the larvae feed chiefly in the soil on the roots of different plants. The adults in this genus eat leaves. The genus *Platycorynus* is associated with milkweeds (*Asclepias* spp.), which contain substances poisonous to some vertebrates, and it is assumed that these beetles get a measure of protection by ingesting these chemicals.

Colasposoma fulgidum, a leaf beetle, is a brilliant metallic-green insect, about 12 mm long. The species is relatively common in gardens in South Africa where it may be observed on the flowers and leaves on which it feeds.

▲ Carabidae > Platyninae > *Metagonum* sp.

▼ Eumolpinae > *Colasposoma fulgidum*

▲ Coccinellidae > *Declivitata bohemani*

▼ Coccinellidae > *Hippodamia variegata* (Spotted Amber Ladybird)

▼ Coccinellidae > *Harmonia axyridis* (Multi-coloured Asian Ladybird)

Coccinellidae (ladybirds)

These well-known friends of the gardener come in a surprising variety of species. Ladybirds are oval, very convex beetles and range in size from very small to small (0.5–10 mm). The colour varies from yellow to black and the beetles are often bicoloured or spotted, The males and females of some species are coloured differently. These round-bodied beetles, which gave their name to the Volkswagen Beetle, are important in their adult and larval stages for controlling garden pests such as aphids. The good work that ladybirds do often goes unnoticed as they have voracious appetites and can consume vast quantities of so-called pests. If they are disturbed, a yellow fluid oozes from between the joints of the legs. It is extremely bitter and protects the ladybird, making it unpalatable to birds, lizards, frogs and other insect-eaters. As a result the ladybird has no need to conceal itself, and its conspicuous markings and colouration advertise this fact. The adults of many Coccinellidae aggregate during winter, sometimes on the roofs of houses.

Declivitata bohemani, a ladybird, is a small beetle, approximately 5 mm in length. The black body is smooth, with a striking cream pattern mirror-imaged on the wing covers. The adults and larvae feed on a variety of small insects. This is a common garden resident and can be observed on plant stems and foliage, often those infested with insects.

Hippodamia variegata, the Spotted Amber Ladybird, is a small beetle approximately 4 mm in length. The head and neck shield is black with pale-yellow markings. The wing covers are red and it has nine black spots, one split by the mid-line. It is a common garden resident and can be observed on plant stems and foliage, where it feeds on aphids.

Harmonia axyridis, the Multi-coloured Asian Ladybird, is a small beetle approximately 8 mm in length. The body is very convex, glossy and hairless. The coloration is variable, and the neck shield bears black central markings of up to five spots and two curved lines frequently forming an M-shaped mark. The sides of the neck shield have yellowish-white oval spots. The wing covers vary between yellow, orange and red, sometimes with no black spots and sometimes with as many as 19 spots. This is an alien species which has received a lot of attention recently from local ecologists due to its voracious appetite and aggressive nature. It is an arboreal species rapidly spreading across South Africa and preying on all soft-bodied insects. When insect prey is scarce, it switches to plant material.

HETEROPTERA

Pentatomidae (shield bugs)

The gardener will come across a number of different species of Pentatomidae. They can all be recognised as shield bugs by the shape of their bodies and the nature of their wings. *Bagrada hilaris*, the Bagrada Bug, is one of the most interesting. Black with a few bright-orange or yellow spots and not quite 6 mm long, it feeds on all kinds of plants. The bugs only have an impact on young plants when congregated in sufficient numbers. The female lays her small, oval, cream-coloured eggs in the soil, which hatch into black bugs. The young bugs feed on the sap of the plant for about 12 days, rest and then moult to the second stage. Their colour changes and the second-stage nymph is gaily spotted in yellow and black. It feeds again for a fortnight and then casts its skin for the second time with the first sign of wings appearing on its back. In all, the skin is cast five times. After the fifth moult the adult stage is reached. The female deposits several batches of eggs before her ovaries are exhausted and she dies. The duration of the whole life cycle from the egg to the death of the adult is approximately 100 days. There are usually three generations in a year. Their development in winter is slower than in summer. Very little is known about the biology of the many species that occur in southern Africa. Many species are found on the ground at the roots of grasses or amongst low vegetation. These are rarely observed.

Acrosternum sp., a medium-sized bug, is approximately 10 mm in length. This species varies in colour from light to dark green. As in the case of all the Pentatominae, there is an enlarged triangular scutellum, or shield. This is a very adaptable species feeding on a large variety of plant species. It has also been recorded as feeding on vegetables and fruit and appears to target the new growth points of plants. The adults sometimes hibernate in compost heaps in urban gardens. It is a widespread species and can occur in relatively large numbers when climatic conditions are optimal.

Bagrada hilaris, the Bagrada Bug, is a small bug approximately 6 mm in length. This species is brightly coloured in orange, white and blackish blue, with an enlarged triangular scutellum present. It may occur in large numbers and feeds predominantly on the shoots of young plants. The adults are often observed mating and separate with difficulty when handled. The Bagrada Bug is common in urban gardens and in arid, semi-arid and forested areas throughout South Africa.

▲ Pentatomidae > Pentatominae > *Acrosternum* sp.

▼ Pentatomidae > Pentatominae > *Bagrada hilaris* (Bagrada Bug)

Agonoscelis versicoloratus is a medium-sized insect approximately 12 mm in length. The body is shield-like and tapers strongly towards the end. This species is light brown with a dark scutellum and a patch of cream on the forewings. It has characteristic banding in yellow and black on the exposed abdomen. They are common bugs, feeding on plants in most gardens and parks.

Coreidae (twig wilter bugs)

Some species, like *Carlisis wahlbergi*, can spray defensive secretions from both scent gland openings for a distance of up to 15 cm. One can often smell a tree harbouring twig wilter bugs from some distance, for they often congregate in thousands in the same tree at all stages in their development. A foul-smelling 'bug' liquid is excreted from glands found near the bases of the legs. If they are disturbed, they drop a rain of repugnant fluid, the smell of which makes humans feel ill and will burn the skin or eyes on contact. This fluid seems to be poisonous to other insects and is used as a defence mechanism to deter would-be predators, enabling the bug to escape. Anyone who has ever had a bug accidentally fly into their mouth would agree that these creatures taste the way they smell. Certain species are known to spray a defensive fluid when they are merely alarmed.

Carlisis wahlbergi, a large twig wilter bug, is approximately 25 mm in length. It is characteristically bulky and boldly marked with tan-and-black forewings

▲ Pentatomidae > Pentatominae > *Agonoscelis versicoloratus* (Sunflower Seed Bug)

▶ Coreidae > Coreinae > *Carlisis wahlbergi*

▼ Coreidae > Coreinae > *Carlisis wahlbergi* (nymph)

and orange underwings. The antennae are characteristically banded with white and black. In this species the hind legs are also considerably enlarged. This species often congregates in huge numbers on a single tree which can be smelled some distance away when the bugs inhabit it. It can spray a defensive secretion some 15 cm. It is common in bushveld areas and in urban gardens, where it appears to favour the Transvaal Gardenia *Gardenia volkensii*, but even when they are present in large numbers they do not damage the plant A community on a tree may include a number of generations, and adults with larvae of various sizes are also common.

Cletus sp., a bug belonging to the tribe Gonocerini is approximately 10 mm long. The body is elongated. Its long, light-brown antennae have clearly segmented tips. This species is light brown in colour with some mottling of darker brown on the neck shield. The neck shield has raised margins at the thorax, with dark spines on each side. The insects feed on a variety of different plant species and are common in the urban garden environment.

Alydidae (broad-headed bugs)

The Alydidae usually sit on the grasses on which they do not feed. They are associated with the Mimosa family and usually on *Acacia* spp. The nymphs and adults feed on the fallen seed pods found under these trees.

Mirperus jaculus, a medium-sized bug, is approximately 12 mm in length. It has a slender, very elongated body, a broad triangular head and enlarged hind legs. The bugs are greyish brown in colour and the membranous wings are dark when folded over the abdomen. These are extremely alert and active and extremely difficult to observe as they fly rapidly. They are predominantly feeders of legumes and other forb seeds and are common in a variety of habitats, including urban gardens.

HYMENOPTERA

Both from an economic and ecological perspective, the honey bee is of enormous value as a pollinator. Its pollinating role is so important that if they were to become extinct, over 65% of the trees in the Kruger National Park could ultimately become extinct. Interestingly, although it is called a 'honey' bee, no bee carries honey. It manufactures honey from nectar which it carries in its crop. It carries pollen, which is stored in its pollen baskets on its hind legs. This is changed into honey at the hive with the addition of special

▲ Coreidae > Coreinae > Gonocerini > *Cletus* sp.

▼ Alydidae > Alydinae > *Mirperus jaculus*

enzymes. Bees have barbs on their stinging organ to keep the sting in place. When a bee stings, this organ is torn from its body and the bee subsequently dies. In contrast, wasps and ants have a barbless sting and can therefore sting many times. Bees have a complex gregarious and hierarchical structure, with a colony working to feed and protect a central queen, whose responsibility is purely to lay eggs and increase the bee population of the hive. Bees usually swarm in spring when the hive becomes overpopulated. A mass of bees on a branch is a common sight during this process. These bees are said to be non-aggressive during the process as they are not protecting the hive. The swarm, with the queen in the middle, may move a number of times before settling in a suitable spot to produce a new hive. Time is of the essence, as during this period they have no food and flight is draining on the energy supply.

Apis mellifera, the well-known honey bee, is a regarded as one of the most important and beneficial of all insects. It is a medium-sized insect. The workers are approximately 13 mm in length and are black, with pale hairs on the head, thorax and base of the abdomen. The segments of the abdomen are a brownish orange, creating a banded effect. In some instances, the honey bee can be found in swarms of several thousand individuals. Their gregarious

▼ Apidae > *Apis mellifera* (Honey Bee)

structure is built around a single queen. They nest in various locations, in tree stumps, crevices and various other cavities, where they build wax combs in which eggs, larvae and honey are kept. This species is vital to the pollination of many plant species. It is distributed right across South Africa and is diverse in its selection of habitat.

MANTODEA

Mantids are sometimes regarded as gruesome because they eat their prey alive. However, they usually start with the head and any sign of a struggle is usually merely post death muscle contraction. There are records of green mantids feeding almost exclusively on cockroaches, yet they will feed on butterflies, moths, flies, crickets and even grasshoppers, which are substantially larger than themselves. Mantids have a voracious appetite, spending a great deal of time attacking and eating insects caught in a light trap. They often move with a swaying, almost rocking motion, while moving their triangular head from side to side, appearing to be alert to every move. Mantids rely more on their legs than their wings but, when disturbed, will readily fly a short distance. The female mantids are notorious for grabbing their male counterparts and consuming them while they are mating. From time to time, this does occur but it also depends on how well the female has eaten prior to the mating encounter. The unfortunate male continues to mate with her and sperm continues to be pumped into the female's body long after the male has been decapitated. Having a meal in such close proximity to the site where she lays her eggs could give the female an immediate protein boost, which assists the development of the eggs. Interestingly, when the numerous young hatch, they are reported to feed on their siblings. As a result few reach adulthood. This continues only until they are large enough to catch bigger prey and the survivors eventually disperse. The eggs are laid in an egg sac, an odd-looking, frothy ball, which hardens to protect the eggs she has laid. It can be attached to grass stalks, branches, windows or even kitchen utensils.

Sphodromantis gastrica, the Common Green Mantid, is a large insect about 55 mm in length, commonly found in a variety of habitats across South Africa. This mantid is green or fawn-coloured, usually with a white spot near the anterior corner of the forewing. The sides of the abdomen are normally a yellowish cream. There is considerable sexual dimorphism in the species and females are usually a lot fatter than the males. This is the commonest

▲ Mantidae > *Sphodromantis gastrica* (Common Green Mantid) (egg sac and nymph)

▼ Mantidae > *Sphodromantis gastrica* (Common Green Mantid)

▲ Tropiduchidae (unknown species)

▼ Syrphidae > *Phytomia natalensis* (hover fly)

▼ Syrphidae > *Eristalinus taeniops* (hover fly)

mantid in the southern African region, occurring in most habitats, including inside houses, where they may become relatively tame. They are carnivorous, feeding on a variety of other insects, which they actively hunt.

The egg sac of the Common Green Mantid is sponge-like with a series of vertical chambers along either side of a central 'keel', in which numerous eggs are laid. When the young hatch, they have been known to feed on their siblings, resulting in very few individuals surviving until adulthood. They usually remain at the site of the egg sac, in certain cases remaining in the vicinity throughout their adulthood. This obviously depends on the availability of food and environmental conditions.

HOMOPTERA (leaf hoppers)

This interesting leaf hopper (top left) belonging to the family Tropiduchidae has probably not been given a name yet. It is small, approximately 6 mm in length. It has a greyish head and brown thorax, legs and wing covers. Although small, its eyes are extremely prominent. It is a particularly alert and active little insect. As the name implies, they are excellent jumpers able to cover a remarkable distance for their size. They feed on plants and are common in relatively large numbers in most urban gardens.

DIPTERA (flies)

This large fly, *Phytomia natalensis*, is approximately 20 mm in length and mimics bees. The fly is yellow with two broad black bands on the abdomen. The black eyes are enormous, appearing to cover the entire head of the creature. The wings are clear and project backwards. This species is common in gardens, where it feeds on nectar and pollen. Like the honey bee, they are also important pollinators of flowers. The fly is quite a convincing bee mimic and at a glance looks like a stinging insect.

Eristalinus taeniops, a fly, is a convincing bee mimic. It is approximately 15 mm in length and has clear, backward-projecting wings. This species has a brown head and thorax with a yellow-and-black-banded abdomen. The eyes in this species are characteristic, large and striped. As in the case of other species within this group, the adults pollinate a number of different plants. The larvae, which are rat-tailed, live in a variety of aquatic habitats, feeding on bacteria and other debris. However, this does not mean that the species only occurs in wetlands. It is well distributed and common in urban gardens.

Eristalinus taeniops has also been observed in dry areas, where it may breed in small aquatic habitats, such as rainwater puddles. The larvae may also be observed living in buckets containing water.

LEPIDOPTERA

Mylothris agathina, the Common Dotted Border, is a large butterfly with a wingspan of approximately 60 mm. The males are creamy white, while the females are pale yellow in colour. Both sexes have yellow hind wings and pale forewings with an orange base and yellow area demarcated with black. The outer margins of the wings have sparse black dots. The undersides of the wings are lighter in colour and are also edged with black dots. The species is slow-flying and readily attracted to garden flowers. The elongated, cylindrical, barrel-shaped eggs are laid in batches on a variety of plants. This is a common garden species, which favours well-wooded gardens, where there are adequate patches of flowering plants.

Precis archesia, the attractive Garden Commodore, is a medium-sized butterfly with a wingspan of approximately 50 mm. The wings are earth-coloured with maroon bands lying parallel to the outer wing margins. The front margins of the forewings are suffused with blue. The species is a fast flyer, often settling with spread wings on the bare ground, rocks, wood or paths. Green bulb-shaped eggs with prominent glassy longitudinal ribs are laid singly. This common garden species favours rocky areas and the larvae feed on *Plectranthus* sp.

Hyalites eponina, the Small Orange Acraea, is a medium-sized butterfly with a wingspan of approximately 42 mm. In the male, the wings are orange with black borders dotted with orange. The forewings have a partial black border along the front margin and a black mark at the end of the forewing. In the female, the background colour of the wings varies from dark brown to grey. The dark tip to the forewings and wing borders is relatively constant in the species. The hind wings have a pale base. The species has a slow, low, fluttering flight and often settles on herbaceous vegetation. It often occurs in large numbers and may perch communally on long grass stalks. It flies year round but is more common during the summer months. It favours patches of long grass at the edges of wooded areas and savannahs and is also relatively common in urban gardens.

▲ Pieridae > Pierinae > *Mylothris agathina* (Common Dotted Border)

▼ Nymphalidae > Nymphalinae > *Precis archesia* (Garden Commodore)

▼ Nymphalidae > Heliconiinae > *Hyalites eponina* (Small Orange Acraea)

▲ Nymphalidae > Biblidinae > *Byblia ilithyia* (Spotted Joker)

▶ Nymphalidae > Heliconiinae > *Acraea horta* (Garden Acraea)

▼ Nymphalidae > Nymphalinae > *Vanessa cardui* (Painted Lady)

Byblia ilithyia, the Spotted Joker, is a medium-sized butterfly with a wingspan of approximately 45 mm. The wings are a rich orange boldly marked in black. The margins have a broad, black band enclosing a line of orange spots and a row of small black dots in the mid-hind wing. This species is a slow, low-flying butterfly, often attracted to faeces, mud and rotting fruit. The pointed, barrel-shaped, cream eggs have longitudinal rows of spines and are laid singly on the young shoots of plants within the family Euphorbiaceae. This widespread garden species is a regular visitor to gardens and parks in Johannesburg.

Vanessa cardui, the aggressive Painted Lady, is a medium-sized butterfly with a wingspan of approximately 45 mm. The wings are mostly orange in colour and the tips of the forewings are black with several white markings and a broken black bar across the orange area of the wing. The hind wings have three rows of black spots parallel to the outer margins. The undersides of the wings are cryptically marked for camouflage purposes. This species does not appear to be affected by cold climates and is often the only butterfly to be seen flying in the winter months. The pale-green, barrel-shaped eggs with their conspicuous glassy ribs are laid singly on a wide variety of plants. This common garden species is a regular visitor to wooded gardens and parks in Johannesburg.

Acraea horta, the Garden Acraea, is a medium-sized butterfly with a

wingspan of approximately 49 mm. The wings in the male are a reddish colour, while those of the female are reddish orange. The top parts of the forewings are characteristically translucent, with prominent veins and a small dark bar at the end of the forewing. The hind wings have several black dots and outer margins chequered with black. The pale, elongated eggs are laid in clusters on a variety of different plant species. This popular garden species is commonly found on flowering plants. It flies year round but more often from October to April. The species is common in parks and urban gardens in Johannesburg.

Pinacopteryx eriphia, the widespread Zebra White, is a medium-sized butterfly with a wingspan of approximately 50 mm. The wings are easily recognisable, black with creamy white bars and spots. Interestingly, in the dry season the black areas on the underside of the wings are replaced with brown or pinkish colours. It is a low-flying species, capable of considerable speed, and is regularly found near food plants and flowers. The spindle-shaped egg is laid in batches on *Boscia* sp. This species is found throughout the year in warmer climates but in Johannesburg gardens more often between October and April, depending on the rainfall.

Belenois creona, the African Common White, is a medium-sized butterfly with a wingspan of approximately 45 mm. The wings are creamy yellow, with characteristic broad, black-veined margins and sparse windows of pale yellow. The upper side is white with a dark border, and there is a distinctive spot in the upperside cell instead of a bar. This distinguishes it from the Brown-veined White. This fast-flying species is a regular visitor to food plants and flowers. The elongated egg, tapering towards the top, has vertical ribs and numerous smaller cross-ribs and is laid singly or in batches on *Boscia* sp. It is found throughout the year but more often between November and March in Johannesburg gardens.

Junonia oenone, the well-known Blue Pansy, is a medium-sized butterfly with a wingspan of approximately 45 mm. The wings are black with a broken white bar and three white spots across the tips. Each of the hind wings has a large blue spot and three broken white lines run parallel to the outer margins. The brownish underside is well camouflaged. The species is a fast flyer which is often observed darting to chase off an intruder, to return to the same spot later, its wings slowly opening and closing. The bulb-shaped, greenish-yellow eggs with prominent glassy ribs are laid singly. It is a territorial garden species favouring well-wooded gardens and parks.

▲ Pieridae > Pierinae > *Pinacopteryx eriphia* (Zebra White)

▼ Pieridae > Pierinae > *Belenois creona* (African Common White)

▼ Nymphalidae > Nymphalinae > *Junonia oenone* (Blue Pansy)

▲ Nymphalidae > Nymphalinae > *Junonia hierta* (Yellow Pansy)

Junonia hierta, the alluring Yellow Pansy, is a medium-sized butterfly with a wingspan of approximately 45 mm.. The wings are black with large yellow-and-orange patches on the wings. Each of the hind wins has a violet-blue spot. The greyish-brown underside provides good camouflage when the wings are closed. The species is a fast flyer, which favours damp sand and wet riverbanks. The bulb-shaped, greenish-yellow eggs with prominent glassy ribs are laid singly. This species flies year round but is more common between October and November, when it is a regular visitor to gardens and parks in Johannesburg.

Urban Gardens, Gauteng Province 137

Junonia orithya, the Eyed Pansy, is a medium-sized butterfly with a wingspan of approximately 42 mm. The forewings are black with two parallel white bars running across the tips. The lower window on the forewing is blue, stippled with eyes. The hind wings are predominantly blue in colour with two large reddish eye spots. The underside is cryptically marked for camouflage purposes. This widespread but uncommon species is a fast flyer, found in flat grassland and savannahs. It flies year round in warmer climates but is more often found between August and November.

Papilio demodocus, the Citrus Swallowtail, is a large butterfly with a wingspan of approximately 85 mm. The black wings are banded, spotted and speckled with yellow. The hind wings each have two black-, blue-and-orange eye spots. The larvae are well camouflaged resembling bird droppings. The large, spherical eggs are laid singly on a variety of different plant species. It is agile and fast-flying, readily hovering with quivering wings over flowers without settling. The Citrus Swallowtail is also often observed drinking at mud puddles or where creatures have urinated. It is a common garden butterfly widespread throughout South Africa, particularly in well wooded areas.

The striking Green-banded Swallowtail, *Papilio nireus*, is a large species with a wingspan of 80 mm in length. The butterfly is unmistakeable, black with iridescent silvery blue-green bands down the centre of each wing and with blue apical spots on the forewings, and a row of blue-green spots along the outer margin of the hind wings. The hind wings are without tails. This is a fast-flying butterfly which regularly visits flowers, where it appears to shiver as it feeds. The larvae feed on citrus and certain other indigenous

▲ Nymphalidae > Nymphalinae > *Junonia orithya* (Eyed Pansy)

▼ Papilionidae > *Papilio demodocus* (Citrus Swallowtail)

▼ Papilionidae > Papilioninae > *Papilio nireus* (Green-banded Swallowtail)

▲ Nymphalidae > Nymphalinae > *Hypolimnas misippus* (Common Diadem)

▼ Thomisidae > *Thomisus daradioides* (Yellow Flower Crab Spider)

plants, e.g. Small Knob Wood (*Zanthoxylum capense*). It is predominantly a bushveld and forest species, but has become common in urban areas, where it predominantly flies between November and February.

Hypolimnas misippus, the Common Diadem, is a large butterfly with a wingspan of approximately 70 mm. The black males are unmistakable, with circular, violet-ringed white patches on each wing and smaller white patches near the forewing. The female mimics the African Monarch and is only distinguishable from it by its hind wings, which have an open margin and a single black spot on the margin of the hind wing. The barrel-shaped, yellowish-green eggs are laid singly on a variety of different plant species. This is a common garden butterfly in warmer areas, particularly those that are well wooded.

ARACHNIDA

Thomisus daradioides, a strikingly colourful spider, is approximately 15 mm in length. The body is a bright canary yellow. The first two pairs of legs are characteristically longer and stronger than the last two and often have a series of well-developed spines. The male is generally smaller than the female. Interestingly, like chameleons Yellow Flower Crab Spiders can change their colour over several days to blend with the flower on which they are sitting. This species is an ambush hunter, sitting and waiting for its prey. Its venom acts quickly on insects, enabling itm to catch prey significantly larger than itself. They do not crush their prey but use their fangs to pierce tiny holes into the bodies of their victims through which they suck out the body fluids. Crab spiders are common in most urban gardens and are important in controlling insect numbers and thus maintaining a healthy, balanced environment.

Many people think that the Daddy Longlegs spider is terribly venomous. This is a worldwide urban legend: the truth is, they are completely harmless. However, they should not be confused with the deadly venomous Violin Spider. The web of the Daddy Longlegs is domed, with a central sheet and seemingly haphazard lines below and above. The spider's body is approximately 10 mm in length. The body is a grey-brown with darker symmetrical patterns on the dorsal side and yellow book lungs, or respiratory organ, on the ventral side of the slender, cylindrical abdomen. The legs are very long and slender, with characteristic banding at the joints. When removed from their nests, they run with a characteristic jaunty movement. They are often found in association with humans and are probably the most common group of spiders found in our homes. They often catch prey that is significantly larger than themselves.

◄ Pholcidae > *Smeringopus natalensis* (Daddy Longlegs) (female with eggs)

◄ Smeringopus natalensis (Daddy Longlegs) (female with eggs or with large moth)

East Coast, KwaZulu-Natal: landscape

◄ The sub-tropical east coast of South Africa with its lush coastal vegetation and high humidity provides ideal conditions for many forest-dwelling species.

The east coast of South Africa is characterised by lush tropical forests and coastal thickets, and is home to a vastly different world of invertebrates.

While the west coast waters are characterised by the upwelling of the cold, nutrient-rich waters of the Benguela Current, the east coast waters are warmed by the southward-flowing Agulhas Current. Along the south coast, there is an extensive mingling of the water masses. The currents influence the composition of plant communities and thus the invertebrate communities along this coastline. Temperatures are relatively stable though the distribution of species may be limited in the south by the colder climates. Besides the rainfall and temperature, important environmental parameters are the wind and salt spray. The tall trees in the forest may be severely stunted by high winds and salt damage, and this restricts the distribution of forests on exposed dunes. The east coast forests are restricted to the frost-free areas that have a mean annual rainfall greater than 700 mm and are more prevalent in the summer rainfall areas.

The alkaline and medium coarse-grained soils in these areas are deeply consolidated calcareous sands and there is generally little soil development. Common plant species occurring in these forests include the Coast Red Milkwood (*Mimusops caffra*), the Natal Guarri (*Euclea natalensis*), *Apodytes dimidiata*, *Sideroxylon inerme*, and Natal wild banana (*Strelizia nicolai*). Shrubs and scramblers are common and include species such as the Cat-thorn (*Scutia myrtina*), Numnum (*Carissa bispinosa*), Cross Berry (*Grewia occidentalis*) and Dragon tree (*Dracaena hookeriana*). Plants on the forest floor include Durban Grass (*Dactyloctenium australe*), *Cyperus albostriatus* and *Achyranthes aspera*. There are distinct strata of trees, shrubs and herbs in these forests.

142 A Landscape of Insects

The insects that live in these forests favour heat, humidity and thick vegetation. The milkwoods and Natal wild banana in the forests skirting the east coast are host to some uniquely beautiful and specialised species. These areas are usually windy and the insects take cover in the dense undergrowth and leaf litter. Species associated with wood and fungi are abundant. With the high moisture level in the air, woody material decomposes quickly, and nutrient cycling takes place more rapidly than in drier areas. Forests often appear dark and foreboding, even lifeless, but if one sits quietly for a while, one sees that there is life in every crevice. For some reason, the insect species living in forests appear more shy and elusive than their relatives in the western part of the country, This may be a result of their sheltered existence. Because of the humidity, the forests rarely burn, however, under extreme dry and hot conditions fires may occur and destroy the forest structure. The forest canopy is continuous, comprising mostly evergreen trees. Beneath it the vegetation is multi-layered. Herbaceous plants, particularly lianas and epiphytes like mosses and ferns, are a common feature.

The ground layer is very sparse as a result of the dense shade. On the edges of the forest there are a number of distinctive species which are able to tolerate fire. The forests, rich in plant diversity and micro-habitats, are also home to some fascinating and unique invertebrate species, as the higher rainfall and

▲ Unpolluted streams flow through these sub-tropical forests on the east coast.

▼ The rapid breakdown of plant material in these areas creates a suitable habitat for detritus-loving species of insects.

more stable climate encourage luxuriant forests and an abundance of insect and other invertebrate life.

The indiscriminate use of trees for firewood and timber puts these forests and their associated invertebrate communities at risk, as does the uncontrolled use of certain species for the muti trade. Other threats to the forests are the greatly increasing holiday traffic along parts of the eastern coastline and dune mining in some parts.

▲ Well-vegetated gorges and thick bush are characteristic features of this region of South Africa.

▲ Anthribinae > *Xylinades maculipes*

▼ Carabidae > Lebiinae > *Catascopus rufipes*

▼ Carabidae > Lebiinae > *Thyreopterus limbatus*

COLEOPTERA

Anthribidae (fungus weevils)

Xylinades maculipes, a large, slightly elongated fungus weevil, is approximately 20 mm in length. This strange-looking species is dark with pink patterns on the head, thorax and abdomen. The weevil has a relatively long snout and long, beaded antennae. The mandibles are well developed for feeding on plant material. It is a nocturnal species, which feeds on pollen, fungi, bark and rotting wood. The larvae develop in rotting wood and emerge as adults after an extended period of time, depending on climatic conditions. As can be expected from their food preferences, the fungus weevil favours subtropical forests, where the damp humid conditions provide a suitable habitat for them.

Carabidae (ground beetles)

The east coast Carabidae, a nocturnal family, tend to have functional wings. Ground beetles rely mainly on their speed and agility as a defence mechanism but they can bite when molested. Some species are wingless, while those with wings are at times attracted to artificial light in large numbers. *Catascopus rufipes* is largely arboreal and therefore better represented in the more luxuriant vegetation of the eastern part of the subcontinent. They have specialised claws on the undersides of their feet to enable them to walk on smooth leaf surfaces. Others have flattened bodies, allowing them to tunnel under bark and to creep into narrow crevices in wood. These beetles are often metallic green or black and with or without yellow markings on their wing covers.

Catascopus rufipes, a strikingly attractive ground beetle, is a small insect about 10 mm long. The head, thorax and wing covers are a smooth, brilliant metallic blue. The antennae are relatively long and forward-projecting. The legs are brick red and well adapted to running on wood and other decaying matter. *C. rufipes* is a nocturnal predator, inhabiting dense forest. They are regularly encountered in decomposing plant material, where they feed on a wide variety of small insects.

Thyreopterus limbatus, a ground beetle, is quite small, about 8 mm long. It is dark brown with reddish-brown legs. On close inspection, fine longitudinal grooves are found on the wing covers. The species is relatively common in subtropical forests with a high humidity and rainfall. It is a predator of other insects, especially those associated with decaying wood.

Chrysomelidae (leaf beetles)

Iscadida mniszechi, a large leaf beetle, is approximately 22 mm in length. The head, neck shield and wing covers are a purplish-brown colour. The neck shield is heavily pitted while the wing covers carry characteristic ventricles and bumps, especially towards the edges. The antennae are bead-like and project forwards. The adults are alert and active. This is a plant feeder in subtropical forest with dense foliage.

Sphaeratix latifrons, a medium-sized leaf beetle, is approximately 11 mm in length. It is bulbous in shape, the head being readily retracted into the neck shield when it is distressed. The head, neck shield and wing covers are a glossy black. The neck shield and wing covers are smooth. The adults feed on plants in subtropical and tropical forest with dense foliage.

▲ Chrysomelidae > Chrysomelinae > *Iscadida mniszechi*

▼ Chrysomelidae > Chrysomelinae > *Sphaeratix latifrons*

146 A Landscape of Insects

▲ Chrysomelidae > Cassidinae (including the former subfamily Hispinae) (spiny leaf beetle)

▼ Chrysomelidae > Galerucinae (formerly Alticinae) > *Toxaria* sp.

▶ Chrysomelidae > Cassidinae > *Cassida irregularis* (tortoise beetle)

▼ Chrysomelidae > Galerucinae > *Blepharida* sp. (flea beetle)

The spiny leaf beetles (top left) are small insects, approximately 5 mm in length. They are oblong in shape, greyish in colour, with long, pointed black spines on the neck shield and wing covers. Both the adults and their larvae are plant feeders, the larvae mining into the leaf structure and feeding while hidden in leaf tunnels. They are usually observed in densely foliaged trees in subtropical forests.

Toxaria sp. is a small insect, approximately 4 mm in length. The short, compact bodies are a matt black, with a bright orange-yellow head and neck shield. Both the adults and larvae are plant feeders and favour subtropical forests.

Blepharida sp., a flea beetle, is a small insect, approximately 8 mm in length. The head and neck shield are brown, and the wing covers are strongly punctured with small creamy-white and brown tile-like patches. The hind legs are strongly developed for jumping. The antennae are thread-like and forward-projecting. The adults sometimes congregate in large numbers at a suitable food source. They are plant feeders and widely distributed in South Africa.

Cassida irregularis, a tortoise beetle, is a medium-sized insect, approximately 11 mm in length with a broad, flattened body. The transparent wing covers, with gold and black 'tortoise markings', expand sideways, the corners extended on each side of the neck shield, giving the body an oval outline The head is hidden within the neck shield. An interesting fact is that these metallic

colours fade shortly after death. Tortoise beetles feed on plants in subtropical forest areas along the east coast of South Africa.

Tenebrionidae (darkling beetles)

The Lagriinae subfamily of the Tenebrionidae includes a number of interesting species, varying in size between 8 and 16 mm and with the head and neck shield much narrower than the body, which is often pear-shaped. The brown/black outer covering of the body is rather soft, with a dull metallic sheen. It may be bicoloured. The antennae are moderately long, often broadening gradually towards the tip. These species have well-developed defensive glands, through which they can exude a colourful substance. The Lagriinae are plant feeders and in the larval stage some *Lagria* species are known to defoliate certain plants.

The small tenebrionid beetle pictured here is approximately 10 mm in length and belongs to the subfamily Lagriinae. The head, neck shield, wing cover and legs are a slate-grey colour. The bulbous abdomen contrasts with the head and neck shield, which are a similar size, giving the insect an interesting appearance. The wing covers are well rounded. They are plant feeders and recorded on a variety of plant species in subtropical forests.

This medium-sized *Erycastus* sp. (middle right) is approximately 15 mm in length. It is a smooth species with a flattened, elongated shape. The head, neck shield, wing cover and legs are black. They are often found climbing tree trunks in subtropical forests, where they feed on a number of different organic materials.

Erycastus sp. (bottom right), a large tenebrionid beetle, is approximately 22 mm in length. The head, neck shield, wing cover and legs are black. The head and the neck shield are smooth, while the wing covers are longitudinally grooved. The wing covers are also sturdily rounded. They are found regularly on dead or living trees in well-wooded forests, where they feed on a variety of different organic materials.

Discolomatidae

The Discolomatidae are small, broadly ovate to oblong, evenly convex beetles. They have a dull body surface with a very dense covering of short, stiff and recumbent hairs, often forming a spotted or mottled colour pattern on the neck shield and the wing covers. The head is deeply set into the neck shield. The antennae are nine- or ten-segmented, ending in a single, large clubbed segment.

▲ Tenebrionidae > Lagriinae

▼ Tenebrionidae > *Erycastus* sp.

▼ Tenebrionidae > *Erycastus* sp.

▲ Discolomatidae > *Notiophygus* sp.

▼ Histeridae > *Hololepta scissoma* (hister beetle)

148 A Landscape of Insects

The majority of species within this family occur in forest regions, where the larvae and adults live on tree trunks and under bark. The larvae are broadly ovate, flattened and pigmented. They tend to be more active in wet weather and congregate under stones, grasses and leaf litter. Other species are found under various conditions in plant litter. The family is very well represented in South Africa by three genera and the extremely species-rich genus *Notiophygus*.

Notiophygus sp., a small beetle, is approximately 8mm, oval and convex in shape. It is covered in short, stiff, flat-lying hairs, giving it a velvety feel. This species is grey, with numerous black spots mirror-imaged on the head, neck shield and wing covers. The antennae end in a distinct club. They tend to be more active in wet weather, when the beetles congregate under stones, in grass and in leaf litter. They are predominantly a forest-dwelling species, feeding on bracket fungi and lichens.

Histeridae

The tribe Hololeptini of the subfamily Histerinae is represented in southern Africa by the genus *Hololepta*, which contains only a small number of species. These are unique on account of their extremely flat body shape and their inability to retract the head into the neck shield. They occur mainly beneath bark where they take shelter and await their prey. The adults and larvae of most species prey on the larvae of other insects, particularly those of flies, beetles and other small arthropods. Some species are strongly associated with fungi on whose spores they feed. Representatives of this subfamily are also commonly found in decaying plant and animal matter. The larvae are strongly elongated and cylindrical, with protruding mouth parts. Simple eyes in this subfamily are generally absent. The wing covers in the adults are considerably shortened and may have one or two abdominal segments exposed. The antennae are three- or four-segmented and the mandibles are characteristically symmetrical. The five-segmented legs are well developed.

Hololepta scissoma, a hister beetle, is a medium-sized insect, approximately 13 mm in length. The head, neck shield and wing covers are glossy black and the wing covers relatively shortened, exposing the abdomen. This species has characteristic mandibles, which project forwards and are used when preying on insects. It is found in decaying plant material and under bark in sub-tropical coastal forest on the east coast of South Africa.

Coccinellidae (ladybirds)

There are a number of ladybirds that do not feed on aphids. These less colourful species are recorded as feeding solely on plant matter, especially on the leaves of herbaceous plants. The 'vegetarian' ladybirds can generally be recognised by their rather dull, brick-red and black coloration, which is due to the layer of short, fine hairs or down covering the body. The vegetarian types, such as *Henosepilachna firma*, are common on the east coast of South Africa, their main host plants being members of the cucumber family (Cucurbitaceae). Both adults and larvae feed on leaves and fruit. The adults usually feed on the upper surface of the leaves while the larvae prefer the under surface. The larvae can be distinguished from other species of ladybirds by the presence of long branched spines on the dorsal and lateral surfaces.

Henosepilachna firma, a large ladybird, is approximately 8 mm in length and covered with short, pale down. The head and neck shield are black and smooth while the wing covers are brick red with a black margin running longitudinally to divide the body into two halves. Each wing cover bears a series of yellow patches. Unlike their predacious cousins, the adults and larvae of this species feed on herbaceous plants. The species is restricted to the east coastal forest regions of South Africa.

Afidenta capicola, a tiny ladybird, approximately 6 mm in length, is covered with pale down. The head, neck shield and the wing covers are a pinkish brown with a number of black dots. The adults and larvae of this species feed on herbaceous plants. This species is inhabits sub-tropical forests on the east coast of South Africa.

Harmonia vigintiduosignata, a chequered ladybird, is a small insect approximately 9 mm in length, smooth and yellowish in colour with a few black spots on the neck shield and wing covers. The head is characteristically hidden by the neck shield. The adults and larvae of this species have a voracious appetite consuming large numbers of soft-bodied insects. This species inhabits the eastern coastal regions of South Africa, where it is commonly observed on the stems and foliage of herbaceous vegetation.

Curculionidae (weevils)

Little information is available on the reproduction of South African Curculionidae, although most species lay their eggs inside plant tissues in slits or holes prepared by using the snout, which can be extremely well developed

▲ Coccinellidae > *Henosepilachna firma* (Red Herbivorous Ladybird)

▼ Coccinellidae > *Afidenta capicola*

▼ Coccinellidae > *Harmonia vigintiduosignata* (Chequered Ladybird)

▲ Curculionidae > Hyperinae > Cepurini > *Frontodes brevicornis*

in the female. The larvae of weevils are pale, crescent or wedge-shaped, fleshy grubs with a well–hardened, retractable head. They are always legless but have swellings with stiff bristles on the thoracic segments in some species. The majority of larvae develop inside the tissue of roots, stems, flowers, leaves, fruits, seeds, bulbs or tubers of living plants, and some may cause galls on the plants. Bacteria have been found in some weevil larvae and these appear to regulate their vitamin balance. Pupation takes place either directly in the host plant in special pupal chambers or in parchment like cocoons in plants or directly in the soil. The females of certain species apparently drop their eggs at random while feeding, and their larvae feed on roots or decaying vegetable matter in the soil.

Frontodes brevicornis, a small, buff-coloured, weevil, is approximately 6 mm in length. The body is stout and rounded, with a narrow curved snout. The antennae are elbowed and thread-like. This species is shaded and blotched

East Coast, KwaZulu-Natal 151

with white. It is a plant feeder and inhabits coastal subtropical forests.

Blosyrus saevus, a medium-sized weevil, is approximately 16 mm in length. Its body is stout with a well-rounded abdomen and broad snout. The abdomen is punctured and has deep grooves running longitudinally. The antennae are shorter than the head and the neck shield. This species is a dull black with grey legs. It is a ground-dwelling plant feeder, which inhabits a diverse array of habitats.

Caloecus pontis, a small weevil, is approximately 10 mm in length. The body is elongated and oval, with a curved snout equal in length to the head. The species is light brown with darker brown wing covers. It is characterised by two longitudinal cream stripes on the neck shield and wing covers. It feeds on the trees in subtropical coastal forests.

Ellimenistes laesicollis, a small weevil, is approximately 5 mm in length. Its body is round with a broad snout. The species is a bluish white in colour and has a dark line running from the tip of the snout to the end of the wing covers and is characterised by numerous longitudinal grooves on the wing covers. It is a plant feeder which inhabits a wide range of habitats.

Sciobius bistrigicollis, a medium-sized weevil, is approximately 10 mm in

▲ Curculionidae > Entiminae > Blosyrini > *Blosyrus saevus*

▼ Curculionidae > Entiminae > Tanymecini > *Caloecus pontis*

◄ Curculionidae > Entiminae > Otiorhychini > *Sciobius bistrigicollis*

▼ Curculionidae > Entiminae > Oosomini > *Ellimenistes laesicollis*

length. Its body is stout with a broad snout. The head, neck shield and wing covers are dark brown with lighter-brown underparts. The antennae are elbowed and thread-like. It is a plant feeder which inhabits subtropical forests.

Erotylidae (pleasing fungus beetles)

Erotylidae, a striking family of beetles, are not well known as they are quite reticent and unobtrusive. They can vary from small to large but are usually between 5 and 15 mm long. They are an even oval shape, usually hairless, and often found with patterns of black and red and yellow. The head is deeply set into the neck shield. The eleven-segmented antennae are quite short with a broad, compact and flattened three-segmented club at the end. The last segment of the maxillary is usually enlarged and often hatchet-shaped. The wing covers always extend over the abdomen. The erotylid beetles are associated with the fruiting bodies of bracket fungi and most frequently with those growing on tree trunks and branches. Some of the larvae are external feeders; others tunnel into the fungi and are lightly pigmented. The adults of some species may be attracted to artificial light at night. These beetles are usually found in damp, humid climates where they may be observed in cracks in wood or in the breaks of branches where the wood is decaying.

Megalodacne sp., a medium-sized fungus beetle, is approximately 12 mm long. The body is a shiny black oval, with bright-orange patterns mirror-imaged on the wing covers. They are found on the fruiting bodies of fungi, especially bracket fungi, growing on tree stumps and logs in coastal forest areas. Adults regularly spend the winter months under bark, often in small groups. The larvae, which are heavily chitinised, are also found on fungi and feed on them too.

▲ Erotylidae > Erotylinae > Megalodacnini > *Megalodacne* sp. (Red-banded Fungus Beetle)

Elateridae (click beetles)

The beetles falling within the family Elateridae are mostly crepuscular* or nocturnal creatures and only a few species are diurnal. The adult beetles are found on foliage and flowers or in worm-eaten wood, under bark, in recently killed or living trees. Some species are carnivorous while others are herbivorous, eating leaves, flowers or pollen. The male, and to a much lesser extent the female, of some species are attracted to light. The larvae of some of these beetles are found in decaying wood, in compost or in the soil. The smooth, shining, tough-skinned, yellow grubs are popularly known as wire

worms. The larvae of click beetles are found in the soil feeding on the crowns and lower parts of the stem of many plants. Although these beetles mostly feed on plants, the larvae of many genera are reported to be predacious. Some species occurring in wood appear to prey upon other insects feeding on wood, while those in the soil hunt insect larvae and small worms. The fully mature larvae, when living in the soil or in compost, build an earthen cell in which they pupate. The life cycle of these beetles may take as long as five years to complete.

The small click beetle (top right) is approximately 9 mm in length. The body is brown with pale, grey-brown down, which rubs off to leave bare patches. The antennae are thread-like. They are nocturnal feeders on pollen, petals and foliage. This species inhabits subtropical forests and savannahs.

Cetoniinae (fruit chafers)

This attractive fruit chafer (right middle) is a specialised forest dweller and fairly common in the forests of KwaZulu-Natal. It thrives in humid environments and can be seen flying beneath the tree canopy in the forest undergrowth. By doing so, it avoids the strong winds that are often prevalent in these areas. The biology of this species is uncertain; it is assumed that the larvae probably feed on compost. This species is light brown, stippled with black. The wings covers are flattened, with longitudinal ridges running from the neck shield. The species is regularly found on fruit and flowering plants in the forest and is readily attracted to fermenting fruit. It commonly flies between November and December but may be collected as late as April.

These beetles are a subspecies of the common Brown and Yellow Fruit Chafer *Pachnoda sinuata*. The subspecies *Pachnoda sinuata* subsp. *sinuata* is a similar size, approximately 24 mm in length. The solid dark-brown central area in the latter species is broken by a pattern of yellow markings in the former. This subspecies also feeds on a variety of different flowers and fruit. It is restricted to the subtropical east coast of South Africa.

Cerambycidae (longhorn beetles)

Copulation in cerambycid beetles usually occurs on the branches of the main stem of the host plant. Before laying her eggs, the adult female looks for a suitable site on the plant. The range of host plants is greatest in the species which lays its eggs on freshly cut, slightly damaged or decaying wood. The

▲ *Elateridae* (click beetle)

▼ Scarabaeidae > Cetoniini > *Porphyronota maculatissima*

▼ Scarabaeidae > Cetoniinae > *Pachnoda sinuata* subsp. *sinuata*

▲ Cerambycidae > Lamiinae > *Sumelis occidentalis*

▼ Cerambycidae > Lamiinae > *Nupserha apicalis*

species that lays its eggs on healthy living wood only is considerably restricted in range, often to a single genus of tree. The eggs are usually laid in cracks or fissures in bark, often in compact batches of six or more. In certain species, the female makes a girdle of small branches or twigs with her mandibles before depositing the eggs beyond the girdle. This apparently slows down the flow of the plant sap and may cause the stem to break off in time, providing suitable conditions for larval development. The species that pupate and hatch in the late summer or autumn remain in their pupal cells until the following spring before they emerge. Such species have an adult life span of at least seven months. Those species that pupate in the spring emerge about a week after hatching and seldom live for more than a month to six weeks. The males usually hatch before the females and their lifespan is often several days shorter than that of the females. Certain longhorn beetles belonging to the subfamily Lamiinae resemble the group of beetles that other creatures find repugnant, such as the Lycidae, which provide the models for other beetles to mimic.

Sumelis occidentalis, a small longhorn beetle, is approximately 5 mm in length. Its body is brown with light-brown mottling on the wing covers. The antennae are long and evenly banded in brown and white. This species is relatively uncommon but inhabits well-wooded areas in subtropical coastal forests.

In the insect world some non-poisonous species evolve to resemble a distasteful or poisonous species, which makes predators respect them. This brightly coloured longhorn beetle is mimicking a lycid beetle, its bright colours suggesting that it is poisonous and should be left alone. *Nupserha apicalis*, a small but brightly coloured longhorn beetle, is approximately 10 mm in length. Its body is orange, its head and legs are black and there is a black band across the end of the wing covers. The antennae are long and black. The neck shield has two characteristic black spots. This species is a cerambycid that possibly mimics a lycid, which is distasteful to predators. It is not observed regularly as it inhabits well-wooded areas in subtropical coastal forests.

Brentidae (primitive weevils)

The Brentidae fauna of South Africa are closely related to the tropical Brentidae fauna of Central Africa. They are more diverse and abundant on the eastern subtropical side of the subcontinent. Even though the diversity of this group diminishes rapidly southwards, the members of this family are often found

in wooded areas in our region. The Brentidae are narrow, elongated beetles, which occur predominantly in well-wooded tropical and subtropical regions. They have slender heads with an elongated, beak-like, piercing and sucking mouth parts. The back of the head is constricted to form a definite neck approximately equal in length to the neck shield. The thread-like antennae may be slightly widened at the tips but they are never clubbed. South African brentids vary in colour from black to reddish brown, and their wing covers sometimes bear irregular lighter markings. The body surface is often deeply grooved and pitted.

This unknown Brentidae species (top right) is an uncommon inhabitant of subtropical forests. It is a large beetle, in the region of 22 mm. Its narrow body is parallel-sided and elongated, with a slightly elongated snout on its head. The antennae are forward-projecting and beaded. This species is purplish black in colour. The wing covers are deeply grooved longitudinally with two black marks on their lower section. The females of the species drill holes into wood in which they lay their eggs. They are omnivores and feed on fungi, sap and woodboring insects.

HETEROPTERA

Pentatomidae (shield bugs)

The majority of Pentatomidae feed on several different indigenous veld plants. Certain species also feed on indigenous fruits and make small punctures to draw out the nutrients. The area around the puncture fails to develop and the depression remains, marking the site. The small hard lumps that develop just below the skin clearly indicate that the fruit has been spoiled. In some cases, gum oozes from the punctures and the fruit may drop off prematurely. The tiny holes made by the bugs serve as a means of entry for other organisms. Certain Pentatomidae, such as the Asopinae, prey on soft-bodied insects such as butterflies and beetle larvae. Their legs are not specially adapted for seizing prey and they rely on the paralysing effect of their saliva, which they inject into their prey before seizing it.

Carbula blanda is a medium-sized shield bug approximately 7 mm in length. The body is brown in colour with a wavy cream pattern on the neck shield. The neck shield also has a light-brown edge above the head. Another diagnostic feature of this creature is the presence of two small white dots on the scutellum. These insects feed on plants in well-wooded areas.

▲ Brentidae

▼ Pentatomidae > Pentatominae > *Carbula blanda*

156 A Landscape of Insects

Aspavia albidomaculata, a small, unusual-looking shield bug, is about 8 mm long. The body is brown with characteristic sharp spines on the margins of the thorax. The scutellum is brown with three white spots forming an upside-down triangle with the two large spots at the base. They are common plant feeders and frequent grasses and forbs.

Caura rufiventris is a chunky, medium-sized, shield bug approximately 13 mm in length. The upper body is matt black, while the underparts are a striking reddish orange, with reddish-orange and black banding on exposed margins of the abdomen. The upper parts of the legs are also reddish orange but the lower legs are black. These insects feed on plants and are widespread in savannah regions of South Africa..

Boerias pavida is a flattened, medium-sized shield bug approximately 12 mm in length. The entire body is a dull brown but there are four small, black dots on the neck shield. The forewings have two longitudinal ridges near their edges. The yellowish antennae are long with some banding towards the tips. These bugs feed on plants in subtropical forests.

▲ Pentatomidae > Pentatominae > *Aspavia albidomaculata*

▶ Pentatomidae > Pentatominae > *Boerias pavida*

▼ Pentatomidae > Pentatominae > *Caura rufiventris*

Coreidae (twig wilters)

The Coreidae all feed on plants, injecting their saliva into the young shoots and causing them to wilt and die back. *Hydara tenuicornis* is an uncommon twig wilter in KwaZulu-Natal that feeds on coastal flowering plants near the ground. It has been recorded as feeding on a number of different plant species. *Dasynus nigromarginatus* is presumed to be scarce in this province but may be more common than initially thought. Both species have hard, sharp rostrums, or beaks. Certain species do not seem to cause wilting in their host plants. Sometimes large populations weighing a number of kilograms have been recorded on medium-sized shrubs. As a result of the infestation, the shrubs fail to flower. The horn-like projections on either side of the prothorax are common in the species. Some of the Coreidae in southern Africa feed on a variety of different plant species.

Dasynus nigromarginatus, a medium-sized bug, is approximately 12 mm in length. The green body is elongated and it has brown membranous wings. The neck shield is a greenish brown. This species has one white band clearly visible near the end of the antennae. It is uncommon in forests on the east coast of South Africa and is not often collected by enthusiasts as they are exceptionally alert bugs. It is an arboreal species, feeding on the fruit high up in trees.

Hydara tenuicornis is a medium-sized bug, approximately 10 mm in length. The light-brown body is elongated, with fine mottling on the forewings. Two projections on the neck shield resemble an upturned collar. The antennae are long and jointed with black tips. This species is found in subtropical forests on the east coast of South Africa.

Reduviidae (assassin bugs)

Many species of Reduviidae are able to produce audible sound by rubbing a plectrum-like device, situated at the tip of the rostrum, across a narrow groove or striation between the front legs. The sound they produce may allow them to recognise like species. In southern Africa, some species are known to bite humans in self-defence when squeezed or handled causing a burning numbness which may last for several hours and make the arm and leg glands swell, while allergic reactions and secondary infections may also occur. Interestingly, certain species of Reduviidae appear to show a modicum of parental care in that the male guards the eggs and larvae up to a few days after they hatch.

▲ Coreidae > Coreinae > *Dasynus nigromarginatus*

▼ Coreidae > Coreinae > *Hydara tenuicornis*

158 A Landscape of Insects

Nagusta sp, is a medium-sized assassin bug approximately 12 mm in length. The body is uniformly dark brown, with dark and light- brown banding on the legs and antennae. The triangular scutellum has a light-brown pattern indicative of the species. This bug catches other insects, ambushing them in the foliage, and is usually found on leaves waiting for its prey. It is found regularly in subtropical coastal vegetation.

Pyrrhocoridae (cotton stainers)

The Pyrrhocoridae are brightly coloured, medium-sized bugs (5–20 mm) They are characterised by their colour and also by scent gland openings that are present but not prominent. All the spiracles are on the lower surface of the body; the three trichobothria on the fifth sternum that detect airborne vibrations are grouped together in front of the spiracle. On the sixth sternum one is found near the front border in front of the spiracle and the other two are behind the spiracle. In several genera the lower abdominal seam between segments 3, 4, 5 and 6 are produced forward and sideways and sometimes do not reach the lateral margins. The Pyrrhocoridae are mostly winged but some wingless genera are also known.

Antilochus nigrocruciatus, an attractive cotton stainer about 14 mm long,

▲ Reduviidae > Harpactorinae > *Nagusta* sp.

▼ Pyrrhocoridae > *Antilochus nigrocruciatus*

has an elongated body. It is very boldly marked in black and orange. It feeds on plant material, especially seeds and pods. It is a gregarious species and may form small groups at a suitable feeding source.

Cenaeus pectoralis, a medium-sized bug approximately 14 mm long, is unmistakable with its distinctive markings. It has a light-brown body, a black neck shield and scutellum, with a clear white band across the neck shield. The larvae are a similar shape but have a light-pink abdomen with three distinctive spots and reduced black wing covers and neck shield. They feed on plant material, especially seeds and pods. This is a common species in the subtropical coastal forest regions of South Africa.

Cydnidae (burrowing bugs)

The Cydnidae are small to medium-sized (4–15 mm) bugs, ovoid and shiny black or brown in colour. They are characterised by a comb of closely set, stiff bristles at the tips of the mid- and hind legs and by multi-haired tibiae. They also often bear bristles or spines along the margins of the head and neck shield. The spiracle on the second abdominal segment is placed in the membranous front strip of the sternite, or hard cover on the underside, and is normally hidden by the exoskeletal plate. They are mostly found under stones, dead leaves and other vegetable matter or at the bases of plants just beneath the surface of the soil. Certain species are also attracted in great numbers to artificial light.

Biologically the Cydnidae can be separated into two groups. The Sehirinae, consisting of a few genera, belong to the first group, the adults and nymphs of which feed on plant parts growing above the ground. The rest of the Cydninae prefer the roots and other underground parts of plants and may be found as deep as two metres below the surface of the soil. The females usually lay their eggs in a hole or cracks in the soil and are reported to guard their eggs until they hatch.

Macroscytus sp., a burrowing bug, is small with an approximate length of 12 mm. The oval body of this species is shiny black and it has light, membranous wings. The thorax is smooth and particularly large. The hind legs are spiny. This species feeds on the leaves, stems and roots of plants and is well distributed across a variety of habitats in South Africa. It is strongly attracted to artificial light and may swarm in large numbers. They also secrete a repugnant smelling and tasting substance from their thoracic glands.

▲ Pyrrhocoridae > *Cenaeus pectoralis*

▼ Pyrrhocoridae > *Cenaeus pectoralis* (nymph)

▼ Cydnidae > Cydninae > *Macroscytus* sp.

▲ Tessaratomidae > *Piezosternum calidum*

▼ Plataspidae > *Brachyplatys testudonigra* (pill bug)

Tessaratomidae (inflated stink bugs)

This small family is characterised by the exposed spiracle on the second abdominal segment which is removed from the back margin of the exoskeletal plate. Representatives of this group are usually large (15–30 mm) and are found in green to yellow-bronze colours. The insects have a relatively short scutellum, which stops short of the middle of the abdomen. The abdomen is often expanded laterally so that the wing covers do not cover it completely. The rostrum or beak-like extension is usually short, barely reaching the level of the first segment of the leg. The lower legs are usually segmented into four but may be two-segmented in certain species. Tessaratomids are all plant feeders but very little else is known about the biology of the southern African species. They are collected and eaten in certain areas by the local inhabitants, who either cook them or eat them raw.

Piezosternum calidum, the inflated stink bug, is a medium-sized insect approximately 20 mm in length. This is a particularly attractive species with a dark blue-green upper body, lower legs and antennae and bright-orange underparts. The body is distinctly flattened, with an expanded abdomen and a short thorax that does not cover the wings. These bugs also have a very short beak which does not reach the end of the front legs. They feed on the sap of forest trees and shrubs.

Plataspidae (pill bugs)

The Plataspidae are small to medium-sized bugs that could easily be mistaken for beetles. They are dull-coloured insects, more or less roundly ovate, convex and shiny on the upper side and flattened on the underside. They have a greatly enlarged scutellum covering all of the abdomen and wing covers except for a small area at the base. The wing covers are much longer than the abdomen and are folded between the membranes in order to fit beneath the scutellum.

The Plataspidae slightly resemble the shield-backed bugs but can be distinguished from them by the long wing covers and because they are shiny, more convex and rounded in outline.. In several species, the male and female may look different. The males of some have outgrowths on the head. Very little is known about the biology of the South African species. They are plant feeders and prefer plants belonging to the Leguminosae as hosts.

Brachyplatys testudonigra is a small pill bug approximately 8 mm in length. The glossy black body has an armour-plated appearance. This species is oval and very round, convex on the upper side and flattened on the underside. The

East Coast, KwaZulu-Natal 161

scutellum is large, almost covering the entire abdomen and wing covers. It is a small species and relatively common in KwaZulu-Natal but as a result of its size is easily overlooked. It is thought to feed on the foliage of forest trees and shrubs.

LEPIDOPTERA

Bycyclus anynana anynana, the Squinting Bush Brown, is a small, sandy-brown butterfly approximately 45 mm long. It has an off-centre eye in the forewing and a series of small eyes and a wavy cream line on the underside of the wings. This butterfly is common and relatively easy to approach. They are extremely well-camouflaged butterflies, resembling dead leaves. The larvae feed on forest grasses. This species inhabits the wooded kloofs and subtropical coastal forests on the east coast of South Africa.

The Pearl Emperor is a large, beautiful butterfly, with a wingspan of around 75 mm. Its orange-and-pearl wing coloration is conspicuous against foliage in flight. The underside is cryptic, coloured a golden brown suffused

▲ Nymphalidae > Satyrinae > *Bycyclus anynana anynana* (Squinting Bush Brown)

▼ Nymphalidae > Charaxinae > *Charaxes varanes varanes* (Pearl Emperor)

▲ Pamphagidae > *Stolliana* sp.

▼ Cercopidae > *Locris areata*

with darker brown. It is slow-flying, bobbing in and out of the foliage. The larvae are green, with medial horns on the head shield that are longer than those of the lateral ones. It is a relatively common species in the warmer, subtropical parts of South Africa, where it may be observed all year round.

ORTHOPTERA

The genus *Stolliana* is a group of medium to large-sized grasshoppers. They are greyish brown in colour with clear segmental divisions. A slightly raised neck shield and cylindrical antennae are characteristic. The male has dark-brown wings and a black bar on the hardened forewing and flies vigorously when disturbed. The female is wingless. This species inhabits rocky areas in forested environments.

HOMOPTERA

Locris areata is very closely related to the Red-spotted Spittle Bug, *L. arithmetica*, which is found further inland and away from the east coast of South Africa. This eye-catching spittle bug has a bright-orange head and thorax, with sparse black markings, and red wings. It is a relatively common insect in KwaZulu-Natal and is often found in small groups. The nymphs are associated with their 'cuckoo spit' froth.

ARACHNIDA

Caerostris sexcuspidata, a bark spider, is a medium-sized spider approximately 15 mm in length. The colours of the spider imitate those of bark and lichen. The legs are pale and hairy with reddish bands. The abdomen is dark with four characteristic white spots. When in the web, the spider positions itself head-down at the hub. This species of nocturnal spider is known to make its orb web usually during the night and then remove it by morning. It is relatively common in well-sheltered, forested areas in KwaZulu-Natal.

Gasteracantha sanguinolenta, a kite spider, is small, approximately 8 mm in length. The characteristic orb web is often positioned quite high above the ground. The pink-and-white body is hard, with thorny pink projections. The spider sits head-down at the hub of the web during the day. The male is recorded to be a lot smaller than the female while the female is not as brightly coloured as the male and lacks the thorny projections. The web is distinctive

with closely placed radii and an open hub. This species is well distributed and common over paths in the forested areas of KwaZulu-Natal.

CRUSTACEA

Woodlice are brown, flattened, alien-looking crustaceans approximately 15 mm in length. They live under stones in cool, damp locations and feed on decaying wood and fungi that grow on dead wood. Females carry the eggs attached to the underside of the body until the young hatch. One or two generations are born each year. Adults live for up to two years. They are harmless but can be considered objectionable in large numbers. These are relatively well represented in the forests of KwaZulu-Natal.

▲ Araneidae > *Caerostris sexcuspidata* (bark spider)

◄ Araneidae > *Gasteracantha sanguinolenta* (kite spider)

▼ Isopoda (woodlouse)

Kimberley, Northern Cape: landscape

◄ Open acacia savannah, with wide-open vistas and Camelthorn trees dotting the veld, is one of the beautiful characteristics of the areas surrounding Kimberley.

Kimberley is unique in that it has mixed Karoo and Kalahari influences in the different vegetation communities found in the area. It is an arid area with a complexity of strikingly different habitats, ranging from kalk pans through to Vaal River thickets. The area is classified as Kalahari Thornveld invaded by Karoo, while an area along the banks of the Vaal River consists of the False Orange River Broken Veld. The mountainous landscape varies from upper- and lower-lying valleys and drainage lines together with steep to moderately steep mountain slopes and relatively flat to undulating plateaux lying at an altitude from 1050 m to 1187 m above sea level. There are outcrops of the andesitic lavas of the Ventersdorp Supergroup, which mainly occur as rocky hills (koppies), with outliers of dolomite (Transvaal Sequence). Some low, flat ridges of quartzite (Ventersdorp Supergroup) are also found in the area. The northern sections are mainly underlaid by Aeolian sand with surface limestone and sometimes by alluvial gravels of Tertiary to Recent age covering Dwyka tillite.

During the 1920s, relatively rich diamond deposits were found in the ancient gravel-filled watercourses of the Vaal River. The soil type varies from deep (> 0.8 m) red-brown and yellow-brown sands (Hutton and Clovelly soil forms) to shallow (< 0.3 m) and stony (Mispah, Prieska and Kimberley soil forms) while the soil on the western floodplain is moderately deep (0.3–0.8 m) and clayey (Valsrivier and Swartland soil forms).

The banks of the Vaal River consist of clay silt (Oakleaf soil form) while the soil of the old diamond diggings is very disturbed. The soil of the pans is moderately deep and very clayey, with a 35% clay content, and is of the Arcadia, Rensburg and Willowbrook soil forms. The rainfall, mainly during

▲ Calcrete pans in the low-lying areas provide an excellent habitat for insects hiding among the shrublands.

▼ This area lies at the eastern edge of the Kalahari system, which is indicated by the characteristic red sands.

▼ Due to a good average rainfall and nutritious soils, the open plains support a strong grass system.

summer (January to March), is erratic and can vary between as high as 700 mm per year and as low as 300 mm (July to June).

The temperature is less erratic than the rainfall, with cold winter temperatures (coldest months June–July) as low as –4°C while the summer temperatures (warmest months December–January) is as high as 44°C. Frost can occur: its earliest recorded appearance is 27 April and the latest date 23 September, and it can last as long as 107 days.

The *Schmidtia pappophoroides–Themeda triandra* Grassland is characterised by diagnostic species such as the grasses *Themeda triandra* and *Pogonarthia squarrosa*, the forbs *Elephanthorrhiza elephantina*, *Rhynchosia nervosa* and *Plinthus sericeus* and the geophyte *Moraea verecunda*. The poorly developed tree stratum is 5 m tall, with a canopy cover of 1%. The sparsely distributed *Acacia erioloba* and *Acacia tortilis* are the prominent trees in this community. The shrub stratum, with species such as *Grewia flava* and *Tarchonanthus camphoratus*, is poorly developed with a canopy cover of 1% and a height of 2 m. The herbaceous stratum is well developed, about 0.3 m tall with a canopy cover of 68%. The dominant grasses are *Schmidtia pappophoroides*, *Eragrostis lehmanniana*, *Stipagrostis uniplumis* and *Aristida congesta*, while the most prominent forb is *Hermannia tomentosa*.

The diagnostic species for this Shrubland are the tree *Boscia albitrunca*, the shrubs *Phaeoptilum spinosum* and *Asparagus laricinus* and the forbs *Barleria rigida*, *Blepharis furcata* and *Phyllanthus parvulus* as well as the grass species *Aristida meridionalis*. Only two tree species are prominent in this community, namely *Boscia albitrunca* and *Acacia tortilis*. Except for the grass species *Aristida meridionalis*, *A. congesta* subsp. *barbicollis* and *Eragrostis lehmanniana*, no other grass or forb species are prominent in this Shrubland. The physiognomy of this shrubland sometimes changes to impenetrable *Acacia tortilis – A. mellifera* thickets.

The *Acacia mellifera* Shrubland is strongly correlated with the mountainous areas in the study area. The total size of the community is 5292 ha and is distributed throughout the study area. The soil–rock complex consists of rock and Mispah soil form, with outcrops of andesitic lava and quartzite occurring in the community. Rocks and stones cover more than 80% of the soil surface, while the soil is shallow and well drained.

In general, the vegetation of the area is characterised by the presence, and in some areas the dominance, of the shrub *Tarchonanthus camphoratus* and the

grass species *Eragrostis lehmanniana*. The riverine vegetation has a distinct species composition, which is different from the pan vegetation.

The Kimberley Thorn Bushveld receives a summer rainfall between 400 and 500 mm. Temperatures are extreme, ranging between –8 °C and 41°C, with an average of 19°C. Rain sometimes falls in autumn but the winters are very dry.

The soils are predominantly deep, sandy to loamy, underlaid by calcrete, an accumulation in the soil of a layer of calcium carbonate and other alkaline minerals just below the surface. The geology and soils vary from andesitic lavas of the Allanridge Formation in the north and west to the fine-grained sediments of the Karoo Supergroup in the south and east. Deep sandy to loamy soils are found on slightly undulating sandy plains.

Kimberley is situated in the transition zone at the junction of three ecosystems, namely the Karoo, Grassland and Kalahari Thornveld systems.

▲ Good summer rains fill up shallow pans, providing breeding habitat for many animal species, including insects.

168 A Landscape of Insects

The area is characterised by some beautiful woodlands of Umbrella Thorn (*Acacia tortilis*) and other plants typical of the Kimberley Thorn Bushveld of the Savannah Biome. The landscape undulates with ridges and depressions with numerous temporary pans. The grassy plains are scattered with tall Camel Thorn trees (*Acacia erioloba*) and the smaller Wild Raisin bush (*Grewia flava*). The hills and ridges are covered with Lavender Fever Berry (*Croton gratissimus*) and Black Thorn (*Acacia mellifera*), which gradually merge with the Sweet Thorn (*Acacia karroo*) along the Vaal River. The harsh climate and low average rainfall result in a burst of insect life during the rainy season.

This area is generally an open savannah, with Umbrella Thorn (*Acacia tortilis*) and Camel Thorn (*Acacia erioloba*) being the dominant trees and scattered specimens of the Shepherd Tree (*Boscia albitrunca*) and Sweet Thorn (*Acacia karroo*) dotted about. The shrub layer is moderately developed with Camphor Tree (*Tarchonanthus camphoratus*), Black Thorn (*Acacia mellifera*), Wild Raisin (*Grewia flava*) and *Lycium hirsutum*. The grass layer is fairly well

▲ Water-filled pans induce a growth of vegetation around their edges, providing breeding cover and habitat for birds and insects.

▶ The Camelthorn tree, *Acacia erioloba*, is the dominant tree in this area and its large shape and size provides shelter for many mammal and bird species.

▼ The sandy, open plains provide good habitat for aardvark, whose burrow can be seen in this image.

developed and grasses such as Redgrass (*Themeda triandra*), the Common Nine-awn Grass (*Enneapogon cenchroides*), Lehmann's Lovegrass (*Eragrostis lehmanniana*) and *Cymbopogon plurinodis* being conspicuous.

The landscape is characterised by predominant plains, which are often irregular, with a well-developed tree layer, *Acacia erioloba*, *Acacia tortilis*, *Acacia karroo* and *Boscia albitrunca*. There is a well-developed shrub layer with occasional dense stands of *Tarchonanthus camphoratus* and *Acacia mellifera*. The grass layer is open with a lot of uncovered soil patches.

Soil erosion is very low in these areas, and overgrazing in cattle and game farming usually lead to the encroachment of *Acacia mellifera*.

▲ Further west from Kimberley, the country opens up into the classic Kalahari-type scenery, with red soils and acacias dominating the trees.

▲ Carabidae > Anthiinae > *Anthia thoracica*

▼ Carabidae > Carabinae > *Calosoma chlorostictum* (Pupa Thief)

COLEOPTERA

Carabidae (ground beetles)

The southern African species of ground beetles are distributed within 23 or more subfamilies. The *Chlaenius* species are black, with dots of yellow on the wing covers. Other species within this group are greenish in colour and densely covered with fine hairs. The two-spotted *Anthia thoracica*, a black ground beetle, is approximately 50 mm in length. It has yellow patches at the front corners of the upper thorax, which is significantly raised. The wing covers are black with a white marginal line and fine longitudinal grooves. The long black legs are smooth. This species has large mandibles for hunting ground-dwelling insects. It generally hunts at night, but may be observed during the day, especially when overcast. Extremely active, it is capable of considerable speed. It is relatively widespread in most arid and semi-arid environments in South Africa. Interestingly, *Brachinus subcostatus* (page 173) is characterised by seven or eight visible abdominal segments instead of the usual six found in other groups. The wing covers are short, leaving the tip of the abdomen exposed.

The bombardier beetles of the subfamily Brachininae can produce an explosive jet of hot, corrosive, irritant liquid, which can burn and stain the skin of vertebrates. The jet can be directed and is very effective against insect and bird predation. The hot quinones are produced as a result of two chemical reactants stored in adjacent compartments in the abdominal gland. These combine when the beetle is threatened. Both groups of the bombardier beetles advertise their bombarding capability in their warning colours of bright orange, red and black.

The eggs of the ground beetle are laid in the soil by means of a hardened ovipositor, especially after rains when the soil is moist. Some *Chlaenius* lay their eggs singly on the underside of leaves, covering them with a thin layer of mud. The larvae are well hardened and pigmented. They are active, free-living predators with an imperfectly cylindrical and elongated, lined shape. Their legs are well developed for running or burrowing, and their head has prominent, projecting, sharp, cylindrical mandibles. A few larvae are parasitic on other insects. There are three larval stages, and pupation takes place on the ground or in a sheltered spot under the cover of a stone or log.

Calosoma chlorostictum, a carabid beetle, is a medium-sized black insect approximately 27 mm in length. The wing covers of this species are punctured

Kimberley, Northern Cape 171

and grooved longitudinally and there is a series of even white dots in parallel lines. The head is relatively small compared to the body and the beaded antennae project forwards. The legs are well developed and adapted for climbing on tree branches. This largely arboreal species hunts other insects on the branches at night.

Chlaenius coscinioderus, a small attractive carabid beetle, is about 12 mm in length. The head, neck shield and wings covers are a pleasing olive-green colour. The wing covers have a broad white marginal line and are covered with fine hairs. The head is relatively small when compared with the body and the legs are pale in colour. This species is a hunter of other insects and is relatively common in semi-arid areas.

Graphipterus limbatus, the Velvet Ground Beetle, is a small insect approximately 10 mm in length. The head is black with two longitudinal bars of white flattened hairs between the compound eyes. The head, thorax and abdomen are clearly differentiated. The neck shield and wing covers are densely covered with yellowish-brown flattened hairs, outlined with a margin

▲ Carabidae > Licininae > *Chlaenius coscinioderus*

▼ Carabidae > Lebiinae > *Graphipterus limbatus* (Velvet Ground Beetle)

172 A Landscape of Insects

of pale hairs. This is a diurnal species, which favours high temperatures. Its long legs enable it to move at considerable speed. The adults feed on ground-dwelling small insects which they actively hunt. This species is common in arid areas of the Karoo with sparse vegetation.

Graphipterus atrimedius is a small ground beetle approximately 14 mm in length. The head is black while the neck shield and wing covers are densely covered with yellowish-brown flattened hairs; a single black stripe dissects the beetle. It is a diurnal species, which is most active in the heat of the day. The legs are long, enabling it to move at considerable speed when catching and feeding on small insects. This species is common in arid and semi-arid regions of South Africa, favouring sparsely vegetated areas.

Lipostratia elongata, an eye-catching ground beetle, is a small insect approximately 11 mm in length. The head is black while the neck shield is an orangy brown. The wing covers are a striking metallic green with fine longitudinal grooves. This species is strongly associated with dry wood and bark and it appears to avoid direct sunlight. It feeds on the small insects attracted to these dark places. It is common in the arid and semi-arid regions of South Africa.

Cypholoba gracilis, a ground beetle, is a small insect approximately 20 mm in length. The body is black with a characteristic greyish line running over the head and the neck shield. The wing covers have numerous bead-like longitudinal

▲ Carabidae > Lebiinae > *Graphipterus atrimedius*; Single striped Velvet Ground Beetle)

▶ Carabidae > Anthiinae > *Cypholoba gracilis*

▼ Carabidae > Lebiinae > *Lipostratia elongata*

lines and punctures. This is a diurnal species, active during the hottest time of the day. The long legs enable it to catch and feed on small insects. The species is relatively widespread and is common in the drier regions of South Africa.

Brachinus subcostatus, a species of bombardier beetle, belongs to the subfamily Brachininae. It is a small insect approximately 13 mm in length. The body is a reddish brown with contrasting black eyes. The wing covers are matt black with numerous fine longitudinal lines. This species is strongly associated with dry wood and appears to avoid direct sunlight. It feeds on small insects. It is relatively uncommon in the drier regions of South Africa.

Cicindelinae (tiger beetles)

The aptly named tiger beetles are among the fiercest and most voracious of all insects, both as larvae and as adults. The well-developed mandibles are very noticeable. The tiger beetles belong to the family Carabidae. The great majority of southern African cicindelids belong to the genus *Dromica*. The adults have large, prominent eyes, strong, sharp mandibles and long legs, which enable them to run rapidly over the ground. Most of them have wings and fly readily; some have lost their second, membranous pairs of wings and are flightless. Members of the genus *Myriochile* are found throughout South Africa. Most are dark in colour with a metallic sheen; the modified hardened forewing usually has complex patterns of tiny white dots. Those beetles falling within this group revel in the hottest of temperatures, retiring underneath a stone or burying themselves in the sand before the sun sets. They only reappear the next morning when the sun is up and the sand is warm again. They can be seen running around in open patches, along paths and on the banks of rivers and dams, at any time of the year. They have keen eyesight and take short flights if disturbed.

Manticora sichelii, a monster tiger beetle, is a spectacular, large beetle approximately 45 mm in length. The beetle is dark brown with a purplish sheen. There is often a layer of sand on the neck shield and wing covers. The wing covers are flattened, with a dull metallic sheen and fine hairs each protruding from a small tubercle, or raised area. This species has prominent mandibles for crushing the hard skeletons of other insects. It is a flightless, nocturnal species and a voracious predator of ground-dwelling insects, tackling prey larger than itself. It is assumed localised in its distribution, and had not been collected in South Africa for more than 50 years.

▲ Carabidae > Brachininae > Brachinini > *Brachinus subcostatus* (Real Bombardier Beetle)

▼ Carabidae > Cicindelinae > *Manticora sichelii* (monster tiger beetle)

▲ Carabidae > Cicindelinae > *Lophyra reliqua*

▼ Carabidae > Cicindelinae > *Myriochile melancholica*

▼ Carabidae > Cicindelinae > *Dromica clathrata* (wingless tiger beetle)

Lophyra reliqua, a small tiger beetle, is approximately 17 mm in length. The beetle is a copper colour with white hairs on the neck shield and behind the compound eyes. The wing covers are yellowish with characteristic black markings. The legs are a coppery colour with some metallic green sheen, especially on the lower legs. The species has large mandibles for hunting small insects. It is active during the heat of the day, flying readily when disturbed, and usually landing a short distance from its initial position. They often frequent the sandy areas alongside dams and roads.

Myriochile melancholica, a small tiger beetle, is approximately 11 mm in length. The beetle is bronze-coloured with lighter underparts. The wing covers are also bronze with a few scattered creamy markings. The long, brown legs are covered in fine white hairs. This species has relatively large mandibles for hunting small insects. It is active during periods of high temperatures and is most often observed in the mid-day heat. The beetles frequent sandy areas, often near water.

Dromica clathrata, a wingless tiger beetle, is approximately 20 mm in length. This beetle is an overall metallic black colour. The wing covers are black with a glint of gold and have pronounced longitudinal grooves. The long, black legs are covered in fine white hairs and are built for speed. It has relatively large mandibles for hunting small ground-dwelling insects. This is a diurnal species, extremely active, and difficult to observe clearly. Flightless tiger beetles inhabit sandy areas within the shrub veld of the Karoo.

Paussidae (ants' nest beetles)

All paussid larvae are soft-bodied predators of the ant brood. Living amongst their host larvae and pupae, they appease the ants by presenting the saucer-like tip of their abdomens to them. The structure is equipped with trichomes, a filamentous chain of cells, which exude a soothing substance that collects in the centre of this anal cup. The adults are tolerated as guests inside the ant nests because it is believed that they give the ants an aromatic secretion, which they in turn love. The glandular tissue that produces the secretion is lodged in the enlarged antennae, the head, thorax and apex of the abdomen. The more specialised species of ants' nest beetles rely entirely on the food distribution system of their host ants for nourishment. The mouth parts are spoon-shaped to accept drops of liquid begged from the ants. In the species belonging to the specialised genus *Paussus*, the adult beetles probably only

leave the nests of their hosts to reproduce. Their appearance above the ground seems to be correlated with the swarming of ants, and for a short period large numbers, especially the males, may be attracted to artificial light. Their relationship with their ant hosts is obligatory for the beetles, while the ants do not benefit in any way. This appears to be a case of what is known as true gregarious parasitism.

Pentaplatarthus sp., an ants' nest beetle, is a medium-sized insect approximately 12 mm in length. The body is a glossy brown with a smooth surface. The second antenna segment is rounded with the remaining segments characteristically broad and flattened. The wing covers are a light chestnut brown with a darker-brown longitudinal line division. The legs are broad and flattened. If disturbed, the beetle sprays quinine containing gas in explosive bursts, which resemble a puff of smoke. Both the adults and larvae are strongly associated with ants. This species favours semi-arid savannah regions where there is a healthy ant population.

▲ Carabidae > Paussidae > Paussini > *Pentaplatarthus* sp.

▲ Brentidae > *Amorphocephala imitator* (False Snout Beetle)

Brentidae (primitive weevils)

The brentid beetles generally feed on fungi and on the sap that exudes from trees. They also prey on other wood-feeding insects. Some species are known to invade and feed on the brood of other beetles. The eggs are laid in holes, which the female drills into wood with her long, slender, beak-like rostrum or snout, or in other holes made by other wood-boring beetles. The brentid larvae are white and fleshy and have a head with a projecting lower jaw. Small, soft and sparsely segmented thoracic legs are often present. The larvae develop in decaying wood, feeding either on the wood itself or on fungi growing on or in it.

Amorphocephala imitator, a species of primitive weevil, is approximately 11 mm in length. It has a narrow, elongated body, with a slightly elongated snout on its head. The antennae are forward-projecting and bead-like. This species is reddish-brown with glossy, longitudinally grooved wing covers. They live under bark or in dead wood in arid, wooded areas, especially in areas with large Camel Thorn trees (*Acacia erioloba*). This species is an omnivore, feeding on fungi, sap and woodboring insects.

Chrysomelidae (leaf beetles)

The characteristic subfamily Cassidinae is one of the most easily recognisable of the Chrysomelidae group. The African genus, *Isciocassis*, is a small genus with four described species, three of which are only known from southern Africa. Tortoise beetles often attract attention because of their striking shape and colouration. Within the Cassidini, many of the species feed on Solanaceae, a family of flowering plants that contains a number of important agricultural plants as well as many toxic plants.

The adults are all about 8 mm long, flattened and shaped a little like a tortoise. They are golden green with a beautiful metallic lustre. This is not due to a pigment but is structural in nature. It is caused by reflection and interference in the light rays as they reach the different layers of the cuticle. Unless the beetles are kept in alcohol after collection, their colour fades soon after death.

Both adults and larvae live freely on food plants. The larvae are generally spiny. On the tip of its abdomen, it has a two-pronged fork that sticks up jauntily in the air. It retains this tail-fork, which serves an important and curious function throughout the larval stages

The life cycle of the tortoise beetle *Isciocassis* is fairly typical of the other members of the subfamily. The female lays her eggs singly on leaves, dotting them about indiscriminately. Each is yellow and oval and surrounded by a blob of transparent liquid that quickly hardens so that the egg is enclosed in what looks like a tiny disc of glass attached to the leaf. Usually, but not always, the female disguises her eggs by depositing excreta on top of them. In 10 to 12 days the egg hatches into a little greenish-brown lavae with a row of flattened, branched spines running down each side of its body. The newly hatched larva immediately digs a pit in the fleshy leaf, eating away the tissue so as to form a shallow hole in which it can be comfortably lodged. It does not eat completely through the leaf but always leaves the epidermis on the opposite surface intact as the base of its home.

As it feeds, the grub gives off thin, black threads of excreta, which are not dropped but become entangled in the fork of the tail and are retained there. When a few days old, it stops feeding for a time and casts its skin. The moulted skin is not discarded but shrivels up and slips backwards along the body on to the fork and is held there, mingled with the excreta. This process continues throughout its life, until it is fully grown and has a strange

▲ Chrysomelidae > Cassidinae > *Isciocassis* sp. (tortoise beetle)

▲ Chrysomelidae > Eumolpinae

▼ Chrysomelidae > Eumolpinae > *Platycorynus* sp.

unsavoury mass on its tail consisting of four cast skins, one above the other, and a black gluey mess of excrement. If disturbed, it sways this accumulation in the face of its enemy.

The green colour of the larvae harmonises well with the colour of leaves but the shiny, black mass hooked on the tail fork, which it slowly wags to and fro, is very conspicuous and attracts attention, diverting any predator's attention away from the larva itself. Besides being a protective mechanism, its quaint habit of carrying its excrement on its back may also prevent the larva's food from becoming soiled with waste matter.

When the larva is fully grown, it fixes itself to the leaf by digging in the claws of its six short legs. As it takes no more food at this stage, the lump of waste matter on the tail fork dries up and falls off, leaving the bare fork with its two parallel prongs. Then the skin splits and reveals the flattened, green pupa. Finally, about a fortnight later, the adult tortoise beetle emerges.

The body of the adult is broad and flattened and the wing covers are expanded sideways. The corners on each side of the neck shield are extended, giving the body an oval outline. The head is hidden within the neck shield. The wing covers are greyish brown, with gold and bluish markings similar to those found on a tortoise, hence the name of the species. It is a plant feeder in semi-arid environments and is often found on Camel Thorn (*Acacia erioloba*) leaves.

This unidentified leaf beetle (top left) belongs to the subfamily Eumolpinae and is approximately 11 mm long. The body is glossy black. The head and neck shield are smooth but the wing covers are longitudinally grooved. This species is relatively common in arid environments, where it feeds on a variety of plant species.

Platycorynus sp., a species of leaf beetle, belongs to the subfamily Eumolpinae and is approximately 11 mm in length. The body is exceptionally glossy. The head and neck shield are smooth with a metallic green sheen; the wing covers have a metallic purple sheen. This species is common on herbaceous plants on which it feeds and is found under the shade of trees in arid environments.

Dircemella humeralis, a species of leaf beetle, belongs to the subfamily Galerucinae and is approximately 10 mm in length. The body is light brown in colour. The neck shield has six distinctive spots of dark brown. The wing covers are light brown and shaded with darker brown, allowing the under colour to show through. There is also a characteristic line dividing the two

wing covers. This species is common on herbaceous plants in semi-arid environments where the adults and larvae feed on foliage.

Cryptocephalus sp., a species of leaf beetle, belongs to the subfamily Cryptocephalinae and is approximately 6 mm in length. The body is a light chestnut brown. The neck shield is glossy with four distinctive spots of dark brown. The wing covers are a light-orange brown with a clear black division. The antennae are relatively long, gradually becoming darker towards the tips. This species is common on trees and shrubs in semi-arid environments, where the adults and larvae feed on foliage.

Bruchinae (seed beetles)

Seed beetles are generally small (1–5.5 mm), ovoid, compact beetles, clothed with recumbent hairs. The adults take up a position in seeds that allows them to fly off immediately after the seed pod has opened. They are strong flyers but, when disturbed, they drop to the ground and feign death for a few moments. They feed on nectar and pollen.

Some species of bruchids have a single generation of young a year, developing in green pods, but others have many generations, which develop in dry pods or seeds. The large bruchids of the genus *Caryedon* attack the winged fruits of *Combretum* as well as some species of *Acacia*. In the species that attacks *Combretum*, the eggs are laid on fully formed green or dry fruits and the species breeds throughout the fruit-bearing period. Usually only one larva develops to maturity in each fruit, constructing a cocoon within the fruit from which the adult emerges.

By contrast, those species which attack the Leguminosae leave the pod in order to pupate and construct a cocoon at ground level or below it. The female seed weevil waits until the pods are ripe and have partially split open. She then creeps inside the pod and lays her elongated, oval, white eggs loosely inside among the seeds. The newly hatched larva burrows into the pod and is safely lodged inside with the seeds. The beetles that develop from these larvae emerge and mate and lay eggs without ever leaving the tree. The seeds they leave behind are riddled with holes.

Caryedon sp., a small seed weevil, is about 5 mm in length. The body is compact and oval with shortened and grooved wing covers that partially expose the abdomen. The head is small with relatively long antennae. The body is white, covered with fine hairs, with brown mottling. The eggs are

▲ Chrysomelidae > Galerucinae > *Dircemella humeralis*

▼ Chrysomelidae > Cryptocephalinae > *Cryptocephalus* sp.

▼ Chrysomelidae > Bruchinae > *Caryedon* sp.

▲ Tenebrionidae > Praeugenini > *Praeugena* sp.

▼ Tenebrionidae > Praeugenini > *Praeugena* sp.

▼ Tenebrionidae > Platynotini > *Gonopus hirtipes*

laid on to seeds, into which the larvae burrow. They emerge as adults, leaving a characteristic hole in the side of the seed. Both the adults and their larvae feed on seeds, especially those of leguminous plants, such as Umbrella Thorn (*Acacia tortilis*).

Tenebrionidae (darkling beetles)

The interesting tenebrionid tribe Praeugenini are associated with dead wood and fungi on tree trunks. This tribe is well represented in semi-arid wooded areas. The larvae live underground and feed on waste matter or roots. Praeugenini have wings and are readily attracted to artificial light. The wing covers are often dark metallic colours.

The *Praeugena* sp. (top left), is a tenebrionid beetle. It belongs to the tribe Praeugenini and is a medium-sized beetle approximately 20 mm in length. The head, neck shield and wing covers are glossy black. The wing covers are elongated with strongly punctured longitudinal grooves. The antennae are relatively long and project forwards. It is a scavenger, feeding on dead plant and animal material. This species is often found climbing tree trunks and is widespread in semi-arid environments.

This *Praeugena* sp. (middle left), is also a tenebrionid beetle belonging to the tribe Praeugenini, and is a medium-sized beetle approximately 18 mm in length. The head, neck shield and wing covers are black with a purplish-black sheen. The wing covers are elongated and have strongly punctured longitudinal grooves. The antennae are beaded and project forwards. This is an arboreal species favouring semi-arid environments.

This medium-sized tenebrionid beetle *Gonopus hirtipes* is approximately 25 mm in length. The head, neck shield and wing covers are shiny black in colour. The neck shield is characteristically flattened, squarish, with a beaded margin and central longitudinal grooves. The wing covers are rounded and have longitudinal rows of tubercles. The antennae are beaded and relatively short. The legs are stout, strongly developed and armed with teeth. This is a ground-dwelling species which feeds on animal and plant matter in arid savannah and semi-deserts.

Amiantus sp., a medium-sized tenebrionid beetle, is approximately 16 mm in length. The head, neck shield and wing covers are blackish grey. The neck shield is characteristically rounded and heavily pitted. The wing covers are rounded and have a number of longitudinal ridges. The antennae are short and project forwards. The legs are strongly developed ending in strong claws.

Kimberley, Northern Cape 181

It feeds on animal and plant matter in arid savannahs.

Somaticus vestitus, a medium-sized tenebrionid beetle, is approximately 20 mm in length. The head, neck shield and wing covers are blackish grey in colour and are often covered with a fine layer of sand. The neck shield is characteristically enlarged and shield-like. The wing covers are rounded with three well-defined, dark, longitudinal ridges. The antennae are short and project forwards. This species feeds on animal and plant matter in semi-arid environments.

Somaticus sp., a medium-sized tenebrionid beetle, is approximately 22 mm in length. The head, neck shield and wing covers are blackish grey. The head has a pale band across the front and the large black eyes are edged with a line of cream. The wing covers are rounded and have seven well-defined longitudinal ridges. This species has long legs and the body is held particularly high off the ground. The antennae are short and project forwards. It feeds on

▲ Tenebrionidae > Molurini > *Amiantus* sp.

◄ Tenebrionidae > Molurini > *Somaticus* sp.

▼ Tenebrionidae > Molurini > *Somaticus vestitus*

182 A Landscape of Insects

animal and plant matter in arid savannah environments.

Machla verrucosa, a medium-sized tenebrionid beetle, is approximately 20 mm in length. The body is a matt black. The head is light brown and projects downwards. The neck shield is black and heavily pitted, with large, almost swollen, light-brown ridges. The wing covers are rounded and knobbed and have well-defined longitudinal ridges. This species has stout, light-brown legs. The antennae are short and project forwards. This ground-dwelling species feeds on animal and plant matter in arid savannah environments.

Eurychora barbata, a mouldy beetle, is medium-sized and approximately 20 mm in length. The blackish body is flattened oval and bears long, stout hairs on which sand and other organic matter stick. The neck shield in this species is greatly expanded into a protecting collar or flange on either side of the head. The wing covers are also expanded and appear slightly upwardly curved. This species is found on the ground, especially under dead branches and decomposing plant material. They are nocturnal feeders on plant and

▲ Tenebrionidae > Assidini > *Machla verrucosa*

▼ Tenebrionidae > Adelostomini > *Eurychora barbata* (mouldy beetle)

animal matter and appear to rest under stones and dry wood during the day.

Zophosis boei, a medium-sized tenebrionid beetle, is approximately 15 mm in length. The head, neck shield and wing covers are a matt black. The neck shield is smooth, while the wing covers are rounded with a number of longitudinal ridges. The antennae are short and project forwards. The legs are strongly developed for digging and this species rapidly 'dives' into soft sand when it is disturbed. It feeds on animal and plant matter in sandy arid environments.

Echinotus spinicollis, a unique-looking tenebrionid beetle, is approximately 24 mm in length. The head, neck shield and wing covers are grey. The neck shield has two spines projecting like thorns above the head. The wings covers are unique and have rows of spines. The antennae are short and project forwards. The legs are strongly developed and the creature stands high on its legs, possibly to keep some distance from hot sand. This ground-dwelling species feeds on animal and plant matter in sandy arid environments.

Gonocephalum sp., a medium-sized tenebrionid beetle, is approximately 17 mm in length. The head, neck shield and wing covers are grey in colour and have fine hairs to which sand sometimes adheres. The wing covers are rounded and have fine longitudinal grooves. The antennae are short and are often pulled against the head. The species feeds on animal and plant matter in semi-arid environments.

Meloidae (blister beetles)

Blister beetles can cause severe blistering when the substance they secrete, cantharadin, comes into contact with human skin, hence the common name of the family. Certain species are diurnal, while others are nocturnal. It is a common experience on a night drive in a game park to swat at something crawling on one's skin and find a blister there the next day.

This blistering substance is secreted from the leg joints when the beetles are threatened or in distress. Blister beetles of the genus *Mylabris* are very common throughout Africa and are of considerable interest because they do a lot of good at one stage of their career and may cause damage at another. The chemical is erroneously believed to be an aphrodisiac (Spanish fly). In fact, cantharadin is extremely poisonous, causing blisters and possible damage to the bladder and kidneys or even death. *Mylabris* beetles contain large amounts of cantharadin, and there is reason to believe that some traditional doctors in Africa have used these beetles as poison.

▲ Tenebrionidae > Zophosini > *Zophosis boei*

▼ Tenebrionidae > Sepidiini > *Echinotus spinicollis*

▼ Tenebrionidae > *Gonocephalum* sp.

Mylabris oculata, the CMR Bean Beetle, is about 27 mm in length. The head and neck shield are black. The antennae are curved forwards and are orange except for the lower or basal segments, which are black. The wing covers are black with two basal yellow spots and two broad transverse yellow bands. The adults feed on flowers and may occur in large numbers at a suitable food source. Their flight pattern is characteristic as the wing covers are held high with their bodies suspended between them. The larvae of this species are important in the control of grasshoppers and locusts as they feed on their egg pods. The species is common and widespread in a variety of habitats.

Ceroctis phalerata, a small blister beetle, is about 11 mm in length. The head and neck shield are a greyish black. The legs are black with a reddish tinge. The antennae are black and curve forwards. The wing covers are black, marked with two light-pink longitudinal stripes and have red marginal blotching. The adults feed on a variety of flowers and seeds and are relatively common in semi-arid savannahs.

Mylabris burmeisteri ab. perssoni, a medium-sized blister beetle, is about 16 mm in length. The head, neck shield, wing covers, legs and underside are covered in greyish-bronze hairs. The antennae are brownish red, except

▲ Meloidae > Meloinae > *Mylabris oculata* (CMR Bean Beetle)

▶ Meloidae > *Mylabris burmeisteri ab. perssoni*

▼ Meloidae > *Ceroctis phalerata*

for the lower segments, which are black. The wing covers have black spots and irregular yellow blotching among the grey hairs. The adults feed on the flowers, leaves and buds of a variety of plants and are common in semi-arid savannahs of the Karoo.

Trogossitidae (gnawing beetles)

Melambia sp., a medium-sized beetle, is approximately 25 mm in length. The body is strongly elongated with distinctive forward-facing mandibles. This species is matt black and has distinctive longitudinal grooves on the wing covers. The head and neck shield are smooth. It is found regularly in arid savannah woodlands, where it inhabits tree trunks. The larvae live under bark or in the tunnels of woodboring beetles and are possibly predators.

Trogidae (carcass beetles)

Trox and *Omorgus* are most common in arid and arid savannah regions. Most species occurring in these desert areas are flightless, a condition evolved in harsh environments where flight is not desirable for a number of reasons. *Trox* adults and larvae feed almost exclusively on animal matter and are often associated with carcasses, carnivore faeces, raptor pellets and other animal remains. They are among the last in the series of insects to visit any carcass and are usually associated with relatively dry remains. The adults have also been found immediately beneath or in the soil under the food source. Some species frequent the nests of birds and the burrows of mammals, the larvae feeding on the feathers, hairs or other debris found in these places.

The family is represented by two rather different genera, *Trox* and *Omorgus*. The *Trox* species are small to medium-sized (5–20 mm), robust, grey-black beetles with a heavily sculpted dorsal surface. The head is usually concealed from above and the legs can retract. When disturbed, these beetles emit a feeble squeaking sound, which they produce by rubbing the edges of their abdominal segments against the inner margins of the wing covers. The adults are strongly attracted to artificial light at night.

Trox squamiger, a medium-sized carcass beetle, is approximately 12 mm in length. The matt black body is heavily sculpted and well domed. The head and wing covers are coarsely punctured and have rows of serrated ridges. The larvae are typical scarabaeoid, white and C-shaped with a dark hardened head and well-developed legs. This nocturnal species is found often in arid

▲ Trogossitidae > Trogossitinae > *Melambia* sp.

▼ Trogidae > *Trox squamiger*

▲ Trogidae > *Omorgus squalidus*

▼ Curculionidae > *Hipporhinus* sp.

▼ Curculionidae > Entiminae > Tanymecini > *Dereodus* sp.

savannah woodlands, where they feed on animal carcasses, carnivore faeces and the droppings of birds of prey.

Omorgus squalidus, a medium-sized carcass beetle, is approximately 15 mm in length. The body is greyish black with a large, sculpted neck shield. The wing covers are coarsely punctured and longitudinally grooved. This species is known to produce a scraping noise by rubbing its abdomen against its wing covers. It is nocturnal and often found in arid savannah regions, where it lives on or under the dry carcasses on which it feeds.

Curculionidae (weevils)

The majority of weevils are solitary and are largely diurnal, but a few are nocturnal feeders hiding under stones or bark during the day. The habitats in which we find weevils are diverse, ranging from semi-arid savannah through to coastal forests. A number of species stridulate by scraping a file on the wing covers against their abdominal segments. It is assumed that these sounds play a role in courtship and in contacts between the species and are also produced when the beetle is in distress.

If the beetle is disturbed while feeding or while walking with its slow and clumsy gait, it immediately shams death, falling on its side and holding its legs out stiffly. No amount of prodding will reveal any sign of life. This clever trick probably deceives its enemies but it must not be thought that this is a conscious or voluntary act. No insect has reasoning powers and it is probably akin to a reflex action. The weevil's nervous system is such that, whenever disturbed, it falls down automatically in a sort of cataleptic fit. Most weevils act instinctively in this way, shamming death when they are disturbed.

Hipporhinus sp. is a medium-sized weevil approximately 15 mm in length. The elongated body is heavily built with a thick, stout snout. The neck shield is large and significantly rounded. The neck shield and wing covers have very pronounced, rounded, black tubercles with white and light-brown, almost bead-like scales The thread-like antennae are elbowed, ending in a distinct club. This is a wingless species which inhabits a diverse array of habitats.

Dereodus sp. is a medium-sized beetle approximately 12 mm in length. The elongated body is greyish black in colour with fine white speckling on the neck shield. The neck shield is relatively long and flat. The antennae are short but project directly forward. The wing covers are smooth with broken, white longitudinal striations or striping. This species is common on the Umbrella

Thorn (*Acacia tortilis*) in semi-arid savannahs.

Polyclaeis equestris, the Pink-banded Weevil, is a medium-sized beetle approximately 18 mm in length. The body is blue-green with a short, stout snout. The wing covers have broad diagonal pink bands, which are due to the covering of hair. If these beetles are handled, the hairs rub off and the band is lost. The legs of this species are well adapted to climbing on branches, where they are commonly found. The weevils feed on plant material, especially *Acacia* sp. It is a bushveld species but is also recorded in semi-arid savannahs.

The weevil (bottom right) is a small beetle approximately 4 mm in length. The body is pale blue in colour and has an exceptionally long, narrow snout for its size. The neck shield is large and the head is partially retracted into it. The longitudinally grooved wing covers are pale blue with numerous fine, white hairs. This species is common but is regularly overlooked as a result of its size. It feeds on plant material and inhabits semi-arid savannahs.

Macrocoma sp. is a small beetle approximately 6 mm in length. The body is greenish white in colour and it has a short, stout snout. The antennae are relatively long and project forwards. The head, neck shield and wing covers are covered with numerous fine, white hairs. The species is commonly observed on the Raisin Bush (*Grewia flava*) in semi-arid savannahs.

▲ Curculionidae > Entiminae > *Polyclaeis equestris* (Pink-banded Weevil)

◄ Eumolpinae > *Macrocoma* sp.

▼ Curculionidae

▲ Scarabaeidae > Dynastinae > Pentodontini > *Temnorhynchus coronatus*

▼ Dynastinae > *Heteronychus arator*

Dynastinae (rhinoceros beetles)

The rhinoceros beetles are familiar to many people in South Africa. The horns on the male rhinoceros beetle may be quite long in some species and as a result have been included in the 'Little Five', representing the rhino.

Temnorhynchus coronatus, a medium-sized scarab beetle, belonging to the subfamily Dynastinae, is approximately 25 mm in length. The body is a shiny dark brown with light-brown hairs. The head has two tooth-like horns of equal size. The neck shield is disc-like and elevated to form an uneven extension. The slightly elongated wing covers are smooth and shiny. The legs are powerful and toothed for digging. This species is active at night and may be attracted to artificial light. It feeds on decomposing plant material and may gnaw into the stems of plants just below the surface. It is relatively common in semi arid grasslands and savannahs.

This rhino beetle, *Heteronychus arator*, is approximately 25 mm in length. The upper parts of the body are glossy black with brownish hairs underneath. The wing covers are black and finely grooved longitudinally. The head is smooth and has no projections. The enlarged neck shield is exceptionally shiny and distinct. The legs are well developed and toothed for digging. The species is relatively common in the semi-arid savannahs of the Northern Cape.

Scarabaeinae (dung beetles)

Copris species are generally rounded, black or brown beetles are mainly nocturnal in habit and are of medium to large size (10–45 mm). The characteristic first segment of the foreleg is transverse where the leg joins the body. The head clearly protrudes in these species but the bases of the antennae are characteristically hidden from above.

The females of many species desert the ball of dung they have buried after laying their eggs, but in some species of *Copris*, for example, the females remain underground in the chamber with the brood until the next generation of adults emerge, after which they leave the chamber. The female does not always feed while caring for the brood. For some reason the brood does not emerge without her being present.

Copris elphenor, a medium-sized scarab beetle, is approximately 30 mm in length. The body is glossy black in colour, with a strongly punctured surface. The wing covers are glossy black, with distinct longitudinal grooves. The male has a large, backward-curving horn, hence the name rhino beetle. The size of the horn varies between individual males depending on a variety of factors, including the larval food supply. The neck shield is adapted into a large hump-like projection, which may differ depending on the species. The legs are powerful and toothed for digging. The adults mould soil-coated dung balls, which are drawn into burrows below or next to the original dung pad. Some of the dung is retained as food, the rest being used as food for the larvae once they hatch. The female shows parental care and remains with the progeny until they mature. The horns of this species (top right and middle) show disproportionate growth and are a clear indicator of whether the beetle has had sufficient nutrition. They are relatively common in semi-arid grasslands and savannahs.

Catharsius sp., a medium-sized scarab beetle, is approximately 20 mm in length. The body is glossy black and generally smooth. The wing covers are black with distinct, longitudinal grooves. The male has a short, slightly backward-curving horn. The neck shield is adapted into a blade-like projection with two distinct knobs. The powerful legs carry a series of teeth for digging and moulding dung balls, which they bury for food or use to breed in. The species is common in the arid and semi-arid savannahs of the Northern Cape.

▲ Scarabaeidae > Scarabaeinae > Coprini > *Copris elphenor*

▼ Scarabaeidae > Scarabaeinae > Coprini > *Copris elphenor*

▼ Scarabaeidae > Scarabaeinae > Coprini > *Catharsius* sp.

Bolboceratidae (earth-boring dung beetles)

Meridiobolbus quinquedens, a medium-sized scarab beetle, is approximately 14 mm in length. The body is very convex and globular in shape. This insect is reddish brown. The head has a slight projection, while the neck shield is heavily pitted, bearing two small, forward-facing projections. The wing covers are rounded with fine, longitudinal grooves. The body has reddish hairs on the margins of the neck shield and wing covers. This species is similar in appearance and habit to most dung beetles. It is attracted to artificial light and is observed regularly in semi-arid bushveld and grassland.

Melolonthinae (leaf chafers)

Monkey beetles account for more than three-quarters of the leaf chafer genera and species in southern Africa. These colourful, furry beetles are locally regarded as members of the Melolonthinae. They range in size from small to medium (4–15 mm) in length. The movable tarsal claws, especially on the hind legs, are unequal in size and are the most reliable factor differentiating them from the other scarabaeoids.

Monkey beetles are small, mostly brightly coloured, hairy beetles, abundant in certain areas, especially the Northern Cape and the Karoo. Their extraordinarily developed legs and claws are used firstly to anchor them and then to extract them from the flowers into which they tunnel to feed. Several of the anatomical features in monkey beetles are atypical for leaf chafers, and some authors regard them as belonging to a different subfamily.

This unknown species (bottom left) of monkey beetle belonging to the tribe Hopliini is approximately 8 mm in length. The hind legs are strongly developed in the male. The body of the beetle is typical of a small scarab. The head and legs are black; the neck shield and wing covers are striped in black and white. The adults of this species feed on the flowers of forbs. They are relatively common in the semi-arid savannahs of South Africa.

▲ Bolboceratidae > Bolboceratinae > *Meridiobolbus quinquedens*

▼ Melolonthinae > Hopliini (monkey beetle)

Cetoniinae (fruit chafers)

Dischista cincta, a common species of fruit chafer, is approximately 24 mm in length. The body is brownish yellow in colour, with distinctive yellow edges to the neck shield. The adults feed on flowers and fruit and on a flowering *Acacia* sp. on which many individuals may congregate. This is one of the most abundant fruit chafers in South Africa.

This species (bottom right) is common in South Africa, its distribution stretching from Southern through to West Africa. It is glossy black in colour, with large white maculae, or patches, on the wing covers and on the neck shield. The broad chalky band along the sides of the neck shield is often separated into two maculae, especially in smaller specimens. Adults of this species are active from September to May and are attracted to sap flows, fruit and flowers. They are regular visitors to *Acacia* sp., *Protea caffra*, *Terminalia sericea*, *Grewia* and *Diospyros*. They have also been recorded inside bird nests and have been found breeding in zebra dung.

The 'All Black' fruit chafer (below) is common in arid areas with a relatively low rainfall. As the name indicates, it feeds on fruit and flowers. In certain areas it is strongly associated with wasp nests.

▲ Scarabaeidae > Cetoniinae > *Dischista cincta* (Common Savannah Fruit Chafer)

◄ Scarabaeidae > *Oplostomus fuligineus* (Black Wasp Nest Chafer)

▼ Scarabaeidae > Cetoniinae > *Mausoleopsis amabilis* (White-spotted Fruit Chafer)

▲ Buprestidae > Chrysochroini > *Agelia petelii* (Meloid-mimicking Jewel Beetle)

▼ Buprestidae > *Sternocera orissa* (Giant Jewel Beetle)

Buprestidae (jewel beetles)

The larvae of the jewel beetle are often called 'flat-headed borers' because the prothorax is flattened and very much enlarged, being broader than the rest of the body. These borers gnaw wide galleries between the bark and the sapwood. Often their gnawing is audible. The larvae have no legs but the expanded prothorax enables them to grip on to the sides of their tunnels as they tunnel their way forward. Not all buprestids are sapwood borers; the larvae of certain genera bore right into the heartwood, while others are not borers at all. While most species belonging to the large, common genus *Sphenoptera* are woodborers, some species form galls in the living tissue just above the root crown of various plants or bore into forbs. The members of the genus *Sphenoptera* are small to medium-large in size and are mostly dark metallic in colour. Many species are covered in a waxy coat. In most species, the rear end of each wing cover has three points. The attractive *Agelia peteli* is also observed regularly at certain times of the year.

Agelia petelii, the Meloid-mimicking Jewel Beetle, is a large insect approximately 26 mm in length. This species is characteristic as it mimics *Mylabris* blister beetles. The body and neck shield are black, the former with a pair of wing-like extensions that have a metallic red hue at the bases. The neck shield and wing covers are clearly well punctured. The wing covers are black with four patches of yellow, the rear pair edged with red. They are regularly found in the same location as blister beetles, occurring on the Raisin bush (*Grewia* sp.). They are common in areas of semi-arid savannah and, interestingly, they seem to appear and disappear in a short period of time.

Sternocera orissa, the Giant Jewel Beetle, is a large, bulky insect approximately 37 mm in length. Its body is black, with numerous yellowish punctures. The head is also black with pale-yellowish hairs on top and between the compound eyes. The neck shield has large yellowish punctures and a patch on either side. The wing covers are black with rows of punctures and pale-yellowish patches at the base and along the sides. They are found regularly on *Acacia* trees, on which they feed. The female lays her eggs on the ground or just drops them there, after which the larvae hatch and are free-living root feeders. This species is commonly observed in bushveld and semi-arid savannahs.

Acmaeodera foudrasi, an attractive jewel beetle, is approximately 7 mm in length. The body is torpedo-shaped and metallic bronze in colour. The neck shield is heavily sculpted. The wing covers are bronze with characteristic bands of metallic green and carry fine, longitudinal grooves. This species feeds on flowers, pollen and foliage. The adults are active during the hottest time of the day and are extremely common in the Umbrella Thorn (*Acacia tortilis*)-dominated woodland in semi-arid environments.

Agrilus sp., a small jewel beetle, is approximately 8 mm in length. The body is torpedo-shaped and metallic bronze in colour. The neck shield has a small pale line and a patch on either side. The wing covers are bronze and almost flattened with characteristic pale yellowish spots of various sizes forming a mirror-image pattern. This species feeds on flowers and pollen. The adults are active during the hottest time of the day and are regularly observed on Umbrella Thorn (*Acacia tortilis*) in semi-arid environments.

▲ Buprestidae > Acmaeoderini > *Acmaeodera foudrasi*

▼ Buprestidae > *Agrilus* sp.

▲ Buprestidae > Sphenopterini > *Sphenoptera* sp.

▼ Buprestidae > *Sphenoptera* sp.

▶ Buprestidae

▼ Buprestidae > *Psiloptera foveicollis*

Sphenoptera sp., a medium-sized jewel beetle, is approximately 18 mm in length. The body is torpedo-shaped and glossy black in colour. The neck shield is strongly punctured. The well-tapered wing covers are black, with fine longitudinal grooves and rows of punctures. The neck shield and wing covers look as if they are hinged together. This species feeds on flowers and pollen. The adults are often observed on *Acacia*, *Rhus* and *Terminalia* in semi-arid savannahs.

Psiloptera foveicollis, a medium-sized beetle, is approximately 24 mm in length. The body is dark with glossy wing covers which are of an indefinite black edged with creamy white and which carry a series of longitudinal ridges and rows of punctures. The neck shield has two conspicuous, black eye-shaped dots. This species has a widespread distribution and appears linked to the Umbrella Thorn (*Acacia tortilis*).

This unknown species (below) of small jewel beetle is approximately 4 mm in length. The body is a metallic bronze. The antennae are short and forward-projecting. This species is relatively uncommon and appears to feed on the Raisin Bush (*Grewia* sp.).

Cerambycidae (longhorn beetles)

The majority of cerambycids are fully winged and are active flyers. A large percentage of the subfamily Lamiinae are active during the night or just before sunrise. They are plant feeders, eating predominantly flowers, leaves and other woody material. True bark and stem feeding is confined almost exclusively to the Lamiinae. Some species feed only on bark while others feed also on stems, twigs and even buds. Savannah ecosystems are often deficient in minerals because of the slow rate of mineralisation in the detritus layer that is the result of low rainfall, consequent lack of water and microbe resistance in leaf-defence compounds. Wood detritivores, such as beetles, play a vital role in this mineralisation process, particularly by releasing phosphorus. This serves to speed up the breakdown of dead wood and the return of nutrients to the soil. The beetles therefore play a very important role in the functioning of a healthy ecosystem.

Dichostates lignarius, a species of longhorn beetle, is a medium-sized insect of approximately 10 mm in length. The light-brown body is short and stocky. The head, neck shield and wing covers are hairless but heavily pitted with black and marked with squiggles and slightly raised lines of chestnut brown. The antennae are brown and beaded only towards the tip. This species favours semi-arid woodland savannahs, where the larvae bore into the wood of a number of different tree species.

Phoracantha recurva, an exotic species of longhorn beetle, is a large insect approximately 26 mm in length. The body is brownish black with a distinctive broad yellow band across the base of the wing covers, which are interrupted by two black spots on each wing cover. The antennae are longer than the wing covers and project forwards. Once the eggs of this species are laid beneath the loose bark of the eucalyptus, the larvae bore deep into the wood. This species was initially introduced to South Africa from Australia; it has now established itself and occurs wherever eucalyptus trees grow. Some are concerned that these beetles cause trees to die; the truth of the matter is that they usually only attack sickly or dead trees.

Prosopocera lactator, a delicate-looking species of longhorn beetle, is a large insect approximately 32 mm in length. The body is broad and stocky and pale turquoise. The head, neck shield and wing covers are also turquoise with a striking pattern of broad brown lines. The antennae are brown, segmented and tend to curve forwards. This species cuts through the branches and young

▲ Cerambycidae > Lamiinae > *Dichostates lignarius*

▼ Cerambycidae > Cerambycinae > *Phoracantha recurva* (Yellow banded Longhorn)

▼ Cerambycidae > Lamiinae > *Prosopocera lactator* (Turquoise Longhorn)

▲ Cerambycidae > Lamiinae > *Crossotus plumicornis* (Plumed Longhorn)

▼ Cerambycidae > Lamiinae > Acanthocinini > *Exocentrus echinulus*

▼ Cerambycidae > Lamiinae > *Titoceres jaspideus*

stems of trees to lay its eggs. Interestingly, these beetles fall to ground and feign dead when disturbed. This is a relatively common beetle in semi-arid woodland savannahs.

Crossotus plumicornis, a cryptically marked species of longhorn beetle, is a large insect approximately 16 mm in length. The body is broad and grey with some shading in brown. The head is greyish white with fine black stripes. The neck shield and wing covers are coarsely sculpted, especially at the base of the wing covers. This species has two characteristic brown projections on the wing covers. The antennae are brown, forward-curving and fringed with hair. The larvae attack sickly and dead trees and are relatively common in semi-arid woodland savannahs. The species may be attracted to artificial light.

Exocentrus echinulus, a small longhorn beetle, is approximately 8 mm in length. The slightly curved body is brown with some cream mottling on the wing covers; these are also sparsely covered with long hairs, especially noticeable at the ends. The long antennae have characteristically long, brownish hairs. The upper parts of the legs are red, while the lower parts are dark brown. This species is relatively common in savannah and semi-arid Karoo woodlands.

Titoceres jaspideus, a unique species of longhorn beetle, is a large insect approximately 26 mm in length. The body is broad, stocky and grey. The neck shield is also grey and heavily punctured. There is a diagnostic band separating the neck shield and grey wing covers, which are heavily pitted with broken wavy lines in light brown. The antennae are exceptionally long, grey and segmented and tend to curl forwards and then backwards. The legs are strong and well adapted to climbing on bark. This is a relatively common beetle in the semi-arid woodland savannahs of the Northern Cape.

Passandridae (flat bark beetles)

The small family Passandridae is mostly represented in tropical and subtropical regions and only a few species have been recorded from southern Africa. The passandrid beetles are medium-sized (8–20 mm), smooth brown or black, hairless and elongated and have cylindrical, moderately flattened bodies. The head is broad and the forward-projecting process partially conceals the maxillae. The adults are relatively reticent insects, usually observed living under bark. The larvae, which have reduced structures, are ectoparasites on the larvae of woodboring insects. The species within the genus *Nicolebertia* are often attracted to artificial light.

The *Nicolebertia* sp. is a medium-sized beetle approximately 12 mm in length. The body is elongated and flattened. This species is purplish-black with characteristic orange legs and some brown shading on the lower parts. The brown antennae are beaded and project forwards. The neck shield and wing covers are flattened to enable this insect to fit between the cracks in dry wood. The wing covers are finely grooved longitudinally. This species is not often observed as a result of its elusive habits but is relatively common in semi-arid environments.

▲ Passandridae > *Nicolebertia* sp.

▲ Scutelleridae > *Solenosthedium liligerum*

▼ Pentatomidae > Pentatominae > *Pseudatelus foveatus*

HETEROPTERA

Scutelleridae (shield-backed bugs)

Solenosthedium liligerum, a bug, is approximately 14 mm long. The body is a metallic olive and finely pitted with greenish speckles. The forewings are blotched, with a band of yellow marks, which is diagnostic for this species. It is widespread in savannahs and subtropical areas, where individuals or pairs are commonly observed.

Pentatomidae (shield bugs)

The Pentatomidae are very widespread in South Africa and form important components of a healthy ecosystem. Some are rather attractive as they often have brightly coloured markings. This coloration is variable and specimens may be found that are plain green, brown or black. If roughly handled, they give off a strong 'buggy' odour that comes from fluid produced in special glands lodged on the underside of the thorax. The fluid is secreted from a pair of slits just behind the bases of the hind legs and is designed to deter would-be predators.

Pseudatelus foveatus is a medium-sized shield bug about 15 mm long. The body is blackish brown with numerous fine, pink speckles on the neck shield and forewings as well as a line running down from the head over the middle of the forewings, which are shortened to expose part of the abdomen. As in the case of most members in this group, the head is sharply pointed and the eyes are situated on the base of this projection. The antennae are relatively long, forward-projected and curve outwards; they are blackish brown in colour with the last two segments a pinkish colour. These insects are plant feeders and are common in semi-arid savannah woodlands.

Coreidae (twig wilters)

The Coreidae eggs are cylindrical, barrel-shaped objects, deposited in rows of about 15 each on the stems of young and healthy plants. They hatch after one or two weeks. In South Africa, two, three or four generations of these bugs are produced a year, depending on the climatic conditions and the type of host plant chosen. The female twig wilter lays her oval brown eggs in a row, generally fixing them along a twig of the food plant. Each egg has a lid at one end, and the young bug is armed with a sharp T-shaped egg-piercer

on top of its head., which it uses to force its way out of the egg. Once it has burst open the lid of the egg, the youngster, halfway out of the shell, takes a break, casting its skin in this position and leaving the egg-piercer behind in the empty shell. This T-shaped instrument can be seen in the eggshell if examined through a hand lens. All the coreids have this special mechanism of breaking out of the egg.

Prismatocerus auriculatus is a medium-sized bug about 16 mm long. The elongated body is light brown with numerous fine, pale speckles on the neck shield and forewings. The head is light brown with bulbous eyes. The antennae are light brown, clearly segmented and project upwards. The neck shield has characteristic forward-projecting spikes on each margin. These camouflaged creatures are plant feeders and are common on bark in semi-arid woodlands.

Homoeocerus nigricornis is a medium-sized bug about 15 mm long. The head and stout, smooth body are green in colour. The head has short brown stripes alongside the orange bulbous eyes. The green antennae are tipped with orange and held horizontally to the head. The neck shield is green and raised, forming a wedge-shaped structure. There are two short brownish stripes on the neck shield while the forewings are brown with darker-brown projecting spiked margins. These well-camouflaged insects feed on plants and are common on foliage in semi-arid woodlands.

Lygaeidae (seed bugs)

The family Lygaeidae are a very large and diverse cosmopolitan family. In general they are recognised by the membrane on the forewings, which has 4–5 longitudinal, simple veins, and by the four segmented antennae with antennifers inserted below a line drawn between the centre of the eye and the apex of the head. The veins on the membrane are sometimes inconspicuous. In some genera a cross-vein connects the two inner veins to form a cell close to the base of the membrane. The Lygaeidae usually have simple eyes; the feet are mostly three-segmented; the rostrum is distinctively four-segmented; and the thoracic scent-gland openings are usually prominent. Wing modifications (wingless, short-winged or fully winged) are common in the Lygaeidae, especially in the species that lives in ground litter and grass and also those that live in leaf sheaths.

Spilostethus pandurus is a medium-sized bug about 13 mm in length. The elongated body has a combination of red bars and dots on a grey body. The

▲ Coreidae > Coreinae > *Prismatocerus auriculatus*

▼ Coreidae > Coreinae > *Homoeocerus nigricornis*

▼ Lygaeidae > Lygaeinae > *Spilostethus pandurus*

antennae are grey and project forwards. The neck shield has two characteristic tan stripes. The forewings are beautifully patterned in red, grey and black. These striking insects feed on milkweeds (*Asclepias*) and indigenous *Solanum* sp. They are found in a wide variety of habitat types and are especially common in grassland environments.

Reduviidae (assassin bugs)

The large and diverse Reduviinae subfamily is characterised by the absence of the cubital cell in the forewings, by the shield that bears a spine or tubercle at the tip, and by the well-developed simple eyes (ocelli) in the winged forms. The first segment of the antenna is shorter than the second, the forewings are constricted near the middle, and the tarsi have three segments.

The habits of the Reduviinae are varied as they occur almost anywhere, in buildings and caves, under bark, in debris, under stones or in termite mounds. The subfamily Peiratinae are all nocturnal and some species are attracted to artificial light. Representatives of the group are given the name 'night bee' because of the burning bite they give when brushed away. Most Harpactorinae seem to be general feeders and will attack most arthropods of a manageable size. Interestingly, some species within this group are reported to prey on ticks. The nymphs and adults of many genera accumulate debris consisting of soil particles, leaf fragments, seed coats and the corpses of prey on their body and legs. This debris is attached to the body by a sticky secretion produced by secretary hairs and serves to camouflage the insect.

This assassin bug nymph of the family Reduviidae is small insect approximately 6 mm in length. The body is dark brown, but to camouflage itself the nymph has attached sand particles to every part of its body. It inhabits a dark and sheltered environment before it reaches adulthood. This creature is an ambush predator of other small insects.

LEPIDOPTERA

Azanus jesous, a delicately patterned small blue butterfly, has a wingspan approximately 26 mm in length. The male and female are slightly different in colour. The male is sky blue, while the females are mostly black with a blue sheen in the lower parts of the wings and almost square blotches on the forewings just below the tips. Both sexes have a black-and-white chequered fringe of hairs on the outer wing margins. The undersides of the wings are

▲ Reduviidae > Reduviinae (nymph)

▼ Lepidoptera > Lycaenidae > *Azanus jesous jesous* (Topaz-spotted Blue)

brownish grey with pointed white spots. It is a slow, low-flying butterfly which sometimes congregates in large numbers, especially around puddles and dams. This is a relatively common species, abundant in semi-arid savannahs.

Gonometa postica is a medium-sized, stout and very hairy moth. The forewings are brown with pale wavy lines, bands and spots while the hind wings are rounded and reduced in size. The antennae are characteristically comb-like in the bottom half only, the end half being toothed and bent backwards. The male are smaller than the female, which has a large yellow-and-black abdomen. The adults rest well camouflaged during the day. The species produces a tough cocoon which has short stinging hairs woven into it. This moth has just emerged from the cocoon, as can be seen from the photograph. The wings still have to set and harden.

The photograph (middle right) provides evidence of true parthenogenesis (virgin birth) in this species of moth. The female has just emerged and immediately starts laying eggs. The female has not mated and thus has not been fertilised by a male of her species. The eggs are laid on the branch and even on herself.

These eggs (bottom right) were fertile and hatched sometime later. Interestingly, the offspring hatched through parthenogenesis are said to be only male young. This could be some unknown ecological pattern of adjusting the numbers of males and thus ensuring the meeting of female young hatched through copulation. Interestingly, parthenogenesis occurs more frequently in species where there is a chance that they will not meet a mate and therefore they are assured of continuity of their species. This happens particularly in semi-arid and arid environments where there are wide, open spaces and the chance of meeting other like insects may be reduced by these environmental factors.

ORTHOPTERA

The pyrgomorphid grasshoppers, or foam grasshoppers as they are commonly known, contain a number of strikingly coloured members, which are common throughout Africa, especially in rather dry areas. The species within this group are excellent examples of warning coloration in insects. The bright colours are a warning to enemies that the pyrgomorphids are distasteful and foul-smelling, as a result of protective glands that produce repugnant secretions. A young and inexperienced bird or baboon might be tempted to seize such an easily caught victim but would soon drop it because of the foul taste. The

▲ Lasiocampidae > *Gonometa postica* (African Wild Silk Moth) (parthenogenesis, 1)

▼ Lasiocampidae > *Gonometa postrica* (parthenogenesis, 2)

▼ Lasiocampidae > *Gonometa postrica* (parthenogenesis, 3)

predator soon learns to associate the nauseating taste and smell with these bright colours.

The milkweed locust, and most of the 'bush locusts', belonging to the genus *Phymateus* exaggerate the impact of their warning colours by suddenly spreading their highly coloured wings. These locusts are also protected by a frothy liquid that exudes from openings situated near the bases of the hind legs. This liquid is in fact the blood of the insect and it has the same distasteful properties as the rest of its body but to a greater degree. The froth is given off only if the grasshopper is roughly handled.

The female *Phymateus viridipes* lays her eggs in the ground. The four hard, horny points on the tip of the abdomen are common to the females of most grasshoppers and locusts. The male abdomen has a soft, rounded tip. When the female is ready to lay her eggs she presses the tip of her abdomen against the soil and, by applying steady pressure and a slow turning movement, she drills it into the ground. Her abdomen is more or less telescopic and she can elongate it to about one and a half times its normal length. The large, yellow, cigar-shaped eggs are laid at the bottom of the hole. Then she discharges a frothy fluid to bind the soil particles together and form a case or pod enclosing the 50 or more eggs she has laid. Finally a little soil is scraped into the top of the hole to cover the eggs, and the egg laying is complete. A week or so later, the female may lay another batch of eggs and continue until three or four egg pods complete her contribution to the next generation of locust. When the embryo is fully formed and ready to emerge, a swelling called the 'egg burster' appears in the join between the head and the thorax at the back of the neck. This swelling throbs, eventually breaking the egg shell and allowing the young grasshopper to wriggle its way out.

At this stage the grasshopper is still enclosed in a thin membranous covering, and it has to struggle in this covering up and through the frothy plug and soil until it reaches the surface. The first to emerge has all the work to do as the others usually follow its route. The membranous coat is cast off as soon as the little insect reaches the outer air and shrivels up at once. The tiny white debris strewn around the hole after the young have emerged consists of their discarded first coats, which are intended only to protect them during their struggle to the surface. The skin of the larva soon hardens and turns black. It is then ready to move off and feed in company with the rest of the locust family.

Dictyophorus spumans, the Koppie Foam Grasshopper, is a large insect

▲ Pyrgomorphidae > *Phymateus viridipes* (Green Milkweed Locust)

approximately 65 mm in length. The bulky body is characteristically black and red, a warning to potential predators that they are poisonous. The abdomen is large and black. This species is flightless and therefore has reduced wings. It is a predominant rocky, arid grassland species, which feeds on milkweed. The poisons from this plant are stored in the grasshopper and exuded when it is disturbed. This very striking species is common and well known because of its bright, easily recognisable colours and relatively calm nature.

Phymateus viridipes, the Green Milkweed Locust, is a large insect approximately 70 mm in length. The body and the forewings are green, while the hind wings are red and blue. The characteristic neck shield is green with a raised serrated ridge tipped with red. This species raises its wings and produces foul-smelling foam from the thoracic joints when alarmed. It is predominantly a grassland species, known to fly well and in large numbers when migrating.

Gryllotalpidae (mole crickets)

One species, *Gryllotalpa africana*, is widespread all over Africa. They are attracted to light at night, causing distress to households by entering homes, flopping down on the floor and then scurrying about. At certain times of the year they may be particularly numerous but these plagues do not last long and the mole crickets soon disappear. In these insects, the front legs are highly adapted as digging implements, being very stout and armed with strong teeth. The crickets burrow in damp earth and often damage lawns and bowling greens by throwing up small mounds of earth during the night. A male mole cricket beneath a stone in a damp spot in the garden will keep up a shrill, whirling song for minutes at a time but its source is difficult to locate. These insects feed mostly on roots but may also be carnivores. They sometimes damage garden crops, eating holes in potatoes and strawberries. The females lay their oval, white eggs in groups in holes in the ground.

The robust, cylindrical, hairy, light-brown mole cricket *G. africana* is approximately 35 mm in length and can be identified by its massively developed, mole-like forelegs, which have been suitably adapted for digging. The forelegs are very strong and, when handled, the creature can easily push its way through one's fingers. This cricket lives in burrows and feeds on the roots of herbaceous plants. The eggs are laid in a nest chamber in a burrow and the larvae may take up to two years to reach maturity. The species is well distributed and is found in wet and arid areas. Interestingly, they emerge in

▲ Pyrgomorphidae > *Dictyophorus spumans* (Koppie Foam Grasshopper)

▼ Gryllotalpidae > *Gryllotalpa africana*

reasonable numbers and are abundant for a week or so, after which they seem to disappear.

HYMENOPTERA

Camponotus fulvopilosus, the Yellow-haired Sugar Ant or *Balbytmier* in Afrikaans, is pictured here. It seems to be trying to catch an adult lycaenid butterfly, which is a bit puzzling as there is an association between these ants and butterflies. The larvae of some lycaenids live in *Camponotus* nests and eat the ant larvae. *C. fulvopilosus* is common in the Karoo and arid savannah regions of southern Africa. In the Karoo, the hairs are quite a dark yellow whereas in savannah regions they are a light yellow or buff colour.

This medium-sized ant, *Anoplolepis custodiens*, is approximately 10 mm in length. The body is reddish brown, with the head redder than the rest of body. Its waist has a single segment and the abdomen appears chequered because of the rows of refractive hairs. The workers have well-rounded abdomen. The species does not run in trails and tends to wander. The nests are built below ground, without a mound around the nest entrance. Workers are fast-running, very aggressive and predatory. This species is important in seed dispersal. Interestingly, the spider mimic, *Myrmarachne* sp., is regularly found with the ants.

▲ Formicidae > *Camponotus fulvopilosus* (Yellow-haired Sugar Ant)

▼ Formicidae > *Anoplolepis custodiens* (Pugnacious Ant)

▲ Mutillidae > *Cephalotilla* sp.

▼ Mutillidae > *Dasylabris merope*

Cephalotilla sp., a female velvet ant, is a medium-sized insect approximately 10 mm in length. This species has a reddish-brown thorax and a series of silver bands on the abdomen. The head and legs are a greyish-black colour. The body is extremely hard and coarsely punctured, covered with soft velvety hairs. This species is common in semi-arid, sandy parts of South Africa, where it is regularly seen on the ground in the heat of the day.

Dasylabris merope, a female velvet ant, is a medium–sized, wingless wasp approximately 18 mm in size. This species has a brownish thorax and large yellow blotches on the abdomen. The head and legs are slate blue. The body is extremely hard and coarsely punctured, covered with soft velvety hairs. The majority of species in this group parasitise the larvae of other insects. This species occurs in arid woodland savannahs and is regularly observed on sandy patches under Camel Thorn trees (*Acacia erioloba*).

ARACHNIDA

Peucetia viridis, a green lynx spider, is approximately 20 mm in length. The male is the same size as the female. Their bodies are green overall with red or pinkish markings and a darker, leaf-shaped pattern on the dorsal side of the abdomen. Like chameleons, these spiders are known to change their colour slowly to blend with the colour of the plant on which they live. Their long, strong legs taper towards the ends and are covered with conspicuous spines. They are found on vegetation and are active hunters of other insects. They have excellent vision, bounding up to grab passing insects. The female guards her egg sac by hanging beneath it. The species is well distributed and common in the semi-arid savannah regions of the Northern Cape.

▼ Oxyopidae > *Peucetia viridis* (green lynx)

This small spider, *Ammoxenus amphalodes*, is approximately 7 mm in length. The body is brown, with a bright reddish-brown abdomen. The males are usually more brightly coloured than the females. The legs are long and flexible, almost antennae-like. All members within this family are endemic to southern Africa. The species specialises and feeds on harvester termites, *Hodotermes mossambicus*. This sand-dwelling spider can be found wherever its prey is active and lives in soil heaps at the mouths of harvester termite burrows. They also rest and bury their cup-shaped egg sacs in these soil heaps. They can move exceptionally fast and, if disturbed, will dive head-first into the soil heaps, flip over on to their backs and bury themselves. They spin sand particles in a silken lid under which they seek protection and avoid excess heat. This species is relatively common in arid and semi-arid environments.

This ant-mimicking spider, *Myrmarachne* sp., is a small creature approximately 10 mm in length. The body is very similar in coloration and form to the Pugnacious Ant, *Anoplolepis custodiens*. This spider mimics the ants, not necessarily to prey upon them but to gain the protection of numbers. This also prevents the ants from preying on the spiders. Potential

▲ Ammoxenidae > *Ammoxenus amphalodes* (sand-diving spider)

▼ Salticidae > Myrmarachninae > *Myrmarachne* sp.

▲ Eresidae > *Seothyra* sp. (buckspoor spider)

spider predators tend to avoid ants because they bite, sting and swarm over their predators. This spider is a solitary hunter which feeds on small insects. Interestingly, a method of observing this species entails knocking a branch with perceived ants and spiders; the ants fall to the ground, while the spiders 'bungee' on a thread of silk. The species is relatively well adapted to living on the ground and on foliage. It is well distributed in South Africa, ranging from semi-arid to subtropical regions.

The buckspoor spider *Seothyra* sp. does not build true webs but constructs vertical silk-lined burrows in the sand, closed with a lobed silky mat built flat on the ground, which incorporates sand and is slightly concave in the centre.

The two-lobed webs resemble the hoof print of a medium-sized antelope, hence the common name. This spider catches insects like ants and other small insects in a similar way to antlions; it literally catches prey on the 'spoor'. The trap is often found in sandy areas, sometimes alongside the pits of antlion larvae. The insect falls into the 'spoor', their feet hook on to the silk and the spider is attracted to claim a meal.

The male buckspoor spider *Seothyra* sp. is approximately 10 mm in length. The body is reddish brown in colour with a greyish abdomen. This species is thought to mimic the velvet ants Mutillidae, which have a painful sting. This species is active at night and during the day and does not rely on sight to catch its prey.

This interesting species of Daddy Longlegs, *Smeringopus pallidus*, is similar to the traditional species found in most urban homes. It is slightly smaller, approximately 12 mm in length. The body is brownish grey in colour with a distinct pattern on the abdomen. The photograph shows hundred of individuals under a rock during winter. It is assumed that this congregation is linked to a hibernation pattern during cold weather, after which they probably disperse when temperatures increase. This group was relatively inactive; one individual was carrying an egg sac. The distribution range of the species is not known but it appears to occur in semi-arid environments.

▼ Pholcidae > *Smeringopus pallidus* (aggregation)

Kalahari, Northern Cape: landscape

◀ Summer rains in the Kalahari bring a flush of green plants and flowers. With them come the insects – in this case a young armoured ground cricket.

The name Kalahari is derived from the Setswana word Kgalagadi which has been given several interpretations, the most likely being 'the land that has dried up' or the 'dry land'. There is a romantic magic to the Kalahari, which affects anyone visiting the area. This may be caused by the wide open spaces, with red, rolling sand dunes, dotted with Camel Thorn (*Acacia erioloba*), or perhaps a feeling that this is a very ancient land. This is truly another world. The vast areas of red sand, shrubs and tall trees in the western interior of the country are home to an amazing variety of invertebrates, specially adapted to survive in this harsh, dry yet savagely beautiful part of the country. What appears to be homogeneous sometimes turns out to be very diverse, and a single dune may harbour a different species of tree, which may be host to a specific species of insect. During the dry periods, the area often resembles a desert, but when the first rains come, there is an explosion of life. Seasonal rivers and streams start flowing again and for a period the area becomes a 'fairyland' of flowers and beauty. Very large numbers of butterflies are seen dipping in and out of the foliage, beetles emerge on the red sand and pollinators visit the various flowers which appear during this time of plenty. Insects of all shapes and sizes create a true 'buzz' in the air, and life is everywhere.

Rain is the driving force behind the Kalahari ecosystem: plants and animals alike respond dramatically when it arrives. The timing and amount of seasonal rainfall in summer, the existence of relatively long rainfall and drought cycles, and the seasonal flow of streams are key factors in the ecological dynamics of this system. The Kalahari is notorious for its harsh climatic extremes. The rainfall is so erratic that in some years parts of the Kalahari receive no rain at all. In other years it is drenched with more than adequate rain. Night

▲ A couple of days after rainfall, yellow devil's thorn flowers carpet the landscape, providing scrumptious food for many mammals and insects.

▼ Good summer rains turn the Kalahari into flowering grassland dotted with Velvet Raisin Bush, *Grewia flawa*.

temperatures can drop significantly below zero, while day temperatures can exceed 40°C. The heat and drought have made water the overriding need of all creatures. The water supplies are often hidden and creatures often make use of moisture in the ground and air, as well as in plant and animal material. In these areas of high evaporation and low annual rainfall, deep soils are needed for trees and shrubs to survive. As the rainfall increases and evaporation decreases, shallower soils can support the growth of trees and shrubs.

The soils in the Kalahari are of Aeolian origin and are characterised by red, deep, sandy soils overlaying a bed of calcrete. The landscape is a sea of rippled sand plains interspersed with islets of pale pans. These sandveld dunes and plains play interlocking roles in the cycles of climate and insect behaviour. The dunes sometimes converge and cross like waves in turbulent seas, blanketing a bed of sandstone, calcrete and conglomerate. The striking shades of redness vary from pink through to orange and almost crimson and are caused by the minutely thin coating on every sand grain of iron oxide, which leached out of the earth millions of years ago in slow geological and climatic processes. The redeeming factor of the sand is that it quickly absorbs and holds the precious rainfall, saving it from evaporation and giving life to an abundant growth of edible grasses, flowers, shrubs and trees. In good seasons, these cover the countryside in a multi-coloured patchwork of white-gold grasses and beautiful flowering plants. The sand is also a very good insulator, as a few centimetres beneath the soil the temperature can be 15 degrees lower while its surface is roasting at 70°C. This makes it possible for invertebrates to live there in their own micro-ecosystems. The pans are considered to be the remains of old water courses that once drained the region until the wind covered it with sand. They are no particular shape or size and are scattered throughout the Kalahari. The pans consist of more different kinds of soil than the sandy area; they accumulate rainwater, sustain a more varied and denser growth of plants, and concentrate chemicals, including salt. In this way, the pans make an important contribution to life in the Kalahari.

Kalahari vegetation is unique and varied. There are seven different vegetation types, the two most important being the thorny Kalahari dune bushveld and the shrubby Kalahari dune bushveld. The latter has been found on deep sand at an altitude of about 1000 m above sea level and is characterised by 'dune streets', or parallel rises and valleys. The vegetation is sparse, mainly Camel Thorn (*Acacia erioloba*), Black Thorn (*Acacia mellifera*) and Shepherd

Tree (*Boscia albitrunca*). The abundant Kalahari grasses include Lehmann's Love Grass (*Eragrostis lehmanniana*), Kalahari Sour Grass (*Schmidtia kalihariensis*) and Kalahari Dune Bushman Grass (*Stipagrostis amabilis*). The Grey Camel Thorn (*Acacia haematoxylon*) and Silver Cluster Leaf (*Terminalia sericea*) growing on the crests of dunes are the dominant tree species.

The vegetation of the Kalahari dune veld is dominated by perennial herbaceous plants, whose new buds grow close to the soil level, and by annual plants. It has been suggested that in sandy soils these growth forms have root systems that are better able to utilise the sporadic or light rainfall than shrubs.

The high percentage of annual species is typical of most arid or semi-arid

▲ The sun sets behind a caterpillar feeding on a Lavender Fever Berry bush.

▲ The Kalahari houses many excellent beetles and bugs – especially in the summer months.

▼ A blister beetle feeds on a yellow Devils Thorn flower with a Camelthorn tree in the background.

areas. Although the contribution of trees and shrubs to the spectrum of life is relatively low, they are virtually the dominant growth form. There are very few species of succulents in this summer rainfall area; this is possibly due to the severe frosts, which occur at night.

The perennial plant species form the backbone of the system, providing many invertebrates with a stable supply of food in both wet and dry seasons. The annual species can be regarded as an unreliable luxury, abundant only during favourable periods but absent during droughts. Their seeds survive the unfavourable periods. But the annuals often have large, flamboyant flowers to attract insects and give the desert short-lived but spectacular splashes of colour. Seed dispersal at the end of the rainy season is efficient and many seeds are dispersed by wind, ants, mammals and birds. The seeds of certain grasses corkscrew into the sand.

During the hot, dry season, most woody species are leafless so as to reduce water loss. The perennial grasses remain dry and dormant; nutrients are stored in their deeper-penetrating roots. Bulbs and tubers survive beneath the ground while other plants survive as dormant seeds in the soil banks. Plants and invertebrates are under duress during the early summer months and conserve their water reserves as best they can.

Flat to undulating grassy plains on deep-reddish sand are widespread throughout the Kalahari and encompass the major part of the dune veld in the interior. The vegetation is well-developed grassland interspersed by shrubs such as the Grey Camel Thorn (*Acacia haematoxylon*) and velvet Raisin Bush (*Grewia flava*). *Hermannia burchellii* and Sandganna (*Plinthus sericeus*) are conspicuous while Dune Bushman Grass (*Stipagrostis amabilis*), the Giant Three-awn (*Aristida meridionalis*), Lehmann's Love Grass (*Eragrostis lehmanniana*), the Silky Bushman Grass (*Stipagrostis uniplumis*), Gha Grass (*Centropodia glauca*) and Kalahari Sour Grass (*Schmidtia kalihariensis*) are the dominant grass species. Noteworthy herb species are *Heliotropium ciliatum*, *Ipomoea hackeliana*, the Wild Sesame (*Sesamum triphyllum*) and the Waxberry (*Pollichia campestris*).

The dune valleys and the edges of pans are associated with white, compact sands. The high calcrete content of the soil contributes to the colour of the sand. A shrub savannah develops in this habitat, characterised by Three Thorn (*Rhigozum trichotomum*), Blouganna (*Monechma incanum*) and *Aptosimum albomarginatum*. The dominant grass species are Small Bushman

Grass (*Stipagrostis ciliata*) and Silky Bushman Grass (*Stipagrostis uniplumis*).

The numerous pans scattered through the Kalahari are focal points for many of the wildlife species. Soils in these pans are generally white calcareous sandy or clay soils. The vegetation around the pans is quite distinctive and often marked by concentric zonation. The pan floors and their periphery are dominated by grasses such as the Small Dropseed (*Sporobolus coromandelianus*), the Pan Dropseed (*Sporobolus rangeri*) and Eight Day Grass (*Enneapogon desvauxii*). Dwarf shrubs such as Ganna (*Salsola* spp.) and Kriedoring (*Lycium cinereum*) are also found here.

The Kalahari is not a true desert but rather an arid savannah. It is quite densely covered with grasses, shrubs and trees. It is regarded as one of Africa's last wilderness areas and is probably one of the largest relatively undisturbed arid savannahs in Africa. Its inaccessibility and lack of prominent landmarks and surface water for most of the year have contributed to minimal human impact and the consequent preservation of this area.

Besides an abundance of game and bird species, the Kalahari's remoteness attracts people to the area. Fires, though infrequent, can be caused by lightning

▲ After good rains, a variety of herbaceous plants start flowering, increasing substantially the amount of food available for invertebrates.

▼ Large hatchings of caterpillars can strip the surrounding plants bare of all their foliage.

especially after a year of high rainfall. Under such conditions, large fires can sweep through the veld and have a disastrous effect. Even large Camel Thorns can be felled as a result of the intensity of the fire. Most Kalahari species are adapted to deal with fire and their mortality is low.

The Kalahari is a rich store of bugs and beetles. Many inhabit the sand or live in the vegetation or water. In contrast to the often bewildering complexity associated with forest life, the relative simplicity of the arid ecosystem in the Kalahari enables us to better understand the involvement of invertebrates in ecological processes. Beetles, mainly tenebrionids, are abundant in the Kalahari though most of them are also found in adjacent areas. Certain tenebrionids show the rudimentary signs of gregarious behaviour and appear to congregate in the same area and share the same food store with others of its species. Unless one sets out with the specific intention of observing invertebrates in the Kalahari, their diversity and sheer abundance may often be overlooked.

All the invertebrates living in the Kalahari share a remarkable capacity to survive the extreme aridity. Some have evolved notable physical adaptations to retain moisture. The pyramid of life is elegantly revealed in the Kalahari. Many invertebrates rely on the moisture in their food sources to survive without drinking for long periods of time, some indefinitely. The moisture they absorb from the plants and from soil and air is sufficient for many invertebrates. When the desert becomes too dry, as it often does, many invertebrate species need to take special action in order to survive. The unusual climatic conditions cause extreme patterns of insect activity. In some cases, a species may be present in very large numbers but after a week may have disappeared entirely. During times of plenty, the invertebrates, too, are abundant and breed prolifically. If a harsh period follows and they have consumed all the available food, or the air becomes so dry that the vegetation loses all its moisture, they either migrate or perish.

Wet conditions cause the immense swarming of insects as they emerge from the egg or from their dormant period. There are few areas in the world as exciting as the Kalahari ecosystem, which works together as one giant organism. In the savagely extreme conditions of the Kalahari, where everything that can sustain invertebrate life is taxed to the limit, every possible species of plant plays an important role in the endless cycle of life. Even fallen trees provide important hideaways for an enormous variety of

▲ Sociable weaver nests are characteristic of the Kalahari with one nest housing hundreds of birds.

insects living in the desert. As barren as the terrain sometimes appears, there are actually hundreds of species of flora represented, from tiny ephemeral flowers clinging to the sand to the majestic Camel Thorns scattered across the rolling sand dunes.

In the Kalahari one can expect to bake in the day and freeze at night. It is also a unique and fascinating ecosystem, one of the world's few wilderness areas to have survived largely intact over the past century. At first glance, the Kalahari may appear barren yet if one is in the right place at the right time, the invertebrate diversity one can experience is astounding.

▲ Storm clouds build over a Kalahari sky.

COLEOPTERA

Beetles have mandibles for chewing, allowing them to feed on a variety of different creatures and plant matter, including mammal and bird skins, other insects, wood, fruit, nectar, fungi and leaves. Their mandibles differentiate them from the bug species.

Lycidae (net-winged beetles)

The lycid beetles are plant feeders and large numbers may be found on grass stalks, where they occur singly or as mating pairs. Interestingly, when harassed, they do not attempt to escape but become comatose, cleverly 'playing dead'. The diurnal adults occur on foliage and flowers, sometimes in very large numbers. Their striking colours are a warning to predators, and a diverse number of other species mimic them, including the longhorn beetles *Nupserha apicalis*. The bright colours warn other creatures that they are distasteful. Little is known about the biology of this family. The larvae resemble those of the Lampyridae, and they are reported to live in rotten wood, dissolving the woody matter with their digestive juices and then sucking up the fluid.

Lycus rostratus, a net-winged beetle, is a medium-sized insect approximately 20 mm in length. It is black in colour while the neck shield is orange with a central dark spot. The black wing covers are expanded and have an uneven band of orange across the middle. The antennae are also black and strongly serrated. This species feeds on flowers and is common in the Kalahari dunes, where large numbers can be observed on the flowery growth of grass inflorescences.

Carabidae (ground beetles)

A number of ground beetles noted for their chemical defence mechanisms are members of the genus *Anthia* and related genera. These are strikingly large, black beetles, about 25–50 mm in length, many of them with yellow or white spots or stripes on the thorax or wing covers. They are found throughout Africa and can often be seen running about rapidly during the day. They cannot fly as their wing cases are firmly joined and the lower membranous wings have now disappeared. These beetles are fierce hunters with strong, sharp jaws and can inflict a nasty bite on a careless collector's hand.

Some species are well known for their defence mechanism, squirting a

▲ Lycidae > *Lycus rostratus*

strong jet of formic acid and a cocktail of other organic acids, which results in itching and burning of the skin or eyes. Special pygidial glands in the region of the ninth abdominal segment secrete these substances. The beetles seem to have exceptionally accurate aim, often hitting the attacker straight in the eye. The *Anthia* beetles can squirt the formic acid up to 30 cm in any direction when threatened. The fluid can cause severe pain if it comes into contact with human skin and more serious problems if it gets into the eyes. Some species of the genus *Chlaenius* have parasitic larvae, which feed on the eggs of mole crickets.

A *Chlaenius* beetle recorded from the Kalahari demonstrates another departure from the typical predacious behaviour of carbids. These often gregarious beetles have been seen dismembering large, dead or dying insects.

Chlaenius perspicillaris, a ground beetle, is a medium-sized insect approximately 12 mm in length. The body is a uniform black in colour, with two large rust-coloured patches on the wing covers. The neck shield is almost square and finely punctured. The wing covers bear deep longitudinal grooves. The relatively long antennae are black with yellowish bases and project forwards. The legs are pale with dark joints. The beetles are well adapted to preying on insects that live on the ground. This species is relatively common in the savannah woodland areas of the Kalahari.

Passalidius fortipes, the Burrowing Ground Beetle, is approximately 32 mm in length. The body is black and parallel-sided. The head is relatively small when compared with the rest of the body but has large, serrated mandibles. The antennae are bead–like, projecting sideways. The neck shield is large and smooth and narrows considerably at the abdominal link. The wing covers are oblong with deep longitudinal grooves. The adults of this species burrow in the soil, where they hunt and feed on insect larvae and worms. This species is widespread in a variety of different habitats in the Kalahari.

Graphipterus atrimedius, a diurnal species of ground beetle, is approximately 15 mm in length. The head is black with large compound eyes. The neck shield and wing covers are densely covered with yellowish-brown flattened hairs, outlined with a margin of pale hairs. A single, broad, black stripe runs longitudinally through the centre of neck shield to the end of the wing covers, where it appears to taper. This beetle has thin, forward-projecting antennae, which are black with brownish-orange bases. The brownish-orange legs are long, slender and well suited for swift movement as they catch and devour

▲ Carabidae > Licininae > *Chlaenius perspicillaris*

▼ Carabidae > Scaritinae > *Passalidius fortipes* (Burrowing Ground Beetle)

▼ Carabidae > Lebiinae > *Graphipterus atrimedius* (Single-striped Velvet Ground Beetle)

other ground-dwelling insects. This species is active at the hottest time of the day and is common in the grass-covered areas of the Kalahari.

Graphipterus bilineatus, a diurnal species of ground beetle, is approximately 12 mm in length. The body is black, with two strips of pale hairs between the compound eyes. The neck shield has a black line in the centre, with indistinct brown edges. The wing covers are densely covered with brown hairs and have two longitudinal black stripes. This species is an active hunter of other ground-dwelling insects. It is relatively widespread in sandy conditions in a number of habitats.

Graphipterus limbatus, a small diurnal species of ground beetle, is approximately 10 mm in length. The body is black, with two longitudinal bars of white flattened hairs between the compound eyes. The neck shield and wing covers are not striped but densely covered with yellowish-brown flattened hairs, outlined with a margin of pale hairs. This species is an active hunter of other ground-dwelling insects. It is relatively widespread in arid areas of the Kalahari with limited vegetation.

Anthia limbata, a large ground beetle, is approximately 30 mm in length. The beetle is glossy black with a particularly large head and compound eyes. This species has large mandibles for preying on other ground-dwelling insects.

▲ Carabidae > Lebiinae > *Graphipterus bilineatus* (Two-striped Velvet Ground Beetle)

▶ Carabidae > Anthiinae > *Anthia limbata*

▼ Carabidae > Lebiinae > *Graphipterus limbatus* (Velvet Ground Beetle)

◄ Carabidae > Anthiinae > *Anthia homoplata* (White Patch Ground Beetle)

▲ Carabidae > Anthiinae > *Anthia cinctipennis*

▼ Carabidae > Anthiinae > *Cypholoba gracilis*

The neck shield is broad and slightly flattened. The wing covers are black with conspicuous longitudinal grooving. The antennae are long and segmented and project forwards. This is a nocturnal species which is extremely active and capable of considerable speed. It is relatively widespread in the Kalahari system.

Anthia homoplata, a large ground beetle, is approximately 37 mm in length. The beetle is a smooth and a matt black. The head is relatively elongated with large compound eyes and mandibles. The neck shield is large and bulbous in shape. The wing covers are matt black and smooth, with two conspicuous, irregular, faded white anterior patches and a white posterior margin. The antennae are long and beaded and project forwards. The legs are well developed for running. This is a nocturnal species which feeds on small insects and is relatively common in the Kalahari system.

Anthia cinctipennis, a large ground beetle, is approximately 35 mm in length. The body is shiny black with numerous light, fine hairs. The head is relatively elongated and flattened with large compound eyes and mandibles. The neck shield is large, slightly raised and shaped like a shield. The wing covers are matt black, with a distinctive white margin. The antennae are long and project forwards. The legs are long and appear to hold the body high off the ground. This is a nocturnal species which feeds on small insects and is relatively common in the flat, open, sandy areas of the Kalahari.

Cypholoba gracilis, a small ground beetle, is approximately 20 mm in length. The head and neck shield are black and clearly separated from the

▲ Carabidae > Anthiinae > *Atractonotus mulsanti* (Ant-mimicking Ground Beetle)

▼ Carabidae > Cicindelinae > *Manticora tibialis*

rest of the body. The neck shield has a distinctive grey, longitudinal line. The wing covers are black and grooved longitudinally, forming a characteristic pattern of raised lines and punctures. This species is relatively widespread and is common in the open sandy or grassy areas of the Kalahari, where it is a predator of ground-dwelling insects.

Atractonotus mulsanti, a tiny ground beetle, is approximately 11 mm in length. The body is black and ant-like as a result of the combination of an elongated head, separated by a narrow neck from the neck shield, and relatively narrow wing covers and bulbous abdomen. The black antennae are longer than the head and neck shield and tend to project forwards. The wing covers are black and grooved longitudinally, with four, pale spots of hairs. This ground-dwelling species mimics large ants. It is relatively widespread and common in the Kalahari where it is a predator of small ground-dwelling insects.

Cicindelinae (tiger beetles)

Tiger beetles are medium-sized to large (10–70 mm) and often colourful. Some are brilliantly coloured with vivid patterns on the wing covers, such as *Dromica*. Others, such as *Mantichora*, are uniformly black. The *Dromica* are a genus of typical tiger beetles and are common in South and East Africa. Less typical are the members of the genus *Mantichora*, which are commonly recorded in arid and semi-areas in South Africa. Their mandibles crush through the hard exoskeletons of other beetles with ease and they can inflict a painful bite on a careless human handling them. The adults prefer open sandy areas like roadsides and the edges of dams. They are mainly active during the hottest hours of the day, running rapidly in search of prey. When disturbed, many of them take flight but settle again soon. Even the wingless species, such as the streamlined *Dromica*, are very agile and fast.

Manticora tibialis, a large, wingless tiger beetle, is approximately 40 mm in length. This beetle is blackish brown with numerous, erect, fine hairs. The wing covers are blackish-brown and well flattened. This species has enormous mandibles, which are used for feeding on other ground-dwelling insects. It is nocturnal in habit but may also be active in the early mornings, late afternoons and on overcast days. They are exceptionally active insects and can move quite fast. The female thrusts her ovipositor into soft sand, usually after rain, and lays about half a dozen eggs. This species is relatively common in the Kalahari but seems to appear and disappear depending on the climatic conditions.

Myriochile melancholica, a small tiger beetle, is an insect approximately 11 mm in length. The beetle is bronze-coloured with lighter underparts. The wing covers are also bronze with a few scattered creamy markings. The long, metallic-brown legs are covered in fine, white hairs. This species has quite large mandibles for hunting small insects. It is relatively widespread in semi-arid conditions and is common around watering points in the Kalahari.

Cylindera dissimilis, a small tiger beetle, is an insect approximately 10 mm in length. The beetle is metallic black with sparse, white, irregular markings on the wing covers. The head is large with bulbous compound eyes and a conspicuous cream colouring around the mandibles. The head and the neck shield are metallic bronze. The long, metallic-black legs are covered in fine, white hairs. This species has quite large mandibles for hunting small insects. It is relatively widespread in semi-arid conditions and is common on sandy areas around water in the Kalahari.

Dromica costata, a flightless tiger beetle, is approximately 22 mm in length. The entire beetle is a metallic-black colour. The head is black with large, bulbous, compound eyes and conspicuous white colouring around the mandibles. The wing covers are black with pronounced longitudinal lines and punctures, creating a beaded effect. The long, black legs are well adapted for rapid movement. The underside of the abdomen has patches of pale hairs, which contrast with the black body. This species is a diurnal hunter of small, ground-dwelling insects and inhabits the sandy and grassy areas of the Kalahari.

Dromica lateralis, an attractively marked tiger beetle, is approximately 16 mm in length. The beetle is a metallic blue-black colour. The head is black

▲ Carabidae > Cicindelinae > *Myriochile melancholica*

▼ Carabidae > Cicindelinae > *Cylindera dissimilis*

◄ Carabidae > Cicindelinae > *Dromica lateralis*

▼ Carabidae > Cicindelinae > *Dromica costata*

▲ Chrysomelidae > Cryptocephalinae (formerly Clytrinae)

▼ Chrysomelidae > Galerucinae

and coppery green on top. These beetles have conspicuous, large, bulbous, compound eyes and white colouring around the mandibles. The neck shield is blue-black underneath and a coppery green on top. The wing covers are coppery green with pronounced punctures and a broad cream edge. The long, black legs have patches of white hairs at the bases. The underside of the abdomen is a metallic blue-black. This species is a diurnal hunter of small ground-dwelling insects and inhabits the shady savannah regions of the Kalahari.

Chrysomelidae (leaf beetles)

The members of the subfamily Galerucinae of the large family Chrysomelidae are common in South Africa. *Dircemella* is a well represented genus of the Galerucinae and has a wide distribution. Many species of the Galerucinae can jump. This is a large subfamily consisting of very variable beetles. It includes large, semicircular ones, broad and flattened parallel-sided ones, and long and slender species. The wing covers are often comparatively soft.

This species of chrysomelid (top left) is greenish grey in colour and approximately 11 mm in length. The head is partially embedded in the neck shield. The first four antennae segments are reddish in colour, becoming dark toward the end. The body is elongated with fine longitudinal ridges and punctures. The greenish legs of this species are well adapted to its life amongst the foliage. The species is relatively common in the semi-arid savannah areas of the Kalahari.

Many species are often metallic or brightly coloured and with or without spots or bands. Some are elongated, metallic green beetles with quite soft wing covers and are often found on flowers, whereas other species live in large numbers on their food plants, which they often completely defoliate. Some females lay their eggs in clusters on the underside of leaves, others directly in cracks in soil. The oval, often yellowish eggs gradually darken to a dark-brown colour. They take a week or so to hatch and the larvae feed ravenously on either the leaves or roots of the host plant. The larvae then change relatively rapidly into pupae and within about a week the adult beetle emerges. There may be as many as six generations in a year.

This pretty leaf beetle (bottom left), belonging to the subfamily Galerucinae, is a small insect approximately 6 mm in length. The body is light brown and somewhat elongated. The antennae are long and light brown in colour with dark-brown ends. The head and neck shield are light brown with dark-brown markings. The metallic-green wing covers are a diagnostic feature of the species. The legs are light brown and well adapted to clinging to leaf surfaces.

This species is relatively common in the semi-arid savannahs of the Kalahari, where it feeds on the foliage of a variety of different plant species.

Phaedonia circumcincta, a leaf beetle, is a small insect approximately 5 mm in length. The body is black and orangy-brown and relatively rounded. The antennae are short and orange. The head is small and black, while the large neck shield is a brownish orange with a distinct black longitudinal band above the head. The wing covers are black, glossy and bulbous and have orangy-brown margins. The legs are black with some orange banding. This species is relatively common in the Kalahari and feeds on the foliage of a variety of plant species.

Afromaculepta sp. is a small insect approximately 4 mm in length. The body is beige and black. The antennae are beige and relatively long for an insect of this size. The black head is reduced, with a large, glossy neck shield of an orangy-brown. The wing covers are beige with black spots. The legs are beige and well adapted to climbing smooth leaf surfaces. This species is relatively common in the Kalahari and feeds on the foliage of a variety of plant species.

Caryedon multinotatus is relatively common in the Kalahari system, yet not often observed as a result of its effective camouflage and habit of lying flat against the stems of branches.

Tenebrionidae (darkling beetles)

The larvae of Tenebrionidae resemble mealworms and live mainly in the soil or other concealed positions, where they generally feed on dead vegetable matter, although certain species specialise in feeding on bracket fungi. The *Psammodes* have long, smooth, yellow larvae which live in the soil and feed on the roots of grasses and other plants. The tribe Drosochrini is predominantly southern African with several genera comprising over 100 small species. They are all wingless and nocturnal, and usually found under stones. They are well adapted to arid environments, some of them even to extremely sandy conditions, and form part of the characteristic wingless tenebrionid fauna of southern Africa. *Anomalipus* and *Gonopus* are predominantly inhabitants of the savannah and semi-arid regions of South Africa. These species are from the tribe Platynotini and are medium to very large black beetles. Together they are characterised by their well-developed stridulatory organs. Many tenebrionids are exceptionally fast-moving and have well-developed legs, allowing them to skim across the surface of the sand. Members of the subfamily Tentyriinae vary greatly in size (2–65 mm) and are the largest of all the tenebrionids in the Kalahari species e.g. *Psammodes sulcicollis*.

▲ Chrysomelidae > Chrysomelinae > *Phaedonia circumcincta*

▼ Chrysomelidae > Galerucinae > *Afromaculepta* sp.

▼ Chrysomelidae > Bruchinae > *Caryedon multinotatus*

▲ Tenebrionidae > Adelostomini > *Stips dohrni* (Ridged Seed Beetle)

▼ Tenebrionidae > Adesmiini > *Epiphysa flavicollis* (Tortoise Darkling Beetle)

▼ Tenebrionidae > Adelostomini > *Eurychora* sp.

Stips dohrni, a tenebrionid beetle, is approximately 11 mm in length. The body is oval, flattened and creamy brown, often with a layer of soil covering the body. The legs and antennae in this species are relatively short. The head with its longitudinal ridge is diagnostic of the species. The neck cover is expanded with two longitudinal ridges. The flattened wing covers have one longitudinal ridge running down the mid-line and two semicircular ridges that join the legs at the back. This nocturnal species feeds on decomposing plant material and inhabits the vegetated dunes in the sandy, arid areas of the Kalahari.

Epiphysa flavicollis, the striking Tortoise Darkling Beetle, is a medium-sized insect approximately 22 mm in length. The body is a matt black and rounded, with a transverse band of golden hairs on the back of head and in front of the neck shield. There are distinctive swellings in front of the eyes. The thick mandibles are short but prominent. The legs are well developed for running. The rounded wing covers are covered with fine tubercles. This species is long-lived and appears to hibernate in burrows or disused shelters during unfavourable climatic conditions. It feeds on decomposing plant and animal material and inhabits the arid savannah parts of the Kalahari.

Eurychora sp., an interesting-looking mouldy beetle, is a medium-sized insect approximately 14 mm in length. The neck shield is expanded into flanges on either side of the head. The upper surface is flattened and covered with red Kalahari soil particles, held in place by long stout hairs and waxy filaments. These particles camouflage the beetle in its surroundings, where they are scavengers and feed on a variety of plant remains. This ground-dwelling beetle is observed regularly in semi-arid desert environments such as the Kalahari.

▲ Tenebrionidae > Molurini > *Psammodes vialis*

◀ Tenebrionidae > Adelostomini > *Serrichora murina*

▼ Tenebrionidae > Platynotini > *Gonopus puncticollis*

▼ Tenebrionidae > Platynotini > *Gonopus deplanatus*

Serrichora murina, a mouldy beetle, is approximately 12 mm in length. The body is grey-black. The head is an indefinite square, with broad, dark, forward-projecting antennae. The neck shield is expanded into flanges on either side of the head. The upper surface is flat and covered with soil and vegetable debris, held in place by long, stout hairs and waxy filaments; this makes the beetle look as if it is covered with spider webs. This nocturnal species is associated with burrows and plant debris in semi-arid habitats such as the Kalahari.

Psammodes vialis, a large tenebrionid beetle, is approximately 28 mm in length. The body is black or brown, glossy, stout and globular in shape. The bead-like antennae project forwards. The wing covers are smooth, with characteristic tubercles on the sides and at the back. The neck shield is large and pronounced. This is a wingless, ground-dwelling species which is well adapted to running. It is often found in arid parts of the country and is relatively common in the Kalahari, where it feeds on plant and animal material.

Gonopus puncticollis, a medium-sized tenebrionid beetle, is approximately 20 mm in length. The matt black body is relatively flattened. The head is small and embedded into the large neck shield, which is finely punctured. The wing covers are moderately rounded with conspicuous longitudinal grooving. This species has stout and strongly developed legs, each leg armed with sharp, forward-pointing spines. The antennae in this species are fairly short and beaded. The larvae live in soil, feeding on roots and dead plant matter. This species is regularly found on Kalahari dunes.

▲ Tenebrionidae > Platynotini > *Anomalipus* sp.

▼ Tenebrionidae > Molurini > *Phanerotomea* sp.

▼ Tenebrionidae > Drosochrini > *Diestecopus* sp.

228 A Landscape of Insects

Gonopus deplanatus, a large tenebrionid beetle, is approximately 25 mm in length. The body is flattened and matt black. The head is small and partially embedded into the neck shield. The neck shield is squarish and flattened and has a distinct slightly ridged margin. The wing covers bear shallow, longitudinal grooves with fine punctures. This species has stout, serrated, strongly developed legs. The antennae are fairly short and beaded. The larvae live in soil, feeding on roots and dead plant matter. This species is regularly found in the semi-arid savannah areas of the Kalahari.

Anomalipus sp., a large tenebrionid beetle, is approximately 30 mm in length. The matt black body is heavily built. The head and neck shield are smooth and finely punctured. The neck shield is expanded sideways and wider in the middle than at the abdomen. The ribbed wing covers are strongly sculpted. This species has stout, strongly developed legs. It is diurnal and lays a single egg in a shallow hole, after which the larvae feed on roots and dead plant matter. This species is often found in shaded areas in the semi-arid Kalahari, where the adults feed on plant litter.

Phanerotomea sp., a medium-sized tenebrionid beetle, is approximately 24 mm in length. The body is matt black and elongated with tapering wing covers. The antennae are short and bead-like. The neck shield is fairly rounded and strongly punctured. The wing covers are smooth and dome-shaped. This is a wingless, ground-dwelling species well adapted to running. The individual in the photograph has obviously escaped predation, as demonstrated by the large hole in the abdomen. This species feeds on plant and animal matter and is common in sandy Kalahari conditions.

Diestecopus, a small tenebrionid beetle, is approximately 15 mm in length. The body is matt black and rounded. The neck shield is somewhat square and finely punctured. The antennae and legs are relatively short. The dome-shaped wing covers are strongly sculpted and punctured. This species feeds on plant and animal matter and is relatively common in plant debris in most Kalahari habitats.

Decoriplus sp., a small tenebrionid beetle, is approximately 14 mm in length. The grey-black body is slightly flattened and densely covered in fine, erect, brown hairs. The neck shield is large and finely convex in shape. The antennae are long and project forwards. The wing covers are characteristically patterned with fine, brown hairs, giving a streaky effect. The species feeds on plant and animal matter in the semi-arid sandy conditions of the Kalahari.

◄ Tenebrionidae > Molurini > *Decoriplus* sp.

◄ Tenebrionidae > Sepidiini > *Echinotus spinicollis*

230 A Landscape of Insects

Echinotus spinicollis, a spiny tenebrionid beetle, is approximately 24 mm in length. The head, neck shield and wing covers are grey, usually camouflaged with soil particles. The neck shield has two distinctive spines, which project thorn-like above the head. The wing covers are unique with rows of spines. This interesting, ground-dwelling species feeds on animal and plant matter in sandy, semi-arid Kalahari environments.

Somaticus aeneus, the Tar Darkling Beetle, is approximately 22 mm in length. The head and neck shield are a matt black. The wing covers are a shiny black and have well-developed longitudinal ridges with sculptured lines forming a network in between. The long legs are strongly developed with numerous punctures. The adults scavenge on plant and animal material, while their larvae feed on the roots of plants. This species is abundant in the semi-desert and dry savannah conditions.

Stridulomus sulcicollis, an enormous tenebrionid beetle, is approximately 60 mm in length. The elongated body is a glossy black, with smooth, well–

▲ Tenebrionidae > Molurini > *Somaticus aeneus* (Tar Darkling Beetle)

▼ Tenebrionidae > Molurini > *Stridulomus sulcicollis*

tapered, dome-shaped wing covers, The antennae are short and bead-like. This species is probably the largest insect to be found in the Kalahari. When alarmed, the beetle makes a loud squeaking sound. It is a flightless, ground-dwelling species well adapted to running and able to disappear rapidly despite its size. This species feeds on plant and animal matter and is common at night on the sandy roads of the Kalahari.

Meloidae (blister beetles)

The blister beetle lays approximately 25 white, oval eggs in the ground, which, depending on climatic conditions, hatch within four weeks into tiny, active larvae. These newly hatched larvae are approximately 1.5 mm long, with a white large head, six legs and two stiff bristles on the tail. The larvae run about over the ground, seeking those spots where grasshoppers and locusts have laid their eggs. By some mysterious means, perhaps by a keen sense of smell, they usually find the eggs if they are in close proximity to them. They bore down into the soil to reach them. While lodged safely inside the pod, the larva casts its skin and becomes a fat, white maggot with very short legs as it no longer needs to run about, and for the rest of its time as a larva it is very sluggish, feeding on the eggs and growing rapidly. Towards the end of summer, it burrows into the ground alongside the pod, changing its form and entering the larval resting stage in which it passes the winter months. When summer comes, it casts its skin and enters the next stage of its development, changing into a white pupa without feeding. This slowly darkens in colour and finally, after a further four weeks, it emerges as an adult. It rests for a time in its underground cell until its skin hardens and then makes its way to the surface, to feed on flowers, lay its eggs and die.

Mylabris oculata, the CMR Bean Beetle, is about 27 mm in length. They are soft-bodied and elongated in shape. The head and neck shield are black, the antennae orange with the exception of the basal segments, which are black. The wing covers are also black with two basal yellow spots and two broad transverse yellow bands. The posterior band in the specimen depicted here has red-and-yellow banding. This is the most common meloid in South Africa and may occur in large numbers in the Kalahari, when the trees are flowering.

Cylindrothorax bisignatus, a blister beetle, is a medium-sized insect approximately 20 mm in length. The black body is very elongated with greyish hairs. The black head is relatively large on a thin neck shield. The neck shield

▲ Meloidae > *Mylabris oculata* (CMR Bean Beetle)

▼ Meloidae > *Cylindrothorax bisignatus* (Slender Grey Blister Beetle)

▲ Meloidae > *Prionotolytta binotata* (Tiny Grey Blister Beetle)

identifies the species as it is orange and contrasts with the grey-black body. The antennae are long and very thin. This species may occur in large numbers in the Kalahari, where it feeds on the flowers of a range of different plants. It is attracted to artificial light. As a result it comes into contact with humans and can cause blistering of the skin at night.

Prionotolytta binotata, a blister beetle, is a small insect approximately 9 mm in length. The body is strongly elongated and a distinctive grey. The grey head appears bulbous on the thin neck. The orange neck shield sometimes has blackish shading. The antennae are dark and relatively short. The wing covers are elongated and appear grey as a result of the numerous fine hairs covering them. This species may occur in large numbers on *Tribulus* flowers in the Kalahari. It is known to feed on a number of different flowering desert plants.

Curculionidae (weevils)

The family Curculionidae is generally considered the most highly evolved of all the beetles. Its members are all primarily plant feeders, but specialisations have occurred in various groups. These specialisations include seed eating, gall forming, dung feeding and parasitic or predacious habits. The members of the species are extremely varied and diverse in appearance and habit. A few subfamilies include forms well adapted to arid conditions, and these are largely restricted to the western regions of the subcontinent, i.e. the Brachycerinae and the Lixinae. Certain genera, such as *Hyomorea*, *Leptostethus* and *Sciobius*, are endemic to southern Africa

The weevils are the largest of the insect families, with more than 60 000 species having been described, and doubtless thousands more await discovery and description. Several genera of broad-nosed weevils are found in Africa. The long-nosed weevils are much more numerous and varied in their biology. These are characterised by the lengthened snout at the front of the head and the usually elbowed and clubbed antennae. In some species, the rostrum, or beak, is short and broad while in others it is long and narrow and may even exceed the rest of the body in length.

The mandibles are lodged at the tip of the snout. The female of many species use this as an instrument to bore holes into which they lay their eggs. The snout of the male is often shorter than that of the female. Its function is unknown. These weevils vary in colour, size, and shape and can be wingless or strong flyers. Among the genera of broad-nosed weevils is *Brachycerus*, numerous species of which are found in South and East Africa. They are medium to large, strongly sculpted beetles and mostly brown or black in colour. The adult cannot fly, although most of its numerous relatives are excellent fliers. The round, hard back of the abdomen really consists of the fused wing covers, which form a hard protective cover. Some species of *Brachycerus* congregate during winter under shelter on the ground. The larvae can impact on lilies as they often develop in the lily bulbs and related monocotyledons.

Orthomias sp., a species of weevil, is dark grey with clear white margins to the wing covers. It is approximately 10 mm in length, with a distinct forward-facing head. The body is considerably elongated, with fine longitudinal ridges and punctures. The legs of this species are well adapted to climbing on branches. The antennae are relatively short and project forwards. These creatures feed on plant material and are often found on *Acacia* spp. and *Boscia*

▲ Curculionidae > Entiminae > *Tanymecini* > *Orthomias* sp.

▲ Curculionidae > Entiminae > Leptostethini >
Leptostethus viridicollis

▶ Curculionidae > Brachycerinae > Brotheini >
Synthocus nigropictus (lily weevil)

albitrunca in the Kalahari.

Leptostethus viridicollis, an eye-catching weevil species, is a small insect approximately 11 mm in length. The body is grey-green with white and sulphur-yellow striping on the underside and a white stripe on top. The species is slender and well elongated with a head and stout, broad snout. The neck shield is humped and deeply punctured. The wing covers are narrow with clear longitudinal ridges and punctures. The pale legs of this species are well adapted to climbing on the branches of bushes in semi-arid environments.

Synthocus nigropictus, a spectacular species of weevil, is a medium-sized insect approximately 16 mm in length. The cream body has light and dark-brown stripes and blotches on the head, neck shield and wing covers. This

species is broad and stocky, with a broad snout. The neck shield is sculpted and deeply punctured. The wing covers are broad with clear longitudinal ridges and punctures. The dark upper legs bear tufts of cream hairs, while the lower legs are dark brown. This species occurs on or under lilies in the Kalahari dunes.

Hadromerus humeralis, a dark-grey weevil, has a distinct white margin to the wing covers. It is approximately 12 mm long, with a short head and broad snout. The neck shield is slightly rounded with numerous punctures. The wing covers are clearly grooved longitudinally. The legs of this species are well adapted to climbing on foliage, where they are commonly found. These insects feed on plant material and are common in the semi-arid woodland areas of the Kalahari.

This interesting species (top right) of weevil belonging to the subfamily Lixinae is a medium insect approximately 18 mm in length. The pale cream body has tan and light-brown blotches on the neck shield and wing covers. This species is broad and stoutly built, with a very broad snout. The eye is large and almost slit-like. The antennae are short and project directly forwards. There is no apparent division between the neck shield and wing covers, which are convex in shape with noticeable longitudinal ridges and punctures. The legs are cream with sparse dark markings and are well adapted for movement on the ground. This species is well camouflaged and lives under Karoo-type plants in flat and arid parts of the Kalahari.

Spartecerus rudis, a species of weevil, is a medium insect approximately 15 mm in length. The reddish-brown body has numerous markings and

▲ Curculionidae > Lixinae > Cleonini

◄ Curculionidae > Entiminae > Tanymecini > *Hadromerus humeralis*

▼ Curculionidae > Entiminae > Tropiphorini > *Spartecerus rudis*

▲ Curculionidae > Brachycerinae > Brachycerini > *Brachycerus* sp. (lily weevil)

puncturing. The insect is broad and stout, with a very broad snout. The eye is dark and conspicuous. The antennae are short and project directly forwards. The legs are stout and strongly developed. The wing covers are a browny red with numerous darker-brown markings. This species plays dead when disturbed, stiffening its legs and lying completely motionless. It is well camouflaged and inhabits the flat savannah areas of the Kalahari.

Brachycerus sp., a species of weevil, is a medium insect approximately 14 mm in length. The body is light brown with longitudinal ridges and tubercles. The head is short with a broad snout. The neck shield is somewhat round with numerous tubercles. The antennae are banded and short and curve forwards. The legs are stout and strongly developed. The light-brown wing

covers are bulbous, with numerous black tubercles. It is well camouflaged and inhabits the flat, sandy areas of the Kalahari.

Brentidae (primitive weevils)

The different brentid species in South Africa range considerably in size between 4 and 20 mm. However, the size of the individuals of many species is often subject to great variations, and the male is usually larger than the female. In addition, many species exhibit pronounced sexual differences in that the males have a broad, beak-like snout with large mandibles, used to clutch on to the female prior to mating, while the female has a narrow, beak-like, piercing and sucking mouth part and small mandibles. Adult brentids seem to be exclusively nocturnal and are often attracted to artificial light. They may be observed under bark and in soft dead wood. Some species are known to form gregarious aggregations, but this habit needs further research.

Cylas sp., a tiny species of primitive weevil, is a small insect approximately 5 mm in length. The body is smooth, glossy black and very rounded, and has dome-shaped wing covers. The head is small and elongated with a long, thin, downward-curved snout. The legs and antennae are black with a slight red tinge. These weevils chew holes in leaf surfaces and may feed on the sap from holes they pierce in stems and flowers. The species lives in the foliage of a number of semi-arid plants and is relatively common yet readily overlooked as a result of its size.

Scarabaeidae subfamily Scarabaeinae

The majority of the Scarabaeinae species feed on dung but there are also some that feed on carrion, fungus and litter. The dung feeders utilise the dung in a number of different ways. Mites can be found on the upper side of the head and thorax in most species of dung beetle. Most of them are predators on the eggs of flies, which utilise the beetles for transport from one dung source to another. A few species of small dung-breeding flies also use the dung beetles for transport. A group of Scarabaeidae breed inside the dung pad without burying any part of the dung. The females lay their eggs in dung, which they then mould into balls, in which the eggs remain. Externally, there is no sign of dung beetle activity. An example of a beetle with this form of behaviour is *Phalops rufosignatus*.

Pachylomerus femoralis, a scarab beetle, is approximately 16 mm in length.

▲ Brentidae > Cyladinae > *Cylas* sp.

▼ Scarabaeinae > Onthophagini > *Phalops rufosignatus*

▲ Scarabaeinae > *Pachylomerus femoralis* (Flattened Giant Dung Beetle)

▼ Melolonthinae > Sericini

▼ Dynastinae > Phileurini > *Syrichthoschema cribratus*

The two-toned body is slightly flattened with hairy underparts. The head and the neck shield are a shiny bronze and heavily sculpted. The bronze-black head is axe-shaped but has no toothed margin. The large neck shield is a metallic bronze and heavily punctured. The wing covers are shiny, metallic light-brown with numerous dark-brown markings. The legs of this species are strong and toothed. This species is well distributed in the semi-arid Kalahari.

Pachylomerus femoralis, the Flattened Giant Dung Beetle, is approximately 50 mm in length. The dull black body is broad and somewhat flattened, often dirtied as a result of dung tunnelling. This species has powerful, broadly toothed legs, which are used for moulding large dung balls that are then buried. The broad neck shield is characteristically wider than the abdomen. This species is active by day and commonly seen flying in the Kalahari in areas with deep-red soils.

Melolonthinae (leaf chafers)

This unknown species of scarab beetle (middle left) belonging to the tribe Sericini is approximately 9 mm in length. The body is red-brown and bulbous in shape. The dark-brown head is small in comparison with the large neck shield and wing covers. The antennae are clubbed with a dark tip. The legs are reddish brown and strongly serrated. The neck shield is smooth and darker brown in colour than the wing covers. The wing covers are rounded, also red-brown, and have fine longitudinal lines. The adults of this species feed on flowers in the semi-arid savannahs and are strongly attracted to artificial light.

Dynastinae (rhinoceros beetles)

Syrichthoschema cribratus, a medium-sized scarab beetle, belongs to the subfamily Dynastinae and is approximately 18 mm in length. The body is a shiny dark brown, with dense chestnut hairs on the underparts. The head is small and partially embedded in the neck shield, which is large, axe-shaped and heavily punctured with hairy margins. The broad wing covers are shiny, with numerous longitudinal ridges and punctures, and appear to taper downwards. This species is active at night and strongly attracted to artificial light. It feeds on decomposing plant material and is relatively common in the Kalahari.

Cetoniinae (fruit chafers)

Pachnoda picturata, a beautifully marked fruit chafer is a medium-sized insect approximately 24 mm in length. This species is predominantly a shiny buff colour, while the wing covers and neck shield are dotted and striped with black. This species is quite distinct, recorded in the dry savannahs of Namibia and Botswana, even though specimens have been collected in the Kalahari well within the boundaries of South Africa. This is a strikingly beautiful insect and, as the scientific name suggests, the beetle looks as if it has been painted. This coloration is not variable but distinctive. The adults of this species are often found between December and June, peaking in abundance between April and May, on fruits and flowers, especially on *Acacia* spp. flowers in semi-arid environments.

Oplostomus fuligineus, a fruit chafer, is a medium-sized insect approximately 26 mm in length. It is known to associate itself with wasp nests and can destroy the nests of the wasps on which it feeds. The body is shiny black. Certain species of chafers also enter beehives to feed on the pollen and nectar in the combs. Because the Kalahari is a dry environment, one can assume that much-needed moisture is also acquired through this association.

Buprestidae (jewel beetles)

The life cycle of certain jewel beetle species can be exceptionally long, with cases of beetles living over 35 years being recorded. The adult beetle often chews through the bark of trees to the penultimate layer. In this position, they may enter an inactive period for months or even years before they emerge. The duration of this period depends on the rainfall cycles in these arid environments. In contrast to the long larval development, the adult generally seems to be short-lived once it emerges from the host plant.

The beetles in these arid areas are often associated with some species of trees, feeding on the foliage. Others are found feeding on flowers or even on bark. Interestingly, some representatives of the family Buprestidae are the insects most adapted to thriving in the excessively hot environment and are very active at times when most other creatures are taking shelter.

Anadora cupriventris, a jewel beetle, is a medium-sized insect approximately 19 mm in length. This species is unmistakeable as it is coarsely sculpted with large tubercles. The body is a metallic brown, blotched with brown

▲ Cetoniinae > *Pachnoda picturata* (Painted Fruit Chafer)

▼ Cremastocheilini > *Oplostomus fuligineus* (Black Wasp Nest Chafer)

▼ Agrilinae > Coraebini > *Anadora cupriventris*

▲ Buprestidae > Chrysochroini > *Steraspis ambigua* (Cluster Leaf Jewel Beetle)

and cream. The head is small with short, comb-like antennae. The sculpted neck shield is broad and expanded. The longitudinally ridged wing covers are elongated, with patches of brown and cream. The membranous wings appear metallic blue in sunlight. They are observed regularly on the Silver Cluster Leaf (*Terminalia sericea*) and are relatively common on dune crests, where stands of their host plants occur. They are well camouflaged and can easily be mistaken for a piece of bark.

Steraspis ambigua, a large jewel beetle, is approximately 40 mm in length. The body is a brilliant, metallic greenish-gold. The head supports characteristic large dark eyes and relatively short, sideways-projecting antennae. The neck shield is also a metallic greenish gold and is somewhat square with shield-like margins. The elongated, longitudinally grooved and punctured wing covers

are metallic greenish gold with distinct reddish-brown margins. This insect has characteristic yellow patches on the underside of the thorax. The species is abundant at certain times of the year and has been recorded as feeding on the Silver Cluster Leaf (*Terminalia sericea*), which is prolific on dune crests. Towards the end of the season, large numbers of discarded wings cover can be observed on the ground beneath the trees which support this species.

Cerambycidae

The larvae of the cerambycid beetles are woodboring, elongated, subcylindrical or strongly depressed. The body is usually hairy on the sides. The small, more or less jutting head can be extended but is usually buried deep in the front part of the thorax. The larvae are seldom seen because they are usually found deep inside wood but they can often be heard gnawing their galleries. The larvae are cannibalistic and, when a number of young emerge from a cluster of eggs, they continue to devour one another until the survivors are too widely scattered to do any further damage to one another. In their subsequent tunnelling, the grubs carefully avoid the burrows of their siblings, diverting their own tunnels, when approaching another burrow too closely.

Specialised organs along their sides may enable them to detect the proximity of others. A sense of hearing, as we know it, would be of little use to a sluggish larva lodged in a tunnel inside the wood as very few sounds can reach it in such a retreat, but the specialised organs are probably useful in enabling the larva to detect the vibrations set up by predatory birds or by the jaws of another larva feeding in close proximity. Most cerambycid larvae grow slowly, possibly as a result of the poor nutrients in wood. Some species take three or four years to reach their full size. When mature, the larva usually tunnels towards the surface of the branch and hollows out a chamber just below the bark in which it develops into a pupa. When the pupa changes into an adult, the beetle bites its way out of the chamber.

Olenecamptus olenus, a medium-sized longhorn beetle, is approximately 16 mm in length. The elongated, slender body is a pale red-brown with a pale overlay. The head supports characteristic long, segmented antennae. The neck shield is relatively long and elongated. The wing covers are also red brown with a white overlay and have distinctive white blotches. This species is abundant on *Acacia* sp. and the Silver Cluster Leaf (*Terminalia sericea*) in the Kalahari.

▲ Cerambycidae > Lamiinae > *Olenecamptus olenus*

▲ Scutelleridae > *Calidea dregii* (Rainbow Shield Bug)

▼ Pentatomidae > Pentatominae > *Andocides vittaticeps*

▼ Pentatomidae > Pentatominae > *Menida decoratula*

HETEROPTERA

Scutelleridae (shield-backed bugs)

The Scutelleridae are a small family of distinctive African bugs, closely related to the Pentatomidae. *Solenosthedium liligerum* may be gregarious and is possibly found in clusters on the host plant. The nymphs are grey, tortoise-like creatures with dark dorsal plates. All scutellerids feed on a wide range of flowering shrubs and trees, but specific biological data on most species do not exist.

Calidea dregii, the beautiful, spindle-shaped Rainbow Shield Bug, is approximately 14 mm in length. The rainbow-coloured body has two rows of black spots on the iridescent green, blue, yellow and red back. The underside is red with a number of green plates. This species occurs in large numbers on the ridges and rocky outcrops in the Kalahari, where it feeds on a variety of trees including the Lavender Fever Berry (*Croton gratissimus*).

Pentatomidae (shield bugs)

Most members of the Pentatomidae are diurnal plant feeders and live on a wide variety of different plants. They are avoided by insect-eating creatures because of their unpleasant smell. They do, however, have one enemy that destroys a large number of their eggs. This is a tiny black parasitic wasp that may infest as many as 90% of the eggs in some seasons, causing them to turn black. The offspring of the parasites then emerge from the eggs instead of the young bugs.

Andocides vittaticeps, a medium-sized shield bug approximately 12 mm in length, has a shield-shaped body with a yellow striped head, white-tipped scutellum and exposed, pale-yellow banded margins to the abdomen. The forewings are a greyish brown with numerous cream speckles and two characteristic bright-orange spots on the lower section. The antennae are dark in colour and project forwards and sideways. These insects feed on seeds and are relatively abundant in the Kalahari regions.

Menida decoratula, a small shield bug, is approximately 5 mm in length. The body is broad and flattened, with a slightly raised neck shield. This species is black, with a pattern of white-and-yellow markings of various sizes on the neck shield and forewings. There is also conspicuous black-and-white banding on the edges of the abdomen. The legs are pale orange in colour. These

creatures feed on young shoots, buds and fruit of a variety of plants. This species is common in the semi-arid Kalahari thornveld.

Coreidae (twig wilters)

One of the most widely spread of the African coreids is *Prismatocerus auriculatus*, which can be encountered in virtually any part of South Africa. The bugs vary in colour from pale grey to dark brown. The hind femora are enlarged, the males having especially inflated femora with a broad, inwardly pointing projection on each. The area around the gland that secretes a repugnant fluid is often bright orange. *P. auriculatus* feeds on the stems, buds, shoots and leaves of a wide variety of plants. In most cases, the plant shows severe wilting of the tender parts far beyond the initial entry point of the bug.

Prismatocerus auriculatus, a medium-sized bug, is approximately 16 mm long. The body is elongated, and slightly flattened, with long, segmented, reddish-brown antennae. This species has a broad thorax and its head appears quadrangular. It is dark brown with cream mottling on the neck shield and forewings. The neck shield is brown with broad spines on the margins of the thorax. These insects feed on the young shoots and seeds of a variety of plant species. It is widespread in the semi-arid Kalahari systems.

Lygaeidae (seed bugs)

The subfamily Lygaeinae is conspicuous with its many brightly coloured species, red and black predominating. They are generally small-medium to medium-large (5–20 mm); most are about 10 mm in length. Their colour varies from dull brown in many species to brightly coloured in a few. The subfamily is characterised by many specialised anatomical features, three of which are the dorsal abdominal spiracles, the abdominal sutures, or plate-dividing grooves, and the depressed neck shield. Most species are fully winged, as in the case of *Spilostethus macilentus*.

Spilostethus macilentus, a medium-sized seed bug, is approximately 14 mm in length. The head is black with a distinct reddish-pink blotch in the centre. The antennae are black with grey tips. The striking red-and-black markings on the elongated body are unmistakable and the bug is easily recognised by the reddish-pink, slightly swollen margin to the neck shield and its 'hour-glass' shape. The reddish-pink forewings are marked by a broad, black horizontal bar

▲ Coreidae > Coreinae > *Prismatocerus auriculatus*

▼ Lygaeidae > Lygaeinae > *Spilostethus macilentus*

▲ Reduviidae > Harpactorinae > *Pseudophonoctonus paludatus*

forming a distinct, continuous pattern. The membranous parts of the wings create a contrasting black vent. This is a widespread species, which feeds on the pods of herbaceous and other plant species in the Kalahari.

Reduviidae (assassin bugs)

The very large and diverse subfamily Harpactorinae, is characterised by a quadrangular cubital cell on the leathery middle part of the well-developed forewings. They resemble the Reduviinae but are easily distinguished by the first antennal segment, which is much longer than the second. The members of this subfamily are medium to large diurnal bugs. Many brightly coloured genera are found in this group and a few species mimic other bugs, usually members of the the Pyrrhocoridae and Lygaeidae, on which they supposedly prey. The assassin bugs are useful in controlling the numbers of certain insect species and thus important in maintaining an ecological balance. All southern African species are predacious, their prey mainly consisting of insects. They have earned the name 'assassin bugs' from their habit of moving cautiously to within striking distance of their prey and then pouncing on it and grabbing it with their forelegs. They pierce the body of their victims with their sharp stylets, injecting their prey with saliva, which has an almost instantaneous paralysing effect. They suck up the body fluids and then discard the dry body of their victims. The biology of the Harpactorinae is varied. Most species seem to attack any arthropod they can overpower, but some species are specialised in their preying habits.

Pseudophonoctonus paludatus, an assassin bug, is a medium-sized species approximately 13 mm in length. The body is grey with pink dots near the leg bases. The legs and antennae are dark brown, the former with fine hairs. The head is pink and grey, with a dark, powerful, curved beak. The scutellum is pink with two, dark-brown blotches divided by a longitudinal pink stripe. The elongated forewings are pink with dark markings exposing black bands on the abdomen. The membranous parts of the wings create a contrasting dark vent. This insect is an ambush predator of other insects in sunny positions and is usually found on foliage or flowers waiting for its prey in Kalahari woodland savannahs.

Alydidae (broad-headed bugs)

These unidentified species of large broad-headed bug nymphs (top right) belonging to the family Alydidae are approximately 12 mm in length. The

slender body, broad triangular head and enlarged, bowed hind legs are distinctive. They are black with yellow-and-white markings on the abdomen. These extremely active nymphs crawl rapidly to the other side of the leaf when disturbed. Their antennae are characteristically banded in black and yellow. The nymphs congregate in large numbers on the same plants and may include individuals at different stages in their development. This species is common on *Acacia hebeclada* in the Kalahari.

Dinidoridae

Most species in southern Africa belong to the genus *Coridius*. Very little is known about their biology but they all appear to be plant feeders. Dinidorids are moderately large, oval bugs (10–20 mm), usually black or brown. The scutellum, which is rounded on top, only reaches about half the length of the abdomen. The wing-cover membrane is large and usually reticulate. Dinidorids have a short beak that does not reach to the first segment of the legs. They have many specialised anatomical parts, two of which are the semi-stalked eyes and the covered second abdominal spiracle.

Coridius nubilus, a medium-sized, chunky bug approximately 18 mm in length, has a dark–brown, finely punctured body. The small, pointed head is black. The antennae have dark-brown bases and orange ends to the last two segments. The neck shield is punctured and slightly raised. The dark-brown forewings have a cream lower section overlaid by a dark smudge. The legs are dark brown. This species is also sometimes called the melon bug as it sometimes feeds on the shoots of pumpkins and melons. These insects are plant feeders in semi-desert environments and are relatively common in the wooded savannah regions of the Kalahari.

PHASMATODEA

Leptynia sp., a stick insect, is medium-sized, approximately 72 mm in length. This species is slender, delicate and wingless. It is a pale greenish-brown with short orangy-pink antennae. The abdomen is broad and tapers towards the end. The long legs are greenish in colour. This species closely resembles a green grass stalk and is practically invisible when it is not moving. It is a plant feeder, especially on grasses, and is common in semi-arid savannah regions.

▲ Alydidae > Alydinae (nymph)

▼ Dinidoridae > *Coridius nubilus* (small specimen)

▼ Phasmatidae > *Leptynia* sp. (stick insect)

▲ Lycaenidae > Lycaeninae > *Chilades trochylus* (Grass Jewel Blue)

▼ Pieridae > Pierinae > *Belenois aurota aurota* (Brown-veined White)

▼ Lycaenidae > Lycaeninae > *Tarucus sybaris* (Dotted Blue)

LEPIDOPTERA

These tiny, delicately marked butterflies (top left) are light brown, with a conspicuous orange anal patch on the hind wing. They are slow, low flyers and flitter about in the grass, often landing on small flowers before taking off again. They are usually solitary but may congregate in relatively large numbers at a suitable food source or water. This species prefers the warmer areas of the country where it frequents savannah, grasslands and gardens. They breed throughout the year, depending on climatic conditions and rainfall. The single whorled, bun-shaped egg is laid on a forb, on which the pinkish-green larva (which later becomes striped) feeds after hatching.

The Brown-veined White is, as the name implies, a white butterfly with brown markings on the underwings. These are fast-flying butterflies often migrating in large numbers from the semi-arid west to the east coast of the county, halting periodically to feed on flowers throughout their journey. They appear to breed and originate in the arid Northern Cape but migrate to almost all parts of the country. It is uncertain what triggers the migration, but it is assumed that a pheromone influences some to migrate. Other influences may be overcrowding and a decreased food supply. Not all the individuals migrate and relatively large numbers remain resident in an area. The migrating butterflies are conspicuous, attracting attention as they cross highways and gardens, usually from December through to February. The elongated, vertically ribbed eggs are laid mostly on *Boscis albitrunca* in batches or singly. The larvae vary considerably in colour from plain green to longitudinally striped. This is a common butterfly throughout the region.

Tarucus sybaris, an elegant small butterfly is common in grassy savannahs and semi-arid and grassland areas, where it frequents hillsides and flat, relatively open areas. The wings of these delicately marked butterflies have white undersides with dark polka dots, but the upper wings are a brilliant blue. This species is the only member of the genus has a hind wing tail. Their flight is lazy and usually only in the vicinity of their food plants. The eggs are white, cup-shaped and ribbed in polygon shapes and are laid singly on vegetation. The greenish larvae are slug-shaped with a feint longitudinal or diagonal pattern of darker lines. The larvae eat the surface of the leaf, growing rapidly. The butterfly may be seen all year round depending on climatic conditions, but numbers usually peak around November to March.

Kalahari, Northern Cape 247

Hippotion sp., the unique larva of the hawk moth, is brown with a speckled pinkish-white central stripe narrowing considerably towards the head. The head itself is small and light brown and resembles a 'hoover'. The larvae are relatively thick and approximately 30 mm in length. The legs are dark pink in colour and the body has a distinct erect tail like a dog, which sways as the larvae move. This species has two eye-spots, the first being large, yellow and centred with brown and the second pale yellow and considerably smaller. They are plant feeders and are regularly found on *Acacia mellifera* in Kalahari savannah.

Gynanisa maja, the large larva of the Speckled Emperor butterfly, is pale green with ridged segments, each of which has two silver spines. The spines

▲ Sphingidae > *Hippotion* sp. (hawk moth) (larva)

▼ Saturniidae > *Gynanisa maja* (Speckled Emperor) (larva)

▲ Noctuidae > *Helicoverpa armigera* (African Boll Worm)

on the head have reddish shading. The thick-set body has obvious spiracles on each segment. The larvae are thick and approximately 60 mm in length. They are voracious feeders on *Acacia mellifera* in the Kalahari, totally defoliating plants over large areas. The adult moth is large, with a wingspan of approximately 130 mm. The males have large feathery antennae and forewings with a dark-brown marginal band, not hooked and without a wavy margin. A large and complex eye-spot is marked in concentric pink, orange and black rings.

Helicoverpa armigera, the slender African Boll Worm, is brown to greenish brown, with a fine, white, central stripe edged with black and with rounded nodes and cream side-stripes. The larvae are thin and approximately 35 mm in length. They are voracious feeders of *Croton grattissimus* on hill slopes in the Kalahari, totally defoliating plants over large areas. The adult moth is medium-sized, with a wingspan of approximately 38 mm. Their colour varies but the forewings are usually pale or reddish brown and occasionally tinged with green. The hind wings are pale, with a greyish-brown marginal band and brown veins.

ORTHOPTERA

Bradyporidae (corn crickets)

This corn cricket (top right) has a curious pair of eyes, each at the end of a short, immobile stalk. The eye is small and hemispherical, resembling a crab's eye, and protects the head. This gives the insect a goggle-eyed appearance. It is difficult to imagine what eyes like this can see. Because of the way the eyes are positioned, the corn cricket must be very short-sighted, but the shape and position of the eyes must allow a wide angle of vision.

HYMENOPTERA

Dasylabris stimulatrix, a female Velvet Ant, is actually a medium-sized wingless wasp approximately 14 mm in length. The head, antennae and legs are grey-black, the thorax reddish brown and the abdomen is black with four white spots. The neck between the thorax and the abdomen is characteristically white. The body is extremely hard, coarsely punctured and covered with soft velvety hairs. The Velvet Ant parasitises the larvae of other insects and lays its egg on the host larvae. This species occurs in semi-arid Kalahari savannah and is normally observed on the ground. The insects have an exceptionally painful sting and should be handled with care.

Anoplolepis steingroeveri, the Pugnacious Ant or *Malmier* in Afrikaans, is particularly common in semi-arid regions of southern Africa. In high densities they can be troublesome, attacking tourists and field rangers. Harvester termites are an important part of their diet, at least in some areas. As shown in the photograph, the workers are different sizes (polymorphic). Queens do not start up nests on their own; instead, colonies are founded by breaking into an old nest.

DIPTERA

The blowfly or bluebottle fly is no stranger to most South African households and the flies are attracted to most foodstuffs, especially meat left unattended in the kitchen. These relatively slow-flying insects are opportunists and will quickly locate the meat, on which they lay two dozen or more elongated white or cream eggs in bouquets on the surface. The eggs hatch rapidly, depending on the temperature, and before long the meat is teaming with pale, legless maggots. These pupate quickly and the cycle is repeated. The speed in which

▲ Bradyporidae > *Hetrodes* sp. (nymph)

▼ Mutillidae > *Dasylabris stimulatrix* (Velvet Ant)

▼ *Anoplolepis steingroeveri* (Pugnacious Ant)

this cycle completes itself results in an abundance of flies in a relatively short period of time. These are relatively large, metallic flies closely associated with animal matter which they break down and thus help prevent the spread of disease.

Chrysomya marginalis, the Regal Blowfly, is a medium-sized carrion fly with a wingspan of approximately 16 mm. The head is orange, the eyes are red and the body is a metallic greenish-black with violet reflections. It has a black stripe running along the fore margin of the wings. This common species infests carcasses, laying its eggs in masses; within a few days the carcass is a mass of larvae. The male of the species, like the specimen pictured on the grass inflorescence here, is also a specialist pollen feeder.

DIPLOPODA

Little is known about the biology or ecology of *Spirostreptus heros*, the Giant Millipede. These millipedes are long-lived, taking approximately three years to reach their maturity and possibly living as long as seven years. They feed on debris, leaf litter, rotting logs, fruits and even dung. They are the prey of a variety of different mammals (meerkats, wild dogs, mongooses, civet cat) and tend to spend the dry season deep in the soil, only emerging in large numbers after rains, often in large numbers. Records indicate that they may return to the same nest after any activity on the surface. Further research is required, as these creatures appear to play a major role in soil nutrient cycles.

▲ Calliphoridae > *Chrysomya marginalis* (Regal Blowfly)

▲ Spirostreptidae > *Spirostreptus heros* (Giant Millipede)

Namaqualand, Northern Cape: landscape

◄ Namaqualand is known for its stunningly beautiful succulent flowers.

Namaqualand is a true miracle of a landscape in that the area can take on two completely different appearances. It can vary from a dustbowl to a celebration of colour, breathtaking beauty and huge diversity after there has been sufficient rain. The largely flat areas, which taper off to the coastline, are considered one of the true wonders of the world because of the unequalled diversity of annual flowering plants. With this enormous diversity comes a wide range of specially adapted insects, some confined to this part of the country only.

The plains are often studded with rocky boulders in places and even rocky outcrops, which in turn provide a haven for a wide range of species. The vegetation on the west coast of South Africa is stunted to knee height as a result of the usually harsh, dry conditions. This is in contrast to the east coast of South Africa, where the plant growth is extremely luxuriant. Many of the plants found in this region are adapted to hold moisture in their leaves and last out the dry season. As in the case of the plants, the majority of invertebrates found here have also adapted mechanisms to allow them to collect water from sea spray and dew.

Namaqualand is situated on the western side of the country between the Great Escarpment and the west coast. Most of the land consists of extensively flat to gently undulating plains with small hills and some 'broken country'. A variety of geographical types occur and the soils are mostly rich in lime and weakly developed.

Namaqualand has a low winter rainfall and extreme summer aridity. The rainfall is usually caused by cold fronts pushing in from the ocean and usually occurs as light drizzle. Fog is common along the coast and rolls quite far

254 A Landscape of Insects

inland along the major valleys. It is an important source of moisture.

During the summer, temperatures can exceed 40°C, resulting in many insect species seeking cover during the heat of the day. The vegetation is dominated by dwarf succulent shrubs many of which are vygies. Mass flowering displays of annuals, mainly Asteraceae daisies, are famous in the area in spring, usually August and September, and especially when there has been good rainfall. Grasses are rare in Namaqualand, except in sandy areas, and trees are not a common feature either.

For three-quarters of the year, Namaqualand is a barren, vast expanse of land. The contrast between these bleak conditions and the transformation that occurs in spring and summer is almost unimaginable. Namaqualand is unique in being the only desert in the world to have such an extravagant and diverse spring flower display. The succulent plant species with their thick, fleshy leaves are well represented in Namaqualand. No other place in the world has such a diversity of these plants. The succulents and annual plants as well as those that survive by means of bulbs and tubers make the region unique and of international importance in terms of floral and invertebrate conservation.

Wind has a strong influence on insects in these areas. As a result, most of them are wingless or not adapted to ready flight. The hot, dry *berg* winds

▲ Mist from the Atlantic Ocean is a major source of water to the plant life in Namaqualand.

▼ Being so far from major cities, the night skies in Namaqualand are crystal clear, allowing for amazing stargazing.

▲ A large jewel beetle feeds on a *Lycium* sp. along the coastal dunes.

blowing from the interior of the country towards the coast can occur at any time of the year, often burning the flowering plants on which many insect species rely.

The unique biological feature of Namaqualand is the plant life. The veld is short and everywhere low shrubs are found, most of them barely knee-high. The vast majority of plants have juicy, succulent leaves. Each new patch of veld yields a different complement of small, succulent plants, the various species interlocked in a pattern of apparent co-operation. The region has an extraordinary high level of unique specimens, including many secretive and elusive invertebrate species. The thought of spring in Namaqualand generally brings to mind carpets of bright orange, yellow, pink and white flowers. During spring Namaqualand is a wonderland, breathtakingly beautiful in a good year.

It is amazing that such flower masses occur naturally and that each patch is more strikingly beautiful than the next. Namaqualand is green and colourful for only two to three months in spring. The best flower displays usually occur from early August to mid-September. The weather patterns, particularly the hot *berg* winds, influence the duration of the flower season, and for this reason no accurate predictions can be made about how long the season will last. A good season is preceded by good autumn and regular winter rains. The timing of the first substantial rainfall is very unpredictable, but the sooner the rains come the earlier the flower season starts.

The former vast migratory herds of springbok (*Antidorcas marsupialis*) have been replaced by domestic stock, particularly sheep and goats. This has also affected the habitat for various invertebrate species.

◄ The cold and harsh Atlantic Ocean brings vital, life-giving water in the form of mist to the region.

COLEOPTERA

Carabidae (ground beetles)

A well-defined group of the Coleoptera is the Scaritinae. The species of *Scarites* and their related genera live in burrows. Accordingly, their bodies are adapted for this purpose. They are somewhat elongated and parallel-sided, with large serrations on their flattened fore-tibia. Although they are predacious, there is evidence that some species also eat seeds and seedlings. The species is well represented throughout the subregion. Their serrated forelegs are broad and flat to facilitate digging. The beetles burrow in loose soil where they hunt insect larvae and worms with their very sharp, prominent mandibles. The majority of ground beetles are predators and active hunters of other insects; a few are plant feeders and feed on pollen and seeds. Nearly all species of ground beetles are predators. Most of them are generalised and opportunistic hunters, feeding on almost anything they can overpower. Some, however, feed on snails or fly larvae. Their predacious behaviour may result in omnivorous habits, and some have switched to a mainly vegetation diet of seeds, cereals and evergreen plants. Ground beetles search for prey at random and are able to detect immobile prey such as eggs and pupae.

Graphipterus hessei, a ground beetle, is small, approximately 14 mm in length. The body is dark brown, somewhat flattened, with numerous fine hairs which are lost in old specimens. The head, thorax and abdomen are clearly differentiated. The neck shield and wing covers are densely covered with khaki-coloured hairs outlined with a margin of pale hairs, thus the appearance of a thin white stripe. This is a diurnal species, which favours high temperatures. The long legs enable it to move at high speed. The adults feed on small insects, which they actively hunt and outrun. This species is common in the western parts of South Africa and inhabits arid sandy areas with sparse vegetation.

Anthia maxillosa, a large ground beetle, is approximately 45 mm in length and confined to the arid west coast and surrounding areas. This species is black with well-developed mandibles for catching and crushing prey. The head, thorax and abdomen are clearly differentiated. The neck shield has a characteristic raised concave 'dish', which easily differentiates the species in the field. The thorax is narrower than the wing covers. The antennae are long and thin with white hairs on three basal antennae segments. The eyes are prominent. It is a flightless species and a ground-dwelling predator, which can squirt acetic acid from the end of the abdomen in self-defence when

▲ Carabidae > *Graphipterus hessei*

▼ Carabidae > *Anthia maxillosa* (Tyrant Ground Beetle)

▲ Carabidae > *Anthia decemguttata*

▼ Carabidae > *Scarites* sp.

disturbed. The larvae are active predators that can run on the surface of the ground. When mature, they pupate in the ground or under stones.

Anthia decemguttata, a large ground beetle, is approximately 35 mm in length. The body is black with a rufous neck shield. The wing covers are black with deep longitudinal grooving. The legs are dark brown and built for speed. This carnivorous beetle preys on other ground-dwelling insects. It inhabits the sandy, savannahs on the west coast of South Africa.

Scarites sp., a fierce-looking, black ground beetle, is approximately 30 mm in length. This species has vicious mandibles, which are indicative of its carnivorous habits. The antennae are bead-like and usually project forwards. The forelegs are broad, flattened and strongly toothed, being adapted for digging. The adults burrow in the soil, where they hunt and feed on insect larvae and worms. The species is common in arid, sandy areas, especially on the west coast of the country.

Melyridae (soft-winged flower beetles)

Melyris viridis, the Metallic Groove-winged Flower Beetle, is a small beetle approximately 9 mm in length. Its body is soft, elongated and dorsally flattened. The body is a metallic colour and covered with fine hairs. The neck shield has distinct margins. The wing covers are smooth and shorter than the abdomen. The basal segments of the ten-segmented antennae have been modified in the male for courtship and mating. The adults are mostly pollen feeders, often found on flowers. They sometimes visit carcasses and cow dung, possibly for moisture. The larvae are omnivorous, feeding on dry, decaying kelp and other vegetable matter, dung and carcasses, and have also been known to prey on other insects. This species is common on daisies and mesems in the Strandveld and dune vegetation on the west coast of South Africa and Namaqualand.

Tenebrionidae (darkling beetles)

The family Tenebrionidae occurs in all types of terrestrial habitats, but the greatest diversity of species is found in dry areas and deserts. In South Africa, the richest tenebrionid fauna are found in the Northern Cape, where

Melyridae > *Melyris viridis* (Metallic ▶
Groove-winged Flower Beetle)

▲ Tenebrionidae > *Gonopus bellamyi* (Bellamy's Darkling Beetle)

▼ Tenebrionidae > *Physosterna armatipes*

▼ Tenebrionidae > *Eurychora* sp.

there is a remarkable adaptation to life in this harshest of environments. Even areas with sparse vegetation support a rich fauna of highly specialised beetles, which appear to have nothing to feed on. Certain nocturnal species show remarkable behavioural adaptations enabling them to collect moisture from the dew and sea mist. These adaptations allow them to survive in dry environments, feeding on substances with a low moisture content, and have also enabled them to expand their distribution range considerably.

Gonopus bellamyi, a medium-sized tenebrionid beetle, is approximately 20 mm in length. The body is a shiny black with a beaded margin and central longitudinal grooves. The wing covers are moderately round with longitudinal rows of tubercles. The species has stout and strongly developed legs, with each front leg armed with sharp, forward-pointing spines. The antennae in this species are fairly short, with a lighter colouring on the end. The larvae live in soil, feeding on roots and dead plant matter. This species is regularly found in debris in loose dune sand in the arid environments of Namaqualand.

Physosterna armatipes, a medium-sized tenebrionid beetle, is approximately 16 mm in length. It is a ground-dwelling beetle with a globular, very coarsely sculpted carapace. The neck shield is smooth and contrasts with the rest of the insect. The adults are usually found crawling on the ground and scavenging on plant and animal material. The larvae are thought to live in the soil, where they feed on roots and detritus. This species is relatively common in the arid, sandy areas of the west coast and Namaqualand.

Eurychora sp., a strange-looking mouldy beetle, is approximately 16 mm in length. The neck shield is expanded into flanges on either side of the head. The upper surface is flat and usually covered with soil and vegetable debris, held in place by long stout hairs and waxy filaments. The adults are nocturnal, usually hiding under stones and wood during the day. This species can often be observed in dark places, under carcasses and rocks and in the burrows of other creatures. They are scavengers and feed on a variety of plant remains. This flightless beetle is widespread and common in harsh, arid environments, where it appears to thrive.

Phanerotomea sp., a medium-sized tenebrionid beetle (page 261), is approximately 22 mm in length. It is a wingless, smooth, globular black beetle found on the west coast of South Africa. Most people know it as the 'toktokkie'. This ground-dwelling species has strong legs adapted to sand. The neck shield is large and smooth. The adults tap out rhythms on the ground to

locate and seduce mates, hence its common name. This species feeds on plant and animal material in dunes and arid shrubveld in Namaqualand. The larvae are assumed to feed on roots and other detritus.

Somaticus praephallatus, a tenebrionid beetle, is approximately 15 mm in length. This species is commonly found on succulents in the semi-arid Karoo of the Northern Cape. The head and neck shield are a matt black, while the wing covers are black with grey longitudinal striations. The legs are long and built for speed, probably to prevent water loss when the beetle is exposed to the elements. The adults scavenge on plant and animal material, while the larvae are recorded as feeding on roots.

Cryptochile namaqua, a small tenebrionid beetle, is approximately 8 mm in length. The head and neck shield are dark brown with creamy white markings and streaky sculpting. The wing covers are white with black lines and blotches and longitudinal ridges covered with tiny scales. The beaded antennae are a

▲ Tenebrionidae > *Somaticus praephallatus*

◄ Tenebrionidae > *Phanerotomea* sp. (Toktokkie) – page 260

▼ Tenebrionidae > *Cryptochile namaqua*

▲ Tenebrionidae > *Somaticus* sp.

▼ Dermestidae > *Dermestes maculatus* (hide beetle)

dark-brown colour. The legs are a creamy white speckled with dark brown. The adults are mostly active during spring and scavenge on plant and animal material. This species is relatively common in the arid, sandy areas of the west coast and Namaqualand.

Somaticus sp., a tenebrionid beetle, is approximately 22 mm in length. This species is common in Namaqualand and the semi-desert areas of the Northern Cape. The head and neck shield are a grey-black, while the wing covers are a shiny black with well-developed longitudinal ridges. This species is characterised by two white lines on the forehead. The long, greyish legs enable the insect to move rapidly in sandy conditions. The adults scavenge on plant and animal material.

Dermestidae (hide beetles)

The various members of this family are commonly called skin beetles, leather beetles or hide beetles. They are small to medium-sized, oval and either downy or scaly, with a strongly deflected head, which is barely visible when viewed from the top. The neck shield is sharply narrowed towards the front. The three-segmented antennal club is striking. The outer covering of the insect body is dark but often there are patterns formed by scales. These beetles feed on dried animal and plant remains with high protein content. *Dermestes maculates* has a cosmopolitan distribution and feeds on hides, furs and skins as well as cured meat and cheese. The female seeks out any dried animal matter to lay her eggs and is quickly attracted to skins. The eggs are laid in small batches in cracks and crevices in the food material. These hatch into active, black, hairy larvae that feed on the dry material, moulting between six and ten times before they are mature. They are about 15 mm long. When fully grown, the larva leaves its source of food and seeks out a place where it can pupate. It bores into anything it can find to make a sheltered tunnel for itself. Even the area between bricks may be honeycombed with their burrows.

Dermestes maculatus, a small hide beetle, is approximately 8 mm in length. The body is oval and blackish, with patterns of whitish scales on the neck shield. The clubbed antennae can be folded against the body when the insect is alarmed. The cylindrical, hairy larva feeds on a variety of dry animal material rich in protein. This species attacks animal and fish carcasses and has also been recorded as infesting dry manure. They are cosmopolitan, occurring in a wide range of habitats. This species can be found in large numbers at a suitable

food source, assisting in the rapid removal of decaying animal material and hence reducing the risk of the spread of disease.

Meloidae (blister beetles)

These insects are usually brightly coloured in the warning colours red, black and yellow. They are small to medium-sized beetles (5–40 mm), varying in colour in their tough front wings from a uniform yellow, brown, red, grey, blue, green or black to a background black with yellow, orange or red bands. These flamboyant colours are a warning to potential predators that they are distasteful or poisonous. The outer covering of the insect body may also be dull or iridescent and the down may be heavy, sparse or even lacking altogether. The family is characterised by its unequal number of tarsal joints and claws. The shape of the prothorax may be rounded, flattened, bell-shaped, elongated or square, but it is characteristically narrower than the wing covers and usually has a prominent 'neck' where it is attached to the head. Useful factors when identifying the different genera and species are the size and shape of the tibial spurs, the tarsal segments and the structure of the mouth parts.

Mimesthe maculicollis, a blister beetle, is approximately 10 mm in length. The body is elongated and soft and the large head is separated by a distinct neck from the narrow neck shield. In this group the neck shield varies in shape but is always narrower than the wing covers. The species is dark in colour; however the neck shield and the wing covers are beautifully patterned in yellow and black. The adults conform to other species within this group by secreting liquids containing the poison cantharadin from the leg joints, which can blister human skin. There is a relationship between their larvae and the eggs of other insects on which they feed. The adults feed on flowers, nectar and plant foliage.

Curculionidae (weevils)

All Curculionidae are primarily plant feeders in the adult and larval stages, feeding especially on flowering plants; every possible part of the flower is used by one or other species. Many species are common generalists but a number are strictly host-specific and specialised. As the larvae are legless, they cannot feed externally on plants like leaf beetle do, so many of them live inside plant tissue. *Hipporhinus setulosus* lives on the ground or on low scrubs, where it feeds on leaves and shoots.

▲ Meloidae > *Mimesthe maculicollis*

▲ Curculionidae > *Hipporhinus setulosus*

Hipporhinus setulosus, a small weevil, is approximately 12 mm in length. It is dark in colour with broken cream striations across the body. The antennae are characteristically elbowed and clubbed and are attached to both sides of the snout, which bears the mandibles at the end. The fused wing covers in this species have a sculpted surface. The legs are short and stout, with strong claws and adhesive pads, to give a grip on smooth leaf surfaces. The adults and larvae are herbivorous. The female bores into plant material to lay eggs. This species is commonly found in arid scrubveld on the west coast of southern Africa, although the distribution does extend inland.

Scarabaeidae (dung beetles)

The species within the family Scarabaeidae that rolls dung is the best known and most charismatic of the group. The beetle makes the ball by breaking off pieces of dung and then patting and pressing them with its front legs. In *Scarabaeus*, the male makes the 'nuptial ball,' which he rolls a considerable

distance away from the original dung source. The female rides the ball while the male rolls it backwards, with the middle and hind legs controlling the rolling action. When the male has buried it, the female follows him down into the hole and they mate. They then settle down to eat the ball of dung, which may take a few days. After this, either the male or the female prepares a brood ball, which is buried. The female accompanies the dung, and with her curved, toothed front leg, she pats the mass of dung into a perfectly round and smooth ball. She then hollows it out on one side and deposits a single white egg approximately 3 mm in length in any one dung ball. In some species, the female shows parental care, staying underground with her egg until it hatches in the spring. The larvae feed on the dung ball until they change into pupae, hollowing out the ball as they feed. Within two or three weeks, the larva has devoured all the dung in the middle of the dung ball and now lies snugly concealed in the hollow shell of the dry dung. Here, it changes into a pupa, which later emerges as an adult dung beetle. Interestingly, certain flightless desert-inhabiting *Pachysoma* species collect and bury vegetable matter and dry dung pellets in moist ground; it is believed that that they eat the fungus which develops on their 'provisions'.

Scarabaeus rugosus, the Green-grooved Dung Beetle, is a medium-sized beetle approximately 21 mm in length. This shiny black dung beetle is associated with the deep, sandy soils along the west coast of South Africa. The head is strongly toothed, while the neck shield and wing covers are covered with small and coarse punctures; the tough front wings also have fine grooves. The tarsi end in two claws. Interestingly, this is primarily a diurnal species and is often observed in early mornings and late afternoons. The adults cut portions of dung from fresh dung pads, producing balls which are rolled away jointly by male and female pairs to be buried. These are used for feeding and preparing brood balls, in which a single egg is laid.

Pachysoma hippocrates, is a medium-sized dung beetle, approximately 30 mm in length. This shiny black beetle has a characteristic heart-shaped neck shield, edged with fine brown hairs. The head is wide and axe-shaped. This is primarily a diurnal species, and like *S. rugosus* has also been recorded in the early mornings and late afternoons. It is a detritus and dry dung-dragger and does not roll its ball. This species is one of the few dung beetles who has lost its ability to fly. *P. hippocrates* is a relatively common species in Namaqualand on the west coast of South Africa.

▲ Scarabaeidae > *Pachysoma striatum*

▼ Scarabaeidae > *Scarabaeus rugosus* (Green-grooved Dung Beetle)

▼ Scarabaeidae > *Pachysoma hippocrates*

Melolonthinae (monkey beetles)

The less typical members of the Melolonthinae are those placed in the tribe Hopliini, which occurs mainly in arid and semi-arid savannah regions of southern Africa. This is a large group of similar-looking species, and accurate identification is only guaranteed by examining the genitalia under a microscope. The adult monkey beetles are small and hairy, sometimes marked with coloured patterns of scales. Unlike most members of this subfamily, they are diurnal and frequent flowers, especially the Compositae. They are commonly seen with only the hind legs protruding from the surface of the flower into which they have burrowed. The larvae live in the ground and feed on the roots of a variety of different plant species.

Peritrichia sp., a monkey beetle, is a small scarab with a body length of approximately 9 mm. The light-brown body, with the exception of the wing covers, is covered with fine hairs, to which pollen adheres. It is a typical small scarab. The hind legs are well developed in the male. The adults feed on flowers and regularly embed themselves in the discs of daisies and mesems when feeding. It is assumed that the larvae feed on roots and plant debris. This relatively common species frequents mesems on the west coast of South Africa.

▼ Hopliini > *Peritrichia* sp.

Buprestidae (jewel beetles)

Some of the best-known jewel beetle species are the large and impressive 'brush beetles' of the genus *Julodis*. The majority of these species occur in the arid, western parts of South Africa. These jewel beetles are metallic blue and torpedo-shaped, with various bright tufts of wax-coated hairs covering the head, neck shield and wing covers. The large eggs of julodines are laid in the soil. The larvae are free-living root feeders and appear to be strongly associated with the plant genus *Lycium*. Another group of small, metallic, torpedo-shaped beetles in Namaqualand occurs in the genus *Acmaeodera*. With few exceptions, the adults of the species within this genus feed on flowers. Their larvae regularly bore into forbs and the flowering stems of aloes.

Julodis chevrolatii, a unique jewel beetle, is approximately 30 mm in length. It is a metallic-blue torpedo-shaped beetle with bright yellow-and-orange tufts of wax-coated hairs covering the head, neck shield and wing covers. This species is alert and sun-loving and flies readily when disturbed. Another defence mechanism is to fall to the ground when approached and disappear into the vegetation below. The female of the species lays eggs in crevices on the bark of Karoo scrubs, especially *Lycium* sp. The larvae excavate oval tunnels in the stems and roots of these plants. This species is common in the western extremities of South Africa and is an icon of the Namaqualand insect world.

Julodis viridipes, an eye-catching jewel beetle, is approximately 30 mm in length. It is a brilliant metallic-blue beetle with a heavily punctured carapace covered in bright-orange, wax-coated hairs. The colouring is thought to be a defence mechanism informing predators that the beetle is distasteful. The larva of this species tunnels in the stems and roots of plants, while the adults feed on the flowers and foliage of Karoo scrubs, especially *Lycium* sp. The adults are short-lived but can be found in large numbers for a period after they emerge. The species is limited to the arid, western part of South Africa.

Acmaeodera lugubris, a small jewel beetle, is approximately 9 mm in length. It is a metallic dark-brown, torpedo-shaped beetle. The head and neck shield are heavily punctured as are the wing covers which have longitudinal ridges and rows of distinct punctures. The species feeds on flowers, pollen and foliage. The adults are very active during the hottest time of the day and appear to hover around flowers. They are common in the arid west coastal region of South Africa.

▲ Buprestidae > *Julodis chevrolatii* (Yellow Brush Jewel Beetle)

▼ Buprestidae > *Julodis viridipes* (Orange Brush Jewel Beetle)

▼ Buprestidae > *Acmaeodera lugubris*

▲ Lygaeidae > *Haemobaphus concinnus*

HETEROPTERA

Lygaeidae (seed bugs)

Most of the Lygaeidae are plant feeders; more particularly they are seed feeders, hence their common name. Some species, members of the Geocorinae, are insect feeders. The plant-feeding species appear to prefer plants of the families Asclepiadaceae, Malvaceae, Asteraceae, Poaceae and Liliaceae. Certain species have also been observed feeding on crushed millipedes, but this is assumed not to be a regular item in their diet.

Haemobaphus concinnus, a seed bug, is a rather attractive insect, approximately 7 mm in length. The elongated body is pink, red, black and white in colour. The antennae and legs are black. The undercarriage of the thorax has white markings which contrast with the black legs. The forewings are pinkish red with numerous black markings. They have three longitudinal veins in the soft membranous part of the forewings. This is a widespread species, which feeds on plant material, especially on seeds and stems.

ORTHOPTERA

Bradyporidae (corn crickets)

The corn crickets are omnivorous and will feed on both plant and animal material. They are cannibalistic, often feeding on their fellows that have been squashed by vehicles on the roads. Although nocturnal, they are also conspicuous when resting on bushes during the day. The males start singing after dark, producing a loud, continuous and piercing buzz. The female apparently uses her long ovipositor to thrust her eggs deep into the soil. The white, oval eggs are large, measuring nearly 6 mm in length. If a gravid female is killed and dissected, only about 14 of these large eggs will be found inside her. The eggs hatch into small corn crickets that look exactly like their parents but are black. It seems certain that there is only one generation per year.

Hetrodes pupus, a corn cricket, is a common sight in the succulent shrubbery of Namaqualand and the arid west coast. It is a large insect approximately 35 mm in length. Its body is a grey-brown while the abdomen has black spines and tan stripes. This species has four characteristic short spines in the middle of the neck shield, forming a rectangular pattern. This species is predominantly active at night, when the male can be heard from a considerable distance producing a continuous piercing, buzzing call. Large individuals can be observed between September and June when females lay up to 15 eggs in shaded soil.

▲ Bradyporidae > *Hetrodes pupus* (corn cricket)

Glossary

antennifer	the area where the antennae are fixed to the head, often indicated by a bump	brachypterous	having short wings that do not cover the abdomen, used of individuals of a species that otherwise have longer wings
apex (adj. apical)	the top or tip of something		
apterous	wingless	carapace	thick hard case or shell made of bone or chitin that covers part of the body
arboreal	living in trees		
arolium (pl. arolia)	pretarsal pad-like or sac-like structures lying between the claws	cephalothorax	the fused head and thorax typical of spiders and many crustaceans
arthropod	an invertebrate creature that has jointed limbs, a segmented body and an exoskeleton made of chitin, e.g. an insect, arachnid, centipede or crustacean	crepuscular	occurring at dusk and dawn
		cribellate	a peculiar perforated organ of certain spiders used for spinning a special kind of silk
		cryptically marked	camouflage markings
bilobed	having two lobes	cubital	relating to the elbow, ulnar bone or forearm
biomass	the mass of living organisms within a particular environment, measured in terms of weight per unit of area		
		cytotoxic	a type of cell in the immune system that destroys other cells
		detritivore	creature that feed on detritus
biome	a major ecological community, a division of the world's vegetation that corresponds to a defined climate and is characterised by specific types of plants and animals, e.g. tropical rain forest or desert	diagnostic	characteristic features
		dimorphism	two or more different forms within a biological species
		diurnal	active during the day rather than at night
		ecotone	the area where different habitats meet
book lung	breathing organ in spiders and other arachnids, with membranous tissue arranged in folds that resemble the leaves of a book	ectoparasite	a parasite that lives on the outside of its host, on the skin or in the hair
		elytrum (pl. elytra)	a tough front wing, occurring in pairs on beetles and some other

	insects, that acts as a protective covering for the rear wings		resembles the adult and develops into the adult insect directly, without passing through the pupal stage
epiphyte	a plant that grows on top of or is supported by another plant but does not depend on it for nutrition	ovipositor	tubular organ at the end of the abdomen used to deposit eggs
eversible	being turned inside out	ovoid	egg-shaped
femur (pl. femora)	the third and often the largest segment of an insect leg	ovoviviparous	producing living young by the hatching of an egg while still within the female
flange	a projecting collar, rim or rib		
forb	any broad-leaved herbaceous plant that is not a grass	pedipalps	pair of appendages that are part of the mouth of spiders and other arachnids, used for manipulating food
gall	swelling on a tree or plant caused by insects, fungi, bacteria or external damage	pheromone	a chemical compound produced and secreted by an creature that influences the behaviour of others
glabrous	smooth and lacking hairs or bristles		
hemelytra	wing covers in true bugs		
juga (pl. jugae)	the front basal part of the wing close to its attachment to the body	postdistal	relating to the part of an appendage furthest from the body
lateral	relating to the side	proboscis	long or tubular mouth part used for feeding, sucking, and other purposes
lobe	a somewhat rounded subdivision of a bodily organ or part		
macula (pl. maculae)	a small spot on the skin; a small pigmented spot on the skin that is neither raised nor depressed	pronotum	neck shield
		prosternum	ventral surface of the first thoracic segment
mandibles	the jaws or mouth parts of an insect for biting or chewing	prothorax	corset on the thorax
		pygidial glands	glands in the hindmost part of the body in some invertebrates
maxilla (pl. maxillae)	paired mouth parts lying behind the jaws, or mandibles, for holding and chewing food	rostrum	a beak or beak-shaped part
		rufous	reddish brown in colour
medial	situated in or towards the middle	scutellum	a hard plate, shield or scale, e.g. on the thorax of an insect
moribund	dry or dead plant material		
multispinose	many-spined	seta (pl. setae)	hair or bristle
nymph	the larva of some insects that	ocellum (pl. ocelli)	a simple (as distinct from a

	compound) eye	tergite	the primary plate forming the dorsal surface of any body segment
spinneret	tiny tubular structure, usually one of two pairs, that exudes the fluid produced by the abdominal glands of a silk-producing spider	thorax	the part of the body between the head and abdomen bearing the wings and legs
spiracle	a small paired aperture along the side of the thorax or abdomen of an insect or spider through which air enters and leaves	tibia (adj. tibial)	the fourth segment of an insect's leg, between the femur and the tarsus
sternum	an arthropod's abdominal covering	trichobothrium (pl. trichobothria)	elongate setae that pick up fine vibrations
stridulatory organ	parts of the body which, when rubbed together, make a chirping or grating sound	tubercle	a nodule; a small raised area on a plant or animal part
stylet	a thin long organ or appendage shaped like a bristle	tympanal organ	auditory membrane or ear-drum
		ungulate	hooved mammals
tarsus (pl. tarsi) (adj. tarsal)	the group of bones that form the ankle joint in vertebrates	venter	underside of an insect
		ventricle	a small cavity or chamber in the body or an organ
tegmen (pl. tegmina)	the forewing of primitive insects such as the cockroach	vertebrate	creature with a segmented spinal column and well-developed brain

Bibliography

Braack, L. 2000. *Field Guide to the Insects of the Kruger National Park*. Struik Publishers, Cape Town

Carruthers, V. (ed.). 2002. *The Wildlife of Southern Africa*. Struik Publishers, Cape Town

Dippenaar-Schoeman, A. & Jocqué, R. 1997. *African Spiders: An Identification Manual*. Plant Protection Institute Handbook no. 9, Agricultural Research Council, Pretoria

Dippenaar-Schoeman, A.S. 2002. *Baboon and Trapdoor Spiders of South Africa: An Identification Manual*. Plant Protection Institute Handbook no. 13, Agricultural Research Council, Pretoria

Evans, A.V. & Bellamy, C.L. 2000. *An Inordinate Fondness for Beetles*. University of California Press, Berkley

Filmer, M.R. 1993. *Southern African Spiders*. Struik Publishers, Cape Town

Holm, E. & Marais, E. 1992. *Fruit Chafers of Southern Africa*. Ekogilde, Hartbeestpoort

Holm, E. 2008. *Insectlopedia of Southern Africa*. Lapa Publishers, Pretoria

Mucina, L. & Rutherford, M. 2006. *The Vegetation of South Africa, Lesotho and Swaziland*. South African Biodiversity Institute, Pretoria

Leeming, J. 2003. *Scorpions of Southern Africa*. Struik Publishers, Cape Town

Le Roux, A. 2005. *Namaqualand: South African Wild Flower Guide 1*. Botanical Society of South Africa, Cape Town

Leroy, A. & Leroy, J. 2003. *Spiders of South Africa*. Struik Publishers, Cape Town

Louw, A.B. & Rebelo, T.G. (eds.). 1988. *Vegetation of South Africa, Lesotho and Swaziland*. Department of Water Affairs & Tourism, Pretoria

Picker, M., Griffiths, C. & Weaving, A. 2004. *Field Guide to South African Insects*. Struik Publishers, Cape Town

Scholtz, C.H. & Holm, E. 1985. *Insects of Southern Africa*. Butterworth Publishers, Durban

Skaife, S.H. 1979. *African Insect Life*. Struik Publishers, Cape Town

Smith, L. 2008. *Remarkable Insects of South Africa*. Briza Publishers, Pretoria

Stals, R. & Prinsloo, G. 2007. 'Discovery of an alien invasive, predatory insect in South Africa: the multicoloured Asian ladybird beetle, *Harmonia axyridis* (Coleoptera: coccinellidae).' *South African Journal of Science* 103: 123–126

Tarboton, W. & Tarboton, M. 2002. *A Field Guide to the Dragonflies of South Africa*. Privately published

Tarboton, W. & Tarboton, M. 2005. *A Field Guide to the Damselflies of South Africa*. Privately published

Williams, M. 1994. *Butterflies of Southern Africa: A Field Guide*. Southern Book Publishers, Halfway House

Woodhall, S. 2005. *Field Guide to the Butterflies of South Africa*. Struik Publishers, Cape Town

Van Rooyen, N. 2001. *Flowering Plants of the Kalahari Dunes*. Ekotrust, Pretoria

Van Wyk, B. & Malan, S. 1998. *Field Guide to Wild Flowers of the Highveld*. Struik Publishers, Cape Town

Index

A

Acanthoplus discoidalis 40-41
Acmaeodera foudrasi 193
Acmaeodera lugubris 267
Acmaeodera ruficaudis 80
Acmaeoderini 193
Acoloba lanceolata 88-89
Acraea horta 134-135
Acraea natalica 36-37
Acrosternum species 127
Adelostomini 10, 182, 225-226
Adesmiini 11, 226
Adoretus punctipennis 16-17
Afidenta capicola 149
Afromaculepta species 225
Agaristidae 36
Agelia petelii 192
Agonoscelis puberula 90
Agonoscelis versicoloratus 89, 128
Agrilinae 239
Agrilus species 193
Alleculinae 10-11, 66
Allogymnopleurus thalassinus 72
Alphocoris indutus 83
Alydidae 33, 96-97, 129, 244-245
Alydinae 96-97, 129, 245
Amarygmini 65
Amata cerbera 36
Amiantus species 181
Ammoxenidae 205
Ammoxenus amphalodes 207
Amorphocephala imitator 176
Anadora cupriventris 239-240
Ancylonotini 21
Ancylonotus tribulus 21
Andocides vittaticeps 242
Anisorrhina algoensis 77-78
Anomalipus species 228
Anoplolepis custodiens 204
Anoplolepis steingroeveri 249
Antestiopsis thunbergii 85
Anthia cinctipennis 221
Anthia decemguttata 258
Anthia homoplata 221
Anthia limbata 220-221
Anthia maxillosa 257-258
Anthia thoracica 58, 170

Anthiinae 57-58, 170, 172, 220-222
Anthribidae 144
Antilochus nigrocruciatus 158-159
ants
 Pugnacious 204, 249
 Velvet 44, 113, 205, 249
 Yellow-haired Sugar 204
ant lions 45
Apis mellifera 130-131
Arachnida 116-119, 138-139, 162-163, 206-209
Arachnidae 46-49
Araneidae 117, 163
Archibrachon servillei 109
Argiope trifasciata 46-47
Asopinae 28-29
Aspavia albidomaculata 156
assassin bugs 30-31, 94-96, 157-158, 200, 244
Assidini 182
Astylus atromaculatus 60
Atractocerus brevicornis 24
Atractonotus mulsanti 222
auger borers 23
Axiocerses amanga amanga 38
Azanus jesous jesous 200-201

B

Bagrada Bug 84, 127
Bagrada hilaris 84-85, 127
Bankenveld Grassland 51-119
Basiothia medea 35-36
bean beetles
 Carpet 67
 CMR 67, 184, 231
beetles 4-26
 anthicid 12
 ants' nest 59-60, 174-175
 Auger 81-82
 bean 67, 184, 231
 blister 12-13, 67-68, 183-185, 231-232, 263
 bombardier 170, 173
 brentid 176
 carabid 170-171
 carcass 185-186
 cerambycid 153, 241

 chequered 12, 66
 clerid 12
 click 23-24, 152-153
 curculionid 14
 darkling 10-11, 63-66, 147, 180-183, 225-231, 258, 260-262
 diurnal 180
 dung 15-16, 71-75, 189-190, 237-238, 264-265
 erotylid 152
 False Snout 176
 flat bark 196-197
 flea 60-61, 63, 146
 flower 69, 258-259
 fruit chafers 17-18, 75-79, 153, 191, 239
 fungus 4
 gnawing 14, 70, 185
 ground 6, 56-58, 125, 144, 170-173, 218-222, 257-258
 hide 262-263
 hister 25-26, 148
 jewel 18-19, 79-80, 192-194, 239-241, 254, 267
 leaf 9-10, 60-63, 125, 145-147, 177-179, 224-225
 leather 262
 ladybirds 68-69, 126, 149
 longhorn 20-22, 80-81, 153-154, 195-196
 lycid 218
 lymexylid 24
 meloid 192
 monkey 190, 266
 mouldy 182, 226
 net-winged 55-56, 154, 218
 passandrid 196
 pleasing fungus 152
 Real Bombardier 173
 Red-banded Fungus 152
 rhinoceros 15, 74, 188-189, 238
 Ridged Seed 225-226
 rose 15
 scarab 16-17, 71-74, 188-190, 238
 seed 179-180

 ship-timber 24-25
 skin 262
 spiny leaf 146
 Steel 25-26
 tenebrionid 11, 63-64, 66, 147, 180-183, 225, 227-228, 230, 260-262
 tiger 5-7, 58-59, 173-174, 222-224
 tortoise 9-10, 146-147, 177-178
Belenois aurota aurota 246
Belenois creona 135
Belonogaster species 109-110
Biblidinae 134
Billea gigantea 45
Blaberidae 45
Blapton ramentaceus 95
Blepharida ornata 63
blister beetles 12-13, 67-68, 183-185, 231-232, 263
 Lunate 68
 Slender Grey 231-232
 Tiny Grey 232
Blosyrini 151
Blosyrus saevus 151
blowflies 249
 Regal 250
Boerias pavida 156
Bolbaffer princeps 74, 75
Bolboceratidae 190
Bolboceratinae 74-75
Bolbocoris rufus 87
Bonesioides kirschi 61-62
Bostrichidae 23, 81-82
Bostrichinae 23
Bostrychoplites cornutus 23
Bostrychoplites pelatus 23, 82
Brachininae 173
Brachinini 173
Brachinus subcostatus 173
Brachycerinae 234, 236
Brachycerini 236
Brachycerus species 236-237
Brachyplatys testudonigra 160
Braconidae 109
Bradybaenus opulentus 6
Bradyporidae 40-41, 249, 269
Brentidae 154-155, 176, 237

broad-headed bugs 33, 96-97, 129, 244-245
Brotheini 234
Bruchinae 179-180, 225
Buprestidae 18-19, 79-80, 192-194, 239-241, 267
burrowing bugs 159
butterflies 34-39
 African Common White 135
 African Monarch 36-37
 Blue Pansy 135
 Broad-bordered Grass Yellow 103, 105
 Brown-veined White 246
 Bush Scarlet 38
 Citrus Swallowtail 137
 Common Diadem 138
 Common Dotted Border 133
 Crimson-speckled Footman 35
 Dotted Blue 246
 Ella's Bar 37-38
 Eyed Pansy 137
 Foxy Emperor 38-39
 Garden Acraea 134-135
 Garden Commodore 133
 Grass Jewel Blue 246
 Green-banded Swallowtail 137-138
 Green-veined Emperor 105
 Natal Acraea 37
 Painted Lady 134
 Pearl Emperor 161-162
 Red Tip 38
 Small Orange Acraea 133
 Speckled Emperor 247-248
 Spotted Joker 134
 Squinting Bush Brown 161
 Topaz-spotted Blue 200
 Topaz Tip 39
 Yellow Pansy 136
 Zebra White 135
Byblia ilithyia 134
Bycyclus anynana anynana 161

C
Caerostris sexcuspidata 162-163
Calidea dregii 27, 83-84, 242
Calliphoridae 250
Caloecus pontis 151
Calosoma chlorostictum 170-171
Calosoma planicolle 6
Camponotus fulvopilosus 204
Carabidae 7, 56-58, 125, 144, 170-173, 175, 218-223, 257-258

Carabinae 6, 170
Carbula blanda 155
Carbula limpoponis 29
Carlisis wahlbergi 128-129
Caryedon multinotatus 225
Caryedon species 179
Cassida irregularis 146-147
Cassida species 9-10
Cassidinae 9, 146, 177
Cassidini 146
Catascopus rufipes 144
Catharsius species 189-190
Caura rufiventris 156
Cenaeus pectoralis 159
Cephalotilla species 205
Cepurini 150
Cerambycidae 20-22, 80-81, 153-154, 195-196, 241
Cerambycinae 195
Ceratogyrus darlingi 46-47
Cercopidae 100, 162
Ceroctis phalerata 184
Ceroctis species 13
Cetoniinae 17-18, 75-79, 153, 191, 239
Cetoniini 153
Chaetodera regalis 7
Charaxes candiope 105
Charaxes jasius saturnus 38-39
Charaxes varanes varanes 161-162
Charaxinae 38, 105, 161
Cheilomenes lunata 68-69
Cheiracanthium furculatum 118
chequered beetles 12, 66
Chilades trochylus 246
Chlaenius coscinioderus 171
Chlaenius perspicillaris 219
Chrysochroini 192, 240
Chrysomelidae 9-10, 60-63, 125, 145-147, 177-179, 224-225
Chrysomelinae 145, 224
Chrysomya marginalis 250
Chrysopidae 113
cicadas 101-103
Cicadinae 102
Cicindelinae 6-7, 58-59, 101-103, 173-174, 222-224
Cigaritis ella 37-38
Cladophorus marshalli 55-56
Clavigralla tomentosicollis 30
Cleonini 235
Cleridae 66
Cletus pusillus 91
Cletus species 91, 129

Clonia species 41-42
Coccinellidae 68-69, 126, 149
Coccinellinae 68
Coenomorpha nervosa 86-87
Colasposoma fulgidum 125
Colasposoma species 62-63
Coleoptera 4-26, 55-82, 125-126, 144-155, 170-197, 218-241, 257-267
Coliadinae 103
Colotis amata calais 39
Colotis antevippe gavisa 38
Conoderinae 15
Conopidae 111
Coprini 189
Copris elphenor 189
Coraebini 239
Coreidae 30, 91-92, 128-129, 157, 198-199, 243
Coreinae 30, 91-92, 128-129, 157, 199, 243
Coridius nubilus 245
Coryna surcofi 12
Cosmolestes pictus 31
cotton stainer bugs 32, 158-159
Crambidae 36
Cremastocheilini 239
crickets
 armoured ground 40-41
 bush 106-107
 corn 40-41, 249, 269
 mole 203-204
Crossotus plumicornis 22, 196
Crossotus stigmaticus 21-22
Crustacea 163
Cryptocephalinae 9, 179, 224
Cryptocephalus species 179
Cryptochile namaqua 261-262
Ctenuchida 36
Curculionidae 14-15, 69-70, 149-152, 186-187, 233-237, 263-264
Cydnidae 159
Cyladinae 237
Cylas species 237
Cylindera dissimilis 223
Cylindrothorax bisignatus 231-232
Cylindrothorax species 13
Cypholoba gracilis 58, 172-173, 221-222
Cypholoba macilenta 57-58
Cyphonistes vallatus 74

D
damselflies
 Dancing Jewel 115
 Natal Sprite 115
Danainae 37
Danaus chrysippus aegyptius 36-37
darkling beetles 10-11, 63-66, 147, 180-183, 225-231, 258, 260-262
 Bellamy's 260
 Tapering 65
 Tar 230
 Toktokkie 260-261
 Tortoise 226
Dasylabris merope 205
Dasylabris stimulatrix 44, 249
Dasynus nigromarginatus 157
Decapotoma lunata 68
Decapotoma transvaalica 13
Decaria species 61
Declivitata bohemani 126
Decoriplus species 228-229
Dereodus species 186
Dermestes maculatus 262
Dermestidae 262-263
Derocalymma species 45
Dichostates compactus 21-22
Dichostates lignarius 195
Dichtha cubica 63
Dicronorrhina derbyana 78-79
Dictyophorus spumans 203
Diestecopus species 228
Dieuches armatipes 33
Dinidoridae 245
Diplopoda 250
Diptera 44-45, 111-113, 132-133, 249-250
Dircemella humeralis 178-179
Dischista rufa 75
Dischista cincta 18, 191
Discolomatidae 147-148
dragonflies
 Dorsal Dropwing 114-115
 Julia Skimmer 114
 Red-veined Dropwing 114
Dromica clathrata 174
Dromica costata 223
Dromica lateralis 223-224
Drosochrini 64, 228
dung beetles 71-73, 189-190, 264-265
 Bronze 16
 earth-boring 74-75, 190
 Flattened Giant 238

Green-grooved 265
Small Green 15-16
Durmia horizontalis 84
Dymantis relata 84
Dynastinae 74, 188, 238
Dysdercus intermedius 32

E
East Coast 141-163
Echinotus spinicollis 183, 228-230
Edocla species 31
Elateridae 23-24, 152-153
Ellimenistes laesicollis 151
Entiminae 14, 151, 186-187, 233-235
Epiphysa flavicollis 226
Epitragini 65
Eremnus species 69-70
Eresidae 208
Eristalinus taeniops 132
Erotylidae 152
Erotylinae 152
Erycastus species 147
Eumastacidae 107
Eumolpinae 62, 125, 178
Eunidia natalensis 20-21
Eurema brigitta brigitta 103, 105
Eurychora barbata 182
Eurychora species 226, 260
Evides pubiventris 18-19
Exocentrus echinulus 196
Exochomus flavipes 69

F
flies 132-144
 big-headed 111
 tachinid 111-112
flower beetles
 Metallic Groove-winged 259
 soft-winged 8, 60, 258
Formicidae 204
Frontodes brevicornis 150-151
fruit chafers 17-18, 75-79, 153, 191, 239
 Amethyst 17, 77
 black 191
 Black and Yellow Garden 76-77
 Brown 153
 Brown-haired 17
 Common Savannah 18, 75, 191
 Emerald 76
 Painted 239
 White-spotted 191
 Yellow 153
 Yellow-belted 75

G
Galerucinae 61, 146, 179, 224, 225
Gasteracantha sanguinolenta 162-163
Gauteng Province 51-119, 121-139
Gerridae 98-99
Giant Millipede 251
Glenea apicalis 81
Glyphodes indica 36
Glypsus conspicuus 29
gnawing beetles 14, 70, 185
Gonioscelis ventralis 112-113
Gonocephalum species 183
Gonometa postica 201
Gonocerini 129
Gonopsis species 90-91
Gonopus bellamyi 260
Gonopus deplanatus 227-228
Gonopus hirtipes 180
Gonopus puncticollis 227
Graphipterus atrimedius 172, 219-220
Graphipterus bilineatus 56-57, 220
Graphipterus circumcinctus 56
Graphipterus hessei 257
Graphipterus limbatus 171-172, 220
Graptoclerus ludicrus 66
grasshoppers 162
 Elegant 105-106
 foam 201
 Koppie Foam 202-203
 long-horned 40-42
 pyrgomorphid 201
ground beetles 6, 56-58, 125, 144, 170-173, 218-222, 257-258
 Ant-mimicking 222
 Burrowing 219
 diurnal 220
 Marsh 6
 Pupa Thief 6, 170-171
 Single-striped Velvet 172, 219-220
 Two-lined Velvet 56
 Two-striped Velvet 220
 Tyrant 257-258
 Velvet 171-172, 220
 White Patch 221
Gryllotalpa africana 203-204
Gryllotalpidae 203-204
Gymnopleurini 72
Gymnopleurus sericatus 15-16, 72
Gynanisa maja 247-248

H
Hadogenes longimanus 119
Hadromerus humeralis 235
Hadromerus species 14
Haemobaphus concinnus 268
Hapalochrops sumptuosus 8-9
Harmonia axyridis 126
Harmonia vigintiduosignata 149
Harpactira species 47
Harpactorinae 31, 94-96, 158, 244
Harpagomantis tricolor 108
Harpalinae 6, 58
Hecyra terrea 22
Hecyromorpha plagicollis 20-21
Heliconiinae 37, 133-134
Helicoverpa armigera 248
Henosepilachna firma 149
Heteronychus arator 188
Heteroptera 26-34, 82-99, 127-129, 155-161, 198-200, 242-245, 268
Hetrodes pupus 269
Hetrodes species 249
Himatismus villosus 65
Hippodamia variegata 126
Hipporhinus setulosus 264
Hipporhinus species 186
Hippotion species 247
Hister species 25-26
Histeridae 25-26, 148
Histerini 25
Hololepta scissoma 148
Homoeocerus nigricornis 199
Homoptera 44, 100-103, 109-110, 132, 162
honey bee 129-131
Hopliini 190, 266
hover fly 132
Hyalites eponina 133
Hydara tenuicornis 157
Hyllus species 48
Hymenoptera 113, 129-131, 204-205, 249
Hyperinae 150
Hypolimnas misippus 138

I
Imbrasia belina 36
Iscadida mniszechi 145
Isciocassis species 177
Isopoda 163
Italochrysa impar 113

J
jewel beetles 18-19, 79-80, 192-194, 239-241, 254, 267
 Cluster Leaf 240-241
 Emerald 18-19
 Giant 192-193
 Meloid-mimicking 192
 Orange Brush 267
 Yellow Brush 267
jewel bugs 82-84
Julodis chevrolatii 267
Julodis viridipes 267
Junonia hierta 136
Junonia oenone 135
Junonia orithya 137

K
Kalahari 211-250
katydids 106-107
 Leaf 42
Kilima decens 117
Kimberley 165-209
KwaZulu-Natal 141-163

L
ladybirds 68-69, 126, 149
 Black Mealy Bug Predator 69
 Chequered 149
 Lunate ladybird 68
 Multi-coloured Asian 126
 Red Herbivorous 149
 Spotted Amber 126
Lagria species 64-66
Lagriinae 65, 147
Lamarckiana bollivariana 43
Lamiinae 20-22, 81, 154, 195-196, 241
Lanelater semistriatus 24
Lasiocampidae 201
leaf beetles 9-10, 60-63, 125, 145-147, 177-179, 224-225
 diurnal 17
 spiny 146
leaf chafers 16-17, 190, 238
leaf hoppers 132
Lebiinae 56, 144, 171-172, 219-220
Lepidoptera 34-39, 103-105, 133-138, 161-162, 200-201, 246-248
Leptocoris species 34
Leptoglossus membranaceus 30
Leptostethini 234
Leptostethus viridicollis 234
Leptynia species 245
Leptynia trilineata 111
Leucocelis adspersa 78

Leucocelis amethystina 17, 77
Licininae 171, 219
Limnogonus capensis 98-99
Limpopo Basin 1-49
Limpopo Province 1-49
Liochelidae 119
Lipostratia elongata 172
Lixinae 235
Locris areata 162
Locris arithmetica 100
locusts
 Green Milkweed 202
 Rain 43
longhorn beetles 20-22, 80-81, 153-154, 195-196
 Large Brown 20
 Lichen 21
 Plume-antennae 22
 Plumed 196
 Turquoise 195-196
 Yellow banded 195
Lophothericles species 107
Lophyra neglecta subspecies *intermediola* 7
Lophyra reliqua 174
Lycaenidae 37, 200, 246
Lycaeninae 37-38, 246
Lycidae 55-56, 218
Lycium species 255
Lycus rostratus 55, 218
Lygaeidae 93, 199-200, 243-244, 268
Lygaeinae 92-93, 199, 243
Lymexylonidae 24-25

M

Machla verrucosa 182
Macrorhaphis acuta 28-29
Macroscytus species 159
Macrotoma palmata 20
Malachiinae 8-9
Manticora mygaloides 59
Manticora sichelii 173
Manticora tibialis 222
Mantidae 131
mantids 108, 131
 Bark 43-44
 Common Green 131-132
 Flower 108
Mantodea 43-44, 108, 131-132
Mausoleopsis amabilis 191
Megalodacne species 152
Megalodacnini 152
Melambia species 70, 185
Melitonoma mutisignata 9

Meloidae 12-13, 67-68, 183-185, 231-232, 263
Meloinae 67-68, 184
Melolonthinae 16, 190, 238, 266
Melyridae 8, 60, 258
Melyrinae 8
Melyris apicalis 8
Melyris viridis 259
Membracidae 100-101
Menida decoratula 242-243
Menida species 88
Meridiobolbus quinquedens 190
Metagonum species 125
Metriopus platynotus 11
Micrantereus species 64
Mimesthe maculicollis 263
Mirperus jaculus 97, 129
Molurini 63-64, 181, 227-230
moths
 African Wild Silk 201
 Hawk 247
 Heady Maiden 36
 Pearl 36
 Small Verdant Hawk 35-36
Munza furva 102-103
Mutillidae 44, 113, 205, 249
Myla microphthalma 92
Mylabris alterna 68
Mylabris burmeisteri ab. *Perssoni* 184-185
Mylabris holosericea 67-68
Mylabris oculata 67, 184, 231
Mylothris agathina 133
Myriochile melancholica 7, 174, 223
Myrmarachne species 207-208
Myrmarachninae 207
Myrmeleontidae 45

N

Nagusta species 158
Namaqualand 253-269
Neoscona moreli 116
Nephila senegalensis 46
Nephilidae 46
Nest Chafer, Black Wasp 191, 239
Neuroptera 45, 113-114
Nicolebertia species 197
Niphetophora rhodesiana 18
Noctuidae 248
Northern Cape 165-209, 211-250, 253-269
Notiophygus species 148
Nupserha apicalis 154

Nymphalidae 37-38, 105, 133, 135, 137-138, 161
Nymphalinae 134-138

O

Odonata 114-115
Olenecamptus olenus 21, 241
Omorgus squalidus 186
Oncopeltus famelicus 92-93
Oniticellini 71
Oniticellus egregius 71
Onitis crenatus 72
Onitis cupripes 16
Onthophagini 71, 237
Ooidius dorsiger 58
Oosomini 151
Oplostomus fuligineus 191, 239
Orthetrum julia 114
Orthomias species 233-234
Orthopleuroides species 12
Orthoptera 40-43, 105-107, 162, 201-204, 249, 269
Otiorhychini 151
Oxyopidae 206
Oxypiloidea species 43-44

P

Pachnoda picturata 239
Pachnoda sinuata subspecies *flaviventris* 76-77
Pachnoda sinuata subspecies *sinuata* 153
Pachylomerus femoralis 238
Pachylomerus femoralis 72-73
Pachysoma hippocrates 265
Pachysoma striatum 265
Palparellus nyassanus 45
Palystes superciliosus 116-117
Pamphagidae 43, 162
Pantoleistes princeps 94
Papilio demodocus 137
Papilioninae 137
Papilio nireus 137-138
Parabuthus mossambicensis 49
Paraclara species 111-112
Paraivongius species 62
Passalidius fortipes 219
Passandridae 196-197
Paussidae 59-60, 174-175
Paussini 175
Paussus dohrni 60
Pentaplatarthus species 175
Pentatomidae 29-30, 84-91, 127-128, 155-156, 198, 242-243

Pentatominae 28-29, 84-90, 127-128, 155-156, 198, 242
Pentodontini 188
Peritrichia species 266
Petascelis remipes 92
Peucetia viridis 206
Phaedonia circumcincta 225
Phalops rufosignatus 237-238
Phanerotomea species 42, 64, 106, 228, 260-261
Phasmatidae 111, 245
Phileurini 238
Pholcidae 139, 209
Phoracantha recurva 195
Phricodus hystrix 90
Phygasia limbata 61
Phyllocephalinae 88, 90
Phymateus viridipes 202
Physocephala species 111
Physosterna armatipes 260
Phytomia incisa 44
Phytomia natalensis 132
Pierinae 38-39, 133, 135, 246
Pieridae 38-39, 103, 133, 135, 246
Piezodorus flavulus 85-86
Piezosternum calidum 160
pill bugs 160-161
Pinacopteryx eriphia 135
Pisauridae 49, 119
Plaesiorrhinella plana 75-76
Plaesiorrhinella trivittata 77
Plataspidae 160-161
Platycorynus dejeani 62-63
Platycorynus species 125, 178
Platycypha caligata 115
Platyninae 125
Platynotini 180, 227-228
Plinachtus pungens 91
Podopinae 87
Polyclaeis equestris 187
Porphyronota maculatissima 153
Portia species 48
Praeugena species 180
Praeugenini 180
Precis archesia 133
Prioninae 20
Prionotolytta binotata 232
Prismatocerus auriculatus 199, 243
Proagoderus sapphirinus 71-72
Prosopocera lactator 195-196
Prosopocera paykulli 81
Prunaspila bicostata 10-11
Psalydolytta lorigera 13
Psammodes species 63
Psammodes vialis 227

Pseudagrion spernatum 115
Pseudatelus foveatus 28-29, 198
Pseudatelus natalensis 86
Pseudatelus notatipennis 29
Pseudophloeinae 30, 92
Pseudophonoctonus paludatus 31, 244
Psiloptera foveicollis 18, 194
Psiloptera gregaria 80
Pyrgomorphidae 202-203
Pyrrhocoridae 32, 158-159

R
Reduviidae 30-31, 94-96, 157-158, 200, 244
Reduviinae 31, 200
Rhabdotis aulica 76
rhinoceros beetles 74, 188-189, 238
 Fork-horned 74
Rhizoplatodes castaneipennis 74
Rhopalidae 34
Rhynocoris erythrocnemis 96
Rhynocoris pulvisculatus 95-96
Rhynocoris rapax 95
Rhynocoris tristis 96
Rhynocoris violentus 94
Rhyparochromidae 33
Rhyparochrominae 33
robber flies 112-113
Rutelinae 16-17

S
Saginae 41
Salticidae 48, 207
Saturniidae 36, 247
Satyrinae 161
Scarabaeidae 15, 17, 71-73, 75, 77, 79, 153, 188-189, 191, 237-238, 264-265
Scarabaeinae 15-16, 71-73, 189-190, 237-238
Scarabaeus ambiguus 73
Scarabaeus rugosus 265
Scarites species 258
Scaritinae 219
Sceliages species 73
Sceliphron spirifex 119
scentless plant bugs 34
Sericini 16
Sciobius bistrigicollis 151-152
Scolia species 110
scorpions 49, 119
 Long-handed Rock 119

Scutelleridae 26-27, 82-84, 198, 242
seed bugs 33, 199-200, 243-244, 268
 Milkweed Bug 92-93
 Sunflower 89, 128
Seothyra species 208-209
Sepidiini 183
Sericini 238
Serinethinae 34
Serrichora murina 227
shield-backed bugs 27, 198, 242
 Picasso Bug 26-27
shield bugs 29-30, 84-91, 127-128, 155-156, 198, 242
 Antestia Bug 85
 Rainbow 83-84, 242
Smeringopus natalensis 139
Smeringopus pallidus 209
Solenosthedium liligerum 27, 198
Somaticus aeneus 230
Somaticus praephallatus 261
Somaticus species 181, 262
Somaticus vestitus 181
Spartecerus rudis 235-236
Sphadasmini 15
Sphadasmus camelus 15
Sphaeratix latifrons 145-146
Sphaerocoris annulus 26
Sphaerocoris testudogrisea 26-27, 82-83
Sphenoptera species 194
Sphenopterini 194
Sphingidae 35, 247
Sphodromantis gastrica 131-132
spiders
 baboon 47
 Banded Golden Orb 46-47
 Bark 162-163
 Buckspoor 208-209
 Daddy Longlegs 139
 fishing 119
 Golden Orb 46
 Grass Hairy Field 116
 Grass Lesser Wandering 116
 Green Lynx 206
 Hairy Field 117
 Horned baboon 46-47
 kite 162-163
 rain 116-117
 sac 118
 sand-diving 207
 wolf 118
 Yellow Flower Crab 138

Spilomelinae 36
Spilostethus macilentus 243-244
Spilostethus pandurus 199-200
Spilostethus rivularis 93
Spilostethus trilineatus 93
Spirostreptidae 251
Spirostreptus heros 251
spittle bugs 100
 Red-spotted 100, 162
Stenodesia arachnoides 11
Steraspis ambigua 240-241
Sternocera orissa 192-193
stick insects 111, 245
stink bugs 29-30
 Bark 86-87
 Inflated 160
Stips dohrni 226
Stolliana species 162
Stridulomus sulcicollis 230-231
Sumelis occidentalis 154
Synthocus nigropictus 234-235
Syphidae 44
Syrichthoschema cribratus 238
Syrphidae 132

T
Tachinidae 45, 111
Tanymecini 14, 151, 186, 233, 235
Tarucus sybaris 246
Temnorhynchus coronatus 188
Tenebrionidae 10-11, 63-66, 83, 147, 180-183, 225-231, 258, 260-262
Tessaratomidae 160
Tettigoniidae 41-42, 106-107
Thalassius species 48-49
Thalassius spinosissimus 119
Thanasimodes gigus 12, 66
Theraphosidae 47
Thericleinae 107
Thomisidae 119, 138
Thomissus blandus 118-119
Thomisus daradioides 138
Thyene species 48
Thyreopterus limbatus 144
Tibellus minor 116
tiger beetles 6-7, 58-59, 173-174, 222-224
 Monster 5, 173
 Royal 7
 wingless 174
Titoceres jaspideus 196
Toxaria species 146
treehoppers 100-101

Trithemis arteriosa 114
Trithemis dorsalis 114-115
Trogaspidia species 113-114
Trogidae 185-186
Trogossitidae 14, 70, 185
Trogossitinae 70, 185
Tropiduchidae 132
Tropiphorin 235
Trox squamiger 185-186
twig wilter bugs 30, 91-92, 128-129, 157, 198-199, 243
 Giant 92

U
Umfilanus declivis 101
Utetheisa pulchella 35

V
Vanessa cardui 134
Vespidae 109
Veterna sanguineirostris 88
Vutsimus species 65

W
wasps
 Dauber 119
 Mammoth 110
water striders 98-99
weevils 14-15, 69-70, 149-152, 186, 233-237, 263-264
 Fungus 144
 Lily 234-237
 Pink-banded 187
 primitive 154-155, 237
woodlice 163
worms
 African Boll 248
 Mopane 2-3, 36

X
Xeloma aspersa 17-18
Xylinades maculipes 144

Z
Zenonina albicaudata 118
Zenonina mystacina 118
Zonitinae 67
Zonitomorpha stella 67
Zonocerus elegans 105-106
Zophosini 183
Zophosis boei 183